NATURAL MISSOURI

NATURAL MISSOURI

WORKING WITH THE LAND

NAPIER SHELTON

UNIVERSITY OF MISSOURI PRESS COLUMBIA

Library of Congress Cataloging-in-Publication Data

Shelton, Napier.
 Natural Missouri : working with the land / Napier Shelton.
 p. cm.
 Includes bibliographical references and index.
 ISBN 0-8262-1582-3 (alk. paper)
 1. Natural areas—Missouri. 2. Natural history—Missouri. I. Title.
 QH76.5.M8S44 2005
 508.778—dc22

 2005003717

∞™ This paper meets the requirements of the
American National Standard for Permanence of Paper
for Printed Library Materials, Z39.48, 1984.

Typefaces: Adobe Garamond and Franklin Gothic

TO MY MISSOURI RELATIVES

Thanks for all the good times with all you good people.

CONTENTS

Preface ix

Prairie State Park 1

Roaring River State Park 17

Wilson's Creek National Battlefield 33

Pomme de Terre Lake 49

Glenn Chambers: Cinematographer and Otter Champion 67

Mark Twain National Forest 81

Ozark National Scenic Riverways 108

Mingo National Wildlife Refuge 127

Joel Vance: Writer 144

Protecting Ste. Genevieve 156

Ted Shanks Conservation Area 171

Corn, Cattle, and Quail 188

Mapping Missouri's Breeding Birds 198

Dunn Ranch 211

Squaw Creek National Wildlife Refuge 221

Challenge of the Christmas Bird Count 236

Epilogue 247

Further Reading 249

Index 253

PREFACE

I wrote this book because Missouri is my ancestral home and I wanted to know it better, especially its natural side.

My closest ancestors all came to southwest Missouri in the mid-1800s. Grandfather Samuel Azariah Shelton arrived in a covered wagon with his mother and siblings right after the Civil War. Great-grandfather Cyrus Napier moved from Arkansas to Wright County, then to Webster, with his half-Cherokee wife, about 1858. Great-great-grandfather James McCanse left Tennessee and settled in Lawrence County, with his six slaves, in 1840. Great-great-grandfather James Hopper came to Lawrence County in 1853. They were all farmers.

My father grew up in Marshfield and my mother in Mount Vernon. They met at Drury College and later married, ending up in Washington, D.C. From the time I was a baby we made trips back to Missouri. Memories accumulated: adding another engine to the train at Rolla to make it up a long hill; rolling tires and fishing with Artie Thomas around Marshfield; playing kick the can with my McCanse cousins in Mount Vernon; visiting Aunt Edith and Uncle Sam Shelton, right-hand man to Joseph Pulitzer on the *St. Louis Post-Dispatch;* at age five, being persuaded to fire Uncle George Childress's shotgun on his farm near Diggins (it nearly knocked me over); in recent years, visiting cousins in Springfield, Kansas City, and Columbia.

Whenever possible, I roamed the woods and fields, birdwatching and soaking up the landscape. Genes and experience, I guess, made me a naturalist and writer. So now I return, wishing to know the land more deeply. And what better way than through people who *work* with the land. To a large extent, this book views natural Missouri through their eyes.

I picked the places described here to sample the physical variety of Missouri, and the people to sample the variety of professions that deal with the land and water of the state: natural resource managers, biologists, interpreters,

maintenance workers, engineers, a farmer, a writer, a cinematographer, and others. We also meet hunters, fishermen, and birdwatchers—people who "work with the land" for fun.

I define "natural" broadly, from land preserved strictly in its natural state to land (and sometimes water) altered in various ways to produce various things. Thus, the agencies that manage most of the places operate under different philosophies and different legislation. Natural (as opposed to historical) state parks, run by the Missouri Department of Natural Resources, are managed essentially as nature preserves, with restoration of presettlement conditions in some cases. State conservation areas allow a broad spectrum of uses, from hunting, fishing, and some timbering, to nonconsumptive pursuits like hiking and camping. The principal purpose of national wildlife refuges is to protect and produce wildlife, so the two refuges we visit, like many other wildlife refuges, have built impoundments to create good habitat for waterfowl and other wetland species. Units of the national park system vary in their purposes and practices, but always with maintenance of natural processes a high priority. The USDA Forest Service perhaps allows the greatest variety of uses of any land-managing agency described here.

Thus, managing nature is a theme that runs through the whole book. The *degree* of management ranges from largely hands-off, as in state parks, to largely hands-on, as in farming. Some of the practices require justification. The use of fire seems to fly in the face of Smokey Bear's admonitions. Introduction of nonnative species can be dangerous or benign. Why, some might ask, should we turn back the clock and restore earlier landscapes? Such questions are addressed as they crop up from place to place.

My special interest in birds shows up here and there. This has been my opening wedge into knowledge of the natural world, and I hope nonbirders will at least empathize with my enjoyment of the subject and perhaps even catch some of the bug.

We follow a U-shaped route through the state: from southwest to southeast, then north and finally west. We visit state parks, a conservation area, federal lands, a Nature Conservancy prairie, a town threatened by the Mississippi River, and a farm. There are many other places I would have liked to have written about, such as Mastodon State Park; Graham Cave State Park, with its ten-thousand-year history of human occupation; Davis

Minton's vast farm in the Bootheel, where he mixes crop production, water-fowl hunting, and wetland restoration; a commercial cave and its management to protect the delicate features; restoration of mined land; the Missouri River and controversies about its use. Perhaps another time.

Help, as usual, came from many quarters. The book, in fact, is based on that help.

I must give first thanks to Joel Vance and Brad Jacobs, who shared the story of their lives and work with me, read the entire manuscript, and saved me from a few blunders. Joel also directed me to several people who figure in this book.

The following were key contributors. At Prairie State Park: Cyndi Evans, Kevin Badgley, Brian Miller, Racine Myers, and Chris Crabtree; at Roaring River State Park: Jerry Dean, Merle Rogers, Tim Smith, and Tim Homesley; at Wilson's Creek National Battlefield: Gary Sullivan, Richard Lusardi, Lisa Thomas, Ron Smith, and Derek Kothenbeutel; at Pomme de Terre Lake: Leroy Williams, Don Ginnings, Jeff Graham and his parents, Dail and Mary, Jim Davis, Rich Meade, Dennis Wallace, Robert Vader, Laura Hendrickson, Christy Dablemont, "Coach" Jim Wilson, Leslie Rubles, and John Steuber; at Mark Twain National Forest: Jerry Gott, Charlotte Wiggins, Ross Melick, Steve Steinman, Klaus Leindenfrost, Robert Glock, John Bisbee, Kolleen Bean, David Hummingbird, Roberta Page, Jody Eberly, Don Fish, Paul Nelson, Bob Harrell, Jenny Farenbaugh, Jim Voyles, Dwayne Rambo, and Donald Taylor (Doe Run Co.); at Ozark National Scenic Riverways: Chris Ward, William Betata, Jim Price, Keith Butler, Charles Putnam, Larry Johnson, Bill Terry, Mike Gossett, Pam Eddy, Bryan Culpepper, Bill O'Donnell, and Fred Fox (The Nature Conservancy); at Mingo National Wildlife Refuge: Charley Shaiffer, Kathy Maycroft, Molly Mehl, and Pete Koppman (Puxico); at Ste. Genevieve: Jim Zerega and Vern Bauman; at Ted Shanks Conservation Area: Mark Lichty, Russell Smith, Keith Jackson, John Poppe, Dan Simmons, Joe Marshall, Brian Cunningham, Carl Barbee, and Ken Vail; at Dunn Ranch: Keith Kinne, Betty Grace, Doug Ladd, and Randy Arndt (MDC-Albany); at Squaw Creek National Wildlife Refuge: Ron Bell and Frank Durbian.

Many other folks, especially the following, helped in various ways. Chuck Tryon supplied information about fishing and lead mines. Dave Erickson and Dave Hamilton described the Missouri otter restoration

project. Glenn Chambers and Dave Mackey gave me hours or days for their chapters in this book. James D. Wilson recounted his career and creation of the Missouri breeding bird atlas. Dale Humburg lent me documents on snow goose problems. Larry Mecklin discussed Missouri's prairie chickens. For information on the Christmas bird counts, I thank Mark Robbins, Susan Hazelwood, Larry Herbert, Ken Vail, Don Arney, Bill Reeves, Fred Young, Roger McNeill, and Randy Korotev.

At the University of Missouri Press, acquisitions editor Clair Willcox was decisively helpful in shaping this book, and I also thank all those involved in its later stages, especially editor Julie Schroeder.

The wear of many days of travel around the state was happily broken by the hospitality of my cousins Thad and Trudy McCanse, Andy and Barbara McCanse, Rex and Nancy Ipock, and third cousin Clyde Napier and his wife, Maxine, down in Noel. For these and many earlier visits, I give continuing thanks.

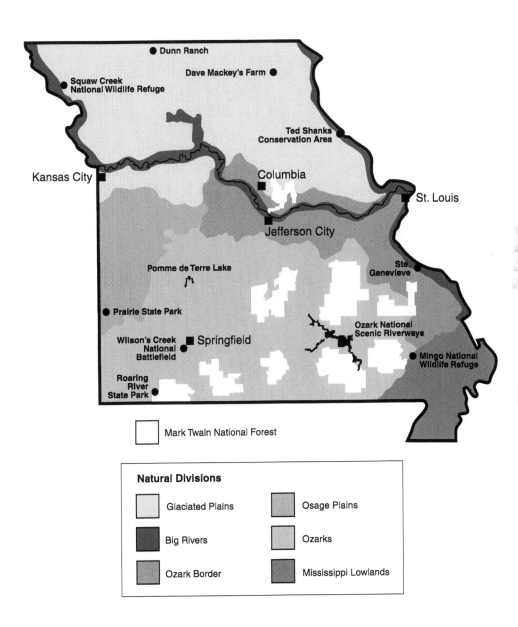

Locations visited in *Natural Missouri.*

NATURAL MISSOURI

PRAIRIE STATE PARK

There are only a few tall prairies left today, but they are worth seeking—worth going to and being in. They are the last lingering scraps of the old time, fragments of original wealth and beauty, cloaked with plants that you may never have seen before and may never see again.

JOHN MADSON, *Where the Sky Began*

Tallgrass prairie once extended from northwestern Indiana to eastern Nebraska and Kansas and covered a third of Missouri. But when better versions of the polished steel moldboard plow were invented, in the mid-nineteenth century, the tough, thick sod could easily be broken. Settlers planted crops in the rich, deep, glacier-deposited, grass-fed soil in most of northern Missouri and in much of the shallower soil in southwestern Missouri. The harvest was bountiful, but a world of infinite variety and beauty was lost. Today, less than a half of 1 percent of Missouri's original prairie remains.

Prairie State Park, west of Lamar, preserves the state's largest remaining public piece. Standing amid its more than three thousand acres of waving grasses in summer, you can imagine the way the prairie once was, extending to the horizon and far beyond. Around you, among the grasses, wildflowers of all sorts and colors bloom. Dickcissels and meadowlarks sing. On a distant rise, the patient, humped shapes of bison graze, following the lead cow. It's an experience too few have known, one to be sought and treasured, one of space, freedom, and peace.

Through the seasons, the prairie changes as much as any woodland—more in its wildflowers—and each season has its own appeal. But no season at Prairie State Park is heralded more thrillingly than early spring—by the booming of prairie chickens. In late February, the males begin gathering

1

at leks—areas where they assemble for courtship and mating—patches of high, bare ground where they strut and swell their orange neck sacs, uttering low moans like the sound of blowing across a Coke bottle. This sound can carry a mile, attracting females to the lekking grounds; as March wears on, females wander through the booming ground until they find an impressive male to mate with. They then depart into the grassland to begin their nesting.

I first saw this strange ritual in mid-March, on a rise that would later in the year become a farmer's wheat field, tucked within the grassland of the park. I waited, some two hundred yards away, in predawn darkness.

5:45—Red streaks the eastern horizon.

6:00—The red ball rises, gradually lighting the open, gently rolling land, taking the edge off the thirty-degree chill. I hear chuckling, cries, and then the low hoots of prairie chickens. Through binoculars I see the orange throat sacs of the booming birds, as they spin and dance, their "ears" and tail pointed skyward. Snow geese fly over, high, headed north.

6:30—The prairie chickens fly off to nearby grassland as a red-tailed hawk sails in and lands on their lek. More snow geese fly over, this time low, as if looking for something. A deer emerges from woods to the north. When the red-tail leaves, the prairie chickens come back and resume dancing and calling.

7:15—They erupt again, flying farther off, as a peregrine falcon comes in low and dangerous over their booming ground. Then the falcon moves on and the boomers return. The males chase each other while two females sit and watch.

8:00—The sounds have stopped. One by one the birds fly off in different directions. By 8:50 they are all gone.

■ ■ ■ ■

Two days later, I return with a group led by Kevin Badgley, then the acting superintendent. There are a dozen of us, from Kansas, Oklahoma, St. Louis, and closer parts of Missouri. It's cold, with a north wind. We watch from the road, and even though it's around 8:00, the birds are still booming. On a cloudy day like this, they go longer.

Kevin explains what's happening and talks about the birds' use of crop

fields. "They feed a lot on milo, corn, and soybeans," he says. "There used to be fields adjacent to the west end of the park. Farmers there said they saw chickens dancing near where the visitor center is now for as long as they could remember." Around 9:00 a few males are still booming up on the rise, but we leave. At the visitor center Kevin shows the group a movie on prairie and answers questions.

Kevin Badgley, a large, tall fellow with a slight stoop and a wry sense of humor, was born and raised in Joplin. He studied biology at Missouri Southern and Southwest Missouri State University. "I always loved being outdoors," he said, "and especially liked to fish." In 1997, before graduating, he was an intern at Prairie State Park, working as a seasonal naturalist. After graduating, he took a position there as tourist assistant.

"I fell in love with the prairie. I love the bison and elk"—the latter roam a unit at the west edge of the park—"and seeing the prairie chickens. . . . We've conditioned ourselves for monocultures. People think the prairie should be like a grass lawn. But prairie is so much more. It's got five hundred or six hundred species of plants and all the animals. People must experience it to know and understand it. . . . It would be difficult

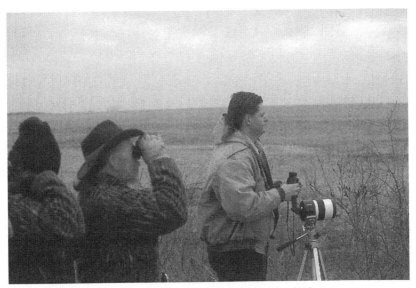

Kevin Badgley (right) and visitors watch distant prairie chickens.
NAPIER SHELTON

for me now to leave this place. But I can still get away and go fishing sometimes."

Kevin's work at the park quickly spread into many facets of resource management and interpretation. That March of my first prairie chickens, I watched him tell six boys and their foster mother about bison and how Indians used all their parts. He had samples of those parts on a big exhibit in a back room of the visitor center used for meetings and for talks to visiting groups.

Kevin asks the boys what they think the bison's big, triangular shoulder blade was used for. One thinks a paddle to spank kids. Kevin shows them this kind of bone with an attached wooden handle and explains they used it as a hoe. A hyperactive little fellow keeps picking up objects and showing off. Kevin absorbs this distraction and continues; he picks up a buffalo chip. "How about a Frisbee for throwing," he says. "No, Indians on the plains used this for fuel. What does it smell like? Grass. This is grass that went through a bison. Indians also used this for a diaper. They crumbled it up, put it in the bottom of a buffalo-skin pack for carrying a child, and put grass on top of that. When the child pooped, they just emptied the stuff out and put new crumbled dung and grass in." He shows them a bison stomach, used for a basket or drum. He drums on it. Then he presents a paper-thin object. "You're right. It's a bladder, but a lot bigger than yours. Indians could use this to drink out of. Same with this bison horn." Then he shows them the short film about the prairie and prairie chickens. All except the hyperactive one sit still and watch, interested.

As a resource manager, Kevin helps monitor plant and animal populations, assists researchers from universities and elsewhere, and from late August to early April is frequently part of a team applying prescribed fire to units of the park.

Emily Dickinson's poetic vision of a prairie was "one clover, and a bee, and revery," but the manager knows that low rainfall, fire, and grazing are the ecological requirements. Historically, North American prairie was maintained by fire and the grazing of bison and other animals. Its organisms were adapted to fire; most prairie plants are perennials with deep root systems safe from the flames, and most of the animals are able to escape fire by running, flying, or burrowing. When the pattern of thousands of years of fires started by lightning or Native Americans ended with European settlement and fire suppression, trees and brush began invading the grass-

lands. Fire, besides killing woody invaders, consumes dead litter that provides a microclimate favorable to woody plants and produces quick releases of nutrients from the ash. Grazing adds diversity to the structure of prairie vegetation, which produces a variety of habitats for animals, from worms, insects, and crustaceans to reptiles, birds, and mammals. Prairie may *look* homogeneous from a distance, but up close you can see many little worlds that subtly vary from one spot to another.

Prescribed fire is now a widely used tool on many kinds of land. Considered in the past to be always bad, unless cooking one's dinner, fire under the right circumstances is now seen as a part of nature, appropriate, useful, and sometimes necessary, at least by natural resource managers. The general public may be gradually understanding the shift in thinking.

Prairie State Park began with the purchase of 1,520 acres of native tallgrass prairie from The Nature Conservancy, which had bought the land after conversion of adjacent prairie to cropland emphasized the need to rescue these remaining, high-quality pieces (now designated the Tzi-Sho, Hunkah, and Regal Prairie natural areas). The park was dedicated in 1982. Subsequent purchases and donations enlarged the park to its present 3,960 acres. In 1987 the first ten bison were introduced from Wichita Mountains National Wildlife Refuge in Oklahoma. By 2003 the herd numbered about 120 animals. Eight elk from Theodore Roosevelt National Park in North Dakota arrived in 1993; by 2003 they had increased to about thirty-five. The bison and elk graze on grassland springing from soils that range from three feet deep to nothing, where sandstone outcrops on hilltops.

These resources, including the streams that wander through the prairie, and all the native plants and animals, present many management challenges. Conditions of the land vary. The highest quality prairie units lie on land that was only hayed or lightly grazed. At the other end of the quality spectrum are about 780 acres that were plowed or strip-mined for coal. In between are units that were heavily grazed or hayed, much of it seeded to nonnative fescue. So restoration of the prairie to its original condition, as far as that can be known, is the number one management goal. The methods are evolving as prairie restoration science grows and experience is gained. Fire, grazing, brush-cutting, spraying with herbicides, and reseeding with native species are the principal tools.

While the primary mission at Missouri's state parks is to protect, preserve,

and interpret them, in some cases, as at Prairie State Park, historic land-scapes are restored. In a few other parks, oak savanna—grassland with scattered oaks—is being restored. No hunting is allowed, except for managed deer hunts in a few parks where high deer populations are a problem. Such hunting is not conducted at Prairie.

Landscapes of earlier times are restored for different reasons. The goal might be to recreate the scene of a historic event, as we'll see at Wilson's Creek battlefield, or to approximate the pre-European settlement land-scape, as at Prairie State Park. It all depends on the purposes of the site.

Wandering the March prairie, I looked and listened for signs of spring. The landscape didn't *look* springlike. The dominant color was a light yellowish brown—the dead grasses from last year. Some sections, recently burned, were black. Others, burned earlier, looked dark brown. At my feet, however, I could see the first tiny green shoots of grasses and sedges. Occasionally I scared up small brown moths. Walking a trail along East Drywood Creek, past swales pooled with water from recent rains, I heard the "prrreeep" of western chorus frogs and the quacks of southern leopard frogs. I wondered if I was also hearing the snore of northern crawfish frogs, an unusual prairie species that often uses the burrows of prairie cray-fish—burrows that are easy to see along the park's trails. A chuckling sound turned out to come from a northern harrier doing roller-coaster dives in courtship flight. A short-eared owl, not yet departed for more northerly breeding grounds, bounded low across the landscape. A bald eagle, apparently on its way north, soared over. Returning to the visitor center, I stopped to watch a herd of fifty bison grazing beside the road. One at a time, three of them rubbed their massive heads and necks on a sign by a service track that said Authorized Vehicles Only.

Park naturalist Cyndi Evans knows the seasons here much better than I. "In a typical year"—this year wasn't typical—"a few things are blooming by mid-March, like wild hyacinth, pussytoes, and prairie anemone. It's usually quite windy. Some days will be warm, but we may have a snow or two. Geese and white pelicans are migrating. Great blue herons, snipe, robins, field sparrows, red-winged blackbirds, and meadowlarks are coming back. The bison cows are very pregnant, and the elk are shedding their antlers. Almost every morning, until mid-April, I'll be counting prairie chickens at the lek. I start doing frog surveys. It's mainly chorus frogs now.

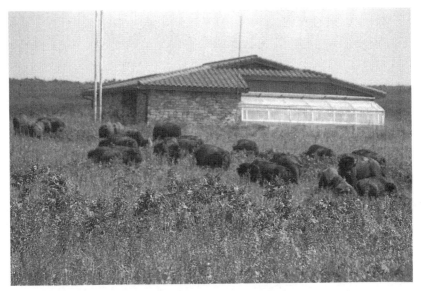

Resident bison graze near the visitor center. NAPIER SHELTON

"In April we'll have arrow-leaved violet, spring beauty, false garlic, yellow star-grass, Indian paintbrush blooming." Most of the early spring wildflowers are small, not sticking their heads up very far, like tundra plants. "Dickcissels and grasshopper sparrows come back. A few butterflies are out. By the third week in April snakes are noticeable. Lizards and turtles are sunning. But we will probably have a frost or two until the first week of May. Grasses are coming on; the bison are having a heyday, and maybe a calf by the end of April. Southern leopard frogs and gray treefrogs are calling, maybe American toads. Lots of school groups come in April and May, especially first and third grades." She does simple talks and projects with the younger kids and covers more complicated subjects, like fire management or careers, with the older ones.

Cyndi has a worried look, as if stamped on her face by concern for all the people, plants, and animals in her life. She also has a vast store of knowledge about the park, where she first worked in the summer of 1988 and has worked full-time since 1992. "I've always been interested in the outdoors," she said. "I went camping, did Girl Scouts." At Missouri Southern she majored in biology and minored in fine arts. She still does some illustrations for the park.

The next year, I arrived in late May, just after a rain. There was a wonderful fresh smell on the prairie, and Regal Prairie was producing an entrancing variety of wildflowers: prairie parsley, with its umbrellas of tiny yellow flowers; lavender prairie phlox; tube and foxglove beardtongue, with tall stems bearing white flowers; green milkweed; blue-flowered common spiderwort, whose blooms last only one day; deep yellow large-flowered coreopsis; bright red Indian paintbrush; white and pink shooting star; and others. Many of these wildflowers were not conspicuous, nestled as they were among the foot-high grasses. At this time of year, sixty to a hundred forbs (broad-leaved plants, as opposed to grasses) are blooming, but only two dozen or so are easy to find. It's a treasure hunt searching for the scarcer ones.

From now through summer, wildflowers and birds will be the big attractions. The flower show changes almost weekly, attended by bees and butterflies, among them the beautiful regal fritillary, a prairie specialty. Most of the birds don't change, but their activities do, from singing in spring and early summer to quietly raising young through the rest of summer. Prairie chickens will be hard to find, as they spread out to nest and feed in the grasslands. Upland sandpipers are easier to see because they like to perch on fence posts and telephone poles. Northern harriers nest here some years, usually in a brushy area out in the prairie. A summer walk on one of the prairie trails will show you many dickcissels and eastern meadowlarks and possibly some of the little brown grassland birds like grasshopper and Henslow's sparrows and, in late summer, the diminutive sedge wren.

As I drove toward the visitor center that late May day, I passed a herd of bison lying down, chewing their cud. Their shaggy, dark brown winter fur was sloughing off, giving them a mottled look. Among these cows, recently born, pumpkin-colored calves frolicked. It had been a banner year for calves. Kevin later said he'd counted twenty-two, probably with a few more on the way. One cow, he said, usually drops her calf around Independence Day. The two herd bulls were somewhere off by themselves, as was a group of younger bachelors.

It was Memorial Day weekend, and more people than usual were dropping by the visitor center, where exhibits tell the story of the prairie and local human history. Always, the people are greeted by a staff member, who answers their questions and often takes the opportunity to give a lit-

tle park interpretation. Unlike state parks with large campgrounds that usually have interpretive programs weekly or more often, Prairie State Park, with only a two-site campground, conducts interpretation primarily with school groups and impromptu contact with visitors, which can number fifty to seventy thousand each year.

Kevin was on duty that Sunday afternoon, when many of the weekend's 177 visitors came in. I admired the way in which he used their questions as springboards into wider pools of natural history information. A woman who was concerned about turtles crossing roads was treated to a short explanation of turtle habits and identification of some of the park's turtles, of which there are at least seven species. A boy who brought in a little ring-necked snake he'd captured elsewhere got a similar discussion. Bison, an inevitable interest of visitors, give Kevin unlimited opportunities to expound on one of his favorite topics, and he did that day.

Two days later, a group from Hermitage High School arrives, with two teachers. They're on a two-week "Missouri as a Classroom" program, in which they visit state parks and historic sites, each student choosing to focus on history, art, or science in these places. Amanda Vansel, a park aide, gives them a bison and Indians talk, then Cyndi takes them on a short stroll up the Drover's Trail. She talks about prairies and tree invasion, and she points out a lone bison bull that has been at a nearby wallow all day. "Bison," she says, "use wallows for a mud or dust bath to keep insects off, or for scratching off itchy fur. Mostly it's the bulls that use them." She asks them to name the signs of bison they have seen on the walk, and the kids answer, having noticed droppings and tracks. A boy, probably from a farm family, wants to know if the park people assist a cow bison having trouble with a birth. "No," Cyndi explains, "bison wouldn't allow this. They view people as predators." She talks about burning and how most animals can escape the fire. She touches on the park's rare or endangered species, like Mead's milkweed, and points out various common plants along the way, inviting the kids to touch sensitive briar, a small plant with balls of pink flowers, to see how its leaves close up on contact, an adaptation for scaring plant eaters.

All this happens in forty-five minutes; the group is on a tight schedule and was late in arriving. They board their yellow school bus and head for their next park.

Nine students and a teacher from Fort Scott Community College take more time. They are on a summer field ecology course. Cyndi gives them an overview of the park and its management, then pulls out a dry-erase board and asks them how they would conduct a burn on the unit including the visitor center, if wind were coming from the north. After various suggestions, some right on the mark, she draws on the board where the fire would be started (at the south end), and how two teams extend the ignition around opposite sides of the unit until they meet at the north end. A piece around the visitor center would be mowed first, to protect the building.

After showing them an excellent new prairie video, she goes into a detailed discussion of various parts of the bison skeleton, including one long vertebra at the animal's hump for holding the muscles needed to support the huge head. She then launches into the Indian uses of bison parts. Next comes a walk behind the visitor center, during which Cyndi calls their attention to the songs of a Henslow's sparrow, a yellow-breasted chat, and a dickcissel. She points out various plants and describes some of their uses: tea from slender mountain mint, vitamin C from the rose hips of pasture rose, a blood-clotting agent from yarrow. Sensitive briar is identified and touched.

The group stayed that night at site 2 in the wooded campground on Middle Drywood Creek. I was at site 1. They, like me, heard great horned and barred owls hooting as dusk arrived, and the howling of coyotes starting on their hunt. I heard these things each of the four nights I camped there; the coyotes especially enthralled me, for it was a sound I hadn't heard since a long-ago trip in the West. The first night, the coyotes were near the campground, with each chorus getting stronger until it was truly heartstirring. What emotion is this? I wondered. What are they saying?

Seasonal naturalists and maintenance men had just come on board and were being trained. Michelle Hoffman and Tarryn Newkirk, the naturalists, Amanda Vansel, the park aide, and the four young maintenance guys assembled with their supervisors in the back room for an orientation session. Brian Miller, the recently appointed natural resource steward (site manager), discussed park policy and practice, aiming most of his talk at the seasonal maintenance men. "Don't take more people to do a job than it requires. If visitors see some of you standing around, they'll let us know

it. They are taxpayers." He spent a lot of time on safety: use of herbicides and mechanical equipment, and precautions against heat stroke and other dangers. "If a bison's tail goes straight out, it's getting real nervous. If it goes straight up, get out of there. Keep two hundred yards away from bison at all times." Cyndi and Kevin presented further overviews of the park and its management. The maintenance guys were urged to learn all they could about it, because visitors would ask them questions.

Racine Myers, at that time the only permanent maintenance person, grew up on a farm that is now part of the park. As a boy, he saw the prairie being burned every spring to promote the growth of grasses, and he helped with the haying of it. Now he likes taking care of the land that had nourished him and his family. He supervises his helpers with an almost fatherly care, making sure they know how to use equipment properly and take the safety precautions Brian Miller had talked about.

One of Racine's more interesting helpers that summer was Chris Crabtree, a tall, slender fellow who traversed the prairie with immense, long-legged strides. Chris had also worked as a seasonal naturalist here and knew the park well. He told me he was one-sixteenth Cherokee. I figure I'm about nine sixty-fourths Cherokee, but Chris looks a lot more Indian than I do, with his black hair tied in a queue hanging down his back. Whether from heritage or experience, he has developed an extraordinarily close relationship with nature. He has camped at the park's backpack camp just to experience the prairie at night. One night, out wandering, he got so close to unseen bison that he could smell them.

On another occasion, after heavy rain, he was confronted with impassable water in the road. While waiting for it to drain off, he left his car and walked on Hunkah Prairie. "Some places I was chest deep in water. I came across a mother coyote and a cub that had been flooded out of their den. Adorable little cub. The mother stood off a ways, watching me as I stood over her cub."

Chris collects cattail pollen for flour, and he makes a salad with wild mushrooms, day lilies, and yucca flowers. He hopes to do graduate work in mycology: "I'm always looking for mushrooms, even when I'm driving. I should have a bumper sticker that says 'I Brake for Mushrooms.'"

The maintenance crew that summer would be spraying patches of exotic invaders like sericea lespedeza and the widespread fescue, clearing trees

and brush, and heightening fences in eastern units of the park before moving some of the bison there—the herd had grown too large for the western units to which it had been confined.

Cyndi and Kevin would spend much time monitoring plant and animal populations. They survey plants in late June or early July, on random plots from fixed starting points on twenty-one transects located throughout the park. On each one-tenth-meter-square plot, they estimate the percentage of cover provided by each species. Each year, they make these measurements on one-third of the transects. "Monitoring shows that some of the poorest areas have improved," Cyndi said, "but that sericea lespedeza is spreading."

Lespedeza cuneata, the sericea, Chinese, or Korean lespedeza, was brought to the United States from eastern Asia for erosion control, soil improvement, food and cover for wildlife, and to some extent for forage and hay. Like so many other introduced plants, it became a pest. It forms dense stands, crowding out native plants, and in fact makes a poor habitat for other organisms. A study in southeastern Kansas found that, in addition to a drastic reduction in native plant diversity, it caused a similarly great reduction in the number of invertebrate species, on which higher forms of animal life could feed. Moreover, the plant proved to be unpalatable to most livestock because of the tannin in its tissues; thus it takes over large areas of grazing land.

■ ■ ■ ■

Kevin counts butterflies along three routes in the park, every month between April and September or October, depending on when the first cold weather occurs. Cyndi counts frogs in March through June. She stops at nine places, after dark, spends five minutes at each, estimating the numbers of each species heard as 1 to 10, 10 to 20, or more than 20. This is a challenge when lots of frogs are really going at it. For birds she visits fifteen locations and spends five minutes at each, recording the numbers of all species seen or heard. These counts take place in early June and July. Prairie State Park has a full complement of all the grassland birds native to this part of Missouri, birds that are declining in most of the eastern United States, and the counts show that most of their populations in the park are stable.

By late July, the composites are taking over the wildflower display, with goldenrods, asters, and sunflowers, including ashy sunflower, the park's most abundant forb, dotting the prairie with yellow, white, and purple. Many will last until September or even into October. The turkey-foot heads of big bluestem, now as high as six feet tall, are flowering. The bison rut begins in July, the bulls bellowing and butting, establishing who will breed. This extends through August, during which some of the lesser bulls may get a chance when the herd bulls become "tired or uninterested," as Kevin put it. In late August, when birds have finished nesting, burning may begin. It will be continued until early April, before most birds begin nesting.

September sees the flowering of little bluestem and the elk rut. Back in their unit at the west end of the park, more often heard than seen, the bulls bugle. At the end of September or the beginning of October, in even years, the park holds its biggest interpretive event—the Prairie Jubilee. With tepees, bisonburgers, period music and dress, they celebrate and recall pioneer days on the prairie. On weekdays, many school groups come to the park to learn the prairie story.

In October, deer begin to mate, and downy gentian, one of the last wildflowers to bloom in Missouri, hits its flowering peak. When the first frosts come, usually by early November, the grasses turn russet, brown, and gold, rivaling the beauty of fall forests. This is also the time for a "wild west show"—the bison are rounded up for their annual vaccinations.

I was there in 2002. Racine Myers had enticed the bison to the corral area, carrying "range cubes"—fifty-pound sacks with protein feed—on the back of an ATV. Some of the bison were already in the corral, but two were in a big adjacent field, and another herd was in a smaller field next to the pens. Two pickups and Kevin on an ATV tried to herd a calf in from the big field, without success. It was left outside, along with about five other bison, including two bulls considered too difficult and dangerous— they might gore other bison in the chutes. The vehicles then turned their attention to the free herd and eventually steered them, thundering, through the corral gate.

Some twenty people, including the park staff, neighboring ranchers, and four men from Roaring River State Park, using long poles and cattle prods, worked the bison a few at a time into successive compartments and

Selected Natural Events at Prairie State Park

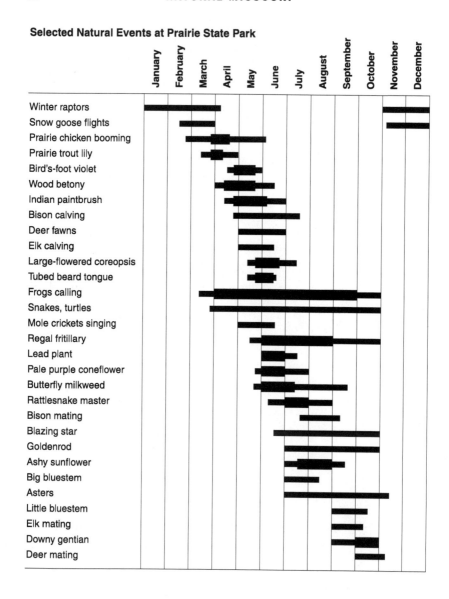

finally, one at a time, into chambers shut off at each end by sliding doors. The last chamber had sides that could be pressed tight to hold an animal securely and a head-sized opening at the end, which was clamped when the animal, seeing daylight, thrust its head through.

Bison are wild animals, and they hate this handling. They bang around continuously in the chutes and chambers, resisting all the way. When one reaches the end, with its huge head sticking out, its terrified eyes bulge as a ring is clipped onto its nose and its head is pulled to the side and immobilized by a rope attached to the ring. All this is necessary for the vaccinations and because the state requires annual testing for brucellosis, a disease that can be transferred to cattle. I watch as a veterinarian draws blood from each bison's neck for testing and fastens an identifying tag on its ear while, through side panels, another vet administers a vaccine for leptospirosis and three other diseases, and Cyndi Evans sticks a temporary tag on its rump. Then the front of the chamber is swung open and the desperate animal lunges to freedom. Sadly, one bison came out with a broken hind leg, which dangled uselessly, like a piece of rope. It had to be shot. Early in the park's bison program, brucellosis was found in some animals,

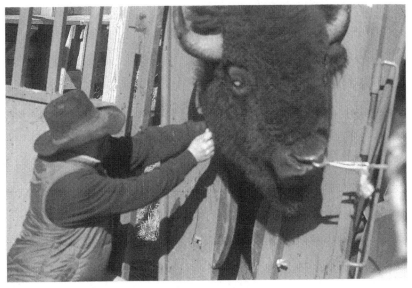

A veterinarian takes a blood sample. NAPIER SHELTON

and that small herd was shipped to Texas A&M for brucellosis research. None of the disease has been found since.

Winter, like every season at Prairie State Park, has different charms. Bothersome insects like ticks and chiggers are gone, and the windblown vegetation is matted down, making it easier to see wildlife like prairie chickens, now in flocks, deer, coyotes, even occasionally a bobcat. Many raptors—red-tailed and rough-legged hawks, northern harriers, and short-eared owls—arrive from the north.

"It can be really beautiful with snow or ice," Cyndi Evans said. "The ice sparkles gold and silver. The bison may have light snow on their backs, like powdered sugar. Some plants have 'frost flowers' at their bases. I like to get here early on those days."

So does Kevin Badgley, and so would I if I had the chance. It would beautifully round out my seasonal memories of ever-changing Prairie State Park.

ROARING RIVER STATE PARK

One travels *down* into the mountains at Roaring River.

SUSAN FLADER et al., *Exploring Missouri's Legacy*

Anticipation was in the air all around southwest Missouri, and no doubt in nearby Arkansas, Oklahoma, and Kansas. School would be closed in Cassville, seven miles away, Opening Day. A sign at the Raney grocery store said, "God Bless America" (in reference to the September 11 terrorist attacks) and "Welcome Fishermen." I was asked, "Will you be at the park March 1?"

Yes. In fact, February 27. That day, nature was anticipating spring. A few dandelions were blooming in sheltered nooks. Cardinals and titmice proclaimed their territories. But Arctic air was moving down from Canada. On the morning of February 28, the thermometer stood at 13 degrees along Roaring River.

Nevertheless, by noon there were quite a few people wandering around, looking at the trout in the hatchery and in the river. A cameraman from KYTV in Springfield was filming hatchery workers netting large trout to be stocked in the pools where the handicapped could fish. By evening several hundred people had filled the campgrounds. Most had campers of some sort, but one group had a bus. Another had pitched two tall white tepees, one with a Confederate flag flying on top. Campfires flickered everywhere. The air was festive.

For two days before the Friday opening, hatchery workers had put seventy-five hundred trout—mostly rainbows but a few browns—into the many pools along a mile and a half of Roaring River. Everything was now ready.

I managed to rouse myself at 5 a.m. on March 1. Cars packed every parking place along the river, whose banks were packed as solidly with expectant anglers, awaiting the starting gun. Above, a nearly full moon peeked through clouds.

Precisely at 6:30, Emory Melton, a former state senator, fired the starter pistol. This tradition goes back to the 1920s, when a rifle shot was fired to signal the start of the fishing season. A siren, as it does at the opening of every fishing day, also sounds. The lines begin flying into the water.

Almost shoulder to shoulder, everyone—grandmothers, children barely big enough to walk, men in coveralls, camouflage suits, hooded sweat-shirts, and baseball caps—cast, miraculously mostly missing each other's lines. And immediately they begin catching trout. One man walks away with his limit of five before 7:00. A bald eagle flies over, as if checking out the fishing.

By now sleet and freezing rain are falling. People pause now and then to warm themselves at blazing barrels of firewood. Some have propane heaters warming their backsides as they continue to fish. In a tent, the Cassville Chamber of Commerce hands out free coffee in plastic cups labeled "Open-ing Day 2002, Roaring River State Park, Cassville, Missouri." In spite of the cold, there's a party atmosphere. Everyone's having a good time, in-cluding me, and I'm not even fishing.

Down the river I talk to a man cleaning fish on the back of his pickup truck. He's from Carthage, Missouri. He says he's been coming here since

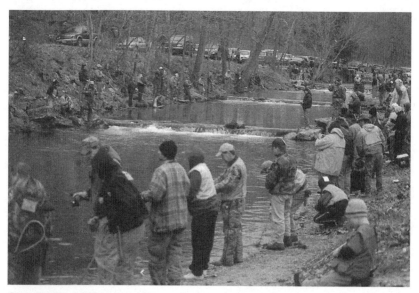

Opening Day, 2002. NAPIER SHELTON

1964. He came yesterday, saw a lot of fish in this pool, and decided to fish here. His wife is just watching.

At the Roaring River Inn, eating breakfast, I meet Richard Witt and his son Alec. Richard already has caught his limit, but Alec has caught only two. "We'll go back and finish," Richard says. "I have a favorite fishing spot—three holes up from the bridge. But if it gets slow there, we may move somewhere else." Reminiscing about this tradition, he says, "I've been coming here since I was Alec's age—about thirty years. On Opening Day I used to play hooky from school in Monett."

Jerry Dean, the fish hatchery manager at Roaring River State Park, is a genial man, devoted to his work, and happy to talk about it. "Many people look down their nose at this kind of fishing," he says, "but socially it's worth it. Generations of folks come here. They have great memories. Often they're at the same spot on the bank each year."

At noon that Opening Day, Jerry was on hand to photograph the catchers of the biggest fish. Among nearly two thousand anglers, an eighteen-year-old from Bella Vista, Arkansas, won in the men's division with an 8.22-pound trout. The winning woman caught a 2.22-pounder, and the youth, who was around fifteen, had a rainbow weighing in at 7.60 pounds. "Those are probably fish we put in last night," Jerry said. (He always includes a few lunkers.) Jerry was happy that everyone was having a good time.

Tim Homesley runs Tim's Fly Shop, a shack chock-full of fishing gear just outside the park. A flashing traffic light on the building's side makes sure you won't miss it. Among the mounted trout on the walls is a fifteen-pound rainbow Tim caught near the hatchery around 1980. His enthusiasm for fishing flows out in torrents of information and opinions. He admits rather sheepishly that he fishes for those put-and-take trout in the park, but he also ventures as far as New Zealand to fish wilder waters.

The preceding winter he had caught and released (as required in winter) a 14.1-pound rainbow by the highway bridge over Roaring River. "Last year I saw a fifteen-pound brown there," he said, "but not this year. Maybe she's moved away on me." Tim knows trout. "Rainbows are dumb," he said. "They streak toward any bright thing. Browns are smart, especially after they reach three to five pounds. They don't like people." He explains

that the difference between a rainbow and a brown "is like the difference between a dog and a coyote."

Chuck Tryon, an avid fisherman from Rolla who has self-published guides to trout and bass fishing in Missouri, fly-fishes many of the state's trout streams, but he shuns places like Roaring River. "But there's one good thing about it—it keeps all those people away from my favorite streams." When he learned I was going to Roaring River, he advised me: "wear your flak jacket on Opening Day."

Trout fishing at Roaring River is possible because of the cold Roaring River Spring, which flows from the base of a dolomite cliff at twenty million gallons per day. The bluish water goes first into a small dammed pond, then into the adjacent trout-rearing raceways and the river. Foot-high dams along the first mile and a half form a series of pools. Farther down, Roaring River is a natural stream dashing through wooded floodplains on its way to Table Rock Lake.

High, forested hills rise all around the river and its tributaries. Driving south from Cassville to the park, you get the opposite view: you drop from uplands into the deep valley. Standing outside the Roaring River Inn, which sits on an intermediate-sized hill, you can absorb the whole delightful scene of hills and river.

The hills have their own special interest, but it's the river and its trout that attracts most of the visitors to this thirty-four-hundred-acre park. And it's Jerry Dean who must make sure that adequate numbers of healthy trout are raised and stocked from March 1 through October. The number to be stocked each day is determined by the number of trout tags sold on that date the preceding year. Normally, the stocking rate is 2.25 fish per expected angler, but in 2002 it was lowered to 2 fish because three years of drought had reduced the spring's flow and the water available for raising trout. Obviously, most people don't get their limit of five.

The fish are moved from rearing pools to the river at night. The assistants work in three shifts: 4:00 p.m. to midnight, midnight to 8:00 a.m., and 8:00 to 4:30 p.m. Campers at campgrounds 2 and 3 hear and then see the truck come down to the river, its bright lights shining ahead; it stops at each pool, and someone steps from the cab and dip-nets fish from the tank towed behind and dumps them in the river. It's as regular as the stars that come out each night over the hills above.

Jerry, who works for the Missouri Department of Conservation, walked me through the process that produces these ten-to-twelve-inch trout. The large females and males that give the eggs and milt swam in a round pool outside the hatchery building. "We begin checking the brood stock the second week of January for egg production. If the abdomen is soft, the fish is ready to give eggs." Inside the hatchery, milt is mixed with the eggs in water to which a saline solution has been added, for better contact of eggs with sperm. The eggs are then placed in foot-wide, vertical cylindrical tubes through which water gently flows from bottom to top, keeping the eggs in suspension. They begin to hatch in about twenty-one days. "The white or orange eggs are dead or unfertilized," Jerry explained. "The brown ones with dark eyes are fertile. When they hatch we put them in a tank covered with a board. This produces the darkness they would experience in nature when they go down into the gravel for safety."

After nine or ten days, the yolk sac is absorbed and the "swim-up fry" are ready to feed. These are placed in long tanks and given commercial feed. At first it's almost powdery, but as the fry grow they get larger pellets. After three or four months, the three-inch "fingerlings" are moved outside to long rectangular pools through which spring water is constantly flowing. Fed twice a day, the fish grow rapidly. "We get one pound of fish from 1.4 pounds of feed," Jerry said. "That's very efficient." After another few months, they are big enough to go to the river and give someone the pleasure of catching them.

The fish are not totally safe in the rearing pools. "There are five or six kingfishers around," Jerry said. "Sometimes they catch three-to-four-inch fish, but they're not bad. We can put a net over the raceway if there's a problem. Raccoons are the biggest problem. They can catch any size but go for the big ones. We just have to live with them. We used to have a little dog that chased them away, but she's gone.

"Great blue herons aren't much of a problem because people are usually around. At Shepherd of the Hills Hatchery," near Branson, one of ten other MDC fish hatcheries, "where they close up for the night, great blues are a problem, along with gulls and now, during migration periods, white pelicans. Minks aren't a serious problem at Roaring River, either. There was a family by the powerhouse for a couple of years, but I haven't seen any recently. We don't have any otters around now, but there are some on Crane

Jerry Dean feeds the trout. NAPIER SHELTON

Creek, sixty miles away. If they arrive here we'll have to trap them, like they do at Montauk and Bennett Springs state parks."

Disease sometimes appears, in the form of external parasites, gill disease, or internal bacteria. If there is more than normal mortality among the fish, specimens are studied under a microscope and appropriate medications are used. Dead fish are not wasted. "We used to compost dead trout," Jerry said. "Now we freeze them and send them to the Chesapeake Hatchery at Neosho. They chop them up to feed big catfish."

Humans, too, are a small danger to the fish in the raceways. Signs warn against feeding the fish anything but the hatchery pellets, which can be bought for this purpose, but some ignore the warnings. One such man, who was tossing bread to the trout, told me, "I've been doing this for ten years." He didn't want to read the sign I pointed out to him.

Jerry Dean has been a hatchery man for most of his working life. Born in 1948 at the Monett hospital, he grew up on a farm west of Mount Vernon. "I liked to fish," he said, "and our farm pond grew some good-sized bass. I thought I would be a vocational ag teacher, but at the University of Missouri in Columbia I took a course on principles of wildlife conservation, taught by Dr. Campbell. I liked that and changed my major to wildlife conservation, specializing in fish."

After he graduated, Jerry's career took him to Butte, Montana, where he tested the effects of effluent from copper mines on different species of fish; Camden, Arkansas, to test effects of paper-mill effluents; Mammoth Springs, Arkansas, for work at a private trout hatchery; Shepherd of the Hills Hatchery, where he was the assistant manager; and finally, in 1991, Roaring River, to become the manager. Here, besides supervising the hatchery work, he serves on the Roaring River Stream Management Team, which makes recommendations on construction and other stream work, and he gives programs at schools about raising fish and on other subjects, such as soil erosion.

At the park he takes great pride in Kids' Fishing Days, which are now held in both spring and fall. The children take classes in how to fish, how to clean and cook them, how to sharpen knives, and related subjects. "At first one person taught. Now we have fifteen, including volunteers. Last year, over nine hundred kids came to the spring program."

Roaring River is one of Missouri's four "trout parks," where hatchery fish are stocked every day during the season. These parks account for 60 percent of the trout stocked in the state. Bennett Springs and Montauk are also state parks. Maramec Spring, south of St. James, is like a state park but is owned and operated by the James Foundation, which was funded by Mrs. Lucy W. James. Fish-rearing there, as at the other parks, is conducted by the Missouri Department of Conservation. "Bennett Springs and Roaring River are the only ones with brood stock," Jerry said. "Montauk gets eggs from Shepherd of the Hills. Maramec gets fish from Montauk and Shepherd. We all trade around—fish and eggs."

Trout are not native to Missouri. They were first introduced in 1879— those were brook trout, which are no longer stocked. Rainbows followed in 1880, and brown trout in 1893. Most of these fish were raised at Neosho, where there was (and still is) a federal hatchery. "Trout were put in milk tins cooled with ice blocks," Chuck Tryon told me, "and then put on a train. Mail carriers took them from the train and dropped them in a stream; 99 percent were put in the wrong places."

Eventually it was learned where trout could survive—mainly in streams near big springs, where the water was cold enough. In his book *Fly Fishing for Trout in Missouri*, Tryon says, "The present trout resource consists of Lake Taneycomo, Bull Shoals and Table Rock Lakes, a few small spring-fed ponds, and somewhere between 200 and 400 miles of streams, depending

on who you ask and how you define trout water." Most of these waters
have rainbows, but five or six have browns. Six or eight streams, he told
me, have wild, reproducing trout and no stocking.

Besides lakes and streams with public fishing, there are private trout
streams and ponds where you pay by the day or by the pound caught. Ob-
viously, trout have contributed significantly to the recreational and eco-
nomic well-being of Missouri.

Roaring River and its surrounding hills have attracted humans for more
than ten thousand years. Early Indians lived in the many rock shelters,
hunting deer, squirrels, and other animals and gathering wild plants for
food. Presumably, the raising of corn, beans, and squash entered the econ-
omy about two thousand years ago, as it did in other parts of Missouri. As
late as the 1830s, Indians still camped near the river.

About this time, white settlers began moving to the valley. A mill was
established at the spring, making this a gathering place that has attracted
people to this day. During the Civil War, limestone hideouts sheltered
bushwhackers. In 1865 the spring was dammed, creating a pond, stopping
the "roar" of the river and providing water power for mills. These mills
ground grain, sawed timber, and carded wool. In 1888, according to *The
History of Barry County*, there were "speckled trout" in Roaring River.
Probably they were brought from the Neosho hatchery. By the turn of the
nineteenth century, Roaring River had become a tourist destination and
fishing retreat. Roland M. Brunner from Kansas City decided to capitalize
on this popularity. He bought nearly thirty-five hundred acres of land in
the spring area and in 1910 built the first fish hatchery, getting his trout
stock from Neosho. He converted the old wool carding mill into an inn
with a hundred rooms and a restaurant, and he built cabins and a hydro-
electric plant.

In 1928, however, he was forced to declare bankruptcy. The property—
then twenty-four hundred acres—was sold at the Cassville courthouse to
Thomas M. Sayman, a wealthy soap manufacturer from St. Louis. Report-
edly, he had plans to further develop the area for tourists but changed his
mind and instead donated it to the state for a park.

The Depression of the 1930s spelled hard times for many people, but it
saw impressive development at the park. Young men seventeen to twenty-
four years old in Company 1713 of the Civilian Conservation Corps were

camped here from 1933 to 1939, building rustic cabins, trails, picnic shelters, restrooms, and the original park lodge. They quarried stone and chipped out the building blocks by hand. Shingles for roofing and lumber for buildings were made in the sawmill at Roaring River from timber cut on the hills. They built well; most of the structures are still in use, including the nature center, originally a bathhouse for swimmers at a lake created by the CCC in 1936 that subsequently silted up. (Campground 3 now occupies that area.) The CCC also built the present hatchery, after a flood destroyed Brunner's hatchery.

The years since CCC days have seen gradual enlargement of the park and purchase of inholdings and commercial structures, some of which had seriously detracted from the peaceful park atmosphere. One finds here today friendly company along the river and near solitude along the forested trails.

On March 4 I walked the River Trail. Snow from the night of March 1 still lay on the ground, and frozen trickles of water across the trail called for careful steps. Draperies and stalactites of ice hung from rock outcrops beside the trail, making me wonder about the chance of one of those huge icicles falling and spearing me. Through the bare trees I could see the river at the foot of the slope and a few anglers still intently fishing. Three adult bald eagles enlivened the day, two perching in a hillside tree, another flying over. Their dark brown and white seemed to match the wintry colors around them.

I asked Merle Rogers, the park naturalist, about eagles. He said they roost along the river in winter, beginning to arrive in October, reaching peak numbers in December and January, and ceasing to roost here around Opening Day, when the increased human activity disturbs them. "They come in around 4 p.m. and leave in the morning. The most we counted this year"—during the winter of 2001–2002—"was seventeen, but we've had as many as sixty-three. The colder the weather the more we have. About 350 winter in Barry County. They're attracted to this area by Table Rock Lake and chicken farms, where dead chickens are thrown out. In the spring they migrate to breeding areas farther north."

I occasionally had seen eagles in open country as I was driving to or from the park, and I now assumed they were commuting to chicken farms. Merle had told me of seeing around fifty eagles at a farm north of Wheaton,

so I drove there to check it out. Southwest Missouri is full of such farms, at which thousands of chickens are raised in long sheds, eating feed automatically delivered to them. Inevitably, some die, and eagles benefit. The farmer at this operation said the eagles come in around 7:00 a.m. and leave later in the morning. I arrived at 9:15 and saw at least twenty eagles still soaring around or perched in trees. There may have been more on the ground where the chickens were dumped, beyond a rise that hid the spot from me. Bald eagles take whatever animal food they can, whether it's dead or alive, frequently fish.

Merle Rogers has seen eagles catch fish at Roaring River, but it doesn't happen often. He's likely to know about any other aspects of the park's natural history, too. He's been the park naturalist since 1974. His choice of career, like that of most people in natural resource work, evolved from an early love of outdoor activities. "I grew up in Enid, Oklahoma," he said, "where I often went to my grandparents' farm. There were sixteen grandkids. We hunted, fished, ran around in the pastures. My dad loved to hunt and fish." In the Boy Scouts he went camping, made Eagle Scout. High school was followed by four years on a nuclear sub, then he went to Northwest Oklahoma State University, where he got a degree in Conservation Law Enforcement and met his future wife, Rita. While working on his wife's parents' cattle farm, he learned of three openings for park ranger/ naturalists in Missouri state parks. "I chose Roaring River because it was the closest to Oklahoma."

He obviously liked his choice. In 1974 the park interpretation program consisted mainly of summer activities conducted by seasonals. Merle expanded it from there, especially with school groups. "I learned a lot from interpretation workshops," he said, "and began a natural resource inventory to learn what we had in the park." (Among the findings: Ozark endemics such as Ozark spiderwort, Ozark chinquapin, and, in the river, Williams' crayfish and Ozark sculpin; southwestern species such as Ashe's juniper, armadillo, Texas mouse, and, occasionally, greater roadrunner.) "Getting to know the area personally helped too." He's still exploring the park: "There is always something new to discover and enjoy."

Merle, crew-cut and direct, is not one to sit around and take things easy, even in winter. He and his staff—another park naturalist and two part-time men—function as resource managers as well as interpreters. "In win-

ter we cut cedars from glades, clear trails and fire lines, pick up litter, take out old fence material from the woods. In the last four years we've taken out ten miles of barb and woven wire fence," undesirable remnants of the pre-park days.

When I met Merle, he was also preparing the nature center for new exhibits: a bluff exhibit ("I've always wanted that"), Ozark glades, "what uses the river," the riparian area, and reptiles and amphibians (live and mounted). A company in Cedar Creek, Missouri, was supposed to deliver these exhibits by the end of March, in time for the annual influx of school groups.

From late fall to early spring, Merle and his crew spend a lot of time opening dolomite glades with prescribed fire, a substitute for the natural and Indian fires that maintained these glades for thousands of years. Glade plants and animals are adapted to this kind of environment, where the dolomite bedrock is above or close to the surface and where sunshine bakes the ground in summer. In spring and fall, glades often experience brief wet periods, the water oozing out over the rock surface—so although they are usually very dry, they can also be wet. Some of the prairie plants, like big and little bluestem, Indian grass, sideoats grama, and compass plant, thrive in glades, as does prickly pear cactus, Missouri evening primrose, and many more species. Typical animals are scorpions, collared lizards, and the scarcer western pigmy rattlesnake.

The great enemy of the glades is the eastern red cedar, which can tolerate glade conditions and grows to shade out other plants. Cedars proliferated when turn-of-the-century logging and heavy grazing opened up much of the Ozark forestland. Standing on a high point in winter at Roaring River, you see wide dark bands of cedars around the lower parts of the hills.

It is mainly these cedars that Merle and company are fighting with their controlled burns, on the park's dozen or more glade areas. "We try to burn every glade every year or two," he said. But fire kills only the small cedars. Larger ones must be cut. This was accomplished on Chute Ridge glade, next to Highway F, by letting a contract to a company that wanted cedar logs. The company removed cedars on forty-four acres of state park land and thirty-two acres of the adjacent national forest land. Then the glade was burned. Now, "it's looking like a glade in presettlement times," Merle said.

Prescribed fire is used at Roaring River to keep glades open. NAPIER SHELTON

However, this solution couldn't be used on most of the glades, which are in the park's 2,075 acres of Wild Area, where power machinery is prohibited—a state park regulation. There, cedars had to be cut with axes or handsaws, a hard, time-consuming process. (A study estimated that, with the presently available staff, it would take sixty-five years to cut and burn cedars by this method on two hundred acres in Ketchum Hollow.) Merle wanted to have a special exception to apply the Chute Ridge methods on these other glades, and later it was granted.

Anyone who wants a good introduction to the park's natural history should walk the Devil's Kitchen Trail, with the trail brochure in hand, because this path traverses much of the ecological variety found at Roaring River. Numbered posts correspond to information in the brochure. The forests along this trail are closely related to the geology and slope directions, and indeed are fairly typical of Ozark forests in general. What is not typical is the juncture of dolomite and limestone, at about the 1,200-foot elevation. In southwest Missouri the more soluble limestone lies atop harder dolomite (made so by magnesium); east of about Branson, there is just dolomite, along with a few outcrops of other rock types. The more rapid erosion of limestone creates a "bench" along the top of the dolomite

layer that can be traced around much of the park. Rock shelters and caves, once used by Indians, occur in the limestone bluffs along this bench, and can be seen on the Devil's Kitchen Trail. Above the bench, pale, sharp-edged fragments of chert cover much of the ground. The trail also passes Trailside Spring Cave, from which issues a small stream. Although the opening is small, cave animals such as the grotto salamander, cave cricket, cave isopods, and cave amphipods have been found here. The Devil's Kitchen, where erosion tumbled blocks of limestone, was used as a hideout by Civil War guerrillas.

The forests change rather subtly with increasing dryness up the northeast-facing slope, from a preponderance of red oak and sugar maple to more drought-tolerant species such as red cedar, post oak, black oak, and dogwood, and highbush and lowbush blueberry grow in the cherty soil. On top and starting down the west-facing side, you pass through a soaring stand of shortleaf pine. Some of the trees here are estimated to be over two hundred years old, but most are younger, having grown since the logging of the early 1900s. This grove is a pleasure, worth a sit-down just to enjoy it. Scarce in Roaring River State Park, shortleaf pine becomes more common eastward in the Ozarks.

The trail does not pass through the moister forests found in the bottom of deep valleys along streams and the river. Along the Roaring River floodplain grow white-barked sycamores, box elders, slippery elm, black walnuts, and some ashes and oaks. In shaded ravines at slightly higher elevations, one sees sugar maple, black walnut, basswood, white ash, slippery elm, shagbark hickory, black gum, and several oaks. Such places seem especially appealing in the generally droughty terrain of the Ozarks.

Most of the park area, like most of the Ozarks, was logged around the turn of the nineteenth century, but a 120-acre section designated the Roaring River Cove Hardwood Natural Area—one of around 150 such natural areas designated in Missouri—is thought to have escaped the ax and saw. Situated north of the Fire Tower Trail, near the disused fire tower, it includes rounded ridgetops enclosing a cove that slopes down to limestone bluff dropoffs and a stream valley. Among the trees growing here are yellowwood and Ohio buckeye, and the rare and declining Ozark chinquapin, victim of the same fungus that killed the American chestnut.

Merle had told me there were trees here as much as three feet or more in

diameter, but I had to search long and hard before encountering any—two giant white oaks and a red oak. It appeared that most trees at Roaring River blow over, break, or die by the time they reach two feet in thickness. Still, such trees may be pretty old. On the Eagle's Nest Trail, in the south part of the park, I counted annual rings on some cut blowdowns. Two oaks only ten inches in diameter had eighty and eighty-three rings. Low levels of moisture and nutrients must inhibit growth of many such trees.

The forests of course were bare and wintry-looking in early March, and when I returned in mid-April they still had that look from a distance. But close up I saw that many shrubs and saplings were beginning to leaf out, a few serviceberries and redbuds were blooming, and the annual dogwood show was beginning. Some oaks, too, were in bloom.

At ground level, the spring wildflowers were absolutely gorgeous. The trickling water that had made the River Trail so slippery with ice in March now nourished a veritable wildflower garden. Masses of yellow trout lily and rue anemone, its little white flowers dotting the hillside like stars on a desert night, were joined by blue phlox, blue violets, bloodroot, May apple, sessile trillium (with dark red petals that never unfurl), cut-leaved toothwort, and others. After the drabness of winter, such a sight seemed a gift from God.

In April, Merle and park naturalist Tim Smith host busload after busload of schoolkids, showing them the spring, the hatchery, and other aspects of nature along the trails, and talking about snakes and other critters. For some visitors, it's part of the Junior Naturalist Program, conducted throughout Missouri state parks, in which children—and adults, too—can earn a patch by fulfilling certain requirements, such as attending these walks and talks, doing cleanups, and identifying plants and animals.

I watched while Merle talked to a group of third graders and their teachers from Diamond, Missouri. They were outside the nature center in a small amphitheater, and the subject was reptiles and amphibians. "Do we have alligators in Missouri?" Merle asks. Greeted by silence, he answers, "No and yes. We have alligators in zoos." He pulls a live speckled king-snake from its box, to an outburst of squeals. He demonstrates how it can be tied in a knot. "With most other snakes that would break their vertebrae." He carries it around so the kids can touch it.

"What kinds of animals are amphibians?" No answer. He explains that amphibians go through a change in their form. "What is the change

called?" More silence. "Meta . . . ," he coaxes. "Metaphor!" I thought I heard a little girl exclaim. "What's the most common venomous snake here in Missouri?" Merle then asks. Hoping to hear "copperhead," he gets from another girl: "black mamba."

Time is now growing short and the children must return to Diamond on schedule. Merle has talked about snapping turtles, and a boy says, "I want to tell you something else about snapping turtles." Looking at his watch Merle replies, jokingly, in his almost military way, "I don't want to hear it." The children and teachers, apparently happy with their day, march off to the bus.

After the spring influx of school groups, the interpreters will launch the summer program of hikes every morning, hatchery tours every afternoon, and evening programs most nights, giving slide talks, video presentations, and brief lectures featuring live snakes or live spiders. An hour each day is reserved for Junior Naturalist work; most people can get their patch in a three-day weekend. Special programs are held on Earth Day, a Wild Area walk is conducted in the fall, and there are two or three Eagle Days in winter, when visitors can see and learn about eagles.

Merle, of course, has seen many of these yearly rounds, and he has come to look for and enjoy the seasonal appearances of plants, animals, and people. **Spring:** turkey vultures coming in February, then woodcocks. In March the blooming of harbinger-of-spring, bloodroot, and serviceberry. The "mass migration of fishermen" on March 1. Birds setting up territories. Garter snakes and water snakes appear. **Summer:** the early-summer glade flowers blooming. Vireos and warblers singing. More vultures. Old friends coming back. Copperheads, pigmy rattlesnakes, occasionally timber rattlesnakes seen. Skinks and bullfrogs. **Fall:** the turning leaves—sumac and dogwood early, hardwoods later. More hummingbirds in August through September than in summer. Chipping sparrows and other birds flocking. In late October, eagles begin to appear. In November, snow geese fly over and the turkey vultures disappear: "They seem to congregate around Branson." **Winter:** few tourists. "I enjoy the eagles, see lots of robins, cedar waxwings, and yellow-rumped warblers eating cedar berries—and spreading them. Some winters we see hundreds of thousands of robins."

Before leaving, I make one last visit to the nature center. Merle's long-awaited exhibits have not yet arrived. The contractor says he hopes by late April. At the fish hatchery, purple martins are coming and going from an

apartment-type nesting box on a tall pole. Jerry Dean is at the raceways with two other men. They are checking out a new two-decker machine, made by one of the men, that can pump fish from one pool to another without sucking the first pool dry; it can also separate fish by size and can pump them into the tank truck that delivers them to the river. Jerry is delighted with this new bit of fishery technology.

As I drive out of the park, a thunderstorm moves in. People scattered along the riverbank keep on fishing.

WILSON'S CREEK
NATIONAL BATTLEFIELD

Today, visitors must stretch their imaginations to picture the
battlefield as it appeared to Private Ware and other soldiers.

NATIONAL PARK SERVICE folder,
Wilson's Creek National Battlefield

Gary Sullivan, chief of resource management and maintenance at Wilson's Creek National Battlefield, is engaged in his own battle. He's trying to change the landscape back to its appearance in 1861, when a Civil War battle was fought here. That landscape was mostly oak savanna: prairie with widely scattered oak trees. Now much of it is forest and brush. Gary's battle is to thin out the forest, beat back the woody brush that keeps encroaching on the restored patches of prairie, and nurture some of the young oaks sprouting in that prairie. His battle, fought simultaneously with other commitments to Wilson's Creek's natural and cultural resources, demands extensive knowledge, diverse skills, and creative thinking.

The 1,750-acre battlefield, administered by the National Park Service, was established in 1960 to commemorate and interpret the battle fought here on August 10, 1861, and to protect the land on which it was fought. That morning, twelve thousand Missouri State Guards under the command of Confederate Major General Sterling Price and General Benjamin McCulloch were encamped along two miles of Wilson's Creek. They were preparing to attack the Union troops commanded by General Nathaniel Lyon, which they thought were at Springfield, ten miles to the northeast, in an effort to bring Missouri to the side of the South. Instead, Lyon's force of fifty-four hundred men attacked them that morning, hoping, although outnumbered, to win by surprise. Sending twelve hundred troops under Colonel Franz Sigel to outflank the Confederate right and fire on

them from the south, Lyon attacked from the north. Initially successful, Sigel's advance was checked by Confederate artillery fire, and his troops were then routed by a counterattack.

Lyon's force was halted on what became known as Bloody Hill, where charge and countercharge continued for five hours. Halfway through the morning, General Lyon was killed (the first Union general to die in the Civil War), and at 11 a.m. his replacement, Major Samuel Sturgis, faced with a dwindling supply of ammunition, ordered a withdrawal to Springfield. The southern army, though victorious on the field, was in no condition to pursue. Lyon's goal was achieved: Missouri remained under Union control.

Soon after my arrival, I took a trip around the five-mile auto tour road, stopping at the designated points of interest, to see what Gary was dealing with. From the parking area beside Wilson's Creek, I set off down the trail to the Gibson's mill site. It was a warm September day, not so hot and humid as on August 10, 1861, but warm enough to make me appreciate the coolness under the streamside trees. A great blue heron, surprised from its fishing, rose with a loud squawk. Contemplating the few stones outlining the former mill, I tried to imagine this structure, the Gibson family huddling in their nearby home, and the chaos of General James Rain's Confederate troops retreating down the creek from Lyon's dawn attack.

At the Ray House, the only home that remains from the half dozen present at the time of the battle, I looked across the wooded creek to distant slopes, where a few fields remain among the forests, and to Bloody Hill, where seventeen hundred died. I could picture the redoubtable John Ray sitting on his front porch watching the battle, in spite of the cannonball that demolished his outbuilding, while his family hid in the cellar. I sensed the sad irony that Confederate Colonel Richard Weightman had died in this house, perhaps on the same bed where later was laid the body of General Lyon, who had been killed leading a charge against Weightman's troops on Bloody Hill.

From here I could also see Ray's cornfield, now maintained as a hayfield, on a nearby slope. During the battle, the Confederates moved up through the tall corn, driving the Union forces back across the stream.

On the tour road I met three hikers doing the loop, along the hiker-biker lane. One said, "We just saw a five-foot copperhead crawling across

the road. It was as big around as this," showing with his fingers. Allowing for some exaggeration—no copperhead in Missouri has been recorded over forty-three and a half inches—I'm willing to believe it was big. Small limestone bluffs on the battlefield make good homes for copperheads—and bobcats, which Gary has seen several times along this road. "I think they may hunt rabbits here. The rabbits like to eat the fresh grass after mowing."

From the next parking place, you can walk to the site of Pulaski's Arkansas battery, which fired on General Lyon's troops on Bloody Hill throughout the battle. Now, however, trees stand in the line of fire, and woods obscure Pulaski's target area, toward which two cannons point. Gary hopes to open up that landscape. It's a goal like that on many NPS cultural sites: restore the historic landscape so visitors can see what the place looked like at the time of the events commemorated there.

Landscape restoration has a long history in national park service areas, and not just at historic sites. Big Meadows, for instance, in Shenandoah National Park, a primarily natural park, has been maintained in an open condition for many years as a valuable cultural landscape. At Wilson's Creek, the legislative history leading to park establishment specifically called for restoring the landscape to its 1861 appearance. Furthermore, a study of visitor opinion found that 65 percent supported this restoration (with 30 percent having no opinion).

The walk to Pulaski's battery crosses the Wire Road, a dirt track that once ran from St. Louis to Fayetteville, Arkansas, a road that saw frequent troop movements during the Civil War. I followed it to the site of Confederate General Sterling Price's headquarters during the battle, beside the cabin of William Edwards (now replaced by another Edwards house that was moved here). Prairie grasses planted on the adjacent flats give you a clear view up the lower slopes of Bloody Hill, but trees and brush now hide the upper terrain the Union held.

Returning up the Wire Road, I paused at the bridge over Wilson's Creek and stared into the shallow water. A school of minnows darted, and a nine-inch fish with a dark stripe on its side hung in the current. Couldn't be too bad, I thought, though one of Gary's concerns is the quality of Wilson's Creek water, most of which passes through a sewage treatment plant upstream.

Farther on, I marveled at the abundance and variety of butterflies. Red admirals, buckeyes, viceroys, and others fluttered by. Little blue butterflies congregated on mud in the road. A giant swallowtail wandered through the woods. Nowhere, I thought, have I seen such a butterfly show. I wish I knew what they all were.

The tour road next crosses Wilson's Creek again and comes into Sharp's cornfield, into which Sigel had advanced before being driven out the Wire Road. Now this large expanse is kept open as a hayfield, which the park service leases to farmers. "It would be too expensive and time-consuming to maintain as a cornfield," Gary says, "even if we could find a farmer interested in doing that." Turkey vultures soared over this space. As I sat there eating lunch, a mower came lumbering back toward the road, scaring up two meadowlarks.

Next stop is Guibor's Battery, where Confederate artillery supported troops attacking up Bloody Hill. Three times they failed, but on the fourth they found that the Union army had departed. Farther up the road, I stopped at the top of Bloody Hill to try to imagine what the Union soldiers saw. But it was hard to see past the brush and trees down the slope.

In 1907, Eugene F. Ware, a former member of the First Iowa Infantry regiment, recalled a different landscape. "Wilson's Creek was in our front, with an easy descending hill side and a broad meadow before us. . . . The hills bore some scattering oaks"—rather large, scrawling, and straggling, he said—"and an occasional bush, but we could see clearly, because the fires had kept the undergrowth eaten out, and the soil was flinty and poor."

A trail takes you down one side of Bloody Hill, where you can see how "flinty and poor" the soil is in a cedar glade. This is the habitat of prickly pear cactus and the Missouri bladderpod, a diminutive plant now federally listed as an endangered species. One of Gary's chief responsibilities is to manage the bladderpod areas so as to protect them and encourage their increase.

In this cedar glade on Bloody Hill, a small granite monument placed in 1928 by the University Club of Springfield marks the approximate location where General Lyon died. It reads: "In honor of General Lyon and the hundreds of brave men, north and south, who, on this field, 'Died for the right as God gave them to see the right.'"

At Stop 8 on the tour road, a field through which the Union army ad-

Bloody Hill is much more brush-covered now than at the time of the battle.
NAPIER SHELTON

vanced and retreated, one can look across the forest-hidden Wilson's Creek to the Ray House. One could also see, when I was there, the effects of grazing by a fenced-in herd of goats, introduced to consume sericea lespedeza, an exotic plant that is invading the battlefield and crowding out native plants. This, too, is a concern of Gary's.

In traveling around the road, I had glimpsed most facets of Gary Sullivan's work: restoring oak savanna, looking after the quality of water in the battlefield, protecting endangered species, eliminating invasive non-native plants, pondering the degree of recreational use that should be permitted, and simply knowing the state of the battlefield's diverse natural and cultural resources. There is much to know and manage on this relatively small piece of ground, about three miles long and a mile wide.

Gary, who was forty that year, looks official and competent in his park service uniform, and contemplative. His dark mustache droops slightly at the ends, like a trim version of an early western sheriff's. His speech is slow and considered, with occasional outbreaks of wry humor. A sign over his desk reads: "Great minds discuss ideas, average minds discuss events, small minds discuss people." He wanted to know what I thought about things,

such as what our response should be to the terrorist attacks on September 11, 2001. "We're in the Bible Belt," he said, "but they don't teach much about other religions in the schools. I think they should." His interests? "Well, I do woodworking, fish a little, and bike ride, but my real interest is my work."

We looked at an aspect of that work near the Ray House, where a patch of prairie vegetation had been restored. Big bluestem and Indian grass rose above our heads. Half hidden among them shone the yellow of goldenrod and a native sunflower, and the blue of Pitcher's sage. Purple coneflower was in seed. So, too, was the coarse-leaved compass plant.

This bit of prairie restoration was actually the work of Lisa Thomas, Gary's predecessor as resource manager at Wilson's Creek. "The usual procedure is to kill the existing vegetation with Roundup, usually in the fall, sometimes again in spring," Gary explained. "Then a light disking. Next, in late May, you drill in or spread the grass seeds, and forbs if you have the money. Prairie forb seeds are expensive. You can get about fifteen kinds from native prairie nurseries. You can also hand collect the seeds, but that's a time-consuming process."

We looked at another field, where Gary himself had done the restoration by scattering seeds after bed preparation. It hadn't looked so good the first year, but it was now better. A few forbs showed among the dense big bluestem, but foxtail, an exotic grass, was prominent along the edges. "I think the foxtail will be killed when we burn the field this fall."

Establishing prairie vegetation is nothing new to Gary. He grew up at Beatrice, in southeastern Nebraska, and worked several summers for the park service at Homestead National Historic Site, where some of the earliest prairie restoration was done. Later he became a permanent park service employee and, while working in the regional office, got a master's degree in natural resource management at the University of Nebraska–Omaha. Now in midcareer, he had been at Wilson's Creek for six years.

Restoring native prairie is a complex art and science. You have to consider soils, climate, weather, and the characteristics of the species presently growing on the site and of those you want to introduce. Your main tools—other than all the knowledge required—are fire, herbicides, and equipment for disking, plowing, mowing, and brush-cutting. You need to know where, when, and how to use these tools.

Burning, as we saw at Prairie State Park, is the chief tool. The grasses

Gary Sullivan points to Bloody Hill; note restored prairie in foreground.
NAPIER SHELTON

were curing out, the tops turning reddish, when I visited Wilson's Creek. "We can burn soon," Gary said, eagerly.

The timing is important. In the fall, Gary tries to burn when the grasses are dry but the woody vegetation is still a bit green, with sap in the stems. That kills much of the brush. However, oaks less than eight feet tall are also killed. In order to establish oak savanna, Gary thinks, it may be necessary to plant some oaks in the prairie vegetation and not burn those areas until the oaks are tall enough to survive a ground fire.

Conducting a prescribed fire is a highly professional activity. Conditions of the vegetation and the weather must fall within a rather narrow band. The wind must be blowing—but not too strongly—from a certain direction to keep the fire and smoke moving where you want them to. Many natural resource agencies and managers now use prescribed fire, always mindful, however, of what can happen if it gets out of control. A few years ago, the park service was seriously embarrassed when a prescribed fire in Bandelier National Monument, New Mexico, escaped and threatened Los Alamos. The service became doubly careful about using this normally safe tool.

When a burn is planned, Gary notifies various agencies in the Springfield

area and all residents within about a quarter mile from the battlefield. They are warned about smoke that might reduce visibility, cause breathing problems for people outdoors, or darken laundry. "The neighbors are understanding," Gary says, "and don't complain when we explain the purpose of the fires and give advance notice."

To carry out prescribed burns, Gary has to get approval for the plan from the regional fire management officer at Ozark National Scenic Riverways in southeast Missouri, and he calls in the fire management team from Buffalo National River in northwest Arkansas. Added to those fire experts are a few people on the Wilson's Creek staff who have a "red card." This means they have the necessary training and physical condition to assist with a burn. To meet the physical requirements, they must be able to walk a course on the tour road from the Ray House to Sharp's cornfield and back, a distance of about three miles, in forty-five minutes, carrying a forty-five-pound pack. The burn itself is carried out on one of the fire management units in the battlefield, each of which is bounded by roads, trails, or mowed fire lines to keep the fire within the unit.

The year I last visited, Gary planned to burn most of the area within the tour road, about seven hundred acres, in fall for the open areas and perhaps winter for the woods, which are difficult to burn until the leaves have fallen. He wanted to begin the last few days I was there, but rain intervened. He would have to wait.

Fire and herbicides aren't the only tools Gary has at his disposal. He and his maintenance crew have chain saws and brush hogs, machines with heavy horizontal rotating steel blades. The workers spend many days every year cutting the sumac, the long-thorned honey locust, and other woody plants that constantly threaten to take over the fields. This sometimes leads to lost working days from injuries and other mishaps. "You can get infected by honey locust thorns," Gary says, "and sometimes somebody will get so many chigger or tick bites or a bad enough rash from poison ivy that they can't work." The staff is making a special effort to avoid injuries, because "the National Park Service has the highest rate of lost working days from injuries of any agency in the Department of the Interior, and perhaps the whole federal government. Maybe it's our can-do attitude. Get the job done whatever the risk."

One day we're out at Sharp's cornfield talking to Mark Blackwell, a

farmer from Monett, Missouri, who is cutting the fescue for hay to feed his cattle. "My nonpaying hobby," Mark says. His main job is running the Monett parks and recreation department. Gary mentions the difficulties with cutting brush, and Mark says, "Why don't you get a Kansas Clipper. They can cut trees eight inches thick." Later, Gary calls a farm equipment dealer, who brings printed matter about such tools. One is called Tree Terminator by the manufacturer. You can mount these giant pincers on the front end of a Bobcat, a versatile machine much used at Wilson's Creek. Gary orders the $4,800 model.

Gary's efforts to recreate oak savanna are the latest in programs the park service started in 1966, just a few years after this park was established, but many years of farming and grazing had eliminated much of the native vegetation. By 1973, 230 acres of native prairie grasses had been planted. In the 1980s and early 1990s, these plantings continued, and thousands of nonnative trees, like the Osage oranges that had been planted along field boundaries many years ago, were cut. By 1989, prescribed burning had been started to maintain the restored prairie patches.

I asked Gary how long he thought it would take to change most of the battlefield to an oak savanna. "Well, if we keep getting the funding, an oak savanna will probably begin to take shape in twenty-five years, and after fifty years we could have the landscape we're working toward. Right now we're just trying to maintain what we've got."

Endangered species are also high on the list of his responsibilities. The Endangered Species Act requires that all necessary measures be taken to protect these organisms and their habitat. The status of the bald eagle, which occasionally visits Wilson's Creek, has been reduced to "Threatened," since the populations have increased substantially after the banning of DDT. This reduces the measures that must be taken for their protection. But two species found at Wilson's Creek have full federal Endangered status: the gray bat and the Missouri bladderpod.

The gray bat may be only a sporadic visitor. Gary discovered some of these bats hibernating in a small cave near Wilson's Creek in October 1995, as he recalls. They remained through the winter. A bat expert studied Gary's photograph and estimated as many as sixty individuals in that one small cluster that was about the size of a basketball. He thought they might be juveniles and would likely winter elsewhere when they matured

and mated. The cave is marginal for hibernating from a bat's point of view, because it faces east rather than south or west, which would make it warmer.

One afternoon Gary and I made our way down the steep wooded slope to the cave. It bends left after going back about twenty feet, and just around that bend was where the gray bats hibernated, along with the common eastern pipistrelle. They had not returned in the first succeeding years, but Gary would need to keep checking. If they did come back, he would have to close the cave to human entrance.

The bladderpod is another matter. Though it's found in four counties in southwest Missouri and two counties in Arkansas, Wilson's Creek National Battlefield shelters one of the largest populations of this species, and because this is federally protected land it offers a safe haven. Safe, that is, as long as the restricted habitat can be maintained.

The Missouri bladderpod *(Lesquerella filiformis),* a member of the mustard family, grows in open glades, barrens, and limestone outcrops in open woods. Here the soils are thin and poor. Baking under the summer sun, they quickly dry out after a rain. The bladderpod, an annual, avoids these tough conditions and competition from summer annuals by enduring those times in seed form. These break dormancy and germinate after rain in late summer or early fall. The tiny rosettes, flat on the surface, remain green through the winter. In early spring, each plant sends up two or three stems, perhaps five inches tall, atop which small yellow flowers open. This is the only time of year the plant is conspicuous; in good years, they sprinkle the glades with yellow. Through fall and winter, you almost have to have a microscope to find it.

Those years of extensive yellow blooms are unpredictable. A four-year study on Bloody Hill estimated between five hundred and seven hundred individuals in 1983, several thousand in 1984, fewer in 1985, and none in 1986. Lisa Thomas, who now heads the Prairie Cluster Long-Term Environmental Monitoring Program (covering Wilson's Creek and six other prairie national parks), has continued to study and record the bladderpod populations on Bloody Hill each year. Her team has seen even greater fluctuations: anywhere from zero to three hundred thousand plants in years between 1988 and 2001. Bladderpod seeds remain viable in the soil for two to five and possibly more years. Thus the species can wait, as it were, for favorable conditions. Lisa's group is trying to find out what those conditions are.

Gary's job is to maintain the open habitat where bladderpod grows and to destroy exotic species that are threatening to crowd out the bladderpod. Chief among these are two species of cheatgrass *(Bromus tectorum* and *B. inermis),* and a perennial, sericea lespedeza. "The annual grasses could be killed by carefully controlled fire," Gary says, "but this is 'critical habitat' under the Endangered Species Act, and I would have to get approval from the Fish and Wildlife Service. That's very time-consuming, and I've got enough paperwork already." So he sends in the maintenance crew with Weedeaters to cut these grasses before they can set seed. They carefully spray the lespedeza with chemicals.

Historic sites in the national park system protect their natural as well as cultural resources, so the invasive exotic sericea lespedeza is removed for two reasons at Wilson's Creek: it threatens native vegetation, and it was not part of the historic landscape.

Yet perhaps most worrisome is the eastern red cedar, whose shade may cool the soil and prevent the bladderpod seed from germinating, and whose terpene-containing litter is also inhibiting. Apparently it did not occur in this area at the time of the battle. "I've never seen one here over fifty years old." Gary said, and he's certainly cut enough of them and counted annual rings on many of the largest. I got the feeling that red cedar is public enemy number one with Gary. One day when I was taking pictures of him, he "strangled" a young red cedar, grinning maniacally.

Red cedar is hard to kill with fire once it grows above six feet. One strategy is to cut cedars, place them around other large cedars, and burn the piles when they dry out, which also takes the enclosed live trees. He likes to do this cutting in winter. "In summer it's hot and humid, with ticks and chiggers, and you get needles down your neck." He was particularly pleased with one area he had opened up this way and wanted to show it to me. We pushed through live cedars and other large trees on a dry wooded slope in the southeast part of the battlefield until we reached it. Charred cedars lay around the edges and big bluestem waved its turkey-foot seed heads in the open middle. "Lisa Thomas introduced bladderpods into the area just downhill from here, and it's spread into this area." He had achieved something for the little endangered species.

One of the toughest exotic nuts to crack is the invasive sericea lespedeza. Ranchers have used one live method of control—the goat, which will eat most anything—and Gary was trying this approach at Wilson's

Creek. We visited the last stop on the tour road, where ten acres had been fenced and fifty goats owned by a local breeder had been brought in. Two large white Pyrenees dogs patrolled the perimeter to protect them from any coyote or bobcat that might get over the solar-panel electrified fence. The goats, which prefer woody browse, had eaten out all the undergrowth in a small patch of woods and had reduced the sumac and other brush in the open part. "Now they're hitting the lespedeza pretty hard," Gary said with evident satisfaction, showing me the empty areas where the plant had been dense. "Luckily, they don't like bluestem. We'll try this for four or five years. After the first year or two, we'll need fewer goats." When the goats have done their work here, this plot could be returned to prairie grasses and the goats moved to another patch of the tough lespedeza.

■ ■ ■ ■

If you're a resource manager, you need to know what resources you've actually got on your land. The park service puts a lot of time and money into learning this on the areas it administers. So far, Gary knows that at Wilson's Creek he has in his care at least 635 species of plants, 33 of fish, 144 birds, and 24 mammals. None of the lists can be considered complete, even on this relatively small piece of land. Lisa Thomas thinks the plant list, for instance, is only about 70 percent complete. Fifty-two kinds of butterflies have been recorded at Wilson's Creek, but it's anybody's guess as to how many total species of insects, the most diverse of all the earth's groups of organisms, exist here.

You'll note that I didn't mention reptiles and amphibians. Some, like the copperhead, and the conspicuous ornate and three-toed box turtles, are well known. But no careful survey of this group had ever been made in this area. So Gary put his most recent infusion of inventory and monitoring money into conducting one. "Who knows," he said, "there might be an endangered species among them."

The task was given to Stan Trauth of Arkansas State University. With several graduate students, he placed one hundred cover boards at sites in a grid system over the entire battlefield, locating these by GPS (Global Positioning System). Some sites have four boards—two metal and two wood—and others have just two. Snakes and salamanders like to hide in such places. Trauth and his students would return periodically to check these boards

and search elsewhere for all snakes, lizards, turtles, frogs, and salamanders they could find. Gary showed Mark Blackwell, the hay mower, where boards were placed in Sharp's field, so he could mow around them.

Among mammals, perhaps sixteen or more additional species could be found, especially among the bats and small rodents. The larger mammals are more conspicuous. People traveling the tour road frequently spot deer, which aren't particularly shy in this no-hunting area. Gary thinks some of the big bucks elsewhere know this and move in just before the start of hunting season. Surprisingly, bobcats are rather common, even though the forest here is not extensive. "I've seen more bobcats in my six years here than I have in the rest of my life," Gary said. A female was thought to den in a rock pile near the maintenance building. For several years, she was often seen around there with her young. Foxes seem to be scarce; perhaps they are scared away or killed by the coyotes.

One morning I asked the maintenance people about a few species that hadn't made the official list. "Yes, I've seen muskrats in Wilson's Creek," said Ron Smith. Reports of mountain lions in eastern United States are rife. Some are no doubt true, but many of these animals are thought to be pets or captives set free. Ron saw one while deer hunting in a cedar glade near Table Rock Lake. "It walked right past me." Tall, ebullient Derek Kothenbeutel, the chief brush-hogger, topped this. "I saw one right here at Wilson's Creek three years ago, as close as from here to that fire cache, and another one about two years before that." A bear will be next, I suppose. Scarce but increasing in Missouri, one had been seen just a few miles away.

Perhaps Wilson's Creek's most unusual wildlife sighting was the emu that appeared a few years ago and stayed for a week. Then it disappeared. "It probably came from one of the local emu growers," Gary said. "The market got saturated, and some people just let their stock go."

The inventory of cultural resources was also still underway. A five-year survey of historic and prehistoric artifacts was being conducted by the Midwest Archeological Center (MWAC) and a professor from the University of Arkansas at Fayetteville. The university has developed a model based on soil types and topography that predicts where archeological sites will be found in the Ozarks, and this was being used at Wilson's Creek. The MWAC was searching for objects related to the battle. They had systematically gone over four hundred acres with metal detectors, digging up each find, recording it, and then storing it in the center's collections. So

far, they had found numerous minié balls, cannon shot fragments, and other evidence that suggested the positions of troops and artillery.

This is the sort of thing that most intrigues Superintendent Richard Lusardi, who came to Wilson's Creek in 1999. He relates most of its resource management issues to the battle. One such issue is water quality. "The Confederate soldiers camped here," he told me in his strong New York accent, "because they could get food from the local farmers and they could drink from the creek—until it started running red with blood."

Nowadays no one would think of drinking from Wilson's Creek, and contact recreational use of it is prohibited in the battlefield, but its quality has improved in recent years after distressing conditions earlier. Around half of the creek's watershed is in Springfield. At low flow, up to 90 percent of the creek's water comes through the Southwest Water Treatment Plant, just a mile and a half upstream from the battlefield. A study published in 1969 recorded 352 organisms per square foot at the upstream edge of the battlefield but consisting of only 8 kinds of pollution-tolerant organisms. This was contrasted with 352 organisms of 27 species at a sampling site in Terrell Creek, a spring-fed tributary just south of the battlefield. In 1986 the Missouri Department of Health had to issue a health advisory for Wilson's Creek and forty-three miles of the James River, into which the creek flows, because of high levels of chlordane in channel catfish and carp. The presumed source of chlordane was termite-control treatments of homes and businesses in the Wilson's Creek basin. Visitors to the battlefield complained of odors from the creek.

Upgrading of treatment facilities during the 1990s greatly improved the water quality, but monitoring continues. Beginning in 1988, the park staff has been sampling macroinvertebrates at two sites on Wilson's Creek and one on Skegg's Branch, a tributary that originates in the Republic area, to the west. This has shown no clear trend in water quality in recent years, though Wilson's Creek does have some mayflies, stoneflies, and caddisflies, the invertebrates most intolerant of pollution, as well as crayfish and those thirty-three species of fish. Now it looks clear and doesn't smell. I thought it attractive as it moves through riffles and pools, maybe nice to canoe.

Gary must consider the whole water regime of the battlefield, however, not just the creek and the occasional breakdowns at the treatment plant upstream. The water flow, as everywhere, is related to the vegetation and

bedrock. Precipitation seeps into the ground or runs off over the surface. Some researchers speculated in 2000 that "the springs have nearly all dried up. The cause, in part, is the current vegetative conditions": the loss of prairie vegetation "with deep, fibrous root systems capable of slowing, capturing, and helping to draw [precipitation and condensation] into the soil." Previously, the springs all flowed because they had a continuous supply of water oozing down from the soil into the porous limestone and thence to the springs.

Gary showed me an example of what the researchers were talking about. In the Manly Woods on the southeast part of the battlefield, he pointed out a few scattered tufts of sedge. "At the time of the battle, these woods were much more open, and much more sedge grew here because of all the sunlight coming through. The sedges absorbed a lot of water." Now, he told me, researchers think "water runs off almost immediately, which causes the downcutting of ravines you can see down the slope."

Thinking about the battle, he said, "Can you imagine pulling cannons and their supply wagons through these woods?" I couldn't. Nor could I imagine how Sigel could have seen his distant targets from here, where trees now limit the visibility to a hundred yards or less.

Overarching all management concerns at Wilson's Creek National Battlefield is the park's situation in a rapidly developing area. To paraphrase the seventeenth-century poet John Donne, "No park is an island. It is a piece of the main." Current projections suggest that the local population will more than double by 2020. The towns of Battlefield, to the east, and Republic, to the west, want to expand virtually to the park boundaries. All this has implications for the battlefield's water quality, possible air pollution, pressure on wildlife populations, visual quality, and—perhaps most difficult to deal with—human use of the park itself.

More and more, people are coming to Wilson's Creek, not so much to learn about the Civil War battle that occurred here, but to walk, jog, bicycle, and ride horses. In the past, time trials for bicycle racers were sometimes held on the tour road, and more recently a woman suffered a concussion when a bicyclist, looking down, struck her. Many park service battlefields discourage these kinds of activities, but at Wilson's Creek most are allowed as long as there's no damage to park resources. "This park belongs to the public," Gary says. "We can influence development but not

stop it," says Superintendent Lusardi. "We can try to persuade counties to develop other recreation areas to take pressure off Wilson's Creek."

As I walked around the battlefield one last time, it was hard to imagine the awful events of August 10, 1861. The place was too peaceful and lovely. Instead, I enjoyed the present: butterflies dancing by, the hawks circling over Sharp's field, the little fish in Wilson's Creek, the vista of woods and fields. Horseback riders and joggers greeted me cheerily. I left with a hope that past events and present realities could be harmonized, and that the battlefield would indeed someday look as it did in 1861.

POMME DE TERRE LAKE

The entire nation was caught up in a dam-building frenzy. Water
projects popped up . . . wherever influential congressmen saw
jobs, money, and votes.

> JON L. HAWKER, *Missouri Landscapes: A Tour through Time*

Pomme is perhaps the prettiest lake in the Kansas City district.
You can't find an ugly area here.

> JIM DAVIS, Corps of Engineers

When you dam a river and make a lake, everything changes: the land-
scape, with its life, and the way people use it. Some will say, Why
kill a beautiful, natural river? Others, especially the Corps of Engineers
and local businesspeople, say, Look at the flood control, the recreational
benefits, the boost to the economy. In any case, both river and lake have
their virtues. Pomme de Terre, one of Missouri's smaller Corps impound-
ments, is one of the state's most attractive. And, as you'll see, it provides a
living for many sorts of people.

When the dam on the Pomme de Terre River was completed in 1961, it
backed water up the Pomme de Terre arm and the Lindley Creek arm,
forming a 7,820-acre lake at normal pool level (839 feet above mean sea
level). The lake is shaped like a very irregular long-rooted tooth, or per-
haps a two-armed octopus: the dam end is broad and open, and the two
arms are long and narrow, giving a sense of intimacy. Compared with most
other impoundments in the Osage River system, such as the Harry S Tru-
man Reservoir and the Lake of the Ozarks, its water is clearer, having
come from a watershed mostly of forest and pasture. Because the dam has
no hydroelectric function, the lake normally fluctuates little during the

year, thus avoiding the unsightly bare shorelines you see on the Truman Reservoir. So "Pommey," as it's affectionately called by locals, is a nice little lake.

To try to visualize the pre-dam landscape, I walked a piece of the Pomme de Terre River upstream from the lake. Starting at the Route D bridge, I followed the river down through narrow, wooded bottomland, with slopes on my right rising to limestone bluffs. It was a blue-sky, warm-cool April day. Lush green grass covered the bottoms under big sycamore trees. Trillium and other wildflowers dotted the hillside. Butterflies abounded. A pair of red-shouldered hawks screamed at me, their nest obvious high in a tree. The river, about fifty feet wide, moved right along through riffles and pools. A fish about eighteen inches long hung motionless in the water near the steep bank. I scared up a pair of wood ducks, then a great blue heron. About half a mile down, I came to a long, narrow pasture, perhaps, in earlier times, a corn or hay field. This must be about the way it had been all along the Pomme de Terre River.

To get the human side of the pre-dam landscape, I talked to old-timers. Leroy Williams, a maintenance worker at Pomme de Terre State Park, grew up on a farm beside the Pomme de Terre River, on a section now flooded. "This was rough country," he said, "just farmers and little stores. There weren't many people. When I was a kid this was the second poorest county in Missouri. We farmed the river bottoms, and mostly cut wood off the uplands. It was a nice, clear, clean river. We kids swam in it all the time. Caught a lot of fish—catfish, carp, buffalo, suckers, bass, a few crappie. Walleyes, too."

Don Ginnings, publisher, with his wife, of the *Hickory County Index*, grew up on a farm two miles east of Lindley Creek. "We were largely self-sufficient," he said, "with a garden, field crops, milk cows, chickens, and growing feed for the animals. We all lived like the Amish do now. In winter I cut timber—white oak—for barrel staves. We cut it thirty-nine inches long, free of knots. These 'stave bolts' were shipped to the stave mill at Lebanon, where barrels for Kentucky bourbon were made. We also cut other oaks and ash for lumber, and some big sycamores for wide boards— you see them on barns. In summer I worked in the bottoms hauling hay.

"A friend of mine lived on Lindley Creek, and we'd swim, catch 'perch,' bass, catfish. Seining was a community effort. Pull the seine up on a gravel

bar, divvy up the fish by species equally to each family. We would have homemade ice cream with the fish fry, a little music. Resources were not so regulated then.

"In June people would go 'noodling' for catfish. Reach in a hole: If it went down, you might grab a catfish. If it went up it was a beaver's and you left it alone. I hated to see Lindley flooded by the dam.

"The Pommey River had some sloughs and swamps. It flooded a good bit. We had a major flood every eight or ten years, but the floods didn't rage, just spread out over a wide area."

Ginnings said there had been a lot of wildlife and den trees. He hunted raccoons and squirrels. "And there was a good bit of fox hunting. You could go most anywhere; owners didn't mind. Now the land is more chopped up. Owners don't want you on it. There's not much fox hunting anymore."

As publisher and editor of a local newspaper, Ginnings followed the post-dam changes closely. "They expected the lake to take a year to fill up, but it filled up after one big rain. Boom, there's the lake! It was nasty-looking from the bulldozing and brush piles. The nutrients from all the flooded land produced a fish feeding frenzy. The bass attacked anything. You could catch a lot."

When the displaced farm families moved away, Ginnings said, the tax rolls were reduced, and the Hickory County population went down to 3,500. "People saw the boom that had happened at Lake of the Ozarks and thought the same would happen here. But it took about ten years just to get back to the tax revenue we'd had before the dam."

During the first ten years, on some weekends, more than ten thousand campers came and up to a hundred thousand people for all recreational activities. "Many of them came from Kansas City. But then air conditioning persuaded many people to stay home, and new reservoirs closer to Kansas City reduced the tourists coming to Pomme de Terre."

Housing developments began to spring up, outside the lake fringe of Corps ownership, in the late 1960s. "These came to be retirement communities. Land, labor, and taxes were cheap. The typical retiree, living mostly on Social Security, would sell his home in Kansas City and buy a cheaper but not necessarily smaller house here. Pay only around $150 property tax. Typically put a hundred thousand dollars in the bank. They boat and fish."

The wooded hills around the lake are now sprinkled with these communities. Many have private docks. Pomme de Terre is one of the last impoundments in Missouri to allow such docks. This helped improve local attitudes about federal (Corps) control of the lake and shores.

Most of the present eighteen resorts, Ginnings said, were developed from the early to the middle 1960s. Many have been improved little since then, but one, the new Eagle's Nest Resort, is an exception. The Graham family runs Eagle's Nest. Dail Graham is a metallurgical engineer who had businesses in Wichita. A lifelong hunter and fisherman, as a young man Dail had guided on the White River for the legendary Jim Owen; his clients had included famous people such as actor Andy Devine and baseball star Ted Williams. During the Wichita years, the family began coming to Pomme de Terre Lake to enjoy its outdoor activities. They bought a home here in 1978 and moved to the lake in 1993.

"My dad's never one to sit around," his son Jeff told me. First he built a cabin for his children, then others as a business. Eagle's Nest Resort is now a year-round operation, with guests that come to fish, hunt, hike, or just relax. The family also has a nearby 280-acre cattle farm.

Jeff Graham, a genial, lanky man in his thirties, helps with all these ac-

Pomme de Terre Lake, seen from the dam. NAPIER SHELTON

tivities, but his great love is fishing. "My dad bought me my first fishing rod when I was four or five. We lived on the Little Arkansas River, and that made fishing easy." At Pomme de Terre he was guiding anglers forty-five or fifty days a year. About half were Eagle's Nest Resort guests. He graciously offered to take me around the lake in his boat, for free, while he fished.

He points the Lund, a "deep-V" boat drawing only one foot, south, takes a pinch of Skoal, spits for awhile, then stops at the edge of a bluff where several other boats are fishing for crappie. Jeff is after bass. "I only fish for crappies three or four weeks a year," he says, "when they're running. This is where I caught my biggest bass on the lake—nearly nine pounds." He casts to the very edge of bushes and logs alongshore. I admire his accuracy. "When you do it a lot, you learn," he says modestly. There's one strike, but he misses it. On this late March day, he thinks the water is still too cool to encourage the bass to feed.

We then speed up the Pommey arm to the part Jeff calls "the mouth of the river." The water here is muddy from recent rains, and logs are floating. Jeff says the white bass are now running up the river to spawn. Schools of small gizzard shad are all over the lake, and inevitably some die. Many ring-billed and smaller black-headed Bonaparte's gulls are picking the dead and dying from the surface. "We have an outstanding gizzard shad population in this lake," Jeff says. "They're the main bait fish. In late summer to fall the white bass are a blast. They churn up the water chasing schools of shad. You talk about fight—they'll wear you out if you catch a lot."

Trot lines are the standard method for catching catfish here. "We have real nice channel cats in the lake," Jeff says, "and really nice blue cats, up to twenty-five pounds. For the first couple of weeks in June, when the catfish start to spawn, you'll see eight million trot lines in the lake. I used to do a lot of catfishing, but now I'm always doing something else."

Up at the dam end of the lake, Jeff points out what he considers the best muskie fishing areas: Martin's Flats, Point 9 (the lake's points are all numbered), and another spot. "I fish for muskie in the fall, you bet, when they're feeding up for the winter. There's some big muskie in the lake. A lot forty to forty-six inches are caught, some even bigger."

The muskellunge was introduced to Pomme de Terre, the first place in

Missouri where they were tried, in the 1960s. (They are now in nine Missouri lakes.) The muskies prospered, although reproduction is small or nonexistent, and they must be restocked every year. Now they are a favorite, though difficult, sport fish here. "They're temperamental," Jeff says. "They can break your heart, or your line. You can see them in shallow water. Sometimes they just stare at the bait. The muskie is a notorious follower—all the way to the boat. They might take the bait or leave it; one might follow four or five times but doesn't want to strike. There's nothing like them for fighting. Usually they come right out of the water."

Jeff fishes several more coves and points. He has tried many lures— "bait"—he calls them: crank-baits, a green tube-jig that looks like a crayfish, favorite bass food, silver, dark blue, red, orange lures, all with no success. "I usually put at least one or two fish in the boat," he says disgustedly, and somewhat shamefully, with an observer on board. I guess he feels his reputation as a fishing guide has been tarnished.

After all his years at Pomme de Terre Lake, Jeff has a deep affection for it. "A nice thing about Pommey is it's not real big. We don't get the big boats like Truman and Lake of the Ozarks. During the week—early on a Monday or Tuesday morning—you might not see hardly another boat. I enjoy my life here; it's peaceful. I have good friends. My parents are here. But most of my friends from Wichita and college are lawyers or accountants. One is vice president of Goldman Sachs in Chicago. They are making a lot more money than I'll ever see." "But you're having more fun than they are," I suggest. He agrees.

Later Jeff gave me a more detailed picture of the fishing year on the lake. In winter, only a few people fish—for crappie deep on bluffs and at brushpiles, or for bass on the main lake points, at mouths of coves, or at channel swings along the bluffs. "We don't fish much in winter. When the water gets below fifty degrees, that's pretty much the turnoff."

In the spring, he told me, "fifty-five degrees seems to be the kickoff," when crappie start into spawning patterns. At sixty-five to sixty-eight degrees, bass start to spawn, continuing from mid-April to early May. The bass and crappie males make beds on rock, gravel, and under brush and timber.

In early summer, crappie and bass feed heavily, the crappie schooling up in deeper water. Bass also school—on deeper drop-offs and on deep brush

piles. "You can catch some muskie, especially on cloudy, rainy days, feeding in shallows."

Young shad—about three inches long—form huge schools in mid-to-late summer. White bass and gulls follow them all summer and into fall. "Everything keys on shad schools—bass, crappie, but they're the main food for white bass. Shad are fat and oily—give a lot of protein. I wouldn't want to be a shad in this lake."

As summer transitions to fall, muskies begin feeding heavily, especially in September to early October, when the water cools below seventy-five degrees. Muskies eat a lot of rough fish—carp, buffalo, drum—also a lot of shad. "We use top-water bait—anything that looks like a shad. Down to fifty to fifty-five degrees is the cutoff on muskies."

Then it's back to the winter lull. If the lake freezes, a few people ice-fish.

Numerous fishing tournaments are held on Pomme de Terre, and on many of those weekends Jeff is out there, usually with his regular fishing partner, Jimmy Williams. Most tournaments are one day, with a five-fish limit. "What you try to do first is get your limit—five fish—then look for 'kicker fish' that will put you above the other people." (The fish are put in a live well, so smaller bass can be replaced with larger ones.) "We spend a lot of time on the water before a tournament to figure out the patterns of fish and find spots with bigger fish. It's kind of tiring but a lot of fun."

Bass clubs, too, have tournaments. Members from Kansas City or St. Louis come down to participate in them. Then there are Friday-night tournaments at the harbor near the dam, beginning around early May. These are especially popular from late June through August, when it's hot in the daytime.

Jeff especially looks forward to the muskie-bass tournaments, now held in both spring and fall. These are sponsored by the Pomme de Terre chapter of Muskies, Incorporated, which has divisions all over the United States where muskies are found (thus, mostly in the north). "This fishing is feast or famine in the spring," Jeff says. "Dad and I will fish the fall tournament this year. That's two and a half days. He's the only guy I could put up with for two and a half days. We'll fish bass. Four years ago we bass-fished and took second. In 1999 we took first."

On the second day of April, in gradually clearing drizzle, I stood on the dam surveying the scene. Through binoculars, the dark specks coursing

over the water became tree, rough-winged, and barn swallows; the larger dark shapes on the water became horned grebes, resplendent in their breeding plumage, with chestnut throats and golden "horns"; and the white spots on a distant, small island became fifty white pelicans, resting on their northward migration. Identification of the immature bald eagle soaring overhead required no magnification.

The broad water spread to dark hills, with a few houses visible through the trees. I could see the more open campgrounds of the Corps' Damsite Park and Quarry Point Park, and glimpses of the more distant peninsulas occupied by Pomme de Terre State Park. Only a couple of boats plied the water, probably driven by die-hard fishermen. Out of sight, along the two main arms of the lake, lay four more Corps of Engineers parks, numerous private docks, and several marinas. Behind me, on the downstream side of the dam, water shot out into the Pomme de Terre River, beside which lay the Corps' Outlet Park. I could only imagine the bottom contours of the lake, which at normal level lie ten to twenty feet below the surface in the upper arms and down to seventy feet in parts of the lower arms and dam vicinity, forming a wide range of habitats for aquatic life.

The dam on which I stood is 7,240 feet long, 155 feet high above the river bed, and 950 feet wide at the base. An intake tower rises on the lake side for controlling the release of water.

Jim Davis, the Corps' project manager at Pomme de Terre, can be thought of as the chief official of the area, since the Corps controls the lake's level and a narrow zone around the lake. He and his staff work in coordination with the Corps of Engineers Kansas City District, which is in overall charge of the Osage and Kansas River systems, as well as the Missouri River from Rulo, Nebraska, to St. Louis. In the Osage system lie Hillsdale, Pomona, and Melvern lakes in Kansas, and Stockton, Truman, and Pomme de Terre in Missouri. Water flowing through the Truman dam enters the Lake of the Ozarks, whose dam is owned by a private company, before making its way to the Missouri River.

"The Kansas City District has computers into which data is fed from stations above and below each lake," Davis explained. "Each lake has a minimum outflow. It's fifty cubic feet per second for Pomme. This is to maintain water quality downstream. Normally we want to stay around 839 feet [above sea level], except in spring. We have an agreement with the

Missouri Department of Conservation to *try* to maintain the lake at 841 March 15 to June 15. This is to get water up into the brush and grass and make more area for spawning crappie, bass, and walleyes. After that the goal is to slowly lower to 839, to keep more water later in the river for fish and canoeing.

"If there's a lot of rain, we look at the whole system, determine how much outflow to have from each dam. This is decided in Kansas City. During more normal times we discuss and jointly decide what to do. There's somebody in Kansas City for each lake—each person in the Water Control Office may be in charge of three or four lakes.

The Great Flood of 1993 called for special care. "In September 1993, the whole Missouri River system was affected. The highest level here was 864.5, twenty-five and a half feet above normal level. On September 24, we reached 3,500-cubic-feet-per-second outflow. We held water, Truman, Stockton held water. Still there was flooding downstream, but we probably saved Lake of the Ozarks, which has only about ten feet they can work with. At Pomme it was still nearly ten feet below the spillway level, which is 874 feet.

"Most of the recreation season was over by that time, so the high level here wasn't too disruptive. But in June 1995 we had 862.65 feet, the third highest level. This raised the docks so you couldn't get to them. It flooded campgrounds and roads. We had very high levels from before Memorial Day to after Independence Day, our two biggest holidays. I think the lowest level was about 834 to 835 feet, in the 1970s. That put many docks on dry land."

One problem with dams is they eventually silt up, ending their useful life. "There's not much siltation here," Davis assured me, "just a little in the upper end. This dam has a projected life of two hundred years. Some dams in the district have a hundred years of projected life, with maybe only sixty left now. Truman has a lot of silt already from all the farmland upstream."

Jim Davis, who has been here since 1984, is definitely partial to his lake. "Pomme," he says, "is perhaps the prettiest lake in the Kansas City district. You can't find an ugly area here."

On that drizzly second day of April, I also got to see the muskie-trapping operation conducted by Rich Meade of the Missouri Department

of Conservation and his assistants each year to obtain eggs for stocking future muskies. There's a window of about two weeks each spring when you can do this, but the dates vary and peaks may be only a few days.

We boat across to the first trap, at the end of a lead net, on the other side of a cove at the harbor. It holds crappies, carp, and turtles, but only one muskie. The crew dipnets it into a tub, adds selzer water for sedation—to calm the fish—and releases the other occupants of the trap. They sex and measure the muskie on a board ruler, then put it in a long white tube for weighing—six and a half pounds. Even at this size, I discover, a muskie is an impressive animal, with its rakish build and large, tooth-filled mouth. No eggs are ready. They release it.

In the second trap, at the west end of the dam, there are five muskies, including a good-sized one, but still no female ready to release eggs. There are several more traps, so perhaps they will get ready females today. When they do, they will take them, with males for milt, to the state park marina. Here, they will call people from the Lost Valley Hatchery, near Truman Dam, to come down and conduct the fertilization. They will express eggs into a mixing bowl and add milt from several males for genetic variety.

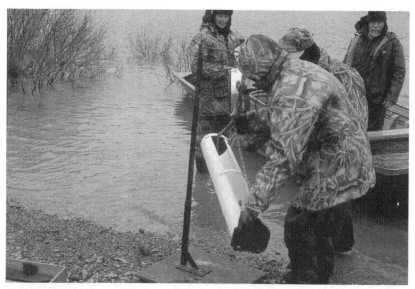

Weighing a muskie. Rich Meade, MDC fisheries biologist, is at far right.
NAPIER SHELTON

After about one hour, the eggs are water hardened and can be taken to the hatchery. At the hatchery, the fry are raised on commercial feed to four inches and then put in ponds and fed minnows. The ponds are covered with nets to protect the fish from great blue herons. By October they will be ten to twelve inches long, ready for stocking.

"We stock them in the evening," Rich said, "so they can disperse during the night and be less susceptible to great blue heron predation." There are many great blues at Pomme de Terre. "We do this in late October, when we think the water temperature will be low enough to inhibit feeding of bass, another potential predator on young muskies."

The MDC stocks four to ten thousand muskies each year. The department hoped to also begin stocking of muskies from Cave Run Lake in Kentucky, where there's a naturally reproducing population. It's believed these will grow even larger than those presently in Pomme. "We'll do this stocking for five years," Rich said, "then evaluate the results for several more years." The Kentucky fish will be freeze-branded with liquid nitrogen and fin-clipped for identification.

Muskies are not native to Missouri, so at Pomme de Terre Lake they are an introduced, exotic species. Many introduced species fail or become a pest, like sericea lespedeza, but a few, like the ring-necked pheasant, succeed without causing problems. The introduction in Missouri of rainbow trout, brown trout, and muskellunge have had generally benign ecological effects. Introducing exotic species, however, remains a risky business—one that, before implementation, is now studied more carefully.

Rich's work involves several species of game fish and measures to increase them. He's been assigned to Pomme de Terre Lake since 1986, and now he has a fairly standard yearly routine. "In March, most years, we put in fish attractors composed of large cedars tied together and weighted with concrete blocks. This is a cooperative effort with the Corps and the Department of Natural Resources. We've placed over three thousand trees at over a hundred sites since around 1992, and put up a green sign on shore at each site to show fishermen the location." At the end of March comes the muskie trapping.

About the third or fourth week of April, Rich and crew are out there electroshocking largemouth bass to assess the population. "We do this in shallow water at night, during spawning. The fish are attracted to the

electrical field and temporarily immobilized. We catch them in dip nets, measure them, and put them in a live well until they recover. Then we release them near the place they were shocked. We go to the same sampling sites each year, under similar environmental conditions. We shoot for at least five hundred fish and usually get seven to nine hundred."

Then, back in the office, "length frequency charts are developed from the data, as well as bass density and catch rate, which ranges from about 80 to 120 per hour. That's really good for a large reservoir, although it's higher in farm ponds, often 140–220 per hour. We have a very good bass fishery here at Pomme, with some trophy bass. Now we're mostly monitoring to see if any changes occur that would require changes in management."

In years when surplus walleye fry or fingerlings are available, Rich stocks them—fry in April, fingerlings in May to early summer. Although Pomme de Terre is not a priority lake of the MDC for walleyes, as Stockton is, Rich thinks it "would provide a really good walleye fishery. I hope by the time I retire there will be a good walleye fishery here."

Creel censuses, the principal method for estimating the sportfishing catch, were conducted earlier at Pomme de Terre. "When money is available," Rich said, "we'll do creel censuses—two years on, two years off, on Pomme, Truman, and Ozark."

In summer, "there's plenty of catching up to do in the office." This is the time for reports, analyzing data, and planning, as well as for work at smaller public lakes and ponds within the counties Rich is responsible for.

In the second half of October, besides stocking muskies, Rich and his associates conduct crappie sampling. For this they use smaller trap nets than the muskie nets, at nineteen to twenty sites that are the same each year, under similar environmental conditions. This samples the overall population, not just the spawning population as with the bass sampling. They record catch size, density, and lengths. "Pomme ranks fair to good for crappie," Rich says. "There's a fluctuating reproduction. Earlier creel censuses and tagging studies showed that anglers could harvest 40 to 60 percent of the adults; therefore a nine-inch size limit was implemented to maintain a healthy population."

He sees a good food supply for the sport fish in Pomme de Terre. "There's plenty of zooplankton. Insects are probably substantial where there's brush or fish attractors. There's a lot of brook silversides two to four inches. But

gizzard shad are the most important prey species. They go all over the lake, spawn on shores. They don't outgrow the predators here as much as in some other lakes. Even crappie can eat them."

Rich has some concern about the lake's water quality. "We have had kills of thousands of crappie and bass, mostly in the mid-to-late 1990s. And in 1995 a kill decimated the white bass. We don't know the cause, but it was probably a disease. That hurt fishing for a couple of years, but they've recovered. A hot summer can cause kills. Fish can be more vulnerable to various diseases and parasites when under environmental stress. Pomme appears to have more frequent algal blooms in the spring than it used to. Nutrients are coming from farms and the Humansville sewage treatment plant, plus homes around the lake. Pomme has very good water quality now, but we need to watch it. That's one of the most important things."

Rich Meade is stocky, with sandy hair and beard. His face is weathered from most of his fifty-some years spent in the outdoors. "There's not much outdoors I don't do," he said. "I prefer crappie fishing, or pond fishing for bluegills, but I also like to fish for walleye, trout, and salmon. Out west I like to creep up on beaver ponds fishing for brook trout.

"I probably hunt more than I fish—bowhunting and muzzle-loading for deer and elk, bird hunting with my retriever. I hunt just about every fall weekend. Fortunately, my wife is understanding."

He traps raccoons, beavers, and otters, and he likes to hunt for mushrooms. "This rain we've been having should bring them out." At home on his seven acres near Truman Reservoir, he burns the open area to encourage prairie grasses.

Rich used to cross-country ski, he said, when he lived in Michigan. This was early in a career that began with lamprey control work out of Ludington, Michigan, mostly on Lake Michigan. While there he got a captain's license and did some charter boat fishing. After obtaining a master's degree in biology at Ball State University, with a thesis on tagging of yellow perch in southern Lake Michigan, he took a job with the Indiana DNR as a fisheries technician. From there he came to the Missouri Department of Conservation.

In the fall, the attention of many people turns to hunting waterfowl on Pomme de Terre and other wildlife on the lands around the lake. This

is allowed on all the Corps of Engineers land except Pomme de Terre State Park, which is leased long-term from the Corps by the Missouri DNR, and on nearby state land. Jeff Graham and his father, sometimes with guests, hunt ducks from a boat blind along the shore, their decoys spread out before them. On land they pursue deer and turkey.

Dennis Wallace, natural resource management specialist with the Corps, is responsible for wildlife management on Corps land, as well as for park recreation and shoreline management. Several measures are taken to improve wildlife populations. Agricultural leases are let for farmers to grow corn, milo, and some winter wheat, but they must leave 5 to 10 percent of the crop for wildlife. The Corps also plants food plots just for wildlife and conducts controlled burning on grassland areas to promote growth of native grasses. "This is better for nesting birds, such as bobwhite," Wallace says, "than fescue, which is too dense."

Watching over the hunting, as well as the fishing, at Pomme de Terre are Corps rangers and MDC conservation agents. Robert Vader and Calvin Jones are the conservation agents for Hickory County, within which most of the lake lies. Vader and I talked one cool April morning in a picnic shelter at Pomme de Terre State Park.

Blond, of medium height, very neat and trim, Vader looked the essence of polite but firm authority. Now in his forties, he had worked in this county for nineteen years. Like so many natural resource professionals, he had followed his parents in outdoor activities. "In high school I learned that people actually get paid to work outside. I thought that would be right up my alley. I got a bachelor's degree in science, biology, with a minor in criminal justice. I probably should also have had a minor in psychology/ sociology. I've learned it's important to respect the diverse personalities in this world. The job is as much people management as anything."

Vader had to feel his way when he came to Hickory County. "This is a rural county—Class III—which means low income. There are few people, and most have lived here a long time. I was the newcomer. I had to establish relationships with people. Now I know who I can call on for help.

"Folks I deal with are knowledgeable of the laws. A majority of the natives are conscientious about what goes on. But a few need to be educated some. I've only run into a half dozen or so life-threatening situations. No one considers getting a citation the high point of their life."

Vader hunts and fishes himself, of course, and so he is knowledgeable about the fish and wildlife he and others pursue. "I do a lot of duck hunting on Pomme de Terre, mostly dabblers. But we get a lot of diving ducks here, too—goldeneyes, buffleheads, mergansers, some redheads—especially when there's a hard winter farther north. Then the dabblers usually go farther south, unless the water level is high and they can reach vegetation up in the coves. People will come all the way from Nebraska to hunt divers here. They usually set their decoys out in a string off one of the points in the main lake, where they can intercept ducks cutting across. The dabblers can go out to food plots around the lake; there's not much cropland beyond the lake."

As on most Missouri impoundments, bald eagles appear in winter, following the waterfowl and seeking fish. "A pair nested on Pomme the last two years," Vader said. Chances are good that eagle nesting will continue. In 2002, the much larger Truman Reservoir had around seventeen nests. The numerous great blue herons nest in colonies. "There are seventy to eighty nests about two or three miles downstream from the dam," he said, "and I suspect there's a colony up the Pomme de Terre arm on this lake."

Mostly, Vader talked about fishing. "I'm a meat fisherman: crappie, and catfish on a trot line. I use shad or crawfish for bait on the trot line. It's a lot of effort. You have to check it every twenty-four hours."

I knew the lake has a wide variety of fish, but I was surprised to learn how much diversity there is in the Pomme de Terre River upstream from the lake. "It has flathead and channel cat," Vader said, "largemouth bass, a few smallmouth, white bass—mostly when spawning, on gravel bars—walleye, green sunfish, bluegill, crappie (in deep holes), carp, gar, suckers, rough fish." He didn't mention the many species of minnows and other small fish that interest mainly naturalists and fish biologists.

Starting in April, Vader spends a good bit of time on the lake. "I drive the perimeter and go in my state boat checking licenses, length, and creel limits. Only maybe one out of one hundred people doesn't have a fishing license. I have a pretty good feel about violations before I talk to people. I watch for awhile first, note body language, like them looking around. Same with litterers. Last year I probably gave out fewer than twenty citations for short fish"—that is, fish under the legal size—"out of seven hundred to eight hundred people checked. Compliance is really good."

When asked, Vader gives fishing advice. "Surprisingly, I get a lot of questions from bass tournament fishermen. And sometimes a problem with them. One kept his and others' lunker bass for his pond. Some tournament fishermen don't even have a license." One of these men was caught and forced to let his bass go before presenting them for weighing. "He almost cried—thought he had a chance of winning the tournament."

Violations sometimes bring a laugh. "I saw one woman put an illegal largemouth in her purse. Another woman's Playmate cooler started shaking with an illegal bass inside it." But other times it's more difficult to find humor. "One of the hardest issues—in the late 1980s—was the mandatory length limit [9 inches] on crappies. Formerly there was no length limit. I had petitions, phone calls, letters—from dock operators and others—against the new regulation. But this was not a good crappie lake before the length limit. Afterwards, people apologized to me when they saw how the length limit improved the crappie fishing."

Inevitably, conflicts arise between different kinds of lake users. "In one incident a man insisted on trolling for white bass near where a hunter had set up his decoys. He even called me complaining about the hunter—said he threatened use of his gun." There are also conflicts between fishermen and boaters, especially water skiers and those on Jet Skis. "Jet Skis are a safety hazard, too. There have been accidents."

Vader likes his work, which he thinks is "the most diverse job in the Department." But it has drawbacks. "I go home wondering if my efforts have had an effect. It's hard to know what my accomplishments were, not like somebody, say, in construction. I especially wonder when I've had a bad contact with somebody. They belittle you. In school I used to be one of the quietest people. In this job you have to climb out of your shell. You have to be thick-skinned too."

One gets still another perspective on the lake at the state park, which occupies two opposing peninsulas. Here Laura Hendrickson, formerly superintendent at Prairie State Park, supervises a staff consisting of an assistant chief, a park ranger, an office support assistant, four maintenance workers, and six seasonals: five in maintenance and a naturalist. The staff does natural resource management, like burning woods and open areas to restore oak savanna and encourage native grasses, but the main mission is outdoor recreation.

"We have the most campsites of any state park in Missouri," Laura says. "On summer weekends and big holidays the campgrounds are often full. The DNR [which runs the state parks] wants to go to a campground reservation system, but there's conflict on this between local clientele and city people. The city people want the reservation system so they'll know they have a campsite when they get here. I think the locals want to be more spontaneous about using the park.

"There's also some conflict over use of the boat docks between anglers and boaters. When a fishing tournament is on, anglers take up all the slips.

"Funding is another problem. Currently it's down because of the economic downturn [funds come from the state sales tax]. I have to close one shelter this year. People don't understand."

Still, most of the seven hundred thousand yearly visitors seem happy with their experience at the park, where they can camp, fish, boat, swim, and enjoy nature. Helping with the last activity is Christy Dablemont, the seasonal naturalist. A biology, chemistry, and physical science teacher at Hermitage High School, she spends her summers at the park educating people about the outdoors. Her programs are especially focused on families with children. Besides conducting walks and talks on all aspects of nature, she has special days: Spider Day, Bug Day, Geology Day, Picnic on the Point (Indian Point), Build a Bluebird House, Stargazing on the Beach. One night I saw the myriad of stars from the beach and wished I could stay for that program.

I'll end my cast of Pomme de Terre characters with three more. All were attracted partly by the fishing.

Jim Wilson, athletic director at Hermitage High School. Wilson, formerly a coach of basketball, baseball, and several other sports, is an avid fisherman. He teaches a fishing class at school, and in his spare time he is a fishing guide. "I probably fish 180 days a year." Coach Wilson plans to go into guiding full-time when he retires. An affable man with an endless fund of stories, not to mention fishing prowess, he'll no doubt have a very successful second career on the water.

Leslie Rubles, manager of the state park marina. Leslie and his wife left their former jobs to accept a fifteen-year contract running the marina. "It's much more relaxed here," Leslie says. "I can go off in my boat fishing for a couple of hours when my wife takes over at the store." He talked about

the loons and the pelicans, then remarked, "If you stay here long enough, you see some interesting things. I saw a mink catch a coot in the water, and another day I saw an otter floating on its back in the lake."

John Steuber, of the U.S. Foreign Commercial Service. I met John at the American Embassy in Baku, Azerbaijan, of all places, where he was on temporary assignment after retiring from full-time service. He lives near Pomme de Terre Lake. His dad, who was a fishing guide and persuaded the MDC to introduce muskies in the lake, started bringing the family here thirty years ago. John's nephew, Jerry Steuber, was a renowned muskie fisherman at Pommey. John's wife died several years ago, and his children, who all live in St. Louis, were trying to persuade him to move up there. When last I saw him, John didn't sound like he was moving.

■ ■ ■ ■

One day I overheard a conversation at a Hermitage coffee shop. An elderly woman, when asked by a cook if she and her husband still fish, said no. "We still have a boat but can't hardly get out of it. Dalton has had two heart attacks, and he can't fillet a fish because he can't use his right hand."

I suspect that many other people around Pomme de Terre Lake will fish until they can't hardly get out of the boat.

GLENN CHAMBERS

Cinematographer and Otter Champion

Glenn has had several bypass surgeries, but it never slowed him down. He doesn't like to talk about them because it makes him think he is human after all and can't do everything he once did.

ROBERT SMITH, friend of Glenn Chambers

Entering Glenn Chambers's home, in a pleasantly wooded section of Columbia, you know at once what the man is all about: wildlife and the outdoors. A sculpted otter stands by the front door. Inside, paintings and photographs of wildlife adorn the walls. Duck decoys sit around, as if waiting for the next hunt.

The otter out front tells you what Glenn's number one interest is these days: river otters and their restoration in Missouri. The only private citizen in Missouri licensed to exhibit these animals, he has two males in his backyard—Splash and Slide—his third pair since 1992. They have a fifteen-hundred-gallon stock tank with slide and a water-filled canoe, with toys, to play in, and a large hollow log to sleep in. We watched them from the deck above. As they came out of their log, one yawned. They ran below us in their fluid way and stood up, responding to Glenn's baby talk. Later, as we talked inside, I heard them pounding on a door below, their signal that they wanted to come into their room in the basement and be fed, or just to play.

Two years earlier, in 2000, Glenn's film for National Geographic Television, "Otter Chaos," had first aired. On the deck above his backyard, he had mounted two cameras that people on the Internet could operate, swinging the camera around to follow the otters in their play. "We had more than six thousand hits a day," Glenn said.

Since 1995, under contract with the Missouri Conservation Department,

he, often with his wife, Jeannie, has been taking his otters around the state to give talks about them and the restoration program to schoolchildren, Scout groups, outdoor clubs, groups at nature centers, and others. In 2002, at sixty-seven, after three open-heart surgeries, removal of his cancerous prostate, arthroscopic surgery on his knees, and other medical problems, he was still combining fifty talks a year with filmmaking around the Midwest. He had slowed down little from the days when he filmed as far afield as the Yukon-Kuskokwim Delta or worked at both research and photography, starting his days at three in the morning. As Joel Vance, a former associate at the Missouri Department of Conservation, put it, "The hyperkinetic wildlife biologist crams more into life than a baker's dozen of ordinary folks."

This exciting life began on June 14, 1936, at Butler, in western Missouri. "I grew up in a farm family," Glenn said. "I had all the components that a farm boy could have. I had pet crows, pet raccoons, pet squirrels. My father was a hunter, so we had bird dogs, raccoon hounds.

"Even before I was in school, I used to go to the one-room schoolhouse where I later went to school, I'd get Audubon's *Birds of America* out of the library, and I'd sit at that little bitty desk for hours looking at that bird book." When his parents could afford to buy things in town, he'd ask them to get the kind of cereal that had bird flash cards in the box. He carried them around in his pocket to help him identify the birds he saw.

"Before the third grade I had set my goal in life, of being a biologist. Photography came with it because if you're out there every day with these critters, you soon learn that you'd like for other people to see some of the things you see. The very first pictures I took were when we had raccoon hounds and bird dogs. We'd feed them on a great big flat rock, out in front of the smokehouse. One of the things we fed them was cracklins. Little songbirds came there in the winter to pick up the morsels left over. I said, 'I'm going to find a way to get pictures of those birds.' So I sawed off a corner of the smokehouse door and punched my Dad's box Brownie camera in that hole. I'd go 'click,' and the birds would fly away. I'd wait about fifteen minutes, and they'd be back, and I'd go 'click.' That's how I got started in picture-taking. I was in the third grade.

"I was also an artist. My sister's family Bible still has some of the drawings I made when I was four or five: bird dogs on point, a bird dog with her babies lined up behind her. The artist's ability just came natural to me."

In high school Glenn borrowed a 35 mm camera "from one of my rich buddies in town." In college at Central Missouri State University, he took a course in photography. "Of course I made an A in it, because I knew how to compose pictures. All that stuff just came naturally."

Over the years, as his income rose, he upgraded his cameras. "In 1961, when I started working for the Conservation Department, I bought my first single-lens reflex camera—an Exacta VXIIa. Then I bought my first Leica. I still have it. I graduated clear on up through all the Leicas. Then along came the modern point-and-shoot crap. I just set my cameras on manual. I know how to get good pictures without all that stuff.

"The first thing I had published that really put me on the map was in 1964—a picture of a ruffed grouse sitting on a log, on the cover of *Missouri Conservationist.*" This photograph was the best of many grouse pictures he had taken, beginning in 1962. In the winter, with snow on the ground, he located a likely looking drumming log with grouse tracks all around it. He set up his blind and over the next few weeks moved it closer and closer. Another year he started photographing a drumming male on March 17 and continued every day that didn't rain until June 14, when the bird stopped drumming.

At this time, having obtained a master's degree in wildlife management from the University of Missouri–Columbia, Chambers was employed by the MDC as a research biologist, administering statewide pheasant research. He would get up in the wee hours, drive to the grouse area, photograph, then drive to work. Such long days became almost habitual, so consumed was he with his camera art as well as with wildlife science.

After awhile, the grouse he was photographing caught on that there was a human in that blind, even though Glenn would enter it in the dark. So he had to bring a friend to the blind, who would later leave, convincing the bird that all was now safe. Crows and sandhill cranes are even smarter, Glenn says. "You have to take seven people to a blind to fool a crow. They can count five real easy. Cranes about the same."

That grouse photograph on *Missouri Conservationist* launched Chambers into a distinguished career as a wildlife photographer and, later, cinematographer. "McGraw-Hill wanted to publish that picture in its book *Life of the Forest,*" he said. "Next thing you know, I'm selling pictures to *National Geographic, Ranger Rick, National Wildlife, International Wildlife,*" sometimes with his accompanying articles.

Charles Schwartz, filmmaker with the Conservation Department, had seen Chambers's pictures in the *Conservationist* and other magazines. "He said, 'Wow! If you can do that with a still camera, you can do that with a movie camera. How'd you like to make a turkey movie?'" This was in the late 1960s.

Still employed as a research biologist, Glenn got up nearly every day at 3 a.m., drove more than a hundred miles to the turkey woods, filmed most of the morning, then drove back to do his biological work. "It was a landmark film," he said, "because people were just getting into the turkey thing—a lot of states were releasing wild turkeys. We showed in that film the restocking effort, the life history of the wild turkey, from the time the babies hatched. It showed predation by coyotes, poaching." (The latter was staged: "You can't just sit there and wait for a poacher.")

When he made the film, there weren't very many turkeys yet, so Glenn had just two filming locations, one near Rolla where there was a good population, and one near Kirksville, where there were just a few birds. The night before filming, he would call his Weather Bureau friends to find out which place would have the better weather.

"I had several blinds in each area, so I could go where the birds were working. For nesting, I had a farmer friend down in Phelps County who owned about twelve hundred acres. I told him I needed a turkey nest. So he got on his horse, and in an old field he found a really really good nest. Redbud sprouts coming up—a perfect place for a turkey nest. It was about a hundred degrees in my blind, and I would sit in there all day. I got pictures of the hen turning the eggs and doing other things. Those babies hatched on the Fourth of July—apparently a second nesting. I got the whole thing on film. It was beautiful, something no one had seen on film before.

"The landowners were interested because no one had ever done a turkey picture before. I had really good cooperation from them for everything from trapping turkeys to doing the nesting stuff, whatever else was in the picture."

It took three years of this demanding, challenging routine to make the film, but the result, the 1971 movie *Return of the Wild Turkey*, won national awards. The MDC now added "cinematographer" to Glenn's job description, but his salary remained the same. Over the following eight years, he made more feature-length movies for the Conservation Department and received additional honors.

In 1979, Chambers went to work for Ducks Unlimited, which had offered him a much larger salary, with one stipulation. Glenn's boss said to him, "I know you're a photographer, that's your first love. But you also have the attributes that can help us raise a lot of dollars in Missouri for the ducks. I'll make you a deal. When you get the three hundred thousand dollars a year we're raising now up to a million dollars, you'll automatically be the corporate wildlife photographer." In five years Glenn became the corporate wildlife photographer.

Three years later, new management decided to move the operation to Chicago, asking Glenn to leave his long-time home in Columbia. He said to them, "I don't think so." He remained in Columbia; within one month, he was working again for the Conservation Department, this time purely as a cinematographer.

By the time Glenn retired from the Conservation Department, in 1995, he had taken many thousands of photographs and produced seven award-winning feature-length films, on forests, furbearers, bald eagles, fishing, and other subjects. Most were several-year projects. His succinct description of the movie-making process makes it sound almost simple: "You develop the treatment, a shooting script, do the filming, do the narrative

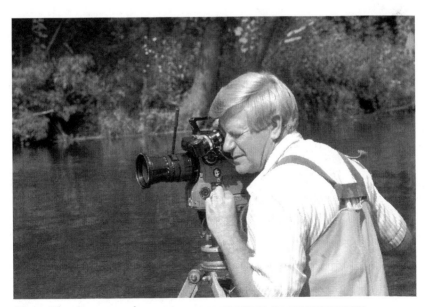

Glenn Chambers at work. MISSOURI DEPARTMENT OF CONSERVATION

script, the sound recording while you're at it. When you get all that, you edit the thing, get someone to write you some real pretty music, get someone that can talk real good to narrate it for you, then you've got a show."

But of course it's not easy, especially when you go after the hard shots Glenn Chambers does. To get photographs of a coyote pup looking out of its den, from *behind,* he dug a hole the size of a fifty-five-gallon drum behind the fork in the den tunnel, climbed in, had a farmer put a tarp-covered gate over the top, punched a hole through to the den passage, and waited. "The coyote pups could smell me but they couldn't see me. I sat in there all day." The reward was photographs of a silhouetted pup looking out of the den mouth at a bright field of flowers, waiting for its mother.

Many of the close-ups Glenn has gotten are of animals that have imprinted on him and think he's their parent. For instance, he imprinted some Canada geese by talking to them while they were still in the egg. Later, he imprinted them on his helpers and a red wind sock. In his film *Back to the Wild,* you see these geese eyeball to eyeball as they follow his boat with the wind sock speeding up the Missouri River.

Doing a story about swift foxes for *Audubon* magazine—"Little Fox on the Prairie"—Glenn photographed four he'd gotten as babies from the zoo at Great Bend, Kansas. "We'd turn them loose—the four of them out there running across the prairie. When we got ready to go we'd head back to the Suburban, holler at them, and here they come like little puppy dogs."

Glenn has brought back Arctic foxes from the North Slope of Alaska, and he has kept coyotes, red foxes, badgers, copperheads, black snakes— even a snapping turtle, with which he had "no relation at all." Through the years, Glenn summarized, he and Jeannie "have had twenty-six species of wild critters living in and around our house."

Not the least of those critters are three pairs of otters: Paddlefoot and Babyfoot, 1992–1996; Little Paddles and Babyface, 1996–1998; and, since 1998, Splash and Slide. They all have been stars of Glenn's educational programs about river otter biology and the restoration program.

That program has been both very successful and very controversial. River otter restoration had been a goal of the Missouri Department of Conservation for some time after the great successes with deer, wild turkeys, beavers, and Canada geese. Otters were once present in every major watershed in Missouri, but many decades of unregulated trapping and habitat

destruction decimated the population. Only seventy were estimated to remain in a 1934 study. A survey published in the early 1980s found that most of the state's otters were in the Bootheel, primarily at Duck Creek Conservation Area and Mingo National Wildlife Refuge, with a remnant population in the upper Osage River drainage.

"Otters were on our state threatened list, they were a species of great public interest, a species targeted for restoration," said Dave Erickson, who was the MDC's furbearer specialist in 1980. "The opportunity came about when we were given the chance to trade some wild turkeys to Kentucky for river otters."

In an experimental program, otters obtained from Louisiana (and paid for by Kentucky) were released in two very different habitats. The nineteen animals taken to Swan Lake National Wildlife Refuge, in northern Missouri, entered a region of the state, Erickson said, "where there were still large numbers of remnant wetlands, both on the federal and state areas and in other parts of the drainage as well." Lamine River Conservation Area, fifty miles west of Jefferson City, "was selected as a contrast. It's a much more riverine habitat." Twenty otters were released there.

The otters did well in both places. Although a few individuals dispersed up to a hundred miles or more, surgically implanted radio transmitters revealed that most stayed in the core area and had frequent interaction. Eighty percent of the animals survived each year. The transmitters gave out before young could have been born, but managers subsequently saw adults with kits.

"If all these animals had died," Erickson said, "we were perfectly prepared to stop the restoration program." But this was obviously not the case, and, by 1992, 845 otters had been released at forty-three sites around the state—in all regions except the Bootheel, where there was already a good population in the remaining high-quality habitat.

When Erickson was promoted to an administrative position, Dave Hamilton took over the program. After several more years of releases, Hamilton and his associates had some surprises. They had thought otters would do best in areas with slow streams, sloughs, and other wetlands—habitats most common in northern Missouri. "We surveyed probably 150 or 200 streams and ranked them in terms of habitat quality. We thought the Ozarks, particularly the lower Ozarks, were probably the lowest priority,

because of not a lot of wetlands, and we thought they were pretty sterile, based on otter food habits as we knew them. What we found out was that Ozark streams are probably some of the best habitat in terms of the otters' ability to find food and reproduce and hide and do all the things otters have to do. For one thing, the crayfish production in those Ozark streams is some of the highest in the United States." Ninety percent of otter warm-season food is crayfish. Otters turn to fish in winter, when crayfish burrow into the bottom and go dormant. "And those streams have been slowly filling up with gravel. Some of the deeper pools are much shallower now, so the fish have fewer places to hide, making them more vulnerable to otters." Otters hunt best in water two to three feet deep. "The Ozark otter population just exploded."

Conservation Department studies also showed that Missouri's otters were reproducing at a younger age than expected. "Females aren't usually reproductively active until they're three years old," Hamilton said. "In Missouri, about 60 percent of them are breeding by their first birthday, and instead of averaging two or two and a half pups per litter, they're averaging three and a half pups. Obviously, food is plentiful.

"The other thing that surprised us is what the otters are using for habitat. They'll go into these little bitty farm ponds, sometimes six or seven miles away from what we thought of as otter habitat. It was a smorgasbord—a half acre or one acre stocked full of fish." Telemetry studies have shown that some otters spend all their lives at farm ponds—about four or five out of the fifty animals monitored. They will enlarge a muskrat burrow and just move in. When that pond is wiped out, they move to another.

Aside from Missouri's estimated five hundred thousand farm ponds, of which Hamilton thinks at least 10 to 20 percent have otters at some time, otters use drainage ditches. Also contrary to expectation, they have occupied large impounded lakes. With all these human-created habitats, in spite of stream degradation and loss of wetlands, he thinks Missouri may have more otters now than in presettlement times.

"Our research changed our mind about what an otter needs. They don't need pristine habitat. They just need groceries—crayfish and fish. They don't care what kind of fish it is—smallmouth bass or a big old sucker—it doesn't matter to an otter. I've never seen a predator that is as efficient as

an otter in catching food. I call them water wolves. They hang around in packs and they are just a ferocious eating machine. Getting groceries is not an issue."

Two surveys, using different methods, estimated that Missouri's otter population in 2000 was about eleven thousand or eighteen thousand. The highest density appeared to be in the central Ozarks, the lowest in the southwest Ozarks, watersheds just south of St. Louis, and scattered regions from the Lake of the Ozarks to far northwest Missouri. But no sizeable part of the state is now without otters.

Conservation Department biologists were surprised at the degree of success. (A publication of the London Zoological Society called this "the most successful carnivore restoration in the world." Other states have modeled their otter restoration programs on Missouri's.) The biologists cannot presently predict how high the population will go. It's fairly common for introduced species to increase rapidly, then taper off to a lower, stable level when they become integrated into existing ecosystems, with all their checks and balances. Only time will tell if this applies to Missouri's otters.

Meanwhile, although most Missourians support the restoration program, the Missouri Department of Conservation has been confronted with loud outcries from farm pond owners, aquaculturalists, and fishermen. These all work with water bodies where fish (or crayfish, in the case of some aquaculturalists) are especially vulnerable to otter predation. The larger streams have more space and hiding places for fish, but upstream ends of the smaller tributaries typically consist of pools separated by riffles or dry streambed, and fish congregate in those pools. Smallmouth bass sometimes move up to a mile to favored wintering pools, where they school up—"sitting fish," as it were, for otters.

Fishermen vary in their attitudes about otters. Chuck Tryon, the avid trout and smallmouth fisherman from Rolla, said, "I dearly love the little critters, but they're eating the hell out of my smallmouth bass." Dave Hamilton said I should talk to Debo McKinney, who runs a hardware store in Houston, near the Big Piney River—"right in the heart of the controversy—at the epicenter. He can give you perspective that reflects the attitude of the Ozark people. He's charismatic—one of those guys that tends to capture the spotlight—and he's a character." So when I walked into

Debo's Hardware one morning I was looking forward to a pithy tirade. Unfortunately, he had left for a couple of days. His attitude about otters remained, however, in the form of a mounted, standing otter wearing a hat and holding a sign that read, No Fishin'. I don't think he loves the little critters, but at least he's got a sense of humor about the whole business.

Under a shower of complaints from people like Debo McKinney, the Department instituted trapping seasons for otters. It divided the state into zones, with limits and seasons determined by otter densities and the number of complaints. During the 2000–2001 trapping season, the limits ranged from five to no limit per season, and the seasons from two to three months. Regulations were most liberal and the harvest highest in Zone E, which stretches from the central Ozarks to the Bootheel. Statewide, trappers took about fourteen hundred otters that season and about two thousand the next season. "The trappers are harvesting about 16 percent of the population each year," Dave Hamilton says, "but at that rate, the population will continue to grow." The interest in trapping always depends heavily on pelt prices, Dave said. In 2001 it was sixty dollars, a high price. Lower prices would probably reduce the trapping effort. (I was intrigued to learn that many of the pelts go to China to make hats for the military.)

In another measure to deal with problems, farm pond owners and aquaculturalists were allowed to trap or shoot otters eating their fish; the Conservation Department has three control agents roaming the state to assist such people.

I wondered: What else, beside trapping, might regulate otter numbers? Large predators? "Probably they've had very little predation," said Dave Erickson. "We saw no evidence that any native predator in Missouri today—bobcats, coyotes, or even dogs—would even mess with an otter. Certainly the common farm dog is no match for a river otter. This is not a groundhog. This is a carnivore of powerful proportions. In the days when we had mountain lions and timber wolves, I don't know. They could have killed otters." Restoring the wolves, which also used to be present in the state, is not an option, Erickson said. Too many Missourians are dependent on livestock raising. The state does have a few mountain lions wandering around—of unknown origin—but at present there's no sign of reproduction.

Disease, such as distemper, which could occasionally kill otters, has not

yet appeared. Densities high enough to lower the food supplies might lead to lower birth rates, or such crowding might socially reduce reproduction. This is being investigated. So far, however, nothing seems to have halted the increase of Missouri's otters.

Most people in the state welcome the otters, and at the same time, according to a 1997 Gallup poll, 70 percent of Missourians support regulated trapping. Animal rights groups, however, oppose trapping. They have brought two court cases challenging the legality of otter trapping and pelt-trade practices and lost both, but they continue their opposition. Thus the Conservation Department is being shot at from two directions: those who want more trapping and those who want it stopped.

Glenn Chambers has been trying to educate people about otters and their restoration since 1992. After he retired from the Conservation Department, he negotiated contracts between his own corporation, Paddlefoot Productions, and the MDC to continue his live otter programs around the state. "I try to limit these trips to a three-hour, one-way drive," he said. "Beyond that the otters get very restless, and I have to let them out at some creek to swim around for awhile." Before a trip he wakes them up and lets them play for a couple of hours so they will go to sleep for most of the trip. Springfield is about as far as he goes from Columbia.

And Springfield is where I saw his entertaining program. His Suburban and otter trailer, with "Paddlefoot Productions" printed on its side, is parked in front of the Conservation Nature Center. From it, Glenn and his assistant Jon McRoberts, a University of Missouri wildlife student, wheel a large fiberglass tank to the auditorium and up a ramp to the stage. They fill it with water and arrange a wire fence across the front of the stage. Beside the tank they place Glenn's artificial log and cover it with towels.

When the audience has settled in—it's mostly members of the Missouri Ozark Mountain Paddlers this time—he begins telling them, in his strong, country-boy accent, about the restoration program and his raising of otters. He explains how the state got its otters by sending wild turkeys to Kentucky, which supplied six hundred dollars apiece for the otters that Leroy Sevin, a Cajun trapper, sent to Missouri. He explains how many animals were eventually released: "We got 845. We wanted 850, but 845 was close enough for government work," Chambers says, eliciting yet another laugh from the audience. He doesn't shirk from the problems. Describing

otter predation at farm ponds, he says, "they leave you with only heads on the pond bank." Aware with hindsight that trapping wouldn't be accepted by all Missourians, he says, "To hold down the rapidly growing population, the Conservation Department very brazenly opened a trapping season."

He talks about otter biology, reasons for the restoration, its great success, and about opponents of the program—in short, the whole story. This audience is entirely with him.

Then he describes his life with otters, especially Splash and Slide. "I got them as newborns from Leroy Sevin at a thousand dollars apiece. Their eyes and ears were shut. They could only feel and smell me. I watched a mother otter with babies and imitated her. I slept with them for three months, a baby at each ear. I let them crawl over me, nip my ears. All this imprinted them on me. I was their mother."

When they got bigger, they spent most of their day outside, but Glenn let them inside on hot nights. "Splash crawled under covers, but Slide didn't like sleeping in the dark. Sevin's wife Diane said, 'Put up a 3-watt bulb,' so I did. Slide has learned to stand up and push it on."

Every morning, he says, he smells their breath to check on their health. One recent morning, while doing this, he got nipped on the cheek. He shows the mark. Otters aren't always cute and cuddly. They can be aggressive. His first two pairs were females, which are more aggressive than males, especially when they reach the age of three or four. Glenn bares a forearm and shows the scars where they had bit him numerous times.

Having set the stage, he and Jon carry in the two otters and release them behind the fence. Rapidly they run all over, investigating, poking behind the curtains, diving in and out of the tank. They climb onto the log and urinate and poop on it, marking their territory. "I used to let Paddlefoot run around the audience," Glenn explains, "but my insurance company said, 'Maybe you better not do that.'" Beyond possibly soiling someone or their belongings, the otters might nip somebody.

He then releases dozens of live minnows into the tank and the otters twist and turn in pursuit, capturing them with ease. Slide eats them one at a time, raising his whiskered head above the water. Splash carries two or more out to the log and devours them there, then returns to the feast. In no time there are no more minnows.

Winding down the show, Glenn fields questions from the audience. "How long do otters live?" "Up to nineteen years, in captivity." "What kind of diseases do otters get?" "What dogs and cats get—like distemper." "What do you feed them?" "Ground sirloin with the fat trimmed off, mixed with cod liver oil, tomato juice, eggs, mink meal, and shredded carrots. They eat fifty pounds of sirloin in eight days. Costs me $360 a month." This is one reason they stay so healthy.

It is fun, informative, professional. Everyone goes away with a warm glow about Glenn and his otters.

As you might expect, Glenn Chambers's life has been full of adventures. "My best adventures were trips to the Arctic," he said. "On one trip I spent three weeks by myself out on the Yukon-Kuskokwim Delta, photographing ducks, geese, and things around them, like shorebirds. I had no communication with anyone. You could see for miles out there—every swan nest in the whole country was visible from my campsite." (Swan nests rise about two feet above the ground.) It was a tough, though exciting, assignment. "I had to make sure the bush pilot picked me up before the Fourth of July, because by then the mosquitoes and black flies are so bad you can't work."

Even so, they were bad enough. "In order to survive up there, you wear a hooded sweatshirt, wear chest waders with a down coat all the time. You put a belt around your waist so the mosquitoes and black flies can't get down into your crotch and down to your feet. You tie bands around your wrists, wear gloves. But they still get in. I had red spots all over my skin. Itched like the devil."

There were no bears on the delta, but when he went to the McNeil and Katmai rivers to photograph brown bears, he carried a .375 Holland and Holland magnum rifle provided by a biologist from the Alaska Fish and Game Department. He told Glenn how to make sure he killed any bear that charged: "'Wait until he gets from here to that stove from you, then break a shoulder down. Get there right quick and shoot him in the ear. You want to remember, we'd rather phone home to your wife and say Glenn shot a bear, rather than saying the bear ate Glenn.'" There were no problems. "On a couple of occasions, a big female stood up on her hind legs and woofed at me, but I just backed off. You can learn a lot by reading the body language of these critters."

I asked if he had any advice for aspiring wildlife photographers. "If you want to pursue a career like I've been through, you've got to decide there's no easy way out. It takes perseverance and hard work, and you've got to know your subject. You've got to be dedicated to getting to hard-to-get-to places, to getting hard-to-get pictures.

"To get the best pictures, number one, you've got to find something that not everybody's been doing. Or take a different approach to the subject. You need really good equipment. And forget about those 600 mm lenses. Drop down to a 135, get in close. The shorter the lens, the better the image. The better the picture, the more the editors want it."

In the summer of 2002, with his arthritic knees, cancer history, and worrisome heart, silver-haired Glenn Chambers was negotiating with National Geographic Television about making another otter film, and he was preparing to go to South Dakota in the fall to make a hunter-education movie about reducing wounding loss in ducks and geese. He would probably have to forget about duck hunting that year at the marsh he owns north of the Missouri River near the Dalton Cutoff. But he would no doubt continue to get hard-to-get, striking shots in difficult places. That is what he does.

MARK TWAIN NATIONAL FOREST

The days have ended when the forest may be viewed only as trees
and trees viewed only as timber. The soil and the water, the grasses
and the shrubs, the fish and the wildlife, and the beauty that is the
forest must become integral parts of resource managers' thinking
and actions.

SENATOR HUBERT H. HUMPHREY, introducing the bill
that became the 1976 National Forest Management Act

All across the hilly Missouri Ozarks lies a forest of oak, pine, and open glades, with rivers, streams, springs, and caves. All sorts of crayfish and fish, large and small, inhabit the streams; scorpions and collared lizards the glades; animals to the size of black bears the forests. Thousands of kinds of insects and plants live in the many different niches sprinkled through this varied landscape.

One and a half million acres of this land lie within the Mark Twain National Forest, in nine large pieces. These are scattered from Table Rock Lake, in the southwest, to Poplar Bluff and Fredericktown in the east, and Cedar Creek, east of Columbia, in the north. Some two hundred men and women, with a cadre of temporary helpers, manage this land. It takes many skills, from bulldozing to silviculture, wildlife management, and computer operation, because the resources and administrative requirements are so diverse and a guiding principle of national forest management is "multiple use." These uses range from wilderness hiking, camping, and canoeing to hunting, fishing, timber cutting, and, in restricted places, breakneck ATV and dirt bike riding. Balancing all these may be the most challenging skill of all.

Looking at the healthy, well-stocked forest today, it's difficult to imagine the sad landscape inherited by the Forest Service in 1931, when it began

purchasing land for the Mark Twain National Forest (the western units were then called the Gardner National Forest and the eastern units the Clark National Forest).

By the end of World War I, most of the Ozarks had been logged, leaving thin stands of small trees. With logging-era jobs gone, thousands of unemployed people tried to make a living on small farms. Further tree cutting, overgrazing by free-ranging livestock, and annual burning of the woods to "green-up" the grass early and kill ticks, snakes, and other pests led to erosion and general impoverishment of the rocky, nutrient-poor soils. The Forest Service was taking over some of the most abused land in North America.

Reforestation, halting the free-range practice, and changing attitudes about burning were the obvious and challenging needs. The Forest Service began reforestation on cutover lands with the massive help of the Civilian Conservation Corps, established in 1933 at the depth of the Depression to create jobs and restore and develop public lands. CCC enrollees (men seventeen to twenty-five years old) collected seed from shortleaf pines that had escaped the logging and planted them at the Forest Service nursery near Licking (now the George O. White State Nursery). Seedlings from the nursery were then planted in the national forest units, most of them on eroding former farm fields. (These plantations can be seen today along many roads.)

By 1942, when the CCC disbanded, its men had planted forty-three million trees in Missouri, on national and state forests. The state joined hands with the Forest Service in reforestation through the work of the Conservation Commission, established in 1936 with the Missouri Department of Conservation, whose director it hires.

Nature, however, was ultimately the most important helper in restoring Ozark forests. Jerry Gott, a retired Forest Service soil scientist, describes the soils as "very infertile, but forgiving." The root systems of scarlet and especially black oak remained alive after logging and began reforesting old pastures. Red cedars sprang up in all sorts of open areas. On national forest land, mostly left to itself, with some thinning to promote growth of the best trees, the forests began to recover on their own.

Permission for livestock to range freely was given by township regulations. As publicity against this practice mounted, many townships got on

the bandwagon. The number of townships allowing open range decreased from 143 in 1935 to 90 in 1951. State legislation in 1969 finally ended the period of free-roaming livestock.

Burning of the woods, a long-standing tradition, was a tougher issue. Some of these fires got out of hand. An Easter Sunday fire burned over one-third of the Ozarks in one day—April 13, 1941—remembered as Black Sunday. The principal weapon against burning was education. State Forester George O. White sent the message through movies shown in the outdoors, at country stores, schools, and churches. Conservation Department and Forest Service employees operated the fire prevention "show-boat"—actually a truck with a lantern-slide program—until the end of World War II. In 1952 the Smokey Bear program continued the message against forest fires.

Fire-fighting crews were organized by the CCC, and these were followed by state and federal crews in the 1940s. Most of the needed fire towers had been built by the end of the 1950s. A 1935 report described the "eyes of the Forest Service, sharp-eyed men selected for their ability to detect faint curls of smoke from infant forest fires, occupying observatories atop 100-foot-high steel towers."

By about 1960, the percentage of fire protection districts that burned annually, including both public and private land, had declined from more than 3 percent to less than 1 percent. Wildfires, however, though much diminished today, are still a problem, and about one-third of these are human-caused, either accidental or intentional. When the use of prescribed fire to achieve various management goals was adopted, the public had to be reeducated. Under certain conditions, burning the woods is now considered a good thing.

The headquarters of the Mark Twain National Forest occupies a pleasantly treed plot of ground in Rolla, somewhat centrally located with respect to the nine sections of the national forest. The nine sections were administratively divided into thirteen districts that are now consolidated under the management of six district rangers.

I began my research on the forest at Rolla, with the invaluable help of Charlotte Wiggins, public affairs director. Her background is unusual for an employee of a natural resource agency. She grew up in Mexico, Peru, and Brazil, where her father worked for the U.S. State Department. She learned

to speak Spanish, Portuguese, French, and Italian, along with English. Moving to the United States, she worked in television and radio, then took a job as national director of media relations for the Army Corps of Engineers, stationed at Fort Leonard Wood, near Rolla. She entered her present job in 1990.

Charlotte is a dynamo, dispensing information and getting people together to communicate and get things done, both in and out of the Forest Service. She has been on the Rolla city council, helped the local theater group, and been president of the Rolla Humane Society. From her house perched on a view-commanding hillside, she also somehow finds time to sell antique handmade quilts. She introduced me to several people at the Forest Service headquarters with various sorts of expertise.

Ross Melick, a silviculturalist who had been on the Mark Twain since 1985, gave me an overview of the present forest and its management. He said the forests don't change much from east to west, except for a decrease in shortleaf pine. Oaks dominate in most areas, especially black, white, and post oak, with some hickories mixed in; there is a high proportion of pine in parts of the southeast Ozarks. Southeastern trees like tulip poplar, sweet gum, and cherrybark oak show up in the Poplar Bluff District of the national forest.

Glades, with prairie plants like little bluestem and black-eyed Susan under the scattered red cedars and post and chinquapin oaks, increase from east to west as the tallgrass prairie region is approached. The Cedar Creek District, north of the Missouri River, is the only unit on glacial soils. These are more fertile and retain moisture better than the cherty soils of the unglaciated Ozarks, and they support a higher proportion of maple.

Timber management has undergone several changes on the Mark Twain during its seven-decade existence. Ross Melick's father, Max, who timber-cruised purchase units in 1935, said the forest then was "largely junk." Twenty years later, the quality had improved, but "we were not clear-cutting in the 1950s and '60s," Ross said, "because the trees were not big enough. We practiced a sort of selection process." By the 1970s, however, the trees were bigger, and research in Ohio and Indiana had suggested that clear-cutting (a form of even-aged management) was best for the regeneration of shade-intolerant oaks. "These recommendations were followed religiously in the Ozarks," Ross said. Then, research on the Pioneer Forest,

part of the vast holdings of private landowner Leo Drey, indicated that uneven-aged management, in which trees of various sizes are selectively cut, at more frequent intervals, maintains an intact forest and produces the same, or more, volume of wood over time than clear-cutting does. Today, as in most of the eastern national forests, uneven-aged management predominates on the Mark Twain (although extensive clear-cutting remains a common, and controversial, practice in the West).

Timber cutting of any sort has drastically declined. From 1988 to 2001, the total annual timber harvest went from 71.1 million board feet down to 16.1. "This was largely because of environmental opposition," Melick said, "and requirements concerning the critical habitat of Indiana and gray bats," which are endangered species. Timber sales cannot be conducted until detailed environmental impact documents have been approved, and even then, I was frequently told, environmental groups (especially one called Heartwood) almost invariably appeal the decision, often sending the matter to court.

Although they are the most important species in terms of management impact, the bats mentioned above are just two of the threatened or endangered species on the national forest. The list also contains Hall's bulrush, running buffalo clover, Mead's milkweed, Hine's emerald dragonfly, pink mucket pearly mussel, Tumbling Creek cave snail, Topeka shiner, and bald eagle. The Forest Service must not harm the "critical habitat" of any of these, and it must try to recover their populations.

In the case of Indiana and gray bats, the practice at first was to allow no cutting or burning within five miles of a cave used by these bats for roosting or hibernating. When the bats' habitat requirements became better known, management practices were changed, under detailed new guidelines. For instance, these allowed some timber cutting to open the forest canopy for better bat foraging. A minimum of five acres of old growth is to be maintained around cave entrances. Caves known to be used by these bats are gated to prevent illegal entry. Prescribed burning is conducted in a way that avoids smoke entering the caves or affecting known maternity roost trees. Potential roost trees (old ones with loose bark) are not cut, and specific numbers of snags (standing dead trees) and den trees are left. "We use these guidelines like Bibles," Ross Melick said.

The staff administers the Mark Twain National Forest under a plethora

of laws and regulations. The guiding document, the 1986 Land and Resource Management Plan, under revision in 2003, takes those laws and regulations into account and spells out what should be done on the forest.

The national forest occupies land in twenty-nine counties, but under law it cannot include more than 50 percent of any county. Within the authorized boundaries of each unit, only about half the area is actually owned by the Forest Service, forming a mosaic of public and private land. Within the 1.5-million-acre national forest, 63,000 acres are wilderness areas, where no cutting or motorized activity is allowed, and 26,000 acres are managed for the protection of unusual resources, such as historic sites, rare plants and animals, and outstanding examples of various types of natural communities. Most of the rest is subject to some form of timber cutting, managed to simultaneously meet other requirements, such as the maintenance of biological diversity. Healthy populations of thirteen "indicator species" of birds and mammals, typical of various types of environments, are to be maintained by a variety of timber-management practices. Most recreational activities are allowed throughout the forest, with the exception of high-impact activities like ATV and motorcycle riding, which are (by regulation, anyway) confined to certain areas; horseback and mountain bike riding are less restricted.

Management is based on detailed information about the national forest, much of it stored in geographic information systems that can display resource data on maps. The vegetative cover has been mapped from air photos refined by checking on the ground. Forest stands were delineated by age and dominant species. The national forest has also been mapped by "ecological landtypes," which are defined by landform, soils, and vegetation.

All this information, plus judgments about recreational and other uses of the forest, has been considered to produce "management prescriptions" for the entire forest. These are irregular zones in each of which certain uses are to be emphasized. MP 3.4, which covers 31.4 percent of the national forest, calls for a managed forest that emphasizes wildlife habitat, with various percentages of woodland in different age classes and amount of crown closure. MP 4.1, 27.4 percent of the area, emphasizes management of shortleaf pine for timber, recreation, and other resources. MP 6.2, 17.3 percent, emphasizes "semi-primitive motorized environment." Smaller percentages of the land are zoned for such things as intensive management of

high-value hardwood species, wilderness areas, Indiana bat habitat management, and grassland management for cattle production.

How does all this translate to action on the ground? To find out, I first visited the Houston-Rolla District southwest of Rolla, a 180,000-acre unit that wraps around Fort Leonard Wood. It is particularly notable for trout and bass streams and rare post oak savannas. Like six other units of the national forest, it has a wilderness area, in this case the 7,019-acre Paddy Creek Wilderness.

Steve Steinman showed me some of these places. Steve, a ruddy, slightly paunchy man in his fifties, was in his twenty-ninth year with the Forest Service. He was born north of Rolla, near where he and his wife now have a four-hundred-acre farm. Being a native of the area, he said, helps him see the point of view of local people, who trust him and give him information about problems and problem people. Steve is a wildlife/range/timber forest technician. He decides what should be done in various areas to benefit wildlife; he sets up grazing schedules for the sixteen allotments in the Houston-Rolla District and the twenty-two in the Cedar Creek District; and he marks timber to be cut, recording information about the trees thus marked. He's also a bulldozer operator: he makes fire lines at prescribed burns and at wildfires, he dozes eroded roads, he creates water bars to direct runoff. "I'm a jack-of-all-trades," he says. "I pitch in wherever needed."

On his farm, he runs a beef cattle cow-calf operation, selling the calves at six to eight months. He has alfalfa, pasture, and other fields on half of his farm, and woods on the rest. He sells a little timber, hunts on his property, and fishes in his six-acre pond. "What I do [for the Forest Service]," he said, "is a lot like what I do on the farm." Informative and constantly helpful, he was a perfect guide.

As we drove around in a Forest Service pickup, Steve told me a little more about the area. We were traversing the ten thousand acres of the Ramshorn Project, where several years of planning, an environmental impact statement, and public review had been required before management actions could be taken. Timber sales would be conducted on part of the area, and Steve described some of the steps involved. First, the Forest Service marks the trees to be cut, depending on tree quality, forest density, the purposes to be achieved, and other criteria. For each tenth or twenty-fifth tree marked, the estimated number of six-to-eight-foot logs in it, the board

feet, trunk diameter, and species are recorded. These are considered representative of all the marked trees. Prospective bidders, needing to know the volume and types of wood available, judge for themselves how accurate this is and make bids accordingly. Usually the highest bidder gets the sale. Throughout the timber operation, Forest Service people oversee construction of logging roads and trails, the cutting itself, and other terms of the contract.

We stopped at the Western Star post oak savanna, a rare community that may be designated a "Natural Area." (Natural Areas are some of the best examples of the state's native ecosystems, designated by a committee of representatives from public natural resource agencies.) This five-hundred-acre savanna lies on clay soils that hold water for a long time in wet periods and become hard and dry in dry periods. Post oaks can tolerate these conditions and, though not growing especially big, they have reached ages of over three hundred years here. The open savanna, with a ground cover including prairie grasses and wildflowers, was created by fire over thousands of years. To maintain it, the Forest Service uses prescribed fire and some thinning of smaller trees, which are cut up for firewood by local people with permits.

At Kaintuck Hollow, a popular area for horseback riding and fishing, we entered the Vessie Wildlife Habitat Improvement Project, where grazed grassland adjoins another post oak savanna. Both this and the Western Star Savanna Project were partly funded by the National Wild Turkey Federation, which is active in many parts of the Mark Twain National Forest. The grassland here is fescue on one side of a fence and native warm-season grasses, like grama grass and bluestems, on the other side. "Missouri livestock raisers favor fescue," Steve said, "because it gives nine-month grazing and is tough—it can regrow after heavy grazing or drought." But the non-native fescue is unfavorable to wildlife. It grows too thickly for creatures like quail to move through it. The native grasses, though having a shorter season, are much more wildlife friendly. The Forest Service, Steve said, tries to establish warm-season grasses in one-fourth to one-third of each grazing allotment.

Both the fields and woods here had been burned in a three-thousand-acre prescribed fire. Helicopters had assisted in this massive operation, shooting "ping-pong balls" to ignite the fire along edges of the burn area.

Kaintuck Hollow is also home to a small fen, another scarce community type in the Ozarks, where water seeps year-round, creating a marshy area with rare plants. Steve's boss, wildlife biologist Klaus Leindenfrost, who had joined us at the Western Star savanna, said the endangered Hine's emerald dragonfly had also been found here. "It's a large one," he said. "The larvae crawl into crayfish burrows," which he then pointed out.

One stretch of Mill Creek, which supports a naturally reproducing population of rainbow trout, flows beside a road in Kaintuck Hollow. The previous landowner had done some channelization here, and the Forest Service, in rehabilitation, had put boulders and logs in the stream for trout cover and planted trees along the banks to provide shade to produce the cooler water temperatures trout need. We'd also seen a section of Spring Creek, another stream with wild rainbows. Here the Forest Service had taken old fields out of grazing, Steve said, and planted "valuable" trees like bur oak, walnut, and pecan along the stream. Both these streams are managed for trophy trout. All trout under eighteen inches must be returned to the water, and only one per day eighteen inches or more may be kept.

Fishing in the hope of catching such trophy trout is mostly wishful thinking. Later I talked to Chuck Tryon, a resident of Rolla, a former Forest Service hydrologist and an avid trout fisherman who has fished here for many years. "It took me thirty years to catch an eighteen-inch trout in Mill Creek," he said. He released it, as he had the smaller trout. The fun is in the catching.

I met some of the other members of the staff at the Houston office. Robert Glock, a forester who oversees timber sales, described timber management on the Houston-Rolla District. "With the Forest Plan, we try to stay within the historical native vegetation types. We used to do a lot of pine planting outside of the natural pine range"—an area that includes much of the Houston District but little of the Rolla District. "We don't do that anymore. And inside the pine-management area, which is mostly along the Big Piney River, we don't need to plant in most cases because we get real good natural regeneration. In the oak-hickory areas we get real good sprouting. We never have a problem with getting back stands of good timber."

Clear-cut stands regenerate thickly, "which is difficult for people to utilize, though the animals like it—it's good cover." Through thinning, he

said, "We can bring some of these stands into a less bushy stage—bring it up into a more people-friendly size."

The Forest Service oversees timber cutting closely, as Steve Steinman had explained. Glock described a further measure taken to protect the forest. "Usually we shut down timber contracts from March 15 to June 16. That's the time when the sap's coming up. When you're skidding a log and you bump a tree, you can sometimes rip the bark off, cutting off the sap flow." Outside this period, timber operations can be conducted any time of year.

A current concern is the die-off of red (mostly scarlet) and black oaks. These species grow on shallow, rocky soils and tend to live only seventy to ninety years. Much of the new growth that sprang up after the Mark Twain National Forest was created was of these species. Several years of drought, accompanied by a great increase of red oak borers, and diseases like armillaria root rot, have hit these trees at the same time they are approaching old age. The result is die-off. A few years ago the Missouri Department of Conservation estimated that there were two hundred thousand acres of severe oak decline on the Mark Twain—about 13 percent of the national forest.

The Forest Service response is usually salvage cutting and regeneration measures. Glock said an area on the west side of the Houston-Rolla District would be their next management project. "We had a flyover last spring and noticed we had a lot of die-back over there. So we thought we should get in there and salvage some of that, and regenerate some of those areas before they come back to cedar and dogwood."

Such die-backs are one of the events that thwart management goals. "Our different management areas," Glock said, "have different conditions that we're trying to achieve. But it may take a hundred years, and we may not actually get there. There's too many natural conditions that we can't predict."

Gifford Pinchot, founder of the Forest Service, envisioned the national forests furnishing timber, flood protection, water supply, and wildlife. For the past two decades or so, the Forest Service has been trying to move from this production-oriented philosophy to ecosystem management that embraces all values of the forest, including biodiversity and aesthetic values. It hasn't been easy. Charlotte Wiggins described the two sides as the "timber

beasts" and the "ologists," those who study various aspects of the forest. One retired "ologist" from the Mark Twain called foresters "tree sheriffs." "All they know is growing and cutting trees," he said. "We others are just considered 'advisors.'" Outside pressures are a factor, too. "The timber lobbies have influence on our budget," Ross Melick said. It's harder to get money for nontimber activities.

The managers I spoke with may have had some lingering fondness for the old philosophy, but they expressed the new. John Bisbee, district ranger in charge of the Houston-Rolla-Cedar Creek District, said, "Boards and logs are just by-products of ecosystem management." Robert Glock said, "At one time I guess the Forest Service probably was a timber beast, but times have definitely changed—to more ecosystem management. . . . We have put all the specialists we can think of to look at an area for wildlife purposes, soil and water, archeological. Specialists in every field have their input into decisions. That's why it's called 'integrated resource management.'"

One of the specialists I talked to at the Houston office was Kolleen Bean, an archeologist. She explained that any land-disturbing project, from timber cutting and prescribed fire to installing a privy, has to have an archeological survey. If a prehistoric site or a "significant" historic site is found there, the project must be revised to avoid disturbing the cultural resource. A planned road may have to be rerouted or timber cutting prohibited around the site. A significant historic site is one with research potential or one that is associated with a significant individual or period of time. Structures built by the CCC, for instance, are considered significant. Some sites are important enough to be provided with interpretation, such as a trail to it or an explanatory sign.

Bean said there were hundreds if not thousands of prehistoric and historic sites across the national forest. Prehistoric sites range from Woodland, the period immediately before European settlement, to Paleo-Indian, ten to twelve thousand years ago. Many of these sites are rock shelters in bluffs along the Big Piney River. "People like to congregate along big rivers," she said, "then and now."

David Hummingbird, a Native American, deals with recreational facilities and activities in the Rolla-Houston District. He spoke with pride about the picnic and camping area at Lane Spring. Such areas may have washrooms, wells, grills, and other amenities, but camping is allowed just about

anywhere in the national forest. During deer season you see many tents and campers along the forest roads, perhaps with a dressed deer hanging from a tree limb.

Several trails are designated for mountain bikes as well as horses and hiking. "We had a big mountain bike ride on the Kaintuck Trail two weeks ago," David said. "It was a state competition with over a hundred riders." With so many kinds of trail use, however, conflicts are inevitable. Horses are scared of mountain bikes, I was told, and some mountain bikers are scared of horses and hide behind a tree. This, too, worries the horses. Mountain bikers are also not fond of horse manure in the trail.

Some form of hunting is in season most of the year outside of summer, with deer and turkey hunting probably the most popular. Fox hunting has dwindled over the years, but coyote hunting has risen with the increase of coyotes, which threaten foxes. Some coyote hunters sit on a hill at night by a campfire and listen to their hounds, as Missouri fox hunters traditionally have done, but others hunt coyotes by day, stationing themselves along a known coyote travel route waiting for a shot when their dogs push the quarry that way. Like fox hunting, hunting in general "has dropped quite a bit," Steve Steinman said rather sadly, "because the younger generation hasn't shown the interest."

Fire in the Ozarks is not as big a problem as it once was, but it's still a problem. "The main fire season is February 15 to April 15," Steve said. "This is usually the driest time of year. Leaves are off the trees and sun can get in. Also there's more wind. The ground dries out fast. I don't make plans for Easter. This is the most notorious fire day of the year."

Some of this is arson. "They do this for a variety of reasons," Glock said. "Sometimes they have a grudge, say against the conservation agent, but to people out there we're all game wardens, or whatever. And some people just believe that the woods need to be burned."

The Forest Service does have its own (few) law enforcement officers, and Roberta Page is one of these. During fire seasons she might be going after arsonists or directing traffic when there's a fire. During the winter, the favorite time for ATV riding, she spends a lot of time watching for illegal ATV travel; many riders go wherever they want to or can go, rather than on designated routes. She checks hunting and fishing licenses, patrols campgrounds. The national forest has become a favored place to set up

methamphetamine labs, and Page looks for these. "When I'm making my rounds, I try to see which roads have the most activity—say old trails that have new activity, especially if it's not hunting season." Usually she's too late, finding what has been left behind: jugs with the tubes coming out, some of the battery acid they've used, and other material. These people are hard to catch because they do their work in a couple of hours and move out. It's a serious problem. Methamphetamines are highly addictive and cheap; Missouri often leads the nation in the number of these clandestine labs. Roberta has protection on her sometimes dangerous rounds, beside her pistol. This is a Dutch shepherd, who only obeys commands in Dutch.

A few days later I wandered around the Houston-Rolla District on my own. It was late October. The muted russet and old gold of the oaks were subdued further by an overcast, drizzly sky. But I can like such moody, brooding days, with their rather romantic melancholy. And this one didn't hinder my looking around.

The Lane Spring Recreation Area was certainly the attractive place David Hummingbird had said it was. Neat picnic tables, campsites, and pavilions were spaced out under tall trees, including a few bald cypresses that must have been planted by the CCC more than sixty years ago. Lane Spring bubbled up through sand and into Little Piney Creek, another trophy trout stream. Downstream a kingfisher flew from its perch. Fresh white chips surrounded a stump where a beaver had been working. The floodplain was richly forested with the usual silver maple, sycamore, and box elder, as well as with unexpected sweet gum and tulip poplar, trees in Missouri normally found only in the Bootheel. I wondered if the CCC had planted these, too. A swarm of cedar waxwings feasted on hackberries and wild grapes.

In the picnic area, the text of a sign about camping intrigued me. Part of it read: "Permanent use or use as a principal residence without authorization is not allowed." This may have referred just to the campground, but it conjured up images of people out in the forest living in a tent or makeshift hut, perhaps commuting here and there to temporary jobs and living partly off the land. This reminded me of something someone once said to me: "You can't do anything in a national park, but you *can* do anything in a national forest." This isn't quite true, of course; there are regulations. But many people seem to think it's true. Witness the amphetamine labs and

the many difficult-to-detect marijuana patches, not to mention out-of-control ATV riding and occasional timber theft.

A recurring problem for the Forest Service is annual encampments of the Rainbow Family of Living Light, a group that could be described as "old hippies," who come to commune with nature, celebrate life, and pray for peace—sometimes going nude and often using drugs. Regional groups of the Rainbow Family camp in the Mark Twain every year before going on to the national convention, usually held in a national forest somewhere.

In 1996 the national convention was held in the Doniphan–Eleven Point District of the Mark Twain. According to newspaper articles, Rainbow Family scouts "consulted with the Spirit to select the site at sunrise." Then twenty thousand participants in the twenty-fifth Annual Gathering of the Tribes for World Peace and Healing descended on the area. They set up tents, dug latrines, built huge ovens, got their water from streams. At stores and offices in nearby Thomasville, they sought free food stamps, condoms, and medical attention.

The Forest Service set up a temporary office in Thomasville. A spokeswoman for the Forest Service said, "For the most part, we are leaving Gatherers alone and letting them know we are there if they need us." The Forest Service did put up signs warning against drinking water from streams, but the Rainbows took them down. Before they left, they cleaned up their camping area, no doubt wishing to return in the future. Apparently, no major damage was done, and no one died.

At Paddy Creek Wilderness, I sought out the Paddy Creek Campground trailhead. Here I saw a few people starting on a day hike and two men from St. Louis, with a black chow saddled with its own pack, preparing for a two-day camping trip. I sampled part of the seventeen-mile loop trail that winds through the center of the wilderness. Big shortleaf pines and white oaks grew on the first ridge. Brush and a few yuccas at a crossing of Big Paddy Creek indicated an old homesite, now returning to forest. Horseback riding is allowed here but no motorized vehicles or mountain bikes. I saw none of these and, on the trail, no one at all. I enjoyed the solitude that wilderness areas were created to provide.

At the west end of the Paddy Creek Wilderness, from the trailhead at Roby Lake, I walked a short distance through burned-over forest and then a patch of dead trees, probably a result of the oak decline so prevalent in

the Ozarks. Great woodpecker country, I thought, as indeed the whole forest seems to be. Big, loud pileated woodpeckers are everywhere. In contrast to the east end of the wilderness area, twenty-nine people had signed the trail register, and on the way in I met ten of them coming out.

The next day I visited some of the loveliest fishing streams: Mill Creek, Spring Creek, and Big Piney River. At Mill Creek, which looked quite shallow, I wondered how any trout could grow to eighteen inches there, and I marveled at Wilkins Spring, a round pool that pours four million gallons of water into Mill Creek every day. Eating lunch beside Spring Creek, I heard the shrieking of a wood duck taking off and a loud splash that could have been beaver or otter. I also heard, far off, an occasional shot; deer, turkey, and squirrels were in season.

Part of the Big Piney River is a Special Smallmouth Bass Management Area, where you can keep only one smallmouth a day and it must be at least fifteen inches. I walked along this section, past canoe rental camps, looking up at high bluffs. This is indeed a beautiful river, and one that attracts people, as Kolleen Bean had said, now and in the prehistoric past. I almost thought I'd like to live in one of those rock shelters up in the bluffs myself.

The bass management sign reminded me of tall, raw-boned Jerry Gott, the retired Forest Service soil scientist. He loves to fish for bass, floating rivers with friends and his wife in a metal johnboat. The Big Piney River is a favorite, he said, along with the Gasconade, which also flows north through the Houston-Rolla District. He spin-casts with artificial bait; he doesn't go in for fly fishing. For fly fishing, he thinks, "You have to have wine and cheese with you. I like the johnboat and beer."

Driving around the Houston-Rolla District was a bit of a challenge. Many of the road signs didn't correspond with the names or numbers on my map, and some roads were blocked by locked gates. Still, I enjoyed the patchwork of national forest and private land, with all its variety. Deep woods alternated with cow-dotted pastures. I passed little family cemeteries, some probably dating from early Ozark settlement.

The Doniphan–Eleven Point District, south of Rolla, down near the Arkansas border, is notable for the Eleven Point River, designated a National Scenic River; the 16,500-acre Irish Wilderness; fifteen "natural areas," preserved for their unusual or special plant and animal communities; and a

project that especially interests me called Pine Knot, which is attempting to restore the sort of pine savanna that existed in much of the Ozarks before settlement in the nineteenth century.

Pine Knot is partly the brainchild of Jody Eberly, a wildlife biologist formerly stationed in the Doniphan–Eleven Point District and now at the Rolla headquarters. "In the middle eighties," she said, "three of us were looking at ways to create wildlife habitat. Why don't we burn this, we said," referring to an area with pine in the Doniphan–Eleven Point District, "and see what happens. We had a couple of prescribed burns on 125 acres. Native grasses started coming in, good forage for deer and turkeys. We picked another area and had the same response. We did some commercial thinning, then prescribed burns. The Nature Conservancy became involved in the mid-nineties. They took people to see our results and did a survey that found over three hundred species of plants.

"We looked at the original government land survey maps to find areas where thick pines existed then. One potential restoration area was near U.S. 60. But burns there might cause smoke on the highway, the main route from Nashville to Branson. We didn't want someone to get killed."

The area chosen for the project is 12,420 acres in extent, most of it within the national forest and the rest Conservancy owned, two miles south of U.S. 60. (The Missouri Department of Conservation, Ozarks National Scenic Riverways within the National Park Service, National Wild Turkey Federation, and Bat Conservation International are also partners in the project.) The government land survey showed this area to be 80 percent pine in the early nineteenth century. It has few inholdings, another important consideration. The plan, Eberly said, is to do commercial thinning, mostly of hardwoods, but some pine where it's thick. Then, they will do understory thinning and prescribed burns to reduce leaf litter, which inhibits growth of grasses and pine regeneration. Periodic surveys of plants and animals will be conducted to monitor changes as the project proceeds.

The goal is an open forest of mature pines, with a few oaks, like the forest that grew here early in the nineteenth century. When this is achieved, it's expected that some of the species originally found in this type of forest will return, among them the Bachman's sparrow and brown-headed nuthatch. Red-cockaded woodpeckers, last seen in Missouri in 1946 in the virgin pine stand north of Eminence, may have to be physically brought here, in hopes that they will find the special conditions they need and will

stay and reproduce. Judicious timber cutting, it has been shown in other such areas, can be conducted without impairing the habitat for demanding species like the red-cockaded woodpecker.

In 2003, the project still had to go through approval of its environmental impact statement, the Forest Service appeals process ("anybody with a postage stamp can appeal," Eberly said), and possible challenges in court. The Nature Conservancy "has helped to blunt opposition to timber harvesting among the conservation groups," she said, "and also has gained support from timber companies.

"Pine Knot is my biggest project. I'll probably be here another ten to fifteen years and should see some results. It's like having a baby."

Resource managers see this kind of restoration as reinstating long-term natural disturbance processes, especially fire. Many species of fire-adapted plants and animals may disappear in the absence of fire. In Missouri, many of the state or federal threatened or endangered species are such fire-adapted organisms. Projects like Pine Knot are undertaken partly to help recover them.

I looked at this area with Don Fish, a silviculturalist for the district. In some places I could see blackened bases of trees, from earlier prescribed fires, and a more open view through the forest. Don showed me maps of the six alternative management plans proposed, with various treatments in different colors, by forest stands. "The Forest Service and Nature Conservancy favor number six, the most aggressive. No doubt there will be appeals and litigation.

"In the pine stands we will remove most of the oaks," he said. "The commercial thinning will take oaks six inches and up for poles and posts, nine inches and up for sawtimber. Under six inches, the Forest Service will have to do the cutting. Fire can kill oaks up to three inches."

We parked and walked to a brush-filled sinkhole pond beside which Don wanted to show me a big pine that had escaped logging. It was twenty inches in diameter, probably two hundred years old, he said. We stood there contemplating it, and I thought about all the history it had seen.

Don said, "The restoration is supposed to get the forest back to its natural, presettlement condition. But what is 'natural'? It was mostly due to Indian fires—human-caused." We couldn't answer the question, but we still looked forward to the forest that would someday be here.

Such restored pine savannas are planned in several parts of the Ozarks,

but complete success of this management will require a change in markets. "Timber companies presently don't seem very interested in long-term pine production here," Don said. "The markets in this part of Missouri are for oak." Ross Melick had also described this marketing situation, saying that oak brings higher prices than pine in Missouri. "There's more pine market in Arkansas. Weyerhauser comes up from Arkansas to get Missouri pine." But he also pointed out that "pine has high volume per acre and grows faster than oak. It has double the fiber production of oaks."

Maybe commercial thinking will change. In any case, pine savannas like those of old, with their towering trees and open space you could drive a horse and wagon through, will please anyone who walks or hunts there.

I couldn't leave the Doniphan–Eleven Point District without at least a quick look at some "natural areas." Back at headquarters, Paul Nelson had told me about the natural areas program, with which he'd been involved for many years, first in the Department of Natural Resources and now in the Forest Service. The goal of the program is "to designate, manage, and restore high quality examples of every extant natural community in each of Missouri's natural sections."

By 1996, 168 natural areas had been designated in Missouri. Nineteen of these are located in the Mark Twain National Forest, and fifteen of those are clustered in the Doniphan–Eleven Point District. I decided to look at Cupola Pond, one of the natural areas Nelson had described as especially interesting, where a disjunct, mature stand of tupelo gum grows, far from the tree's principal southeastern range.

I parked at the end of Forest Road 4823 and walked the quarter-mile trail to the pond, which lies in a sinkhole depression in the forest. The pond had shrunk by this season—late October. Tupelo gums stood in and around it, their broad bases dark with moss, their tapering, slender trunks rising high to the canopy. Their oblong, pointed leaves were still green, but many had already fallen, covering the ground and water. Around the pond grew a few big pin oaks and smaller red maples. Spongy sphagnum moss squished underfoot. Except for the occasional chattering of squirrels and "churring" of red-headed woodpeckers, the place was still. I thought it could seem enchanted or spooky, depending on your mood and the weather. Today, overcast, it felt a little spooky.

Farther east, in the Poplar Bluff District, my main objective was to see

how the Forest Service was dealing with tornado damage. The previous April, I had been in Van Buren, on the Current River, when a tornado came through. It cut a swath from there to Poplar Bluff, with winds over two hundred miles per hour. In the Poplar Bluff District of the national forest, it plowed through Elsinore and mowed down trees for twenty-three miles, in a strip about a half-mile wide. Another tornado at the same time, farther north, tore through the Potosi and Fredericktown districts for fourteen miles.

Bob Harrell, assistant district ranger at Poplar Bluff, explained the local tornado situation. He said this is a transition zone where warm and cold air masses often meet, producing tornadoes. The district gets a tornado about every two or three years, usually coming from the southwest or northwest. The principal period, surprisingly, is late fall to April. Last April's tornado, he said, was "a large event."

We then set out to see the results of this large event, introducing ourselves a bit en route. Harrell is a burly ex-Marine who had been in the fleet sent to blockade Soviet shipping at the time of the Cuban Missile Crisis. His Forest Service career had taken him to various national forests in the East before coming to the Mark Twain, where he had served for fifteen years. He'd seen a few tornadoes.

This one, however, had been especially impressive. At the Pine Cone Estates, a new subdivision of expensive houses, most had been flattened and were now being rebuilt. The pine trees were gone, leaving an open landscape. Nearby, Harrell said, a woman had gotten into a bathtub and put pillows over her, as instructed if you don't have a basement. The tornado smashed her house and carried her, in her bathtub, out to the highway median, where she was found unconscious but alive.

Down a forest road, we came upon a cleanup operation, which was not active that day because the ground was too wet. This landscape, once an area with tall trees, was left with only scattered small trees still standing. The rest were lying uprooted or bent over in huge tangles. These clusters are dangerous to work in because the chain saw may release a pinned-down tree that springs up with great force.

After the tornado, the Forest Service felt it had to respond quickly because the three thousand acres of downed trees presented a serious fire hazard, and many homes were in the area. The Council on Environmental

Quality said the service could make "alternative arrangements" for compliance with the National Environmental Protection Act (NEPA), which would take around six months rather than the two years of the usual environmental impact statement. They then proceeded to bulldoze ten-foot-wide fire lines around the tornado path and, where this was near homes, cleared all materials down to a two-foot height outside the fire line.

The larger downed timber was being cut and removed by timber companies, under sales contracts. On another road, we met the Forest Service man supervising these logging operations. At this point, at the end of October, he said nine companies were doing the work. They had started September 11 and hoped to be finished by March 1.

Tornadoes are one of those natural events that interfere with Forest Service management intentions. "The tornado clear-cut it for us," Harrell said. Clear-cutting was not the original intent.

A totally different management concern is lead mining. The Old Lead Belt, which runs through the Fredericktown District of the Mark Twain, is now inactive. The New Lead Belt, the Viburnum Trend, runs through the Salem-Potosi District, southeast of Rolla. The Doe Run Company has nine mines here, eight of them at least partially within the national forest boundary. From them comes 90 percent of the lead produced in the United States.

The Forest Service, which owns the mineral rights under most national forest land, receives royalties from the Doe Run Company, but it also has concerns about the environmental effects. Former Forest Service hydrologist Chuck Tryon used to fly over the smelter at Viburnum, checking the extent of brown areas where trees had been killed. That smelter has been closed, and emission controls at the company's other smelters have been greatly improved, but he's still worried about seepage from tailings ponds into the porous dolomite underground and thence into aquifers and streams, especially in the event of an earthquake. "Eventually," in his opinion, "the area will have a big one, cracking ponds and dams."

Donald Taylor, the exploration manager and chief geologist at Doe Run, explained the mining process. The lead, with some zinc and copper ore, is mined eight hundred to twelve hundred feet below the surface, in dolomite. The ore is crushed and brought up to a mill, which produces "concentrate" that is 80 percent lead sulphide. The waste, finer than sand,

is mostly dolomite, but it has traces of lead and zinc. This waste is pumped into a tailings pond, constructed in the upper end of a valley. Most of the water is recycled to the mill, leaving sandy-looking flats around the pond edges. These ponds, Taylor said, have impervious, or nearly impervious, clay bottoms. When a pond is completely filled, it is revegetated, eventually looking like a meadow. The concentrate is sent to the company's smelter at Glover or Herculaneum, where 99.99 percent pure lead ingots are produced. Air emissions at Glover, I was told there, proudly, had been in compliance for almost seven years.

Taylor was not optimistic about the company's future, citing high costs, low lead prices, and foreign competition. "At present prices," he said, "I think we can operate only five to ten more years. Missouri undoubtedly has other profitable lead deposits, but the permitting process is so difficult—it takes six to ten years to get permission just to prospect—that there's not much incentive to pursue it." The company had done exploratory drilling in the Doniphan–Eleven Point District, but had to stop when the Bureau of Land Management, which issues prospecting and mining permits, "changed the game on us." Furthermore, Forest Service and U.S. Geological Survey scientists had concluded that tailings ponds would probably leak in that very karsted topography.

Don Taylor was obviously in love with his work and hoped his company could keep afloat. He had just come back from China, where Doe Run was interested in making an investment, because of the lower labor costs and relaxed environmental requirements. The Forest Service, in spite of the substantial royalties from Doe Run ($2.4 million in fiscal year 2001), perhaps would be happy if it didn't have to deal with the mining issue.

To the west of the Doniphan–Eleven Point District are three more sections of the national forest: Willow Springs, Ava, and Cassville, which contain some of the most beautiful and rugged scenery of the Ozarks in their 330,000 acres. They also offer the full range of recreational opportunities and the full range of management challenges. Jenny Farenbaugh is the district ranger in charge of all this.

She grew up in southern California, with a love for the outdoors and athletics. As a teenager she hoped to make the U.S. Olympic swimming team, but appendicitis stopped that shortly before the tryouts. She went to Northern Arizona University on a volleyball scholarship. Forestry won out

over other, more lucrative, career possibilities because of her love for the outdoors.

A range of jobs in the West gave her wide experience of her profession. She was one of the first twenty-five women selected for firefighting by the California Division of Forestry. Moving into the U.S. Forest Service, she did recreational work in the Toiyabe National Forest in Nevada; reforestation in Cibola National Forest in New Mexico; timber sale administration at Lincoln National Forest in New Mexico; and use permitting at Arapaho National Forest in Colorado.

One job—at Carlsbad, New Mexico, on the Lincoln National Forest— "was my most difficult, challenging, and interesting." Here she dealt with recreation, public affairs, helicopter work, and was certified as a para-archeologist. She also got involved in cave management, rappelling down to deep passageways to conduct inventories and research, sometimes with scientists including Merle Tuttle, the bat expert, and Soviet cave specialists. A tour of duty at the Region 2 office in Lakewood, Colorado, as a realty specialist, gave her a wider perspective and close acquaintance with the laws the Forest Service works under, such as the Taylor Grazing Act, the National Forest Management Act, and the National Environmental Protection Act.

So she was fully prepared to be a district ranger, with all its responsibilities, when selected for the job at the Mark Twain in November 2001. Here she relished the change. "There are so many new, different plants and animals from what I knew in the West. Springs are a new thing for me. And there is so much variety on my district, much more than on the forests where I worked in the West."

These are just the latest of the rewards Jenny has found in her career. She talked about "the protection and management of resources; the people I've met throughout the U.S.; the cultural education I've gotten—Hispanic, Oriental, and others; travel—learning about the geography and history of areas I've worked in. I've learned from all sorts of experts, met so many facets of life in my career. I think I have the best job in the world."

On the status of women in the Forest Service, she was upbeat: "Their status has improved. I was an ice-breaker in most of my jobs. I think all the federal agencies are now better in achieving diversity, though there are still a few pockets of resistance."

Still lean and athletic in her forties, Jenny jogs two or three miles every

day. This helps to keep her in shape, and it relieves the inevitable stresses of the job. Besides all the normal supervision of twenty-seven full-time staff members, there are the numerous problems faced throughout the Mark Twain, among them rampant, illegal ATV travel, vandalism, arson, timber theft, trash dumping, and outfitters and guides who haven't bothered to get a permit. The environmental requirements under NEPA, though for a good purpose, consume a great deal of staff time. "The present timber sales on the district are the first in six years," she said.

On Mondays, she conducts the weekly staff meeting after her conference call with the forest supervisor and the other district rangers. I sat in on one. Several senior people, from administration and other specialties, describe what they're doing. They have brought in coffee, and they dip into a bowl of popcorn as the meeting proceeds.

The representative from administration talks about the fiscal situation: "We need to fix the one-ton. . . . You can't buy any big-ticket items now. No new copier."

The GIS-computer man discusses needed GIS boundary work and removal of lower stairs on the fire towers—now disused, they are a public liability: "Be sure you remove them from the *top down*." (Everyone laughs.)

The recreation specialist reports, "The Enduro event two weeks ago had 150 entrants." (This was at the Chadwick ATV area.)

The fire management man states that they may not have a fall fire season because the ground is saturated and many leaves are still on the trees. He encourages staff members to be in the annual Ava Christmas parade.

The man from wildlife management discusses the high-priority Carman Springs Natural Area road analysis and says that the bald eagle surveys will begin soon.

Farenbaugh advises the team: "Ron [Raum, the forest supervisor] says communication flow must stay steady. . . . Forest Plan revisions need to be completed by 2005. . . . Keep up with your NEPA projects. . . . We had three accidents in October. Ask if your people are tired—there's a lot of driving going on. . . . Don't e-mail me, except FYI stuff. Call or come see me with yellow- or red-flag stuff. . . . The Bateman property needs gates to keep ATVs out, but be friendly to hikers and equestrians."

The next afternoon I accompany Jenny, recreation specialist Jim Voyles, and another Ron, a range specialist from the regional office, as they inspect the recently acquired, six-hundred-acre Bateman property. We park at the

farmstead, where there's a burned-out house, a dilapidated frame house, a large shed, and lots of junk. They are thinking about use of the property. The Forest Service has signed a memorandum of understanding (MOU) about the property with the Southwest Missouri Indian Center, the Missouri Fox Trotting Horse Breed Association, and the Department of Conservation. The Native Americans had wanted to use a house here (the now-burned one) as a meeting place and visitor center. The horse association wants to establish equestrian trails. The MDC wants to plant food plots for wildlife. The MOU is not binding, and Jenny wants to rethink it.

The immediate problem is where to put four gates to keep motorized vehicles out. We walk around the grassy fields, long ungrazed, below wooded hills. Ron says, "there's no way you can keep ATVs out." But they'll try. They decide where to put the four gates.

Another day I traveled around the Ava District, looking at the Chadwick ATV trails and a timber sale area, where preparations had been made for cutting. In a light rain I walked up a recently bulldozed road with orange and green flags toward the top of a hill. The sale was fairly big—about two million board feet. A map I'd been given showed the types of cutting to be done. It looked like a jigsaw puzzle, with old growth, small

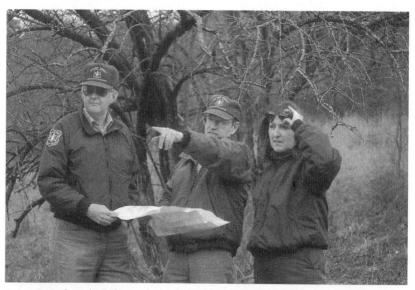

Jenny Farenbaugh and associates discuss plans for the Bateman property.
NAPIER SHELTON

clear-cuts, shelterwood, uneven-aged management, and other areas all intermingled.

Up on the hill I began seeing marked trees, mostly with blue marks at breast height and at the base. Don Fish, back in the Doniphan–Eleven Point District, had told me about the paint used to mark trees to be cut. It contains a tracer, identifiable in a lab test, to distinguish these trees from any that a logger has illegally painted and cut. The mark at the base is still visible after the tree has been cut. Two or three trees had blue numbers and letters, indicating the number of logs in them and wood volume. Others had white slashes, indicating boundaries of areas not to be cut. Where I walked, the number of marked trees seemed relatively few. Most were of medium size. It appeared that the logging impact would be fairly light. Dwayne Rambo, the wildlife specialist, had told me there would be no cutting on slopes greater than 35 percent, and no cutting of trees over twenty inches in diameter, under whose bark Indiana bats like to roost.

These woods had been quiet, but the forested Chadwick ATV area roared with the sound of ATVs and dirt bikes. Bikers had begun using this area back in the 1950s, and in the early 1970s the Forest Service decided it was best to manage it. Today it has 125 miles of trail along ridges, through bottoms, and up and down steep connections. I walked some of these trails, wondering how it was even possible for a small vehicle to get through some places. Erosion appeared to be a problem on steep sections.

Jim Voyles, the recreation specialist, had told me how the area is managed. Since 1997, a permit has been required, costing five dollars a day, or thirty-five dollars a year, per machine. This covers much of the expense of management. A big campground provides overnight accommodation for the users, some of whom come from far away. Jenny Farenbaugh said she'd met a man who had come all the way from California to ride his dirt bike there. The challenging trails have a wide reputation.

I was surprised to learn from Voyles that the bikers and ATVers who use this area do not fit the redneck image I had. "The riders," he said, "are family groups and groups of friends, for the most part. They have higher income and more education than you might expect—quite a few professional people. It's not a cheap sport. They are all ages: from children to age eighty, probably averaging around thirty-five." Mountain bikers use the area, too. "They prefer motorcycles to horses."

Part of the culture of riders, Voyles went on, is to not report accidents.

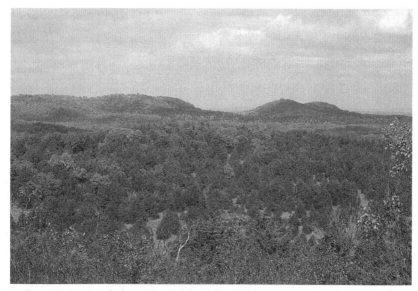

Cedars take over a glade, as viewed from the Gladetop Trail. NAPIER SHELTON

"We don't hear about accidents unless a helicopter has to come in for somebody. There have been no deaths on the trails that I've heard of in my twenty years. But one man on the road hit a tree and died." I saw this spot. There was a cross with plastic flowers on it and a ring of rocks around a tree. A sign read: "In memory of Vilas 'Lee' Compton. 1976–2000. RMX 250—5th gear pinned."

Much more peaceful was the Gladetop Trail, a twenty-three-mile National Scenic Byway that winds along ridges with sweeping views. In the mid-1990s, interpretive signs were put up that discuss the glades and the prescribed fire used to keep them open, the view to the St. Francis Mountains forty miles away in Arkansas, and other subjects. An attractive picnic area looks out on glade and forest and faraway farms. A few snowflakes had fallen that early November day, but the sugar maples and other trees were still in full blaze. I heard a high-pitched bird call that I couldn't place, then remembered. Looking up, I saw snow geese, high, just white dots against the clouds, heading south.

Rex Ipock, husband of my cousin Nancy, worked on the Gladetop Trail in the winter of 1950–1951. He lived in a cabin beneath a fire tower, and he operated a bulldozer with a bucket on front at a former CCC camp four miles away. There he scraped topsoil off two acres and loaded trucks

with the clay under the topsoil. Six inches of clay, then six inches of gravel, went on the road.

Rex said the forest canopy was already closed by then. A local farmer often came by on a horse and talked to him. He paid a dollar per cow per year to run cattle on the national forest. (Rex thinks he understated to the Forest Service the number of cattle.) He shot a deer whenever he ran out of venison, whatever the season.

On my visit to the Gladetop Trail, I stopped at Rex's fire tower, no longer used. A nearby sign commemorated the men who had watched for fires from towers all over the Mark Twain National Forest, in those bygone days.

A bench farther down the road invited me to sit, enjoy the view, and think about the past and future of this national forest. Through Depression, war, and peace, its managers had responded to growing knowledge, the changing needs and wants of society, and the demands of government. They had obeyed Gifford Pinchot, seeking production and watershed protection, then, gradually, complied with new requirements, as voiced so eloquently by Hubert Humphrey. The future, I was sure, will see greater knowledge and further demands. I hoped the managers, and the forest, would continue to benefit, adjust, and thrive.

An old fire tower, monument to another era, along the Gladetop Trail.
NAPIER SHELTON

OZARK NATIONAL SCENIC RIVERWAYS

This Current River . . . is the loveliest of all our Missouri streams
and can hold up its head for beauty alongside any on our North
American continent.

LEONARD HALL, *Stars Upstream*

The national parks, like Yellowstone and Yosemite, are places where nature reigns supreme and human influence is kept to the absolute minimum. As the concept of the national park system broadened, however, some units, like national recreation areas and national preserves, were established where such uses as hunting, trapping, and even, occasionally, oil production were allowed. In all units, though, protection of nature and natural processes is a high priority. In Ozark National Scenic Riverways, that effort focuses especially on the lovely Current River and its tributaries.

When I arrived at Ozark Riverways in April, the steep forested hills were tinged with light green. Flowering dogwoods spread white fire through the woods. Crossing the Current River at Van Buren, I saw that it was in flood.

When it subsided to more normal levels, a few days later, I got into a canoe to experience this famous river from the best vantage point. The clean, blue-green water was clipping along at three miles per hour. Blue sky broke through the clouds. The wind, as seemingly always the case to canoeists, was blowing upstream, sometimes hard enough to turn my boat around. But after I put rocks in the bow to lower it, I could handle the wind better and enjoy my float, ten miles on the upper Current from Akers to Pulltite.

The river was bank-full, submerging the feet of shoreline trees. The Current does not have real rapids, but it does have many riffles, which bounce your canoe pleasantly as you glide through. I had to dodge a few

"rootwads," uprooted trees that have washed downstream and grounded, presenting their mass of roots to boaters coming down.

Aside from such distractions, there was little to keep me from wildlife watching and generally enjoying the passing scene. Cardinals and Carolina wrens called from the forest, where blue phlox and other spring flowers dotted the ground. Great blue herons and wood ducks took off ahead of me, as did a drake mallard for many miles, seemingly playing a game with me. I lost count of the kingfishers and big pileated woodpeckers, flashing their black and white wings as they noisily escaped. At Cave Spring I paddled into the mouth of the cave. Rough-winged swallows, as at all bluffs on the river, were swooping about, and one pair was carrying nesting material to a hole in the rock.

Later, when I paddled quietly up a side slough, a wild turkey just as quietly walked up the bank and disappeared into the trees. Butterflies crossing the river paused to inspect me. Turtles sunned on logs, a muskrat swam slowly along shore. As I passed a steep, rocky bank, a loud splash startled me. Something large, perhaps a beaver, had dived into the water.

In all the ten miles I saw no one else on the river, just one car camper by his tent on shore, and three cabins with no one around. On summer weekends, though, it would be different. Then hordes of canoeists and tubers, many with beer in hand, would be coming down the river, completely changing this otherwise idyllic environment. Some break the rules. This is one of the many challenges that face the National Park Service (NPS), which is charged with preserving the Ozark National Scenic Riverways for the enjoyment of this and future generations.

The park encompasses 80,790 acres along 134 miles of the Current River and the Jacks Fork, a tributary. The Current River begins where the water of Montauk Spring, in Montauk State Park, enters Pigeon Creek. Jacks Fork proper begins where the Jacks Fork North and South Prongs join, north of Mountain View. The Jacks Fork adds its considerable water to the Current at Two Rivers, and south of Van Buren the Current gradually slows and its valley widens. The Ozark Riverways follows it to the Ripley County line, where it proceeds through a section of the Mark Twain National Forest to Doniphan and thence into Arkansas, where it joins the Black River, which flows into the White, a tributary of the Mississippi. Both the Current and Jacks Fork wind quickly and delightfully through densely forested hills

past numerous dolomite bluffs. Frequent gravel bars form convenient landing and camping places, along with additional access points maintained by the park service. Mostly out of sight from the rivers, old fields from past farming occupy some of the bottomlands.

Most of the way along these rivers, the included parkland is no more than a mile wide, but it bulges at Alley Spring, Round Spring, and Big Spring, former state parks, and in the Blue Spring area. These large springs are just four of the 150 or more that feed the rivers. And they are lovely, most issuing from the base of bluffs. My favorite is Blue Spring on the Current River, which you reach through pretty woods along the short spring stream. The springs are actually the mouths of water-filled caves. Divers entered Alley Spring and followed its underground water for thirty-five hundred feet, still not reaching the channel's end. Some 330 air-filled caves, above the water table, have been found in the park, which, like the rest of the Ozarks, lies mostly in karst topography, whose soluble limestone and dolomite are riddled with cracks and holes eaten by water.

The rivers flood frequently, especially in spring, creating different vegetation zones from the river edge to the uppermost levels of flooding. Willows and sycamores are abundant in the most frequently flooded zone. At successively higher levels, typical trees are sycamore, green ash, and hackberry, then oaks, sugar maple, and bitternut hickory, which tolerate little flooding. Shortleaf pine enters the mix mainly on ridges and south- and west-facing slopes, well above any floodwaters.

Within the forests, fields, and waters of the park have been found about 1,000 species of vascular plants, 58 mammals, 200 birds, 113 fish, and 25 mollusks, plus poorly known numbers of reptiles and amphibians and numerous insects, fungi, and other categories of life. Presently, some 1.5 million visits are made to the park each year, the visitors coming mostly from eastern Missouri, southern Illinois, and west Tennessee.

These, then, are the resources the park service must protect, and the visitors it must protect and educate.

Lots of visitors inevitably causes problems. Another, more subtle, long-standing problem is local attitudes about the park. Many landowners were unhappy about giving up their land, which in many cases had been in their families for several generations, and people of the region had a dislike of government that went back just as far. Every public park exists in a cul-

tural context, and park administrators have to understand that culture to gain acceptance.

According to Jim Price, the park archeologist and a sixth-generation descendant of Current River settlers, the key word about Ozark culture is *independence*. Ozarkers want to hunt and fish and work their land with no outside interference. Eighty-five percent of the settlers, he said, were Scots-Irish descendants of people from northern Ireland who came through Philadelphia, settled in western Pennsylvania, and, in later generations, in the hills of Kentucky and Tennessee. When good land there became scarce, many came to the Ozarks after the Louisiana Purchase made that vast area available.

"They had a tradition of being a wild and free people," Price said. "They distrusted government, had little money, and high illiteracy. A missionary called them 'wild and godless.' There were no churches until around 1870. That's why you see so many family cemeteries around here. And family feuds went on for decades."

Donald Stevens, a park service historian writing about the area, said, "the Ozark uplanders displayed a strong leisure ethic. They survived, for the most part, on small patches of corn and hogs that foraged in the open range, and they preferred hunting and fishing to farming."

This reminds me of my Uncle George, who lived over toward Springfield. He had more than corn and hogs, but he was always ready to leave the farm to go fishing. The experience of my third cousin Clyde Napier, who grew up in the 1930s on a farm on Mahan Creek just a few miles from the Jacks Fork, was probably more typical of that of local farmers in the twentieth century. On the four-hundred-acre Napier farm, they grew corn, wheat, and oats on the bottomland and had pasture and woods on the hills. They kept cows for milk and horses for plowing. They sold some white oak for barrel staves and cut lumber at their sawmill for their own use. "Sometimes there were timber thieves who cut trees on our land or the national forest" nearby, Clyde recalled. "We hunted squirrels to help with survival. We were poor, but we did have enough to eat."

The characteristics of Ozark settlers described above had diminished but not died out by the early 1960s, when legislation to create a National Park Service area on the Current, Jacks Fork, and Eleven Point rivers was introduced in Congress. Proponents said designation would protect the

pristine character of the rivers and boost the local economy. Opponents objected to moving people off the land, losing tax revenue, and being subject to federal regulations. And if these rivers had to come under government control, they preferred U.S. Forest Service jurisdiction, as proposed in another bill. On the already existing Mark Twain National Forest, you could hunt, trap, and under contract cut timber. If a local referendum had decided the matter, the park bill probably would have been defeated. When Secretary of the Interior Stewart Udall came for a visit, he saw "Monument NO" signs everywhere; from the air he viewed the same message written on the landscape in five-foot-high limestone letters.

Getting the message, legislators then sweetened the park bill, allowing hunting and trapping and leaving the Eleven Point River in the Mark Twain National Forest. Landowners were given the option of keeping their land, but under a scenic easement that restricted timber cutting and required permission for certain activities, such as building new structures. The federal government would make payments to local counties in lieu of taxes lost. Udall and other members of the Democratic administration continued to press for the bill, and on August 27, 1964, President Lyndon Johnson signed into law the act creating the Ozark National Scenic Riverways, the first American river system to be so preserved. The park was dedicated in 1972, by which time 88 percent of the projected land had been acquired.

Chris Ward, the acting superintendent in 2002, knew the local history and people firsthand, because he and many of his ancestors, beginning in the early 1800s, had grown up here. "We lived in Van Buren," the site of the present park service headquarters. "My mom was a house mother. My father was an extension agent for the University of Missouri, working with local farmers. I used to swim under the old bridge. We had an old johnboat, and I went fishing and camping with friends. Some of us would hang around the pool table at the drugstore. I guess it was all like Norman Rockwell would have painted.

"When I was fourteen or fifteen, some senators from Washington, Representative Ichord, and other dignitaries came for a hearing about the park proposal. Some other kids and I were asked to take the visitors' kids out on the river. We were persuaded by the free fried chicken, served in a big washtub.

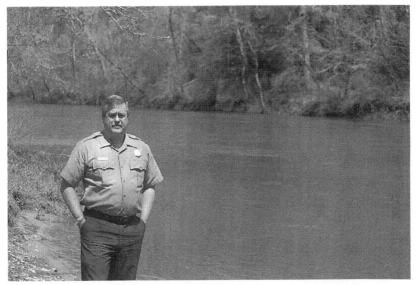

Chris Ward, acting superintendent in 2002, beside the Current River.
NAPIER SHELTON

"When I was fifteen or sixteen, I worked at Big Spring State Park in the summer, picking up garbage, collecting camping fees, doing maintenance work. I enjoyed talking with the campers. Many were families that came for a long, relaxing vacation. I can't believe all the watermelon rinds I pulled out of garbage cans."

He liked this park work, and during undergraduate studies at Southwest Missouri State University (where he also got married) he was a summer seasonal at the newly established Ozark Riverways. Later, he took a permanent position with the park service as an interpretive park technician at Jefferson National Expansion Memorial (the St. Louis Arch). Next came tours at Herbert Hoover National Historic Site, Hot Springs, Shenandoah, Glen Canyon, Great Sand Dunes, Delaware Water Gap, and Death Valley, where he was the chief ranger for six years. After twenty-seven years away from the Current River, he came back as the deputy superintendent in 1997.

The park he came back to is a complicated mixture of landownerships. "Farmers had the option of staying through their lifetime," he said, "but most sold and moved elsewhere. They didn't like the idea of having restrictions on

what they could do with their land." Many of the bottomland fields are now leased by the park service to local farmers for haying, to maintain some of the cultural landscape and to provide habitat diversity for wildlife. "The majority of the park, especially former farms, is owned by the park service in fee title, and the rest is under scenic easement" and thus privately owned. "Most of those owners have small holdings with cabins—as primary or second homes. But large areas are owned by the Missouri Department of Conservation or Leo A. Drey, a St. Louis businessman who is the biggest private landowner in Missouri"—Drey owns nearly 160,000 acres in the state. On these particular tracts, timber cutting is allowed, though not within three hundred feet of the river.

Landownership and timber management are important parts of the park story and call for further explanation at this point. The MDC sometimes practices clear-cutting, but on Leo Drey's Pioneer Forest, as his holdings are called, only part of which is in the park, careful, selective logging that always leaves trees of all sizes is the only method.

One gets the impression that Drey's forest tracts within or outside the Riverways boundary will remain forestlike and ecologically healthy. (It's also reassuring to know that Drey is a member of the Sierra Club.) Though I never had a view from the air, I saw no significant breaks in the park's forest cover other than the retained bottomland fields.

One additional, important landowner is The Nature Conservancy (TNC), a private conservation organization that buys land harboring rare plants and animals or threatened or otherwise significant natural communities. In the Ozark Riverways, it owns ten acres, including Bat Cave, where thousands of the endangered Indiana bats hibernate and thousands of the endangered gray bats have a spring/early summer nursery. It also owns the Chilton Creek watershed, one of the two areas in Missouri of highest plant diversity. One thousand acres of this watershed is in the Riverways. Both areas are under scenic easement. The Chilton Creek watershed is just part, however, of a seventy-three-thousand-acre purchase The Nature Conservancy made from the Kerr-McGee chemical company, which, like most other corporate owners of large timber tracts in the region, had decided to sell. TNC then sold the land outside the Chilton Creek watershed to the Missouri Department of Conservation, which is one of the two largest forest managers in the region (the other being the U.S. Forest

Service). TNC usually sells land it doesn't plan to manage itself to other agencies that will conserve it, thus maintaining a revolving fund for future purchases.

Since settlement, timber management in the Current River country, as elsewhere in the Ozarks, has had a sad, then happy history. Presettlement forests around the Current, as indicated by the government surveyors' notes, were mostly a mixture of pine and oak, with a large area of pine savanna near the Jacks Fork. The settlers themselves cut trees mostly for their own needs and had a minimal impact on the forest. But around the turn of the nineteenth century, big companies moved in to supply lumber and railroad ties for westward expansion. They cut virtually all the pine and oak big enough for these purposes.

One can learn much of the local story from exhibits and photographs at Alley Spring Mill in the park. They tell, for instance, of log drives down the Jacks Fork and the Current River to a collection point at Chicopee, adjacent to Van Buren. From here, logs were shipped by rail to the huge mill at Grandin or elsewhere. Pine logs, up to eighteen feet long and five feet thick, were also skidded and wagon-hauled by mule, then loaded on tram lines in the forest and carried to the nearest railroad.

When the pine neared exhaustion, the timber companies turned to oak for railroad ties and to hickory for such things as ax handles and "sucker rods" for oil-well pumps. The oak was usually hacked into six-by-eight or seven-by-nine-inch ties in the forest, by skilled tie-hackers wielding a broadax. On the Jacks Fork, ties were usually floated down to the Current, where they were fastened together into rafts sometimes as long as a thousand feet. A few ties were still being cut in the 1930s. "My daddy did that," Jim Price said, "in the Depression. In 1933–1934, he got eighty cents a day for hacking seven-by-nines."

By then the forests were denuded. By pushing a red button at the Alley Spring Mill exhibits, you can hear the voices of old-timers talking about the logging days. One woman who came back to the Jacks Fork area after the logging said, "I hated what I saw."

Recovery of the forest was slow, but tree planting and educational efforts by the state and the Forest Service helped nature do the job. The Missouri Department of Conservation also worked hard to restore the deer, wild turkeys, and other wildlife.

Attitudes about government have been slower to change. In recent years, Jim Price, formerly a university professor teaching courses on Ozark culture, has traveled around the Ozarks with each new national forest supervisor, introducing him to people and advising him on how to act. "I told them, don't start out by saying, 'I'm from the government.' First try to establish something in common with them, *then* tell them why you're here." For the most part, the Forest Service presence has been accepted. Park service people hope they will eventually see a similar acceptance.

On the matter of fire, government agencies, including the Forest Service and park service, have done a turnaround. Recognizing that fire has been a part of Ozark ecology for thousands of years, prescribed fire that burns low-level vegetation is now frequently used, though unplanned wildfire is still fought. The Nature Conservancy uses prescribed fire on the Chilton Creek watershed and, according to TNC's Fred Fox, can demonstrate that it increases plant diversity.

Ozark National Scenic Riverways has thus ended up with a forest that has seen many changes and a variety of landowners that share management of the park. Chris Ward had good relationships with these landowners; the NPS, MDC, and Forest Service—the public landowners—in fact share an office building in Van Buren and meet to discuss mutual concerns. But he had a large plateload of other matters to worry about. He described some to me.

Water quality. The water in the Current River and the Jacks Fork comes not only from the surface watershed but also from underground from farther away through the porous dolomite. Dye traces have shown that some of the water issuing from Big Spring comes from as far as forty miles to the west. Horseback riding at times of large trail rides causes a rise in fecal coliform counts. Many houses in the little towns along the rivers use septic systems that can leak pollutants. There's lead mining to the north and west whose tailing ponds are hard to seal. "Now," Ward said, "there are few mussels compared with the past, and there's not as many frogs as we saw as kids." Still, water quality in the rivers remains generally good.

High levels of river use. Canoe rental concessioners are allowed a total of twenty-four hundred canoes, and sometimes all are in use. They have about two thousand tubes for floating, and sometimes the reuse of tubes results in more than two thousand tubers in a day. Nonprofit organiza-

tions and individuals put their own canoes in the water. "Everybody lo-
cally who can, buys a boat, and there's no restriction on the number of
motorboats." Congestion, trash, and conflicts between canoeists, motor-
boaters, and anglers result.

The concessioners seem to want no restrictions on the number of ca-
noes or any other craft. At an annual meeting with them at Round Spring,
Ward got a series of complaints. Big, red-haired Gene Maggard, the presi-
dent of the Missouri Canoe Floaters Association, says, "It's getting to the
point that we can't make a living from rentals. We'll have to look for an
extra job." Ward says good-naturedly, to laughter, that it doesn't look like
he's starving. A man raises another issue: "Why can't we have rafts on the
river? They don't encourage rowdyism or block the river." Ward answers
that the park service thinks otherwise. The group comments about the ris-
ing interest in kayaking, but it doesn't like the park service policy of one
kayak replacing one canoe. They fret but still smile. They know Ward
understands their concerns.

Boundary encroachment. There has never been money in the budget
for marking the 250-mile boundary. Thus, intentional or unintentional

Hordes of canoeists and tubers on the Current River.
NATIONAL PARK SERVICE

encroachment occurs. Where the boundary is not at the top of the watershed, which is usually the case, timber cutting and other activities outside the park can cause erosion into the park.

Poaching. "It's ever-present, historically a rite of passage," Ward said. Hunting freely is part of the culture. "The fines are still minimal. People ignore paying fines and don't get called to court. The courts are very busy and think of this as a small matter and us as tree-huggers."

ATVs. All-terrain vehicle use is allowed on designated roads, "but with the long boundary, off-road travel is hard to manage." One sees ATV tracks on trails, gravel bars, through campgrounds, and elsewhere they are not supposed to be.

Stabilization of historic structures. This is a financial rather than human problem. The park budget in 2002 was $5.3 million, of which $2.6 million went to maintenance. This division must maintain 109 miles of roads, 62 miles of trails, 9 bridges, 29 major parking lots, 54 comfort stations, 6 shelters, 704 picnic and camping sites, 27 boat-launching sites, 5 amphitheaters, 90 "structures," 5 concession buildings, 28 staff quarters, 3 major water systems, 3 sewer plants, various electrical and radio systems, plus assorted major equipment that includes boats and canoes, vehicles, mowers, and fire equipment. It's no wonder that when all this is taken care of and salaries are paid, there's little left to maintain the park's 85 *historic* structures.

This was the acting superintendent's *short* list of concerns. Talking with division chiefs, you get more. Keith Butler, chief of maintenance, supervises about eighty permanent and seasonal workers. He says their main problem is the big backlog of work to be done, due either to lack of funding or of the specific needed skills. Visitors could reduce their workload, he says, by "treading lightly," such as not tossing trash around and avoiding shortcuts on trails, which erode.

Charles Putnam, the acting chief of resource management and interpretation, has additional worries. The forest is encroaching on the open glades, where species requiring sunlight, such as purple coneflower, are being shaded out. There are too many deer, he says, in the wildlife refuge that encompasses the Big Spring area. And "the mussels and hellbenders are not doing well. It could be because of low-level water pollution."

Larry Johnson, the chief ranger, supervises twenty law-enforcement

rangers who patrol two districts: the North (upper Current) and South (Jacks Fork and lower Current, below the junction of the two rivers). They, of course, enforce laws, but also visit with and educate visitors, give emergency medical aid, conduct search-and-rescue operations, participate in wildland fire management, and do many other things necessary to protect visitors and park resources.

Among the things they run into are fights, poaching, drug activity, marijuana cultivation, and drunkenness, especially on the river. Many of the arrests and fines come to nothing because the Shannon County jail has no room and the courts are too busy, Johnson says. "There is no petty offense court docket. One of my chief goals is to do something about this." He goes on: "ATV and horse use are out of control. There's conflict between the different kinds of river users. Many of the primitive campgrounds are in poor shape."

Larry says he came here because he liked the challenge this park offers. He's probably up to it. He's big, experienced, and determined. In 1995, while at Voyageurs National Park in Minnesota, he received the Midwest Region Harry Yount Award for outstanding ranger service.

Coincidentally, North District Ranger Bill Terry won this same award in 2002, while I was there. Chris Ward presented it to him at a Tuesday-morning squad meeting, and everybody felt he richly deserved it. Bill is an even bigger man than Larry Johnson. He looks like one of the professional football tackles, before the present era of fat, three-hundred-pounders. He's unfailingly courteous to visitors, I was told, but he can get rough if he has to. He had worked at Ozark Riverways since 1973 and knew it as well as anybody. Though he'd had a temperature of 103 the day before I interviewed him, he insisted on having the meeting.

Drinking water to keep hydrated, his stomach cramping and growling, he described his life. "I was raised in the military, and we lived in Germany, France, and all around the U.S. We were in Columbia, Missouri, for several years, and in the sixth grade there I joined a Boy Scout troop. We came to the Current River–Jacks Fork every year for a couple of floats. I knew then that I wanted to live down here someday."

He studied wildlife management and park administration at the University of Missouri–Columbia, and after graduation he began working as a seasonal at Ozark Riverways, April to November, and at Everglades National

Park through the winter. In March 1978 he became a permanent ranger at the Riverways.

"For career advancement they expect you to move," Bill said, "but I didn't want to keep moving. I had done that growing up, and I didn't want my kids to have to do that. And there was something about this park. I love hunting, fishing, trapping, hiking, canoeing, and I could do all these things here. I love the Ozarks. The Ozarks' Current River country is the most beautiful spot I've ever seen."

Much of his work takes place on the river, especially during the busy season between Memorial Day and Labor Day. "We have a lot of problems with canoeists. Many are inexperienced and don't know, for instance, that you don't hang on to the front end of a water-filled canoe when it capsizes. You can get mashed against a log or rock. So there's a lot of injuries—broken arms and legs, lacerations. And people get spinal injuries jumping or diving off bluffs. We've had several deaths on the river from drowning or other causes.

"Alcohol causes a lot of problems. We give many citations for disorderly conduct or possession of alcohol by minors. And every year we give almost five hundred citations for drug use or possession, the vast majority for marijuana usage." Methamphetamines are a growing issue, he says, especially in this part of Missouri. The drug is made from over-the-counter materials in clandestine labs. I was told by Jim Price that "one hit makes an addict. The end is death or incarceration."

Of the thousands of canoeists, though, relatively few are misbehaving. But there's been a change in the types of visitors, Bill said. "In the 1960s and 1970s, most of the canoeists were real outdoors people. They knew what to expect and were prepared. Now most are inexperienced and not prepared. For instance, they make poor decisions about where to camp when the river is rising." As before, most are in the eighteen-to-thirty age bracket, but now "most come in large groups to socialize. There's a party atmosphere. The vast majority have alcohol while floating."

Many tubers are also like this, he said. "But don't get me wrong. Not all canoeists and not all tubers are just out having a party. I go in tubes; my family goes in tubes." The park is many things to many people. "One of the best things about the river is that you *can* have a pristine experience. Even on a summer Saturday, if you start at 6 a.m., you can have a ten-mile float before the crowds get on the river."

And during spring and fall, he might have added, it's easy to have such an experience, as my own April float showed and that of fifteen Texans who happened to be staying at my motel. They spent five days on the Current but saw only half a dozen other canoes, most of them in one group of five. More abundant was the wildlife. One of the women said they'd seen an osprey, wild turkeys, ducks, an otter, a copperhead, and possibly a bald eagle.

Of the citations Bill Terry has to hand out, many are still for poaching. "There's a very significant amount of poaching of deer, turkey, and medicinal plants like ginseng," he said. "Poaching is a tradition. It's accepted by many people, with no stigma. If they utilize game for personal consumption, it's their right. God put it there for their use."

In the past, such citations have led to retribution, like the burning of a ranger's house. I asked Bill if he'd had any life-threatening situations. "Not really," he answered. But then he recalled one potentially dangerous experience.

"One evening I was sitting on my porch at Cedargrove, near the river, when I heard a chainsaw and then saw a big sycamore fall. I put on my uniform and went down there. A very drunk man was trimming the limbs off. I asked him if he knew where he was. 'This is South Dakota, ain't it,' he answered." Bill told him he was in the park. "The man said, 'Me and my buddy have a contract to cut timber here.'"

"He was totally out of his mind. It seemed almost funny. But when I told him he was going to have to go to jail, he turned hostile. He said, 'I just got out of jail for killing a cop. I can kill you, too.' That really got my adrenaline going. He took a swing at me, and I pulled out my Kel-Lite"— a long-barreled flashlight—"and shoved it hard into his solar plexus. That knocked the wind out of him and took him down. He said, 'I don't want no more trouble.'

"I handcuffed him and took him in. He spent the night in jail and paid a fine. It turned out he had never killed anybody, just had been arrested for petty theft."

Like all law-enforcement rangers, Bill will have to retire at fifty-seven. He expects to stay in the Current River country.

Humans, plants, and animals in the region, and their relationships, have continuously changed since Paleo-Indians roamed the area some twelve thousand years ago. Those early inhabitants, as shown by pollen cores from

Cupola Pond in the Irish Wilderness, west of the park in the national forest, lived in a time when the forests of juniper, spruce, and jack pine (at lower elevations) and open tundra (on ridges) were gradually shifting toward the oak-hickory-pine forests that characterize the region today. Archeological investigations in the park have found bones of many extinct or extirpated animals, some of which the Paleo-Indians may have hunted: giant armadillo, dire wolf, short-faced bear, stilt-legged deer, porcupine, fisher, jaguar, and ground squirrel. Later human inhabitants, those of the Archaic and Woodland periods, hunted or used many of the animals and plants that live in the park now.

Fire was used by those prehistoric inhabitants to drive game and encourage growth of useful plants. This fire, in addition to fire caused by lightning, was an important part of the environment in which the present plants and animals evolved. So fire, set under prescribed conditions, is now an important tool in maintaining or changing certain park habitats. "We use fire," Charles Putnam said, "mostly in glade areas, to keep them open, keep the forest around them from shading out the plants that need a lot of sunlight, and maintain the environment that certain animals depend on."

The park's natural-resource managers also use prescribed fire to encourage native grasses in some of the bottomland fields. At park establishment, there were about six thousand acres of fields. Some three thousand acres have now gone back to riparian forest, and close to eight hundred more, once in the burn program, have been allowed to begin that process. More than two thousand acres, mostly in fescue and orchard grass, are leased to local farmers for hay production. That leaves around two hundred acres in small fields that are still maintained by prescribed fire.

Burning is also practiced on three bottomland areas for canebrake restoration, a cooperative project with The Nature Conservancy. This is done both to restore areas of this grass (giant cane, *Arundinaria gigantea,* a type of bamboo) that once grew extensively along the Current River and to increase habitat for the scarce Swainson's warbler, which nests in canebrakes in southern Missouri.

With regrowth of the forest and wildlife regulations has come a return of large mammals to the Current River country, and not just of deer. Bears, probably originating from an Arkansas population, are sometimes seen, and there have been at least four reliable reports of mountain lions. Beavers,

extirpated by 1900, are now common, as are otters, helped by stocking here in 1990.

One mammal that the park service wishes wasn't here is the feral horse; at least some have been in the middle part of the park, Putnam says, probably since the 1950s or 1960s. "There were about two dozen. Superintendent Art Sullivan let a contract to capture, break, and sell the horses. But the horse people objected. They liked to see them. A congressman got through legislation to keep horses in the park. They are still here, but the limit is established at fifty. Two years ago a fellow from Ellington shot six of them—said they were eating his deer bait. He got a stiff sentence."

Only two federally endangered species have been found in the park: the Indiana bat and the gray bat. The caves they are known to use, including the very important Bat Cave, are checked about every two years. Of Missouri's rare and endangered species of plants and animals, fifty-two are known to occur in the park: twenty-one animals and thirty-one plants. The MDC's Heritage Program biologists keep track of these species.

Park biologist-technician Mike Gossett has primary responsibility for aquatic issues. One of his main tasks is conducting periodic water quality sampling at a number of sites. So far, he finds no serious pollution, but underground drainage from outside the watershed is a concern. He is interested in all the park's aquatic life, but visitors and locals are interested mainly in the fish they can catch. I ran into Mike one day at the Mercantile Restaurant and Antique Shop in Van Buren. Talk turned to fishing when we were joined by an elderly, white-bearded friend of Mike's who used to guide on the river. He thought there were lots of small bass in the river, that hogsuckers are getting scarce because they are very good to eat and are easy to gig, and that yellow suckers are not scarce because they are difficult to gig.

The river's prime sport fish above Akers are trout, and below there, largemouth and smallmouth bass. Brown trout and some rainbows are stocked annually in the Trout Special Management Area between Montauk State Park and Cedargrove. Chuck Tryon, in his book *Fly Fishing for Trout in Missouri,* extols the trout fishing here. In another book, *200 Missouri Smallmouth Adventures,* he expresses the opinion that much of the smallmouth fishing on the Current "is as fine as the Show-Me State has to offer, and the streamside scenery can be spectacular."

■ ■ ■ ■

The park service is justly admired for its attention to interpretation—
helping visitors enjoy and understand the parks. At Ozark Riverways,
whose narrow lands stretch so far along the Current and Jacks Fork, inter-
pretive exhibits are dotted around at important sites. There is no central
visitor center where the park story is told, as in most national parks.

I encountered one interpretive focus at the Alley Spring Mill, where the
functioning of this 1896 mill and the community that grew up around it,
and local lumbering, are described. Interpretive Ranger Pam Eddy ex-
plained how the wheat and corn had been ground by equipment still pre-
sent and in good shape.

Outside, an exhibit tells about the geological workings of Alley Spring,
whose waters pour over a low dam and once turned the turbine that pow-
ered the mill. Many of the park's exhibits are located at or near major
springs, such as Round Spring, where the water forms a quiet pool, and
Big Spring, largest in the park, where the water boils up and tumbles out
in a small rapid.

The design, graphics, and text of all the recent exhibits came from
Bryan Culpepper, a talented artist stationed in an office near the park
headquarters entrance. Bryan was paralyzed from the waist down and has
only partial use of his arms because of a diving accident in the river. He
works from a wheelchair. When a group of schoolkids enters the building,
he often intercepts them to do a little interpreting. I heard him warn one
bunch about jumping or diving into the river, explaining why he was in a
wheelchair, and then go on to a few more enlightening comments about
the park.

Though the park has a small interpretive staff, it manages to contact
many visitors directly, as Bryan sometimes does. In summer, with the help
of seasonals, daily hikes are conducted, and evening programs are pre-
sented Fridays and Saturdays at the major campgrounds. The rest of the
year, the three permanent interpreters visit schools or give programs to
school groups, mainly elementary, at the park. Bill O'Donnell, interpreter
at Round Spring, says he's become acquainted with all the kids under sev-
enteen in the nineteen school districts they work with.

Bill, now over forty, after a bit of intellectual wandering, had worked at

a state park in Ohio and in some national parks—Everglades, C. and O. Canal, Yellowstone, Shenandoah, Canaveral, Cuyahoga, and Pictured Rocks—before coming to Ozark Riverways. Here he frequently takes groups into Round Spring Cave. The day I met him there he was escorting forty-five Mennonites—schoolchildren of the first eight grades from a one-room Mennonite school at Summersville, their teachers, and some of the parents, the women wearing their traditional lacy white caps. Bill briefed them on the cave walk, making funny cracks to the children, and then led them in, all carrying lanterns.

Afterward, he told me the kids loved the little eastern pipestrelle bats, many of which were hanging from the cave ceiling and, where low enough, could be looked at eyeball to eyeball. The children were serious and asked many questions. In the last large room before exiting, the group, probably stirred by the beauty and wonder of the cave, stopped and sang "How Great Thou Art," the lanterns casting dancing shadows and the sound reverberating through the dark passageways.

Bill graciously offered to take me on a personal tour, so he could show me more than he could a large group. He explained how the bats—nine species of which use the cave—and their guano, in effect, bring the sun's energy into the cave and support the whole cave ecosystem. We saw delicate white threads of fungus rising from small piles of bat guano, and we saw large piles of guano, now drained of their nutrients, deposited by bats millennia ago. We saw fossil algae and the fungus gnat, whose larvae glow in the dark to attract their insect prey. In shallow pools we saw the tiny larvae of grotto salamanders, which, unlike the cave salamander, never leave the cave. As we followed a small stream through rooms of red and white stalactites and rock draperies, Bill observed that after all the years he's been going through this cave, he still finds new things to marvel at.

The Current River country does not claim the hearts of everyone who comes there, but many fall permanently in love with it. Bill O'Donnell said, "When I came here, someone told me I'd stay one year or forever. Now I understand why the forever. This is an interesting and beautiful place. People are friendly. There are real communities." I sensed in Bill's words a feeling of warm security, nestled here in the hills. He might have a hard time making the choice, as Bill Terry had, between moving for the sake of career advancement or staying in a place you love.

Citizens of the Current River country are deeply attached to it, but acceptance of the land's park status is a slow-growing thing, still a new idea in the minds of many. Members of the park staff see some acceptance, though often grudging.

Chris Ward: "The people like us individually, not as a group. It's a love-hate relationship. I think the relationship is gradually getting better, but it might seem that way to me because I'm from here."

Jim Price: People's attitudes "are bittersweet. They know in their hearts it's good. In the private sections on the rivers"—outside park boundaries—"they can see it's wall-to-wall cabins. If it was like that all along the rivers, they couldn't hunt and fish. And they know the park pumps millions and millions of dollars into the local economy, and employs a lot of local people."

Bill Terry: "There was ill will, but people over time are changing their attitudes. They see other rivers in the Ozarks that are overdeveloped. Here they have access to great recreational land, and they wouldn't have much access if a lot of the land was in small private ownerships."

Bill O'Donnell: "We're starting to see attitudes change. When I got here ten years ago, there was a lot of hostility. One of our seasonals is eighteen. I first knew him in the second grade. He comes from a family of poachers. Now he wants to be a ranger."

Park administration aside, there's unanimity—local and national—about the lovely Current River. Many would no doubt second the opinion of Chris Ward: "I've floated the Colorado, Snake, Delaware, and other rivers, but I still think the Current is the neatest river in the world. We've got to keep it the way it is."

MINGO NATIONAL WILDLIFE REFUGE

Water must be managed if it is to be most useful to ducks and geese.

WILLIAM E. GREEN et al., in *Waterfowl Tomorrow*

Mingo Swamp, as the refuge is still called by local residents, is a large wet basin—about eleven miles long and two to five miles wide—flanked on the west by the Ozark Escarpment and on the east by Crowley's Ridge. It lies at the northwest edge of Missouri's Bootheel, once "Swamp-east Missouri" and now mostly farmland. Mingo National Wildlife Refuge preserves the largest of the few remaining stands of bottomland hardwoods in the Bootheel and provides food and habitat for thousands of wintering waterfowl. It is home to bobcats, deer, otters, bald eagles, herons, and a host of other wildlife, including sixty-four kinds of reptiles and amphibians that flourish in this warm, wet environment.

Water is the key word at Mingo. Periodic flooding maintains the bottomland hardwoods and allows the growth of plants that feed the waterfowl. Charley Shaiffer, the refuge biologist, is the man who figures out how that water should be managed—where, when, and how much. It's a complex assignment, one that affects all the life of this rich lowland.

I met Charley at the refuge maintenance shop, where several of the nine-person staff gather first thing in the morning to have a cup of coffee and chat. It seemed a kind of communion, a bonding, a reaffirmation of purpose. Perhaps this gathering was instituted by the refuge manager, Kathy Maycroft, a surprisingly young woman (she's in her midthirties), who had arrived the year before. Morale appeared high under her leadership.

Charley was sitting quietly in a corner of the office, with the coffee cup that seems to accompany him everywhere. I explained what I wanted to do: "I'd like to see this place the way you see it." That was fine with him.

Charley was born in 1948, at Maryville, in northwest Missouri. His love

of the outdoors came naturally: Both his father and grandfather hunted and fished. A great-grandmother was Cherokee. She had entered Missouri on the Trail of Tears and, when unable to continue, was taken to a Catholic mission in St. Louis. Charley didn't explain how she entered his family tree, but perhaps this Cherokee inheritance had contributed to his unusual empathy with wild things. "He knows how waterfowl think," Kathy said.

Charley looked like a man who had spent years working outside, and that's exactly what he had done. He was lean, with close-cropped graying hair and mustache. He told me he'd had a "mild" stroke five years earlier, and now he was trying to "take things easier." But he looked like he could still walk through the swamps all day without breaking into much of a sweat.

Charley's career was atypical in its simultaneous mixture of study and work. He began working for the Missouri Conservation Department right out of high school, then he did research for the Fish and Wildlife Service Cooperative Unit at the University of Missouri–Columbia, where he also took courses. "I just picked up hours here and there." His boss, Reid Goforth, next became head of the service's Northern Prairie Wildlife Research Center in North Dakota. Knowing Charley's talent for research, he brought him up there as a biological technician. After three years in that job and courses at Jamestown College, Charley was promoted to general biologist. He was launched on a distinguished career in wildlife research. "I owe everything to Reid Goforth," he says.

His research included important work on two ends of the question that deeply bothered waterfowl experts in the 1960s and 1970s: Why are the populations so low? The two ends were breeding on the northern prairie and wintering in the southern United States.

Charley focused on mallards, one of the most abundant and sought-after species. He placed transmitters on hen mallards in North Dakota and traced their fates from the air and with the help of workers on the ground. Circling tightly overhead, he pinpointed the locations of hens and then called in the ground crew to determine the state of the birds: on the nest, dead, or what? If dead, what killed them? They learned that several drought years had restricted nesting to relatively few prairie ponds. This concentrated the nesting birds and made it easier for predators, chiefly foxes, to get them. To counter this, ways were found to increase nesting cover and protect it, such as with electric fencing. Subsequent wetter years also helped.

The Fish and Wildlife Service research center at Patuxent, Maryland, then asked Charley to find out what was happening to mallards on their wintering grounds in the lower Mississippi valley. (While there, he was able to finish course work at Mississippi State.) Headquartering in Arkansas, he again tracked birds by air and on the ground—this time usually the flooded woods where mallards gobbled up acorns. He learned there was no problem here. Most of the mortality was from hunting, and this was strictly regulated. So recovery efforts could focus on the prairie breeding grounds.

As you can see, this work involved a lot of flying. Charley got a pilot's license in North Dakota and while conducting research shared the controls with another man. This was sometimes hairy. One day during the mallard breeding studies, they'd landed at a gravel pit. The other man was at the controls when they took off. They thought they had enough distance to clear a shelterbelt ahead of them, but the trees stopped the wind that would have provided lift. Charley thought they were finished, but the pilot spotted a slight gap in the trees, tilted the plane on its side, and squeezed through. Then he righted it and bumped along the ground on the other side until they got enough speed to become airborne again. The pilot circled a bit, then said, "I think I need a break," and landed somewhere safe.

Charley says flying was his greatest risk. "I sweated it out every day." More than one of his associates died this way. But there were other activities perhaps equally scary. While doing research on wood ducks in Mississippi, he had to wade chest-deep through cottonmouth- and alligator-infested swamps at night without a light. "I learned to listen for certain things— like the sound an alligator makes sliding off a log. Then I could turn on my light and see where it was." For some reason he never closely encountered an alligator at night, although he often saw them by day.

Canada goose breeding studies near Churchill, Manitoba, presented the problem of polar bears, which were wandering on land with their cubs at that season. "They flew us in thirty-five miles from Churchill, and came back in thirty days if there was no fog. We had no radio communication. We lived in a wood-frame Quonset hut with a canvas cover on it. There was a woven wire fence with tin cans on it to scare polar bears away. When no one was there, they sometimes broke in through the front door, so we slept as far from the door as we could get. One of us had to sleep with a .30–.06 at his side every night." Sometimes, he said, they had to fire to scare bears away, but fortunately they never had to shoot one.

I asked about any scares here at Mingo. "No, it's been pretty quiet," he said. "Oh, once in awhile a cottonmouth strikes my boot, and one night while I was banding wood ducks on Monopoly Marsh my airboat struck a cypress stump. That took seven thousand dollars of shoulder surgery."

Charley's inventive mind has come up with several new ways to catch waterfowl for banding. One is a shoulder-fired net gun, now widely used by wildlife managers, and sometimes even by police, to capture fleeing suspects! Another is a trapdoor that drops a duck into a lower chamber when it enters a nesting box. Still another is a way to capture wood ducks at night, as I'll explain below.

The refuge staff maintains a hundred nesting boxes for wood ducks and a hundred for hooded mergansers, the two kinds of ducks that breed at Mingo. The "hoodies" prefer the cylindrical metal ones with the pointed "hat" on top, rather like the Tin Man's in *The Wizard of Oz*. The "woodies" prefer the square wooden boxes. In the past, raccoons and black rat snakes got many of the eggs and young, but the installation of metal sheathing below the boxes stopped most of this. The remaining predation is mostly by snakes.

After egg laying begins, the wood duck boxes are checked weekly. When hatching time approaches, the eggs are inspected daily through a tube that reveals the state of the embryo. (The incubating females apparently take all this in stride.) Banding the chicks, in order to get information about their future survival and movements, must be accomplished within twenty-four hours of hatching—before the mother coaxes them to tumble into the water and swim away with her. The bands have plasticine interior rings, which slowly dissolve, leaving just the aluminum outer rings on the fully grown birds.

The Missouri Department of Conservation also wants Mingo to band four hundred older wood ducks each year. Charley and his assistant in this work sometimes band more than seven hundred. Charley figured out his present rather unusual method. At night, preferably when it's cloudy or there's no moon, he drives the airboat on shallow Monopoly Marsh, where many wood ducks congregate, with his assistant in the bow. "The ducks are confused by the noise and don't realize what is happening." The boat moves slowly, a light is shined on the ducks, and the man in front grabs one for banding.

One hazard in this work (other than cypress knees) is cottonmouths, which like to sleep on the large, round American lotus leaves that cover much of Monopoly Marsh. "Some nights there are a lot of snakes," Charley says, "others not so many. I have to drive cautiously because the guy in front has his face practically down in the vegetation." So far there have been no casualties from snakes.

In late August and September, Charley puts together a scenario of food resources on the refuge, in order to plan flooding of the various units for the fall arrival of waterfowl. This is much more controlled than it used to be, and to some degree it mimics the original water regime. A bit of history is needed here.

During the last ice age, the Mississippi River flowed west of Crowley's Ridge through the Mingo Basin. About eighteen thousand years ago, by one calculation, the river shifted to the east side of the ridge and, a few thousand years later, farther east to its present course. But when the Mississippi was in flood, water coming down the St. Frances River was backed up into the Mingo Basin. "Headwater flooding," from streams coming off the Ozark Escarpment, also occurred. The Mingo Basin could be flooded during any month. But these episodes were usually brief. After a few days the water drained away. This was the environment in which bald cypresses, oaks, and other trees of the bottomland hardwoods grew. They flourished on wet soil but were not drowned. Even bald cypresses need bare ground on which to germinate.

Such was the situation in most of the Bootheel until the 1920s, when reclamation for agriculture began, following a period of extensive timber cutting from 1880 to 1920. Drainage was eventually successful in most of southeast Missouri, but not in the Mingo Basin. There, the local drainage district dug a system of parallel ditches one mile apart, with a main collector ditch, and farming was attempted. But water tables remained high, periodic flooding continued, and the soils were not as productive as hoped for. During the Depression in the 1930s, the drainage district went bankrupt; in 1945, after several years when the idea was promoted, the Mingo Basin became a national wildlife refuge. Having been cut over and many times burned, with its wildlife sadly depleted, the refuge wasn't much to start with. But with care it improved—dramatically.

Charley Shaiffer's predecessors had a hard time with water management.

The crops they planted for waterfowl were sometimes under two or three feet of water, and the roads were often impassable. At other times the marshes dried up. Gradually, however, control improved, as dirt plugs were placed to hold water during the summer months and create Monopoly and Rockhouse marshes, and dikes were constructed to form "green-tree reservoirs"—forests that were seasonally flooded—for the benefit of waterfowl. In 1980, structures placed on two of the main ditches provided a more precise control of water levels.

By the time Charley arrived, in 1988, the peak total waterfowl numbers had risen from about 30,000 in the 1940s to about 90,000 ducks and 75,000 Canada geese, although yearly variations were large because of varying food and weather conditions. At first, very few Canada geese had stopped in. To attract more, a small flock of Canadas with clipped wings were placed in a "goose pen." Perhaps this helped a little, but the number had risen to only 4,000 by 1960. Fields planted with winter wheat may have helped more to bring in these grazers and establish a tradition of coming here.

By 1988, the manipulation of water levels had greatly increased production of natural foods for waterfowl. Some of this was in Monopoly and Rockhouse marshes, which covered about five thousand acres. Some was in the green-tree reservoirs, where acorns rained in good years. And some was in "moist-soil units," where annual grasses, smartweed, beggar-ticks, and other plants producing seeds attractive to waterfowl were encouraged by drawdowns before the germination period.

Charley was brought to Mingo specifically to work on moist-soil plant management with Dr. Leigh Fredrickson, a waterfowl biologist at the nearby Gaylord Memorial Laboratory, operated by the University of Missouri. Fredrickson had developed concepts and practices of this kind of management at Mingo from 1968 to 1982. When Charley arrived, they conducted two more years of research to make sure they understood the plant responses to weather, water levels, and other factors. Then, in 1990, they began giving workshops on moist-soil management for biologists, managers, maintenance people, and others. These came from federal and state agencies and private organizations from all over North America. This training at Mingo did much to shift emphasis on waterfowl refuges from domestic to natural crops, which have higher nutritive qualities than many of the

cereal grains, often have higher total energy, and support a much greater diversity of wildlife. Refuge managers, who are usually on tight budgets, also like the fact that the natural foods are cheaper to grow. However, as of 2001, Mingo was still growing about five hundred acres of corn to diversify the food choices.

In late September I visited one of the moist-soil units with Charley at an area known as the Company Farm, which had been a farm before the refuge was established. We walked into the now-dry field to inspect the plants. "The wild millet seed is mature," Charley said, "but the smart-weed and *Bidens* [beggar-ticks] aren't." He showed me the still-soft seeds of the latter. "We'll have to wait about three weeks to flood this field. We'll flood this end to six inches. That's a good depth for ducks and it doesn't cover the seeds. When they've eaten this out, we'll flood another third to six inches. This part will then rise to twelve inches, because of the slope of the field. Canada geese can forage in it and that will be a good level for herons. In spring we'll reverse the process. There will be a lot of inverte-brates for ducks and shorebirds in the shallow water. In late summer and early fall, it's usually too dry for shorebirds."

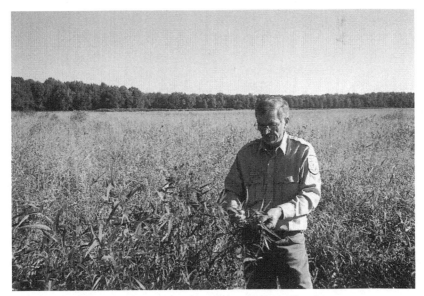

Charley Shaiffer inspects smartweed seeds in a moist-soil unit.
NAPIER SHELTON

This field had plants with large seeds that mallards, gadwalls, and some other ducks like. The adjacent field was in an earlier stage—mostly small-seeded annual grasses such as panic grass and crabgrass. Teal and pintails prefer these, Charley explained. They arrive before the other ducks, and therefore Charley would flood that unit, and others like it, first. In all, there are twenty moist-soil units to be managed—orchestrated, as it were, for the fall-to-spring succession of waterfowl.

That succession, beginning with teal and pintails in September through October, is followed by the other surface-feeding ducks in November. The diving ducks and Canada geese come in mid-to-late December. The diving ducks can stay farther north longer, Charley explained, because the deeper water they inhabit freezes last, and Canada geese feed in fields a lot where there's no water to freeze. The refuge now gets about 10,000 to 50,000 Canada geese and 140,000 to 150,000 ducks.

The ducks stick around during the winter, unless the water freezes for seven to ten days. Then they move farther south. When he investigated wintering mallards in the lower Mississippi valley, Charley found that they moved great distances up and down the valley, depending on food and weather conditions. "They're not glued to any one wintering spot." Sometimes the peak numbers of waterfowl at Mingo occur in early spring, say late February, when migrants are starting north. Pintails can be especially abundant then. "They push the ice," Charley says, in their eagerness to get to the breeding grounds.

You might say that Charley is a farmer of natural crops. Each of the twenty moist-soil units is constantly in succession—or, in farming terms, a rotation, except that nothing is planted; the seeds are always there. The whole cycle takes three or four years: first the small-seeded annual grasses and sedges, then the larger-seeded grasses and forbs, such as beggar-ticks and water plantain. Around the third year less desirable, rather woody plants, such as cocklebur and hibiscus, appear. Next come willows and cotton-woods. These must be cut or mowed down and the field disked or plowed. When flooded, such a field soon supports large numbers of invertebrates, like water boatmen, fairy shrimp, fingernail clams, dragonfly nymphs, and bloodworms—all good duck food. Shovelers in particular thrive on these, straining them out of the water with their large, flat bills. The next year the cycle begins again.

From the field at the Company Farm, Charley and I moved into the woods in Pool 8, now dry, one of the six green-tree reservoirs. He checked the numbers of acorns on the ground. It looked like a good mast year. The good years are usually followed by a poor year, then a fair one, then once again a year with an abundance of acorns. In the better mast years, these woods are flooded in November for the benefit of mallards and wood ducks, which feed on the acorns. They eat those of pin and willow oak, which are small but sink to the bottom. Acorns of overcup oak, which are too large for ducks to swallow, retain their covers and float. These pile up in windrows and are devoured by deer.

The flooding must be kept below twelve inches until the oak seedlings go into dormancy, around November 1 to 15. Before then, at twelve inches of depth, the seedlings are killed. All the water must be off by March 15 at the latest, before oak germination begins. In the poor mast years, flooding is delayed until winter, when mallards enter the woods for pairing. Bonds are developed in little cubicles, as it were, among the trees, each pair being somewhat screened off from the others. Before migrating north, they build fat by feeding on invertebrates that have multiplied in the rotting oak leaves.

There is a definite gradient among the various trees of Mingo determined by levels and duration of flooding. Where water stands longest, bald cypress and water tupelo grow, along with buttonbush. On slightly higher ground, you find overcup oak and red maple, then willow oak, pin oak, and more red maple. The highest levels in the basin, as on "sand boils" (upheavals of gas, water, and earth thought to have occurred during the severe New Madrid earthquakes in 1811), support hickories and sweet gum, as well as oaks. A totally different mix of trees covers the flanking ridges: white and red oaks, hickories, sugar maple, black walnut, and others typical of the Ozark highlands.

Because of the wet soil, the bottomland hardwoods are shallow-rooted. This makes them vulnerable to windthrow, but the density of trees helps to protect them from this. When one does fall, it usually takes several others with it. The light falling into the opening allows seedlings to grow quickly. Because of the greater abundance of faster-growing red maple seedlings, the little oaks are likely to get shaded out. Here in Pool 8 we looked at study plots set up to monitor the fate of oak seedlings, which managers

favor because of their importance for wildlife. In some plots, the red maple seedlings have been removed to see if this helps the oaks. It's a long-term study, in which selective cutting of overstory non-oak trees may be added later to find out if this improves oak reproduction.

The bottomland forest can be comfortably enjoyed on a paved trail adjacent to Pool 8. Though the whole basin was logged early in the twentieth century, the trees now tower to seventy-five feet or more, pushing toward a hundred. Twelve state champion trees, including two national champions, perhaps left by the loggers, were found at Mingo. The paved, wheelchair-accessible trail, with spurs to low hunting blinds, is also popular with bird-watchers. The breeding birds include many warblers, flycatchers, and other species that winter in the tropics. The Fish and Wildlife Service conducts much research on this group of birds because of their decline in recent decades. One of Charley's responsibilities is to supervise a count of breeding birds in the nearby Pool 8 forest. Counts for five years showed no significant decline in the neotropical migrants, but the count will continue to be made every three years.

On September 26 I watched as Charley climbed down behind the main flood-control gates, pulled logs and branches off the concrete floor, climbed up, and turned the wheels that lower the convex steel gates. This is the first act, always performed around October 1, in the fall-to-spring manipulation of water levels. This gate can raise water in any of the marshes and ditches, from which water can then be channeled or pumped into any of the moist-soil units or green-tree reservoirs. Thus, any or all of this area—fourteen thousand acres, more than half of the refuge—can be flooded. The other eight thousand acres are a designated Wilderness Area; those bottomland hardwoods are left alone, to flood or not, as nature dictates.

A couple of days later we stopped at structure 11-5, which can control the water in all but Monopoly Marsh. Here I saw the boards at the gate that determine how high the flooding will go. The concrete floor of the structure is at 333 feet above mean sea level, a level at which all the ditches have water. (The lowest point on the refuge is the bottom of Monopoly Marsh, at 332 feet.) At the top of the lowest "stop log" (actually a thick board), 334 feet, water spills out into tributaries, sloughs, and low basins. At the top of the next stop log, 335 feet, Rockhouse Marsh is full. And at the top of the highest stop log, 335.5 feet, the green-tree reservoirs are

filled to the optimum level for ducks. At 336 feet, the maximum allowed, all bottomland woods are flooded. If the water rises higher, the gates are opened to lower the water level. Considering all the units with their ever-changing vegetation and use by waterfowl, the vagaries of weather, and maintenance needs of levees and ditches, "it's a complex system," as Charley says. Complex indeed! And nature can still occasionally get the upper hand. "Once, in July," Charley noted, "we had seven inches of rain. It flooded everything."

Adding to the problems are beavers, who have their own ideas about what should be flooded. This can kill big patches of hardwoods, and it thwarts drawdowns needed for plant growth. Before humans changed things, the Mingo Basin was unfavorable to beavers, which look for con-tinuously flowing water to dam. And if any beavers came in after human alteration of the water regime, they were trapped out before the refuge was established. Then, around 1959, beavers returned, and over the years they have proliferated. In this flat land, one beaver dam can flood up to nine hundred acres. Trapping at this point doesn't help much. A local trapper took 569 in 1991, but according to the refuge's narrative for that year,

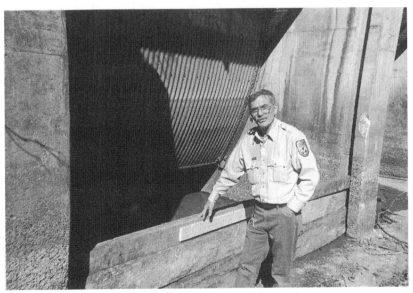

Charley Shaiffer explains water level controls at structure 11-5.
NAPIER SHELTON

"very little change in annual problems are noted." More recently, two trappers were at work, but low prices for beaver pelts have discouraged them. The refuge staff now tries to trap those beavers that are causing serious problems, or blow up their dams.

One day I accompanied Charley to inspect an area where beavers had been at work. In a refuge pickup truck, we bounced along a rough, seldom-traveled levee, getting out now and then to move fallen branches. We passed a beaver dam that had flooded a small area, but not into the oak woods. "That one's not a problem," Charley said. Then we checked a spillway that takes overflow from a ditch. Dead trees stood in this area, which was once flooded by beavers damming the spillway, but now there was no dam and wild millet grew. "We'll come back in March to see if there's dams we need to dynamite."

Water flowed through a hole in the levee into the spillway. "Probably muskrats," Charley said, "and enlarged by beavers." Nearby, three half-eaten longnose gar lay at the edge of the spillway. "Otters, probably. They eat lots of fish." Otters are appreciated more than beavers here. They first appeared around 1967 and now are common. Visitors love them.

The Conservation Department's Duck Creek Conservation Area, adjacent to the refuge on the northeast, occupies an upstream part of the watershed. Primarily devoted to recreational use, it has an eighteen-hundred-acre impoundment with excellent fishing and conducts hunting on both its lands and on the refuge's Pool 8. The two agencies coordinate water management and also work closely on other activities.

Duck Creek has a campground beside the big impoundment, with well water, pit toilets, and a concrete picnic table and metal fire ring at many of the campsites—free to the public. I gratefully camped here, sleeping in the back of my Ford Explorer, and enjoying the signs of fall: red maples starting to turn, monarch butterflies heading toward Mexico, the plop of acorns. At night, sitting beside my campfire, I listened to the loud eight- or nine-hoot calls of barred owls, the quieter four hoots of great horned owls, the squawks of great blue herons disgruntled at something, and the baying of coon hounds. Coon hunting, or more usually coon chasing, is very popular in this part of Missouri, Charley said, and even an ugly coon dog, if it's good, can bring $2,500 or $3,000.

Coon hunting is linked to the white crappie mounted on the wall be-

side Charley's desk. Next to it, a certificate from the Missouri Department of Conservation pronounces Charley a Missouri Master Angler for catching this fish. A brass label on the mount reads: "March 1, 1991. Covert operation crappie. 2 lb. 3 oz. 15½ inches. Charley Shaiffer." The story is this: "The Duck Creek manager asked me to help them watch for illegal coon hunting. I was posing as a fisherman beside a beat-up old pickup truck on the bank of the impoundment. I left my pole for a couple of minutes, and when I came back this crappie was on the end of the line."

Hunting for deer, turkeys, and squirrels is allowed in the eastern part of Mingo refuge, and duck hunting is permitted in Pool 8. A muzzle-loader season for deer was also instituted at the southern end of the refuge, to reduce deer damage on adjacent farms. Bowhunting for deer begins on October 1. That morning, manager Kathy Maycroft appeared at the visitor center wearing her pistol. She, with the assistant manager, represented the law on the refuge, though it was the first time I'd seen her armed. Not that anybody expected trouble, however. Hunting here is peaceful, except for the animals hunted. Relations with the community are good; citizens join Friends of Mingo Swamp, Inc., started by Kathy, to help with various projects. The nearby Mingo Job Corps built the attractive visitor center and assists the maintenance men in other work.

The first bowhunt was held at Mingo in 1967, October 1 to December 15. During that entire season, 930 archers killed just twenty-two deer. This doesn't sound like much of a success rate, but Charley says bowhunters now have the best success here of any place in Missouri. He attributes that to the large number of deer (a population of five hundred to two thousand), their being accustomed to seeing people, and the popularity of bowhunting in this region. Around fifty to seventy-five bowhunters show up on opening day; later, on weekends, around twenty-five appear. "It slows down a lot," Charley said. "The mosquitoes are pretty fierce out there, even into the middle of November."

There does seem to be great respect for Mingo mosquitoes. Pete Koppman, the barber in nearby Puxico, thinks they used to be even worse. "There was a lot more mosquitoes in the thirties, and it wasn't unusual to kill one with two or three ticks on it," he said with a wink. Charley suspects that Indians limited their occupation here to the colder months, when they could hunt without suffering mosquito attacks.

Hunting mallards and wood ducks in forested Pool 8 involves wading in and setting up decoys, calling, or just shuffling your feet in the water. This sounds like ducks splashing around, Charley says, and others will be attracted. "They can land right at your feet." I guess by this time, late November and on, mosquitoes have disappeared.

Fortunately, mosquitoes didn't bother me much the September day I paddled up Mingo Creek. Charley and Kathy dropped me off with one of the refuge's square-sterned canoes and drove my car to the take-out point, on Stanley Creek, maybe three miles away. It was a beautiful, windless day. Red-headed and other woodpeckers, so common on the refuge, were noisily flying around. Slowly and quietly I paddled along, weaving through the cypress trees on still water. No people around, no sound but the birds, my paddle, and the splash of turtles sliding off logs. I expected to see something exciting—maybe otters playing, maybe the refuge's first bear. I stopped for a moment, and when I looked up, a cottonmouth was swimming across my path. Its body was *on top* of the water, its head raised. I took a stroke toward it and it stopped, coiled defensively. I paused, and it swam on toward the other shore. Even a two-and-a half-foot cottonmouth, like this one, looks dangerous, with its thick, dark body and pugnacious actions. That was my excitement for the day—excitement enough.

Canoeing on Mingo Creek or along the many ditches is one of the best ways to get into the heart of the refuge, where you're likely to be alone with the forest, marshes, and wildlife. You'll have more company on Red Mill Drive, where people like to go of an evening to see deer and other animals. And in October and November, when waterfowl are abundant, an auto tour route is open in the southern part of the refuge. Near the visitor center a boardwalk winds through swampy forest; numbered posts relate to a folder explaining the nature of this habitat.

One doesn't expect to see dinosaurs these days, but in August of 2001 visitors to Mingo did see them. Maiasaur, Velociraptor, Placerias, and Compsognathus were all spotted. They were life-sized replicas brought to the refuge by the paleontologist Guy Darrough, whose finds from a dinosaur dig are displayed at the Bollinger County Museum of Natural History at Marble Hill, about thirty miles north of Mingo. Molly Mehl, the public-use specialist at the refuge, said the dinosaurs, placed out along

a refuge road, attracted five thousand people, the most ever to attend a special event here. They got a taste of Mingo's wildlife seventy million years ago.

Bald Eagle Day, held every other year in late February, is also popular. Visitors learn about eagles; they may see one up close, brought in by a raptor rehabilitator, and can view them out on the refuge. In winter, as many as fifty bald eagles may be present, attracted by the multitude of waterfowl. They feed primarily on the sick and wounded; they also snatch fish from the surface of the water. In September, I was watching a large flock of teal on Monopoly Marsh when an eagle landed on top of a nearby cypress. The ducks all took off. If one had remained behind, the eagle probably would have gone after it.

Each winter, in early January, in conjunction with the state waterfowl survey, the Conservation Department conducts an eagle survey. Since the prohibition of DDT and other persistent pesticides in the early 1970s, the eagle count has gone steadily upward. In the mid-1980s, there were almost 1,000 in Missouri. Recent counts have reached the 2,000–2,500 range. Mingo's contribution in 1999 was 13 adults and 20 immatures. Most of these eagles come from farther north, when freezing restricts their food supply.

Nesting of bald eagles in Missouri has also continued to improve, after a long absence. In 1999 there were fifty-three active nesting territories. A pair at Mingo attempted nesting in February 1961, but disappeared a month later. From 1981 to 1988, eagles were raised in a hack box, fed by people they couldn't see, to prevent imprinting on humans. In 1983, Mingo could claim the first Missouri eagle nest with eggs since before mid-century, but the eggs failed to hatch after one adult was killed by lightning. Successful fledging of young began in 1985, and one, sometimes two pairs have continued to fledge young most years since then.

Like other birds, eagles and waterfowl can fly away from unfavorable conditions in winter, but reptiles and amphibians can't. They hibernate, burrowing in the ground or crawling into rocky dens. Many of the snakes at Mingo head for the hills in fall, especially the southeast-facing bluffs on the west side. The dolomite outcrop at Fry bluff is one of the most favored, as a reporter from the *St. Louis Post-Dispatch* recently found out. Visiting the bluff during late October, he wrote, "I counted

six cottonmouths and a lone banded watersnake on the leaves immediately surrounding the rock I was standing on. The sun was behind me, and I found that if I waved my hand, the shadows passing over each individual snake caused it to swell and strike, fearful of some predator overhead. I stood on the rock, waving my hands and causing each snake in turn to open wide its cottony-white mouth. I felt like a maestro conducting an orchestra of cottonmouths."

Other visitors should not try to emulate this imaginative but incautious reporter. The snakes, including copperheads and timber rattlers, are hard to see in the dead leaves.

Through the winter and early spring, Charley keeps adding or subtracting water from various units and conducts a waterfowl count every week with the help of aerial observation by the Conservation Department. He continually checks the condition of levees, which sometimes suffer beaver or muskrat damage. He also checks the condition of pumps. If there's heavy rain, he might have to take water out of some units.

After the waterfowl have gone, Charley monitors migrating shorebirds, which peak in mid-April here. He starts managing units for next year's crop, carefully watching water levels. "We don't want mudflats about May 10 to 20, which would be good for willow germination. We either make sure units are dry then, or flood them so the willow seeds will just float." Through the spring and summer, Charley logs data in his computer, makes plans for the coming waterfowl season, and supervises the management of moist-soil units, some of which must be plowed to kill woody plants and to stir the seeds of waterfowl plants. Rusty pipes must be replaced and levees repaired.

Emotionally, I think, this is downtime. It is the waterfowl that most stir Charley's heart. As Kathy Maycroft said, he understands the behavior of waterfowl. "Ducks are smart," Charley says. "They soon learn where the blinds are and avoid them. They will leave a hunting area five minutes before hunting starts. . . . Ducks budget their time and energy—probably better than we do. We found in a rice feeding area that they left when half the grain was gone: It would take too much of their energy to continue feeding there. But they do take some flights just for exercise.

"Every fall I look forward to seeing them—like family coming to visit. We've spent so much time preparing for them and we wonder if we did

a good job. If there's food left at the end of winter, we've done a very good job. There are implications all up and down the flyway. If they're in good condition, they have a better chance to successfully migrate and raise young.

"I never get tired of going out and seeing the birds."

JOEL VANCE

Writer

There's no such thing as an outdoor writer. There are only writers who write about the outdoors.

JOHN MADSON

Maybe the best way to get to know natural Missouri is to be Joel Vance. He has hunted, fished, hiked, and camped all over the state, floated most of its rivers, searched out the elusive morel in many a wood, worked with his own forty acres, and written about it all—how it is, was, and should be.

I first met Joel in northern Vermont, at the Wildbranch workshop for practicing and aspiring "writers about the outdoors." Short, wiry, with close-cropped white hair—not physically imposing—he led us through the intricacies of article writing. His advice was based on impressive experience—more than forty years writing for newspapers, magazines, books, and the Missouri Department of Conservation—and just plain native talent. His criticism of our efforts was helpful, not wounding.

Perhaps our relative ease in his class was also due to his humor and self-deprecating manner. These characteristics show up constantly in his writing. Consider, for instance, this bit from an article about duck hunting: "The decoys invariably are tangled in the bag, their pointy tails caught in the mesh, their carefully stowed anchor cords unaccountably unwound and tangled. I fumble with them in the water and feel the chilly tickle of a wader leak against my leg. One decoy nestles against me, and when I slosh back to shore it follows like an obedient dog, its anchor cord wrapped around my foot. Two other decoys drift together and bang heads, the sound loud in the still night. I sigh and wade back to set them straight. Then, I plunk down on my bucket seat and wait for shooting time."

Missourians know Joel Vance best from his articles in the *Missouri Conservationist,* particularly the humor pieces. "That's a mixed blessing," he says, "because there wasn't any conservation message in the humor pieces, but I guess if nothing else it got people to read the magazine."

I think writers are born, not made. They can be made better by training and practice, but the talent has to be there in the first place. The desire to write may be unexplainable. Nobody else in Vance's family was a writer. He just knew he "wanted to be a writer of some sort." What writers write about, however, may be shaped by the circumstances of their early life.

When Vance was thirteen, the family moved from Chicago to Dalton, Missouri, "a flyspeck on the road map. . . . I had this outdoor bent from the get-go, because we lived outdoors and hunted and fished. My father owned a 970-acre farm that had quail and all kinds of critters on it." The Cut-off, a nearby oxbow lake left by a channel change of the Chariton River, "had a lot of fish in it. Plus my mother came from a fishing resort town in northwest Wisconsin where we spent many, many vacations when I was a kid. I fished there, too."

With a sea of farms, including his father's, surrounding his tiny town, Joel could hardly avoid contact with farm life, though he didn't much fancy it. "Being a real country boy is a handicap," he wrote in his memoir, *Down Home Missouri.* "It's a long way between girls, movie houses, baseball diamonds, and friends. But it's only a short distance to the machinery shed, where there's a tractor you're encouraged to ride for endless hours, or to a hayfield full of bales and god-awful summer heat, or to other places that are not comfortable."

Summer jobs for teenagers tended to be of a farm variety. "I weighed 115 pounds and could barely lift a bale of hay, much less pitch it to the top of a stack." But he could detassel corn, which anyone could do, but no one wanted to. This involved riding on one of four twelve-inch-wide platforms that extended out from a wheeled vehicle over rows of corn that were intended to receive pollen (from the "bull rows"), not shed it, to produce hybrid seed. As the machine rumbled along, you and the kid sharing your platform pulled off tassels.

Vance described the experience as one Dante Alighieri in his *Divine Comedy* might have substituted for that of souls damned to the sea of ice at the pit of hell: "As quickly as they pulled a sticky tassel, a new one would

sprout. Detasselers would pull and pull in blinding heat, sweat pouring off them, muscles cramping, never quite catching up, plagued by thirst and hunger, always a half-row away from a drink of water and twenty minutes from lunch, reviled by a sneering foreman."

It was the summer of 1951, one of the hottest in modern times. The trial ended for Joel only when he became violently ill one day out in the corn rows, and his mother said, "You're not going back out there." Such experiences may have been hell for him, but they were valuable. Anyone writing about wildlife, the land, and conservation needs to know about farming.

Joel's attempts at stardom in sports fared poorly. In a basketball game, "I shot at the wrong basket" and missed twice. In track, "I was bad enough to finish near-last in every final race of every meet." As a baseball pitcher, he could throw knuckleballs, curves, change-ups, and screwballs, but "there was just one niggling problem: I didn't have any idea where the ball was going when I released it."

Dating was "just slightly tougher than Marine boot camp. Or at least it was for me, with no experience, no self-confidence, and the handicaps of living in a backwater with limited resources."

But he was good at dreaming. In the old former hotel with many rooms but no indoor plumbing where they lived, he listened to the nasal voices of Roy Acuff, Jimmie Rodgers, and other country singers coming over a big Zenith Art Deco console radio, and then, out on the veranda, he strummed his Martin 00–17 guitar and tried to imitate them. "I tried singing like Hank Williams," he wrote, "which really must have set my mother's teeth on edge when I caterwauled 'Lost Highway.'" But in his imagination he was a star of stage and radio. Music of many kinds became a lifelong love.

Joel also dreamed of being a writer. "I've never wanted to do anything but write," he told me. "I started reading when I was really young. Somewhere along the line I decided I wanted to be a writer of some kind. In high school I was sending manuscripts—I think mostly humor pieces—out to magazines. I decided I wanted to be a humor writer because I read Thurber, H. Allen Smith, the great humorists of the day. I wanted to be just like them, but of course it was terrible stuff and got rejected."

At the University of Missouri in Columbia, he took creative writing and went to the journalism school. During his senior year he wrote an outdoor

column for the university newspaper; he wanted to continue this kind of writing as an occupation, but it eluded him for a few years. His first job was in Alabama, copyediting at the *Montgomery Journal*. Here he didn't like "the southern attitude" about race but did, incidentally, develop a love of opera, to which he was introduced by his coworkers. After three years he moved back to Missouri and became the sports editor on the *Mexico Evening Ledger*.

He worked here for ten years. "I probably shouldn't have stayed so long," he said, "but I had a young family to support." (He'd married Martha Lou Leist—Marty—right after college.) "About the ninth year, I started getting restless, because it was a dead-end job. I wanted to be an outdoor editor on a newspaper, but I found out they don't ever turn loose of those jobs. Once somebody gets one he's there until he dies, and there's always somebody on the staff ready to step in.

"About that time the Missouri Conservation Department needed a newswriter, and they contacted me. They'd seen a series of my articles about water pollution problems around Mexico and liked it. I hemmed and hawed and finally accepted it, because frankly I couldn't find anything I wanted. But I found out it was the greatest job I could ever have had. I had all this freedom. After writing on deadlines every day for ten years, this was easy. I had four or five stories a week to do. I could do that in half a day. I started writing stuff faster than they could publish it, because I had so much time and so many things I wanted to write about." He also had a big audience. The department's magazine, *Missouri Conservationist*, has the largest circulation of any agency conservation magazine in the country—about 450,000.

Vance wrote for the *Conservationist* and put out news releases for twenty-one years. "All that time I bet I wasn't *assigned* an article more than half a dozen times. Almost everything I did or whatever I got interested in resulted in an article." He wrote, for instance, about bicycling through Squaw Creek National Wildlife Refuge and canoeing on the Current River, and about natural history, hunting and fishing, and environmental issues.

"I wrote about air pollution, water pollution, habitat degradation. I got most of the industry in Missouri mad at me at one time or another. When I wrote about charcoal kilns—that's a big industry in Missouri—they got really upset about the fact that I was saying they were putting a whole lot

of carbon monoxide, or whatever it is, into the atmosphere. It was true. They just didn't want anybody talking about it. I talked about stream channelization. I'm sure the Corps of Engineers wasn't real happy about that.

"I don't try to be controversial. I just don't pull any punches. If you don't get any angry responses, you're not doing a very good job."

By the time Vance began writing for the Department of Conservation—1969—Missouri had already dealt with some of its biggest conservation issues. Setting wildfires, once a yearly custom in the Ozarks "to kill ticks and chiggers and snakes and all that sort of thing," was mostly a thing of the past. Forest management was much improved. Deer and wild turkeys had been brought back from near oblivion to abundance. "Our turkey biologist in 1967 said he thought maybe half the counties in Missouri would have a season ultimately, and now they all have one—very good seasons."

In 1969, however, soil erosion still plagued the state. "At one time we led the nation or were number two in soil erosion," Vance said, and in the late sixties it still was "not solved by a long way. There was a universal mania for fall plowing. The farmers felt it gave them a jump on next spring, on getting their soil ready for crops. But what it also did was lay the soil bare for all kinds of wind and water erosion. At one time the highway commission had to plow dirt off some of the roads in northwest Missouri. I think more farmers now are using no-till methods and leaving their cover on over the winter. Plowing is almost a thing of the past."

When Vance joined the MDC, air and water pollution also had yet to be adequately addressed. "I believe the polluted Missouri River was just beginning to get some modern sewage treatment plants.

"During my first years with the Conservation Department probably the biggest controversy was over what we call 'scenic rivers.' There was a proposal to designate many of the Ozark streams as scenic rivers and have controls on them. People in the Ozarks just came unglued about that. Some landowners cut down all the trees along their piece of river so there wouldn't be any scenic value—stuff like that. Canoes got shot at. The funny thing is that some of the most ardent opponents of scenic rivers in the Current River valley"—the first designated scenic river—"wound up being canoe outfitters.

"We had the same thing happen on the Katy Trail." In this more recent, 230-mile rails-to-trails conversion, "the landowners along the way were saying, 'We're going to have all these hippies out here, and they're going to throw trash, kill our livestock, cut our fences'—all the same arguments that they put against the scenic rivers—and almost the same thing has happened: first, there haven't been any problems, and second, some of the arch-opponents are making money with restaurants, renting bicycles, or whatever it is, along the KATY. These people never learn, I guess.

"The biggest thing in my whole career was getting our conservation tax." A study of the Department of Conservation chaired by A. Starker Leopold had concluded that it needed to become better able to serve the wider outdoor constituency, not just hunters and fishermen. "Seventy percent of the people who go to any given wildlife area are birdwatching, or hiking, or whatever—not hunting or fishing," Vance says, "and they were not paying their way, either." The goal was to raise twenty million dollars for the department, and conservationists proposed a tax on soft drinks to raise it. "It never even occurred to us," Vance said, that at that time, "Seven-Up had its world headquarters in St. Louis." Even though conservation supporters acquired the largest number of signatures ever on a Missouri petition, the proposal was thrown out in court as invalid because lawyers hired by opponents pointed out that it lacked the required enacting clause—a small but essential technicality.

After this crushing defeat, the University of Missouri studied other possible sources of revenue and concluded that a general sales tax—one-eighth of 1 percent—would raise the twenty million dollars and would be the fairest way to get it. This time the petition included an enacting clause, and the referendum passed in the 1976 election. "We stayed up 'til probably three o'clock in the morning," Vance recalled, "until the final figures were in. We won by 50.7 to 49.3 percent. The tax now generates about eighty million dollars a year, but it's resulted in the best-funded and the best-rounded conservation program in the country. It's met nearly all the targets of the Design for Conservation."

This document, which lays out all the goals of the MDC, including doubling the public land area and establishing a natural history unit and a first-rate public education program, was written by Joel Vance. He also wrote the script for a movie about the Design for Conservation that was

shown all over the state. His role in the push for the conservation tax and creation of the design "was the most exciting and worthwhile thing I've ever done."

There were smaller victories, too. "During the seventies or eighties the Corps was persuaded to put gaps in some of their wing dikes on the Missouri River, so the current could flow through and scour out holes where catfish can live." Vance wishes, however, that the Corps of Engineers was more cognizant of the river's natural values and not so committed to channelizing the river for the benefit of barge traffic. He thinks it's not worth the cost and that it's essentially doomed as a project.

"The Missouri River has been so squeezed and channelized. That's why the '93 flood was so bad. The water all piled into this narrow channel and it just exploded out over the levees and washed them out. If there had been no levees and no channel structure of any kind, that flood would have spread out and eased itself on down to the Mississippi and on down to the Gulf of Mexico without creating one zillionth of the havoc that it did." For about six months after the flood, "everybody said levees are bad. Then the politicians and the Corps and the farmers got into it and the solution to them was to build the levees higher. Well, sooner or later the same things are going to happen again. You can't beat Mother Nature and the Missouri River."

He is much happier about the recent purchases of land along the Missouri between St. Louis and Kansas City for the Big Muddy National Wildlife Refuge and for new state conservation areas. This land continues to be subjected to flooding and will help to restore waterfowl habitat in this formerly important waterfowl area. He found good quail hunting in one part of it, "maybe because people didn't know about it yet."

By the time Vance retired from the Department of Conservation, in 1990, most of the big issues, like air and water pollution, had been effectively addressed. "Sewage treatment is far superior to forty years ago," he says. "The biggest polluters have been forced to clean up much of what they did." The MDC is successfully maintaining its greatly expanded public land areas and programs. "There are no looming crises that I know of that affect Missouri. For the world, maybe global warming, a hole in the ozone layer, but Missouri is in pretty good shape."

He has time now to do the things he loves best. At the top of his list are "me and the kids doing things together, or me and the dogs doing things

together," and writing about it. He goes grouse hunting with his youngest son, Andy, in Minnesota, occasionally pheasant hunting in the Dakotas, duck hunting closer to home.

Of all game birds, he loves quail the most, and of all bird dogs, his six French Brittanys. Quail hunting is his favorite "because that's a Missouri bird and that's where I've grown up. It's probably the best bird there is to work a dog on, because they hold well. They live in neat places—the edge of farmland, in woods. They are a gentleman bird. You don't have to get up at the crack of dawn to hunt them. When you get a covey up there's the excitement of the explosion. And they're absolutely wonderful to eat. Everything about quail is just wonderful."

Vance started hunting with an American Brittany. When this dog was killed by a car, Dave Follansbee, the first editor of *Gun Dog* magazine, told him about a French Brittany puppy from one of his dogs, and Vance now would have nothing else. The French, as opposed to the American, has a black nose rather than a "red rubber nose" and has darker eyes. "They're just a little more refined looking, I think, and livelier and smarter, and more oriented toward the people who are out there in the field with them." (The French Brittany was developed by people who conducted field trials on foot, while American Brittanys have been bred for horse-mounted field trialers.) As with many hunters, his attachment to his dogs is deep. "They are not tools to me, they are friends."

After writing about all these sorts of things for more than forty years, he's at ease with the process. It seems to just come naturally now. His method may seem unorthodox. "Generally, I won't try to write from the first to the last line. I'll write what happens to be hot at the moment, or what I've got the information on, and worry about jiggering it around later so that it's organized. There's a great story about the southern writer Eudora Welty, who would write in little fits of inspiration like that and then get down on her living room rug with a big pair of scissors and clip these paragraphs and move them around until they fit the way she wanted them. That's what you can do with a word processor now.

"I'm sure there's a formal process somewhere in my mind, but I've done it for so long that I don't think about it any more. I tell students at Wild-branch [the writing workshop] to outline if they have problems with organization. But I don't anymore, just because I know how things ought to go."

At Wildbranch, we spent a lot of time on leads. "To me," Vance says,

Joel Vance at home with one of his French Brittanys. NAPIER SHELTON

"that's the most important part of the thing, because you've got to get the reader into it. And the ending. Those are the two vital parts.

"The middle part pretty much takes care of itself. It's the bulk of the information you're trying to convey, and I don't think that's something that needs intense organization. The danger is that it's easy to get sidetracked"— off on some peripheral subject. "At Wildbranch I find it's almost universal that the students can't focus on one aspect of the subject and let everything else be secondary to it. They tend to want to get everything in and give it all equal weight. You've got to decide what's the point, and everything that doesn't pertain to that point in some way doesn't belong there."

As to endings, he sometimes comes "back around to the lead in some way," or builds to a crescendo. "An article shouldn't just tail off. Again, that's a prominent flaw I see at Wildbranch, where students have a really good, well-written piece but they don't know how to end it."

For Vance, shorter is always better. "One thousand words is ten times better than two thousand." That makes it livelier and "gets rid of all the fluff."

His advice on education for an aspiring writer on the outdoors is to focus on writing, such as in journalism school, and learn about the subjects you want to write about on your own, say, by hanging around field

biologists. "I think journalism and newspaper work is a great training ground for any form of writing," he says, "because it teaches you to do research, to be a reporter, to be accurate, to work fast. English majors tend to learn most of the same things, but they don't learn the trick of speed." As to college courses beyond writing and journalism, he says it depends on what aspect of the outdoors you're interested in, so broad is the field these days. "Most people are not hunting or fishing." It might be, for instance, biology, ornithology, natural history, or environmental science.

Writing about the outdoors, he says, "is a whole lot different from other kinds of nonfiction writing. First of all, it's great fun. We're getting paid for doing what other people have to pay to do. And there are a lot of perks. You get great deals on equipment, and you can write it all off on your income tax."

The downside for a freelancer is that it doesn't pay very well. "You'd better have some other source of income," because few make a full-time living at it. Those who do are "either very good marketers and maximize what they do," for instance, by writing several articles from one batch of information, "or they just work like hell all the time."

With retirement income to supplement his freelance earnings, Vance doesn't have to work like hell, but he does continue to put out a steady stream of articles: a conservation column for *Gun Dog* magazine, a humor column for *North American Fisherman,* and some articles for *Bluegrass* (he still plays his guitar and sings to himself) and various other magazines. You can still see his pieces in the *Missouri Conservationist.* Book writing is squeezed in, too, not always about the outdoors. One contains ghost stories he's invented. Another, which was underway in 2002, is about a remarkable professor he had known at the University of Missouri.

He does all this at his small but comfortable home on forty acres west of Jefferson City. Brick on front and back, cedar on the other sides, it nestles attractively in the woods. His wife, Marty, designed the three-bedroom house. "She made herself a little cardboard model and moved the little pieces around until it suited both of us." They had owned the land since around 1970, coming out on weekends from Jefferson City and staying in a cabin up the hill. After Joel's retirement, they felt free to build the house and move there.

"We built it in 1993, just in time for the flood. It didn't flood here, but

it rained all the time. We had a swimming pool instead of a basement in the excavation." Local builders and craftsmen did the major work; a nearby cabinetmaker constructed the kitchen cabinets with solid walnut from Joel's father's farm, collected some forty-five years earlier. Joel, Marty, and two of their sons, Eddie and Andy, did much of the interior work. It was a house with "family" written in the very walls.

A house in the woods! How many of us have dreamed of living in such a place, ever since Thoreau at Walden Pond? You see a suggestion of this over much of America, where people tuck a house back in the trees on their ten-acre rectangle out in the country.

The Vance place is much more than this. It is a microcosm of outdoor Missouri. Off to one side, the Brittanys recline in their pen, setting up a cacophony of barks whenever someone arrives, or quivering with excitement when a hunt is in prospect. From his deck Joel looks down through the trees at their one-acre pond, which he wishes were ten times bigger. It's home to bluegills, bass, channel cats, and a few green sunfish. "We feed the channel cats," he says, "and eat the smaller ones; but we have some that are probably fifteen pounds or more. They are kind of pets." Beside the pond lie three canoes, veterans of many a river run, the battered aluminum one now dedicated to the pond, along with a "little bitty rowboat."

"We tried to make the house fit into the woods rather than stick out"— and they succeeded. They are pleasantly surrounded by oaks, hickories, and cedars, among which dwell all sorts of wildlife. "We hunt turkeys here," Joel said. "Andy killed a twenty-six-pound gobbler this last spring up on the ridge. The deer come and go. There's lots of coons, squirrels, birds of various kinds"—sometimes wood ducks or geese drop in at the pond.

"In October the dogwoods between the house and the pond turn flaming red, and when the sun rises over the ridge on the other side of the pond, they're backlit, and the effect is breathtaking.

"There's always something happening on the place—sometimes Marty and I take a hike along a trail that I cut and maintain. It circles the entire place and we might see turkeys or deer or a gob of squirrels or a bunch of wildflowers that we can never remember the names of. In the summer we sit on the deck and watch lightning bugs. It's never boring. Maybe it would

be to an urbanite . . . but I haven't been an urbanite since I was thirteen years old, and don't intend ever to be again."

About ten of their forty acres are patches of glade or "prairie." "There's one prairie patch up the hill where I planted big bluestem, Indian grass, and a lot of forbs. There's another one that used to be just broomsedge, but little bluestem has come back over the years. I suspect it was pasture at one time and the bluestem was grazed out. Now there's no broomsedge. I guess the bluestem seeds were in there all the time."

Periodic burning is the usual—thousands of years old—method for maintaining prairie. One year Vance tried burning one of his prairie patches "and damn near set the whole county on fire, so I gave that up. But last fall we mowed it down to the ground. It had the effect of burning. I'll probably do that about every third year. On my glades I cut the cedar sprouts because they can take over real fast."

So Joel happily works in this natural haven they call Cedar Glade, his son Eddie and his wife up the hill on five of the forty acres, a daughter within a few miles, and a Minnesota daughter and family seen during the October grouse hunts. He still is closely involved with the Outdoor Writers Association, of which he was once president and now is the group's historian.

Though deeply attached to their place, he and Marty love to travel and enjoy things not available at home. They go to Wildbranch in Vermont for the annual workshop. They go to New York for good restaurants, art, plays, and musicals. One June, they stopped in Pennsylvania at the Martin guitar factory, which, Joel says, "is for me a pilgrimage. They let me play one of their nine-thousand-dollar guitars."

Joel Vance—writer, outdoorsman, husband, father, guitar strummer—has obviously come a long way from that stumbling, dreaming youth in a little town up north of the Missouri River.

PROTECTING STE. GENEVIEVE

A permanent improvement must, of necessity, be designed and
executed in entire harmony with natural laws of the river. A
mighty river is impatient under restraint—it can be led, but
not driven.

COLONEL JAMES H. SIMPSON,
first St. Louis District Engineer (1875–1880)

One who knows the Mississippi will promptly aver . . . that ten
thousand River Commissions, with the mines of the world at their
back, cannot tame that lawless stream, cannot curb it or confine
it, cannot say to it, Go here, or go there, and make it obey.

MARK TWAIN, *Life on the Mississippi*

For most of its history, Ste. Genevieve, the oldest permanent settlement
in Missouri, has been at the mercy of the Mississippi River. Floods
forced its move away from the riverbank, and later floods inundated its
lower streets, at the foot of hills flanking the floodplain. Some say the
flood-control structures completed by the Corps of Engineers in 2002 will
now protect Ste. Genevieve for hundreds of years. Others, considering the
power of the Mississippi, are doubtful. At stake is one of the nation's prime
historic treasures.

Most of the settlers of Ste. Genevieve were French Canadians who had
moved first to Kaskaskia, on the Illinois Territory side of the river. At-
tracted by rich bottomlands on the other side, some of the farmers moved
across in the late 1740s. There, a few miles upstream and near the river-
bank, they built their cabins, most often one-roomed, the walls formed
with logs placed vertically in the ground, the roofs thatched. Many added
a porch, or *galerie*, completely around the dwelling to keep sun and rain

off the whitewashed walls and provide shade during the hot, steamy summers. They surrounded their homes with a square stockade of pointed logs to keep wild and domestic animals out of their gardens. Fearful of fire, they constructed the kitchen and smokehouse away from the cabin, along with an outhouse and well.

Eventually the settlement stretched along a mile of riverfront, the houses spaced out unevenly, some farther back from the water than others. Behind the settlement lay *le grand champ*, three thousand acres of tillable land once the trees were cleared. Each family owned a separate tract, delineated with a fence. The land was divided under the French system, with long narrow plots perpendicular to the river. Most were one arpent wide—192 feet, 6 inches—and nearly a mile long, extending back to the road at the foot of the bluff. Here they planted corn, pumpkins, wheat, oats, barley, flax, cotton, and tobacco. Lacking steel implements, most farmers let their crops compete with weeds until harvesttime. With game and furbearers abundant, they supplemented domestic meat with wild and sent furs and other goods downstream to a factor, who traded them for items from the French export trade.

Relations with Indians were both good and bad. A village of Peorias and Kickapoos lay on *le grand champ* near old Ste. Genevieve, and their children played with the white children. Not so peaceful were the Osages, who had no settlement nearby but ranged widely, hunting game and stealing livestock. The Osage warriors would enter Ste. Genevieve at night, break into stables, and lead livestock away, taking anything else they found of value. The Peorias living here had customarily gone on fall, spring, and summer hunts to supplement their crop harvest, but fear of the Osage caused them to restrict this practice. As Gregory Franzwa puts it in *The Story of Old Ste. Genevieve*, "It wasn't until the immigration of the Americans, who regarded shooting Indians as being somewhat akin to squirrel hunting, that the Osage met their match and retreated to western Missouri."

Contrary to human desires, a river not confined by hills or bluffs will, over time, wander side to side, or meander (a term taken from the Maeander River, now called Menderes, in Turkey, where the phenomenon was first understood). The outside of a bend erodes while the inside builds up with deposited sediment. Eventually a long loop may develop and then be cut off at the neck during a flood, shortening the river and turning the loop into a crescent "oxbow" lake.

Something similar happened at the site of venerable old Kaskaskia, the capital of Illinois Territory from 1808 to 1818 and the first capital of the state of Illinois, from 1818 to 1820. It was situated on the right (west) bank of the Kaskaskia River near a bend of the Mississippi. That bend gradually eroded toward the Kaskaskia until in 1881, during a flood, it broke through. The Mississippi thereafter followed the course of the Kaskaskia River to its former confluence with the Mississippi, and the old Mississippi channel became little more than a slough. The town of Kaskaskia year by year tumbled into the Mississippi and now lies buried beneath the river; today, part of Illinois, whose boundary follows the old Mississippi channel, lies west of the river.

The remains of Fort Kaskaskia, high on a bluff on the east side of the Mississippi, overlook the scene where all this happened. Nearby, three plaques set in stone bear sonnets by Louis William Rodenberg, "To a Sunken City—Kaskaskia." One begins, "O Mississippi, monarch of the plain, despoiler old! We mourn your victim low. Now stay the mighty minions of your train, that this poor vale may no more havoc know."

The inhabitants of old Ste. Genevieve may well have uttered such prayers, as indeed those of "new" Ste. Genevieve have uttered in all their years since the town moved. The earlier settlement saw the river eat away its banks, toward their homes, but an even greater terror was floods. Two of every five years the crops were drowned out. The highest floods swirled around and through the homes themselves. Nature's message became clear: The riverbank is not a smart place to live.

The first people to move may have done so in the early 1770s. In 1777 a terrible flood hit, and by 1784 the pace of removal had definitely quickened. Then, in the spring of 1785, came the biggest flood anyone could remember. The houses were submerged under ten feet of water. The barges of Auguste Chouteau tied up to chimneys projecting above the surface, while some of the boatmen dove in. When the waters receded, the inhabitants returned and cleaned from their homes what was probably the deepest mud that had yet filled them. *L'annee des grandes eaux,* the year of the great waters, was followed by lesser floods in the late 1780s, and most of the remaining citizens were persuaded to move—to *les Petites Côtes*—the small hills a couple of miles away that flanked their vulnerable but essential farmlands. By 1791, the old townsite was virtually abandoned. In

1794 the Catholic church, which had stood on *le grand champ* since about 1754 and had become the center of community life, was moved, in a final closure and a new beginning.

The site of old Ste. Genevieve is privately owned, is not advertised, and is probably buried under silt, but it lies somewhere out near the end of a gravel road that runs to the river from U.S. Highway 61, two miles south of today's Ste. Genevieve. I drove out there one late summer day, past the Indian mound that rises like a long loaf of bread from the plain. This is believed to be a temple mound from the Middle Mississippi period (A.D. 900–1500), whose most impressive remains are the Cahokia Mounds, across the river from St. Louis. Now only sixteen feet high, the mound on *le grand champ* was measured by archaeologists in 1941 at thirty feet and must originally have been appreciably higher. Crops were raised on it for many years, which, with the attendant plowing, and with floods, led to erosion. Today it is grass-covered, perhaps to preserve it longer. Very small mounds around the large one are thought to be burial mounds, further suggesting that this was a religious site.

Tall corn obscured some of the scene, but the view opened up wherever soybeans grew. When I drove up onto the Farmers' Levee along the river, I could see the vastness of this cropland, which is as rich and productive now as it was for the first settlers.

Just beyond the levee, poplars and willows screen the river from view. A bald eagle sat in a dead tree, surveying the scene. Farther along, a hen wild turkey picked her way down the grassy side of the levee. These birds were common in the eighteenth century but later became scarce. Now they are common again. A huge flock of great blue herons flew up from a muddy channel in the trees. A red navigation buoy lay among the tangled tree trunks left here by some past flood. Maybe not much had changed since the days of old Ste. Genevieve except the scale and neatness of farming. And the disappearance of the old town.

The antiquity of the "new" Ste. Genevieve is immediately apparent as you descend past outlying businesses and enter the town proper. Signs as well as appearance affirm the age of the structures. The Beauvais House, at Main and Merchant: 1792. The Janice-Ziegler House, part of which was the Green Tree Tavern: circa 1790. The Jean-Baptiste Vallé House, at Main and Market: 1794. The Price Brick Building, now a restaurant: circa 1804.

Driving around town, you keep passing these old homes scattered among newer ones.

The town celebrates primarily its French heritage, with *Le Reveillon* at Christmas, *Le Bal du Roi* between Twelfth Night and Ash Wednesday, and other festivities, but Americans and, later, Germans came to outnumber French citizens. Spain held this land from the early 1760s until 1800, when it was traded back to France, but Spain had granted land to French as well as to a few American settlers. After the Louisiana Purchase of 1803, the American influx swelled. German settlement began around 1830.

Visitors thus can see a variety of architectural styles. The French colonial houses have walls of vertical posts set in the ground or on stone or have stone walls. The Felix Vallé House, made with local ashlar (squared) stones, was built by an American, Jacob Philipson, in 1818 in the Federal style. Another American, John Price, built his home about 1804 with handmade brick. The oldest remaining German homes, built skillfully with brick, date from the 1840s and 1850s. The Holy Cross Lutheran Church, erected between 1869 and 1875, is Romanesque.

One of the town's most famous, though brief, residents was the bird painter John James Audubon. He arrived in 1811 with Ferdinand Rozier and two hundred barrels of whiskey to conduct retail trade. The partnership didn't work out, and Audubon left after only a few weeks. In the Ste. Genevieve Museum you can see a case of birds he is said to have mounted: a solitary sandpiper, bobwhite, eastern kingbird, northern flicker, American coot, Baltimore oriole, scarlet tanager, yellow-bellied sapsucker, and yellow-rumped warbler. They are in amazingly good shape, except for the warbler, which is beginning to lose feathers.

Perhaps the best way to transport yourself back in time to settlement days is to visit the Louis Bolduc House, near the Interpretive Center on Main Street. Now owned by the Colonial Dames of America in the State of Missouri, it is a museum through which guides take visitors.

Louis Bolduc was one of the wealthier Ste. Genevieve landowners. Like others of his economic status, he owned slaves. He was a merchant, planter, and lead miner (rich deposits of lead had been discovered west of Ste. Genevieve in the early 1700s). It is not certain that Bolduc built the house, which may date from the 1785–1790 period, but he was living in it at the time of his death in 1815. Ernest Connally, who directed the

restoration of the house in the mid-1950s, called it "one of the largest, oldest, and most instructive examples of French colonial architecture in the upper Mississippi Valley."

The house has two large rooms—a living/dining room and a sleeping room—with a central hall between them. The shingled roof slopes steeply down to a flatter section that covers the surrounding porch. Some of the timbers from houses on the old site of the town may have been incorporated into the ceiling or walls, which are made of vertical oak posts on a stone foundation, with wide interstices filled with clay and chopped straw. The house is furnished with period pieces, some of which are believed to come from the old town. In the living/dining room, my guide pointed out the almost childlike dimensions of the dining table and chairs. "Men at that time averaged around five feet tall," she said, "and women less than that." An armoire in the corner, with a dark stain at the bottom, may have survived the flood of 1785. Out back, a reconstructed kitchen stands amid gardens. A stout stockade fence encloses all.

Most of the houses at the new site were built between the North Gabouri and South Gabouri creeks, which join out on the floodplain before flowing to the river. The houses were scattered from the foot of the hills, along Main Street, to the higher slopes. Those who built near Main Street should have been more far-sighted, for the highest floods inundated them. Nineteenth-century flood heights were not recorded, but the major flood of 1844 is said to have reached two and a half feet above the legendary 1785 flood. Visitors today can get an idea of the water depth of twentieth-century floods from a vertical post beside North Main Street, which records the heights in reference to 0 on a gauge downstream at Chester, Illinois. It shows ten flood heights since 1943: The lowest of these was 38.50 feet, on December 11, 1982. On April 30, 1973, the water reached 43.31. The 1995 flood, not shown, exceeded 45 feet. Far above your head, near the top of the post, is the mark at 49.67 feet for August 6, 1993, the worst flood ever recorded for the town.

Before 1973, no permanent levees protected the town. The people of Ste. Genevieve were not very successful in fighting back when the river threatened them, and sometimes it rose into Main Street. For two decades after 1951 the river was peaceful, but in the spring of 1973 something had to be done. The river was rising beyond anything seen in the twentieth

century. National Guard troops and local residents piled sandbags around the clock. The emergency levee held and most of the town stayed dry. When the flood receded, some of the emergency levees were strengthened and left in place to defend against future floods.

After so many floods, and increasingly urgent cries for federal help, city officials asked Congress to authorize the Army Corps of Engineers to study the situation. Those studies were carried out in the early 1980s. The first planning report from the St. Louis District, which justified protection works on the basis of historic preservation, came back from the Washington office with the conclusion that the information presented was insufficient. In 1982 the planning was assigned to Jim Zerega. Together, his Corps of Engineers group and Ste. Genevieve community leaders developed a new plan with strengthened emphasis on the historic importance of the town, placing the levee out in the floodplain, where it would not visually and physically conflict with the historic resources it was supposed to protect. This time the project gained enough support, and Congress authorized it in 1986.

But nothing happened on the ground for ten years. The law required that the sponsor, in this case the city of Ste. Genevieve, pay 25 percent of the cost, and little Ste. Genevieve (pop. 4,500) couldn't come up with the millions required. The whole business was stalled when, in the spring of 1993, the river rose again and commanded the town's supreme effort in defense.

That flood resulted from some of the heaviest, most prolonged rain ever experienced in the Midwest. Above-normal rainfall began in early July of 1992 in the upper Midwest and continued all summer. Autumn was rainy, and the winter of 1992–1993 had heavy snow. Spring saw further storms. The soggy ground could hold no more water. It overflowed down the rivulets into creeks, the creeks into rivers. Iowa and all the surrounding states bordering the Missouri and Mississippi were experiencing floods by April 1993. Dams on the upper Mississippi, the upper Missouri, and their tributaries held back some of the water but not all. Hundreds of miles of levees—those not overtopped by the surging rivers—in many places prevented the high water from spreading onto floodplains, thus increasing the river crests downstream.

At Ste. Genevieve, flood stage—when cropland begins to be inundated—

is 27 feet on the Chester gauge. On April 19, 1993, it reached 37.7 feet. Since the "Christmas flood" of 1982, the levees at the town had been extended, so the spring flood was held out of all but the lowest lying areas. After April 19, the water receded, the barricades were taken down, cleanup proceeded, and everybody breathed easier.

They did not know that nature was preparing their ultimate test. In May a new period of storms began. A stationary mass of hot, dry air over the East Coast blocked the normal exit of storms in that direction. By the middle of July, rain had fallen in the Midwest for forty-nine straight days, sometimes as much as five to twelve inches in a single day. On July 1, predictions from the National Weather Service called for a crest of 39 to 40 feet at Ste. Genevieve. After the Fourth of July celebrations, the town thought of nothing else but the rising water. Ste. Genevieve was fighting for its life.

Fortunately, the townspeople had help. The governor declared Ste. Genevieve a disaster area and sent in the National Guard. Volunteers, seeing the town's plight on television, poured in from all over the country and even several foreign countries. Inmates from a nearby minimum-security prison were brought in, and they, too, gave their all. The Corps of Engineers

Ste. Genevieve during the Great Flood of 1993. BILL NAEGER

came on the scene with advice, technical assistance, and sandbags. The Mississippi Lime Company, which has a large quarry just outside of town, provided tons of "screenings"—tailings from the quarrying—to fill those sandbags. Tower Rock Stone company sent rock from its quarry.

The town became a war zone, building a Maginot Line against a water army of truly awesome size. Night and day, trucks rumbled to the levee carrying crushed rock, sandbags, plastic sheets, even concrete highway barriers. Humvees splashed through a few flooded streets. Military and television helicopters circled overhead. Pumps hummed incessantly, pouring water from inside back out over the levees.

The town was divided into three sections—north, central, and south—bounded by the North and South Gabouri creeks, which dictated the locations of the three main levees, in a scalloped pattern. Each section had a civilian captain and a rotating military chief. Overseeing the whole operation was the county's emergency preparedness director, Mick Schwent, and Levee District 3 president Vernon Bauman. Each day they met at noon with the captains to assess the situation and decide on needed action.

Perhaps no one was more deeply involved in the fight or more essential to its success than Vern Bauman. His roots in the town go back to the 1850s, when his great-great grandfather came to the area with many other Germans. Vern is head of Vern Bauman Contracting, which does excavating and asphalt paving. He knew all about hauling materials and where to get them, with his own trucks and those of other companies. With this experience and that as president of Levee District 3, he was the natural person to direct the levee building needed to save the town.

Each levee section had a sandbag-filling area. Perhaps the largest was the wide parking lot behind the Valle High School—dubbed "Desert Park." "More than a thousand people were filling sandbags," Bauman said, "sometimes around the clock, sometimes with no shade." Many days, the temperature was pushing one hundred. "It was unbelievable how the people worked."

Out on the levees, Guard troops and civilians stacked sandbags in three-deep rows, then placed plastic sheets over them to prevent seepage, all on a foundation of crushed rock. The writer and historian Julie Jenner, working somewhere on a Mississippi levee July 16, described the experience probably common to all: "The heat, the sweat, the grime, the flies and

mosquitoes that hover around you constantly, and the raw, chapped places on your legs where your boots are rubbing, your wet chapped feet, your sunburned face, neck and arms. It's ungodly, and all the while you are fighting against time and the river, trying to hold it back. It keeps seeping in and around and under and over."

Vern Bauman, always wearing his red hard hat, and the section captains and volunteers walked the three miles of levees day and night, looking for any "hot spots" where the river was getting through. It was an unnerving job, with the muddy water rushing by inches below the top of the levee, and a twenty-foot drop on the inside. "I had radio contact at all times with about fourteen mobile units," Vern said. "Code Red was an emergency hot spot."

They were particularly on the lookout for "sand boils," places at the inside base of the levee where the immense pressure of water on the outside had forced water through the sand under the levee and up and out on the inside, carrying sand with it. These had to be immediately ringed with sandbags, creating a column of water whose weight eventually counteracted the pressure from below. Otherwise, sand would move from under the levee and create a void, and the weight of the levee would cause it to sink. Floodwater would then cascade through the opening.

On August 1, a particularly ominous sand boil was spotted at the Valle Spring levee, an earthen dike built earlier to protect agricultural fields and homes and businesses along St. Marys Road at the south end of town. Sandbags were brought in, but it was too late. The boil became a geyser, undermining the levee. A flatbed truck carrying sandbags on top of the levee began to sink into the gap. Vern rushed in with a hydraulic excavator, scooped material from the inside of the levee, and dumped it into the hole. The earth just washed away. Vern had to retreat as the truck fell into the rushing water and was swept through. Not until the water level inside equaled that outside did the torrent stop. Two hundred acres, including several homes and businesses, were flooded.

Crest predictions kept creeping up. On July 7, with predictions of 39 to 40 feet, the city had issued an evacuation order for low-lying areas. By mid-July, the prediction was 47 feet, and by the end of July 49 feet. People were exhausted from months of fighting. But when the final crest came—49.67 feet on August 6—the main levees held. The town could begin to

relax. A few battles had been lost: North Main Street homes were flooded, along with the buildings on St. Marys Road; and on July 23, five inches of rain had fallen, producing flash floods down the Gabouri creeks that overflowed into a few homes. But the war was won. Ste. Genevieve had lived up to its flood-time motto: "We Can Do This!"

Reflecting on all this several years later, Vern Bauman described the effort as "massive." Fighting the river for four months, "we used 110 different trucks, plus forty or fifty military trucks, more than one million sandbags. Around thirty thousand volunteers helped this little town of forty-five hundred, from about thirty-nine states and nine foreign countries.

"Pumps came in from everywhere. We had eighty to a hundred pumps over six inches, and two to three hundred small gasoline pumps one to five inches. For awhile, a truckload a minute dumped crushed limestone around the clock. This was the ultimate strength of the levee, backing the sandbags. Where we gained on the river was pickup trucks bringing sandbags. Sometimes we had thirty pickups doing this. They could bring six to ten thousand bags in three or four hours. The last couple weeks of the battle, this capability saved us.

"We were very lucky. There were no serious injuries. One truck rolled off into the river and turned over, but the driver swam out."

He singled out Betty Seibel, the city clerk, for her steadfast role during the long, trying summer. "She was the motor at City Hall. It seemed that when all things fell apart, she kept her cool. At some time, everyone else hit the panic button."

The town had built its levees so well that when the 1995 flood hit—the second highest in the twentieth century—"we held it back all over. The levee was two years old and had tightened. We had only one-tenth the seepage of '93."

In a sense, the 1993 flood itself helped to save Ste. Genevieve for a longer term. National and international media coverage of the battle (from as far away as China) had called widespread attention to the historic treasures at risk here. The National Trust for Historic Preservation named Ste. Genevieve one of "America's Eleven Most Endangered Historic Places." After the flood, Representative Richard Gephardt was instrumental in securing grants from the National Trust for Historic Preservation and from the state of Missouri to help Ste. Genevieve pay the required 25 percent.

The city also passed a sales tax that supplied part of the needed funds. Once the new sponsor (a joint commission of the city and Levee Districts 2 and 3) signed a cooperative agreement with the Corps of Engineers, the project could begin. Meanwhile, the Corps had been funded to begin the design phase.

The '93 flood prompted more concessions to rivers' use of their floodplains. Even earlier, floodways, such as the one from New Madrid south, had been developed, and some levees had been provided with openings that floodwater could use. After the '93 flood, the federal government bought some farms and allowed them to function as floodplain. Under easements, it paid other farmers to let their land flood during high water. The Federal Emergency Management Association offered to buy whole or parts of towns and move them to higher ground. Many residents of Ste. Genevieve, especially those along North Main Street, took advantage of this program.

Most of the levee systems remained as they had been, with repair as necessary. The new Ste. Genevieve levee would be built in the floodplain about halfway between the town and the river, so the historic resources would be protected from flooding but not adversely impacted by large earthen and concrete structures. Construction began in 1997. Two contractors built the massive gates through which the railroad runs and which can be closed in time of flood. Another relocated U.S. Highway 61 over the levee.

A fourth contractor built the levee itself. It is three and a half miles long, tying into the bluffs north and south of the town. Twenty-five feet high, it is designed to withstand a fifty-three- to fifty-four-foot flood as measured at the Chester gauge—more than three feet above the record '93 flood level. Its crown is sixteen feet wide and the sloping sides are a hundred feet long, now covered with grass.

Clay is often used for levees because its fine particles pack tighter and are more impervious to seepage than coarser materials. The core of the Ste. Genevieve levee is compacted sand, however, with a clay surface on the riverside slope. "A relatively small clay deposit was the only clay we found in the floodplain," project engineer Jim Zerega said. "If you tried to construct the entire levee with clay, you would be borrowing clay from long distances, and it would be much more expensive."

The contractor dredged sand from the river and piped it to the levee. "It was interesting to me that they could deliver piped material to that far south end of the levee," Zerega said. "They had to come underneath the railroad."

Another contractor installed twenty seepage-relief wells. These provide an outlet for water that is forced through the sand under the levee by the weight of floodwater pressing down. These were placed in certain areas of concern, on the "landward" side of the levee and its adjacent seepage berms. Seepage berms, which are grass-covered embankments built with sand and silty materials, lie immediately landward of the levee along most of its length. These cause water being forced upward to flow away from the levee. Monitor wells were sunk into the levee itself. "They tell you what's happening inside the levee. Levees get saturated, too."

A critical structure on the levee is the combined pumping station. This was built at the lowest point on the floodplain, where the creeks from Ste. Genevieve and a gravity drain—after a bit of rerouting—join and flow out to the river. Gates in the gravity drain allow the creek to flow under the levee in normal times. In a flood, the gates are closed to keep river water out of the interior, and three giant submersible electric pumps pump the interior runoff and the underseepage inflow over the gates and into the river.

On August 10, 2002, some seventy-five people gathered at a tent on the levee by the pump station for the dedication of the Ste. Genevieve urban design levee. Many of them had filled or stacked sandbags during the '93 flood. Others had worked for years to get the levee. Still others had constructed it. This was a time of celebration and deep emotion.

The day was hot, and people made liberal use of the water and sodas thoughtfully provided under the tent. The speakers stood out in the sun at a small lectern. Here was placed a photograph, draped in black, of the much-loved former mayor Bill Anderson. He had died just two days earlier, though not before writing his comments to be read at this occasion. Betty Seibel, the city clerk, delivered them. Anderson's message thankfully concluded that "Ste. Genevieve is now ready for another 250 years." Later, a different speaker put it at five hundred years.

Jim Zerega gave a short history of the project and announced that "the total cost will come in well below the 1994 estimate of $46 million." Vern Bauman, when he got to the list of people he wanted to thank,

Participants gather for the levee dedication beside the pump station.
NAPIER SHELTON

became so choked up he could barely finish. Betty Seibel was described as "the backbone of the effort to get flood protection" and was given a special plaque.

The featured speaker, Representative Richard A. Gephardt, was introduced by Mayor Kathleen Waltz as "a gentleman without whom we would not be standing here." Gephardt praised Vern Bauman and the other day-and-night battlers against the '93 flood and described his political fights in Washington to get the levee. He ended with a dramatic flourish: "I promised the people they'd never be flooded again. There aren't going to be any more floods in Ste. Genevieve. The levee will be here forever for the people of Ste. Genevieve and the nation. From space will be seen the Great Wall of China and the levee of Ste. Genevieve."

Everything out there looked so peaceful. Mostly hidden behind trees, the old homes of Ste. Genevieve nestled comfortably along the narrow streets. The levee curved gently northward toward the Ste. Genevieve–Modoc ferry landing. On either side of the levee, corn and soybean fields stretched toward town and river. Beyond the fields, white egrets fished in long, shallow

pools. Across the river, people camped on a wide sandbar. The river itself, now low, flowed quietly along.

Would it sometime breach the new levee? Or would the optimism of engineers and politicians hold true? Perhaps we should give the last word to Vern Bauman, who has known the river as intimately as anyone:

"The Mississippi River is amazing and mighty. It has power beyond belief. The levee may be good for a couple of hundred years, but I think you ultimately lose, no matter what. The river never quits working."

TED SHANKS CONSERVATION AREA

A man may not care for golf and still be human, but the man who does not like to see, hunt, photograph, or otherwise outwit birds or animals is hardly normal.

ALDO LEOPOLD, *A Sand County Almanac*

The sign in headquarters said starting time was 6:24. Exactly at 6:24 a.m., as I was walking along a levee toward a wade-and-shoot unit, I heard two shots, far away. A mallard in a nearby ditch quacked, as if in response.

At Unit 3, I sat in weeds on the side of a levee to see how Mark Lichty and John Lynn were doing. Their decoys floated at the far end of a pond ringed by willows. Mark and John were hidden in cattails. As the sky lightened, I heard a few more distant shots. The sky above Unit 3 remained empty for many minutes; then four mallards flying high came over, circled, and went over the next unit. The hunters there let loose a fusillade that did no harm. The ducks were too high.

Other hunters that chilly late November morning were sitting in blinds in the swampy southern part of the Ted Shanks Conservation Area, amid sloughs, dense buttonbush thickets, and scattered dead trees. They, like the men in the wade-and-shoot units, would have slim pickings. Mark and John fired only a couple of shots that morning, and they missed.

Most of the eight thousand or so ducks on the Ted Shanks were in the refuge section impoundments, at the north end, where hunting is not allowed, and they pretty much stayed there all day, feeding on seeds in the marshes. Their numbers were far below the twenty-five to forty thousand that are here on many November days, most years. No one was quite sure where all the ducks were. Had most overflown northern Missouri, or were they still farther north? Drought in the prairie provinces had reduced

many species of ducks, but mallards, the most numerous kind in the Mississippi Flyway, were down only a little from the previous year.

A birdwatcher like me, however, could have good hunting that day. On the refuge impoundments, mallards and green-winged teal just moved out from the edges as I drove by. With binoculars I picked out a few different ones: shovelers, gadwalls, pintails, wigeons, and male hooded mergansers with their strikingly black-and-white, bushy crests. Two adult bald eagles sat side by side in a willow tree like a comfortable old married couple, which they probably were.

In the wide ditch that parallels the railroad tracks on the west side, I saw something dive. I backed up for a better view and saw the head of an otter, with a fish in its mouth. Another head popped up beside it. As I drove slowly along, the otters paralleled me, diving and rising simultaneously, like synchronized swimmers, always staring straight at me. Then two more slipped into the water from the far bank, and later, two more. My last view was of all the otters in a big bank hole, their six heads all pointed at me inquisitively. Then they disappeared into the burrow.

The 6,705-acre Ted Shanks Conservation Area lies in a floodplain on the west side of the Mississippi River between Hannibal and the town of Louisiana. The wooded Lincoln Hills flank it on the west edge. Levees along the Mississippi and the Salt River, which enters the Mississippi at the south end of the Shanks, keep out all but the highest floods. Trees fringe the river sides of the levees.

Like all of Missouri's numerous conservation areas, this one is open to many uses, among them hunting, fishing, trapping, frog gigging, birdwatching, and photography. Of the fifty thousand or so visitors each year, many are just driving around to see the wildlife. A small staff is in charge of doing the things—especially water management—involved in keeping the Shanks a prime place for enjoying all these activities.

Mark Lichty, from Hannibal, is a regular at Shanks, duck hunting in fall and winter, watching eagles, practicing turkey-calling in spring (though he hunts them elsewhere), frog gigging in summer. Quail hunting is his favorite sport. He hunted quail at Shanks a few times but quit as the population went down, a mysterious and unfortunate phenomenon throughout much of the eastern United States. "Duck hunting was something I did when the weather was too bad to hunt quail." But it, too, has its pull for

The Lincoln Hills flank the Ted Shanks Conservation Area. NAPIER SHELTON

Mark. "You feel silly out there in the cold and dark when you could be home warm in bed, but when the sun comes up and the birds begin flying it's the most glorious feeling in the world."

He started duck hunting at Shanks in the wade-and-shoot Nose Slough Unit, which was much more wooded then, but he found it too crowded and moved to other, marshy, wade-and-shoot units. He preferred this kind of hunting because you could move around, but "if I got a bad number"—in the daily early-morning drawing that dictates hunters' choices of shooting areas—"I had to take a blind and paddle a boat [supplied by the staff] three miles down the main ditch" to his assigned blind. "Eventually, I bought a boat and a small motor."

Duck hunting has its uncomfortable, and sometimes dangerous, moments, and Mark had one around 1983, in early December. "Three of us were coming back with four or five ducks in my fourteen-foot johnboat, with my small new outboard motor. There was ice at the edge of the water." Mark, short and slender, was sitting in back. "Terry, a big guy, was sitting in the bow trying to untangle decoy strings. Gordon, also a big guy, went forward to help him. Their weight tipped the boat forward. It filled with water and turned over. I yelled 'get the guns,' which were in cases. Terry

The main, three-mile ditch leading to duck blinds. NAPIER SHELTON

rolled over on his back in the water, holding the guns, but he lost them," and they sank to the bottom of the eight-foot-deep ditch. "His waders filled with water but he made it to shore. Gordon, who couldn't swim, grabbed the floating decoys and floundered ashore.

"I climbed on top of the overturned boat. I was very cold, but I decided I had to swim to shore, too. It took every ounce of my strength. We sat there looking like drowned rats and started laughing hysterically, from relief, I guess. My propeller was sticking straight up, stuff was floating, including our ducks. We got the heater going in the truck"—which was parked beside the ditch—"and warmed up."

The next problem was what to do about the shotguns. Mark's was a Remington 1100, a Christmas present from his father. Gordon's was a Remington 1100 he'd just bought to hunt ducks. Terry's was a bolt-action Mossberg he'd bought for forty dollars at a garage sale. "We got in a Conservation Department boat and pushed out to where we'd upset. Gordon poked around with a paddle where we'd lost the guns and felt something. I dove under, felt it, and brought it up. It was the forty-dollar Mossberg. I got back in the truck and warmed up. Terry dove in and pulled up another gun— mine. Then he felt something else with the paddle. We flipped to see who would have to go down a second time and I lost. I found it was just a stick.

We're done. Back in the truck to keep from freezing. Later, Gordon returned and managed to snag his gun and bring it up."

After this incident, it was mostly back to the wade-and-shoot units.

Before the flood in the summer of 1993, which inundated the Shanks Conservation Area from July through September, eventually killing many trees, there was a much larger area of pin and other oaks than exists now. During the dormant season, these could be purposely flooded without damage, attracting thousands of mallards, along with wood ducks, which came in to feed on the small acorns. This is the favorite kind of duck hunting for Russell Smith, a resource assistant at Shanks. "There's duck hunting," he says, "and there is duck hunting in flooded timber. It's at close quarters. You call, splash water with your feet. That makes ducks think there's ducks down there messing around. The birds commit when they come down—no changing their mind. Duck wings slapping against branches, acorns falling around you. The ducks may land five feet away."

This kind of hunting virtually ceased in the years following the '93 flood. By 1995 or 1996, most of the stressed oaks had died, leaving a mournful landscape of gray snags. Many of these burned in wildfires, and some, around Horseshoe Lake, were burned in prescribed fires to lessen the possibility of a hot fire and its impact on young trees, as well as the danger of falling trees to fishermen and campers. When this source of acorns disappeared, fall and winter duck numbers, which had reached a hundred thousand in 1979 and averaged over forty thousand up to 1992, dropped further. Some hunters now think of the years before 1993 as the golden age at Shanks, but overall success rates haven't actually changed much; there have been fewer hunters since the mid-1980s.

To restore some of this resource, the staff has planted 10,500 trees on three hundred acres in the central part of the conservation area. Now these pin, bur, and swamp white oaks and sycamores look like big orchards, the trees in rows on the black gumbo soil. Probably in time the forest will look more natural, as other trees, like cottonwood and silver maple, come in on their own, and seeds of the planted trees sprout between the rows. Flooding during the dormant season, from about mid-October to mid-March, controlled by two pumping stations along the Mississippi, will be conducted to mimic the natural seven-year flooding regime: one year of full flood, one year dry, and five at intermediate levels.

Another ecological misfortune caused by the '93 flood was an invasion

of reed canary grass, an exotic (nonnative) species used for erosion control on levees before its invasive character was known. It was in full seed at the time of flooding, and the water carried the seeds here and probably upstream all over the conservation area. When the flooding ended, the seeds settled down on the many bare, muddy areas and a mat of canary grass sprang up. It's so dense that acorns and other tree seeds don't reach mineral soil or are shaded out if they succeed in sprouting.

In open areas, canary grass can be plowed and disked, and then flooded for a year, which kills the massive root systems—but this can't be done in wooded areas. Fire doesn't kill it, and using herbicides would kill other plants, too. Visitors may see a carpet of canary grass under the trees at Shanks for many years.

■ ■ ■

Every Monday during the waterfowl season, the staff makes a duck count. On Monday, November 25, 2002, I rode in a pickup with Keith Jackson, the manager, and John Poppe, a wildlife technician, as they tallied ducks. Bumping along a levee, John honked the horn madly to scare the ducks up out of the marshes so they could be counted. (Or rather estimated—you can't actually count when there's a blizzard of birds in the air.) The men jumped out and yelled, sending up the laggards. What a spectacle! In these days of diminished wildlife, it's a thrill to see such multitudes. The ducks usually come back to the same impoundment, so there's no problem about counting them again elsewhere. We circled all the impoundments where ducks were concentrated and got an estimate of 10,720. That's a lot of ducks, but well below normal for that period.

I asked Keith where they roost at night. He said on the open water, or in the marshes if they need protection from wind. The ducks have a daily routine. Though some feed all day, many are done feeding by midmorning, Russell Smith said, "then they nap and snooze out of the wind." The wooded swamps at the south end "are good for loafing. There's lots of shrubs that give protection from wind. Once in awhile they may fly up just to stretch their wings, then settle back down."

In cold weather, ducks need more carbohydrates for energy and will fly to the fields of corn and milo scattered about the Shanks or to nearby

farms. Some species, such as gadwall, teal, and wigeon, graze on winter wheat. These crops are planted at Shanks by a local farmer with a permit who has agreed to leave part of the food for wildlife.

Eagles are included in the Monday counts. The day I went along, Keith and John spotted just one bald eagle, roosting on the wooded hillside, but I think five or six were in the area. In the fall and winter they move down the Mississippi as ice closes the upper reaches, following the open water, where they can catch fish and infirm ducks. At Shanks, Keith said, they get thirty to fifty eagles by wintertime, and in the spring up to sixty.

Wintering eagles have become a big attraction in Missouri at places such as Squaw Creek and Mingo national wildlife refuges, various state wildlife areas including the Ted Shanks Conservation Area, and along the Mississippi. Many such spots, such as Clarksville, downstream from Louisiana, have Eagle Days, weekend events where the public is specially encouraged to view eagles and attend programs about them. These are popular occasions and sometimes draw several thousand participants.

■ ■ ■ ■

While the duck hunters are out popping at their elusive quarry, a smaller cadre of bowhunters is silently stalking deer on the Shanks (where there is no gun season for deer). Two of the most devoted are Dan Simmons and Joe Marshall. During the season—early October to mid-January—they keep campers in the parking lot near headquarters. Dan, an "internal investigator" for Monsanto, comes up from St. Louis when he can get off from work. Joe, who is retired, stays at Shanks through the entire season, going home to O'Fallon occasionally to see his wife and take a shower. "My wife gets a little annoyed about my hunting sometimes," he said, "but I think she's used to it."

I was introduced to Dan one morning at headquarters. He's a big man, fifty-six years old; with several days' grizzled beard, dressed in camouflage, he had just come in from hunting. We sat down at the observation window looking out at a marsh. "I've been bowhunting here for twenty years," he said. "If the good Lord is willing, I've got another twenty years up here."

Dan started bowhunting "when I got tired of rifle hunting. That's like

licensed murder. Doesn't take a whole lot of skill." Since then, he's hunted about all the western states, Mexico, and Bosnia, where he hunted wild boar. Besides deer and wild boar, he's bowhunted elk, feral hogs, rabbits, quail, and ducks. "Bowhunting ducks is a hoot, but you lose a lot of arrows. I wanted to hunt ibex in Yugoslavia—that's the best place—but right now they're not keen on Americans."

He uses a recurved bow without sights. Using a compound bow, "with wheels and pulleys, cables, and sights," he says, "is like homicide." He makes his own arrows, from hickory dowels.

Dan's hunting method is to "drive around and find an area where no one's hunting. I know several good spots. I hunt the timber, weeds, food sources, 'bottlenecks'"—places where deer pass through. "Most people up here hunt from tree stands. I do that sometimes, but it cuts down on the rush you get. On the ground at ten yards—that's a lot of deer, a lot of fun.

"On the ground, I sit on my bucket or walk around. But on a calm day they can hear me. I'm not the quietest man in the woods. Getting close to deer is a challenge. I have to make sure I have the wind in my face. The wind up here is a very fickle lady. This morning it was northwest, southwest, then northeast. On windy days I move more—they can't hear me as well. But deer are skittish then—hyperalert."

Once, not hunting, he got so close to a doe that he "smacked her on the butt. She made it plain she didn't like that. Reared up on her hind legs. It was time for me to vacate the area. You think slapping a woman on the butt in a bar is bad, you ought to try this."

Dan usually begins coming to Shanks in November, and for that month he hunts bucks. "There are some monster bucks in here," he said, "but they're few and far between. They're too smart. Most of the bucks are six to eight points." That year he had taken a small buck and passed up ten other deer. After he's done his buck hunting, "it's however I feel when they walk by."

Since Shanks is part of a special unit, it's possible to take seven deer on an archery tag: two "any deer" and up to five antlerless with the proper permits. Dan doesn't go for the limit. When he kills a deer, he has to take it home that day or the next for processing, which he does himself. "I love to hunt, but I don't like taking care of the animal once I've killed it."

Like most outdoorsmen, he also enjoys just watching wildlife. He car-

ries a small "box" camera with a zoom lens in his pocket and has gotten shots of many deer, river otter, beaver, eagles, coyotes, ducks, and wild turkey. He likes to bring his grandkids here to see the eagles. Sitting still, in camouflage with only his eyes showing, he has had hawks, owls, and eagles swoop at him, not realizing he's a human. "Have you seen how big an eagle's talons are?" he asks.

He knows pretty well where the deer will be, "but I tell my wife before hunting season I've got to come up here scouting. My wife should be canonized. Yesterday was her birthday. Our wedding anniversary is January 10, but the deer season doesn't end until January 15. She's very understanding."

A few days after I met him, Dan had to go to Taiwan on business, but Joe Marshall wouldn't go home until near Thanksgiving, and then probably briefly. Joe, in his sixties, had taken two does since early October and was still hunting every day. When I went to his camper to talk to him, he was shooting at a bag with a long bow. He had been using a recurved bow, but somebody had recommended the long bow. He wasn't sure if he'd like it. "The long bow gets in the way of branches," he said, "and it's not as powerful as the recurved bow."

Bowhunters Joe Marshall (left) and Dan Simmons. NAPIER SHELTON

Joe hunts from a tree stand; he says he has better luck that way—he can see better. He has four tree stands that he moves around. He can choose according to the wind direction. But as the season progresses, he says, the deer figure out where the shooting has been coming from, looking up in the trees "like a damn birdwatcher." The deer will then avoid such a place.

The last time I saw Joe was the Sunday before Thanksgiving. A dressed six-point buck lay in the back of his pickup truck. He was pleased, because he had killed the deer just a few hours before he had to go home. Joe held the buck's head up as I took a picture. Absently, he fondled its ear. This little stroke seemed to speak of the predawn trek to the stand; the waiting and watching; the excitement as the buck approached; the sure shot. The deer is his. It will become part of his body. Joe said there was a 70 percent chance of snow that day. "You can see them deer real good in the snow," he said. I got the impression he was sorry he couldn't stay and hunt in the snow.

Before leaving the Ted Shanks early that December, I drove down to Horseshoe Lake. On the way I watched a coyote in a field probing for something with its muzzle. From Horseshoe Lake I walked west along the Salt River levee, where cottonwoods and silver maples rise tall from the rich floodplain. Woods birds—woodpeckers, chickadees, and others—abounded, as did cardinals and a variety of sparrows in the thickets. It was a mild day, still coaxing out a few butterflies.

Fox squirrels ran at first sight of me, but a curious doe just stood and watched as I walked by. When I returned, she was still there. I stopped and she cautiously came closer, inspecting me. Even at ten yards, and downwind from me, she didn't get alarmed. She only walked slowly away when I raised my arms and yelled. She appeared healthy, but I concluded she was not very smart. I said a little prayer that a bowhunter would not enter her area. She would not have a sporting chance.

■ ■ ■ ■

Trapping season on the Shanks begins at Christmas (late November elsewhere), after the duck season ends, runs until mid-February, and to the end of March for beaver. This is the peak of the outdoor year for Brian Cunningham, who traps on the conservation area and other places with his wife, Rosa.

The Cunninghams' small, basic house sits on a hill surrounded by out-buildings, various vehicles, and two outboard motorboats. The day I visited, four deer heads lay on some boards. Inside, five guns stood on a shelf, leaning against the wall, along with several pelts. The house appeared to be mainly a storage area for outdoor gear, with a little space left over for eating and sleeping.

Brian is short and stocky, Rosa lean and wiry, with a coiled spring look. As the surroundings strongly suggest, theirs is a total outdoor life. They hunt and fish as well as trap. They make most of their living, however, from building and selling live traps and trapping supplies.

Brian has a permit to trap in the swampy southern part of the Ted Shanks Conservation Area. He and Rosa put their boat in Horseshoe Lake and set traps along its shores, underwater, as required, to reduce the danger of people on foot or dogs getting caught. Then they cross over to the three-mile ditch and set along this and fingers of water running out from the ditch. "Sometimes," Brian said, "we'll walk one-quarter to one-half mile farther up these fingers when the water gets too shallow for the boat."

For beaver and otter, they set Conibear 330 traps at the underwater mouths of beaver dens. The animal gets caught and is instantly killed when it springs a trigger wire going into or out of the den. Brian demonstrated, casually springing one of these traps as he held it in his hand.

Brian increased my already substantial respect for the otter's prowess. With their speed—up to six miles per hour or more—"they can rise up and catch a duck on the surface before it flies. Besides their principal prey of crayfish and fish, they catch rabbits, birds, muskrats—almost any animal smaller than themselves.

"The otter is the toughest animal we have in the state of Missouri," Brian said. "One time I was taking an otter out of a foot-hold trap. It had been accidentally caught before otters were legal. He wasn't any too happy with me and tore off my two-hundred-dollar pair of waders."

Muskrat trapping, Brian explained, is like a smaller version of beaver trapping: set a Conibear 110 at the mouth of a muskrat hole, underwater. For raccoons, he uses a "pocket set": He digs a hole in a bank underwater and places a one-and-a-half-coil spring trap baited with fish parts or "sweet bait" in the hole. The few 'possums they catch usually are caught in this raccoon set.

All this is very hard work. Brian and Rosa often start out at 6 a.m., before dawn, and finish around 6 p.m., after dark. They set two to four hundred traps, and they must check them every day. When the water freezes on the Ted Shanks Conservation Area, they may continue trapping there by walking on the ice, or they can move over to the Mississippi River islands.

They make very little money from all this work. During the four-month 2001–2002 season, trapping at the Shanks and other areas, their many pelts brought in only $2,345. "I am serious as a heart attack," Brian said. "You can't make any money from trapping. It's less than 5 percent of our yearly income. You have to replace traps, and a Conibear 330 is eighteen dollars. We'll use twelve gallons of gas a day in the boat."

So why do they do it? One reason they can afford to spend so much time trapping is that their business of selling live traps is going well. Another is that their hunting, fishing, and trapping supplies food. "We ate over one hundred squirrels this year," Brian said. They eat muskrats and young beavers, too, plus a lot of deer meat. "Ninety percent of our meat comes out of the woods."

There is also the excitement and mystery, as in fishing, of not knowing what you're going to catch. "It's like a treasure hunt," Brian said. The challenge of outwitting animals is also a part of it. "You have to do a lot of planning, and think what an animal is going to do tomorrow."

But at bottom it seems to be an almost spiritual thing for Brian Cunningham, part of his identity. "My grandfather started me trapping when I was seven and a half or eight years old, and he taught me everything I know. It's my way of life. I'll give up deer hunting or squirrel hunting before I'll give up trapping. I'll never give it up."

■ ■ ■ ■

In winter you see many red-tailed hawks on the Ted Shanks Conservation Area, hunting mice, rabbits, and other small animals. They do a lot of sitting in trees, watching for prey. Carl Barbee, a falconer, has a permit to catch two red-tails a year, but they must be young of the year, so as not to remove adults from the breeding population. You can recognize young ones by their brown rather than red tail.

Carl's method is to "drive around the Shanks, and when I see a young red-tail, I drop the trap out the opposite side of my car so the hawk won't

associate it with a human. Then I drive on. I use a BC trap, which is round with nylon nooses around it. I usually put a live mouse or gerbil in the trap, which runs around and attracts hawks." (Rats just curl up in the corner, he said.) "When a hawk tries to get the bait animal, its foot gets tangled in a noose, and when it tries to pull away, the noose tightens."

The hawk is bonded to the falconer by close, careful association and the reward of food. It hunts by instinct. "At Shanks," Carl said, "I've hunted rabbits with my red-tails in the south end. Usually I let the hawk fly up into a tree, where it can have a good view while I try to scare up a rabbit. Sometimes I take my beagle to find rabbits for the hawk. The hawk can't see rabbits as well from your fist, but it's exciting to hunt that way. You're closer to the action. My red-tails would catch around one out of every four rabbits flushed."

Carl, a Hannibal resident, came late to falconry—at forty-nine. "Bill Simpson, one of the first falconers in Missouri, got me interested. I passed a written test and served a two-year apprenticeship under Simpson to get my state and federal licenses." When I talked to Carl, in 2002, he said he was eligible to become a master falconer, which would allow him to take three hawks a year for training. But he was in his late fifties, was overweight, and was recovering from back and heart surgery. He didn't know if he could continue his physically demanding sport.

Many migrating hawks follow the Mississippi River, using updrafts from the flanking hills to help them along. Carl has trapped, banded, and released some of these at the Ted Shanks, as part of the effort to learn more about hawk travels and longevity.

■ ■ ■ ■

Birdwatchers, too, enjoy seeing these flights, but by the time of the Christmas bird counts, they're essentially over. Then, whatever hawks and other birds are still around have settled down for the winter. Ken Vail, a salesman for the veterinary medicine company Ivesco, lived in Quincy, Illinois, and ran Christmas bird counts there and at the Ted Shanks. The Quincy count has been going since 1903—it was one of the earliest established after the first Christmas bird counts were conducted across the country in 1900. The Shanks count began about 1991.

Ken took it over in the mid-1990s. The count circle is fifteen miles in

diameter, comprising 177 square miles, but the Ted Shanks Conservation Area has the largest chunk of good bird habitat, so the counters, usually in three or four parties, spend most of the morning there. It all begins before 6 a.m., when they gather at headquarters to receive keys to levee gates and plan the day.

It can be cold and windy out there on the levees around Christmas. The 2001 count was held in temperatures between nine and eighteen degrees. "Not much walking on the levees that day," Ken recalled, "mostly driving." He recorded bird numbers on a minicassette. "I don't like to write when my hands are cold." He could study far-off birds from the comfort of his car with a window-mount telescope.

One of his cherished sightings was two short-eared owls that flushed from weeds along a levee, bounding away in their easy, floating flight. Another was the hundreds of robins he saw one year that were feeding on sumac along the railroad tracks at the north end of the Shanks. Large numbers of eagles, and of ducks when there's open water, compensate for the chilly conditions.

■ ■ ■ ■

In spring, life at the Ted Shanks bursts forth in response to warmth acting on the water, air, and rich soils. When I arrived one April 30, it seemed that a great blue heron was always in the air somewhere, and the calling of Canada geese, which nest here, was continuous. Red-winged blackbirds were everywhere. Two red-eared sliders and a small water snake crawled across the road in front of me. A big fat water snake lay coiled in a bush over the water, and a black rat snake reclined on a tree limb. Turtles covered logs; frogs called. Spawning carp splashed noisily. White blossoms of hawthorns dotted the wooded areas. I saw ducks that nest here (mallard, blue-winged teal, wood duck, hooded merganser) and a couple still on migration (ring-necked duck and shoveler). Stately white great egrets fished in the impoundments. At the Salt River landing, I asked two fishermen launching their boat what they were after. "We're after big flatheads, that's what we're after," one said enthusiastically.

Earlier in the spring, along with many thousands of ducks, snow geese briefly drop in, sometimes two or three thousand at a time, then move on.

Earlier still, in late winter, eagles nest. There have been one or two pairs since about 1994, and they have successfully raised young every year since 1995. A new phenomenon is the late spring and summer presence of migrating white pelicans. "They didn't come before 1993," Keith Jackson said. "Now they show up every year. In 2000 we had two or three thousand pelicans. They covered the island [in the Mississippi] like snow." Bird-watchers also come to Shanks to see least bitterns and king rails; this is one of the few places in Missouri where these scarce birds are known to breed.

■ ■ ■ ■

Mark Lichty used to fish for bass, crappie, bluegills, and catfish at Horse-shoe Lake, but now his summer sport at Shanks is gigging bullfrogs and green frogs, done at night with a three-to-five-pronged spear. "I drive around and listen for frogs calling to spot concentrations. Then I go in hip boots with a flashlight. There's a certain amount of challenge—it's not easy. The ideal time is when the water has receded and you can see the frogs on bare banks. If the water is higher, it's hard because the frogs are in vegetation." He says frogs are delicious, the wild ones more so than the imported ones from the grocery store.

In September, Mark switches to teal hunting. "It can be warm then," he says, "with lots of mosquitoes." He prefers to hunt mallards, but they're not legal until October. "They're bigger and exquisitely beautiful. They seem to fit more into the art and science of duck hunting. They work around before coming into the decoys. Teal either just drop in or fly by, fast. They don't respond to decoys as well as mallards."

With the cooling days of October, Mark and other regulars, like Dan Simmons and Joe Marshall, can return to the hunting they love best at the Ted Shanks Conservation Area.

Historically, the conservation area was all timbered except for a three-to-four-hundred-acre wet prairie around Perry Lake. During the 1930s and 1940s, the U.S. Army Corps of Engineers built the present system of locks and dams on the upper Mississippi, which flooded some of the adjacent land, creating in essence a series of lakes. The Corps bought over twenty-eight hundred acres in the southern section of the present conservation area in anticipation that it would be affected by Lock and Dam 23,

but this was never built. So in 1954 the Corps, continuing to own it, made this land available to the U.S. Fish and Wildlife Service for wildlife management. That same year, the USFWS signed a cooperative agreement with the Missouri Department of Conservation to use the land for wildlife management. The MDC bought the rest of the Shanks area in 1970 and 1971, developed it in 1977, and officially opened it for public use in 1978. Some of the northern part of the Shanks had become farmland, and here the MDC built impoundments where the water levels could be manipulated, to benefit waterfowl, shorebirds, and other wildlife.

Keith Jackson, a brisk, friendly man in his forties, worked at Shanks as a temporary laborer in 1981, began working full-time for the MDC in 1984 and became manager of Shanks in 1996. He makes the major decisions; chief among these are the water levels to be maintained in each subunit, week to week, and how the vegetation in each subunit should be managed. Water is brought in at the two pump stations from the Mississippi from about September 1 through November to the marshy impoundments, for waterfowl, and pumped out from mid-March through May, to produce shallow water and mudflats for shorebirds and plant growth.

As we saw at Mingo National Wildlife Refuge, the vegetation goes through a succession. The best plants for waterfowl, such as smartweed, wild millet, and beggar-ticks, give way to woody plants over time, and the succession must then be set back by cutting, plowing, and flooding.

What Keith can't control is the mighty Mississippi. Every year, it rises over its banks and occasionally, as in 1973, 1993, and 2001, overtops the levees and floods the whole conservation area. Aerial photos show the headquarters building during one of those floods; it was turned into a small island by a ring of sandbags. The '93 flood, as we've seen, led to the death of many mast-producing oaks and the invasion of reed canary grass.

Now a further concern is the water table, which lies at about the level of the river's surface. Since the 1930s, when construction of the lock-and-dam system began, the average stage of the river during the growing season has increased seven feet. Crops planted on the conservation area sometimes die from root rot in the saturated soil, and any further rise in the subsurface water level would threaten much of the remaining forest and the planted trees. To improve the shipping channel in the river, deepening the channel from its present nine feet to twelve feet has been discussed. If this

were done by dredging, Keith says, it probably wouldn't affect the water table, but if it were done wholly or partly by raising the water level of the river, it will raise the water table, to the detriment of the conservation area.

The Ted Shanks Conservation Area, established in 1978, is one of the MDC's later acquisitions in its long history of obtaining land for public use. The DuPont Reservation Conservation Area, adjoining the Shanks upstream and donated by the DuPont Chemical Company in 1938, is one of the first. The thirty-six-square-mile Peck Ranch, in the southeastern Ozarks, was acquired in 1945 and became the focus of deer and turkey restoration efforts. Among the major waterfowl areas, Otter Slough (then called Bradyville), in the Bootheel, entered the system in 1944; Fountain Grove, in north-central Missouri, in 1947; Duck Creek, next to Mingo National Wildlife Refuge, in 1951; Schell-Osage, near Nevada, in 1958; and Four Rivers, just west of Schell-Osage, in 1982.

The Ted Shanks Conservation Area is named for Charles R. ("Ted") Shanks, who became the head of the conservation department's Game Section in the late 1950s. He died of a heart attack on March 16, 1968, and was buried at the Fountain Grove Conservation Area. The love he bore for waterfowl and other wildlife lives on among all those who enjoy his namesake area today.

CORN, CATTLE, AND QUAIL

Game is a phenomenon of *edges*. . . . The quail hunter follows
the common *edge* between the brushy draw and the weedy corn.

ALDO LEOPOLD, *Game Management,* 1933

Dave Mackey has a farm that is both profitable and wildlife-friendly, a rare combination in these days of fence-to-fence, big-field agriculture. It lies in Knox County, east of Kirksville, where crops, hay, and pasture occupy former prairie on the uplands, and woods and brush cover the drainages leading to branches of the Fabius River.

I met Dave through Joel Vance, a friend who comes to the farm to search for morels and to hunt. Dave is a short, sturdy man with a balding head and a sense of humor that is always near the surface, ready to rise, with a laugh, at the slightest provocation.

He came to Knox County in 1972, after an early life in northwest Missouri. Born in 1945, Mackey grew up in Bethany. "Technically, I'm a small-town boy," but he got interested in farming. "It was a magnet—just sort of happened. When I started into high school, I got some what we called 'bucket calves' and raised them as my FFA project. That's what put me through college."

That college was Northwest Missouri State University, in Maryville, where he majored in animal science and minored in plant biology. After graduation, Dave took a job with the U.S. Department of Agriculture's Soil Conservation Service (later renamed the Natural Resources Conservation Service) in Maysville, then, two years later, became the district conservationist at Grant City. "I was the youngest one in the state to go into that management position." After four years at Grant City, he moved across the state to a similar job at Edina, covering Knox and Scotland counties. Here he supervised a wide range of conservation projects, from terracing

and promotion of no-till farming and of grazing practices that reduce soil erosion, to forest-stand and wildlife-habitat improvement.

"We tried to get all the land uses on a farm under some kind of management, including wildlife, because almost every farm here has some kind of area that could be considered wildlife land. We tried to get a whole package deal. If you get the livestock out of the timber, then do the timber stand improvement, that helps wildlife, too. One thing feeds on another."

Much of the wildlife work was for absentee owners, people who lived in places like St. Louis and bought land up here on which to hunt. A group from Georgia had leased three thousand acres in Knox County. They wanted trophy deer, which northern Missouri, because of its rich croplands interspersed with woods, produces much better than do the pinelands of Georgia.

Back around 1980, the Missouri Department of Conservation was persuaded to put wildlife people working with private landowners in USDA offices, using Knox County as a pilot. Now, almost every county in Missouri has such an arrangement. Perhaps partly because the Knox County pilot program was such a success, Dave Mackey received the Missouri District Conservationist of the Year award in 1981.

He was doing so well that offers to move up to higher-paying jobs kept coming along. But these would require moving to a more urban environment, and he and his wife decided they wanted to stay where they were and raise their four children in a rural environment. To compensate for the higher income they had turned down, Dave started buying land around 1984. At the same time, his administrative duties kept expanding. "When I first started, I'd say 90 percent of my time was in the field working elbow to elbow with farmers and about 10 percent doing the paperwork and administrative things. And that just reversed. That's not me." So on April 17, 2000, after thirty-three years with the USDA, he retired. He was still only fifty-five.

By this time, Dave had the five hundred acres of farmland he wanted. The property was knowledgeably chosen. He knew virtually every farm and farmer in Knox County and had the county soil survey and air photos in his office. He wanted each piece of land to be suitable for crops, pasture, and wildlife, so he would not be committed to just one kind of activity on it, and so he would not have to pay the high prices for pure cropland.

With his background, he had a good idea what any piece of land was worth. "Vacant land is only worth what it will produce," he said, "unless it's in downtown Dallas. The first tract I bought, I saw a 'For Sale' sign on it and checked the soil survey to see what kind of land it was and what I should offer for it. The owner quoted me exactly that price, and I bought it after fifteen minutes' discussion. I bought the second piece at the local bowling alley, in ten minutes."

Mackey's Chigger Ridge Farms now consist of four properties, plus a sixty-acre tract with a ten-acre pond on it that he bought more recently with Doug Rainey, an MDC wildlife biologist at the USDA office. (He also leases another hundred acres, primarily woodland, for hunting.) His land is about one-third in crops, one-third in hay and pasture, and one-third in woods. It thus had great potential for producing wildlife as well as income, and Dave, an avid hunter and fisherman, set out right away to realize that potential.

On my first visit, in early May, he showed me some of the things he was doing to benefit wildlife. Along a bare fence line he shares with a Mennonite neighbor, he'd planted Osage oranges. "I'm probably the only person in the county doing this," he said with a smile. "Most people are cutting them down." Paralleling the "hedge," he'd planted shoots of gray dogwood, hazelnut, and wild plum. "It'll have dense cover eventually."

As we walked farther along the track, he pointed out part of a field that was in the Conservation Reserve Program (CRP), planted to grasses, clover, and other vegetation for wildlife. We saw turkey droppings in the track. "Female is straight, male is curved," he explained—to me an amazing piece of wildlife lore. In a wet place, he found a turkey egg that had been carried from the nest. He cut it open to see how fresh it was. Very fresh—just yolk. We crossed a wooded gully that was eroding. "I'm going to stop this by building a dam," he said. "I don't want sediment running down to the Fabius River." All along the field edge was a strip of grass, clover, and blackberries about twenty feet wide, merging into a fence line with brush and trees.

In a far corner, he had planted winter wheat as a food plot for wildlife, and next to it he'd killed the vegetation with Roundup so his Mennonite neighbor could plant alfalfa there—good wildlife food and cover: "This is ice cream and cake for deer." Nearby, branches from an Osage orange bor-

Dave Mackey at a pond he built to stop erosion. NAPIER SHELTON

der had been cut and piled. "That will make nice weedy brush piles." Always alert for interesting natural things, Dave found two morels along the edge, near a dead elm with loose bark. His theory is that morel spores lodge under the bark and fall to the ground with the bark—which seems a logical deduction. (Mycologists say that morels are symbiotic on the roots of elm and because of stress when the elm dies, produce more spores.) Dave had killed the elms because "they have no wildlife value and would shade out these valuable pin oaks."

Back in the woods, he showed me openings where he had dropped trees, made brush piles, and added salt licks for deer. The licks looked well used. Near one was a deer stand. "Sometimes I come without a gun and just sit up there," he said, "enjoying nature."

Affirming Dave's efforts on behalf of wildlife, a tom turkey went running off through one field and a tom and hen through another. Chuckling, he said, "wildlife comes from neighboring farms to feed on mine because the others have inadequate food."

Dave now has eight ponds on his land, all stocked with fish—bluegills, crappies, largemouth bass, and channel catfish. There are state limits on the *number* of fish you can take from your own ponds, but no size limits. He

has instituted his own size limits, however—keep crappie *less* than twelve
inches and bass *less* than fifteen inches—to achieve the proportions of species
he wants.

Even the farming is done with wildlife in mind, while also protecting
against soil erosion. Kenny Jansen has been renting Dave's cropland for
close to twenty years, at sixty to seventy-five dollars per acre. (Mackey, the
canny Scot, figured someone else should buy the expensive machinery and
do the work. The rent paid for the cost of one piece of land in five years.)
He requires no-till farming and leaving a little of the crop standing, along
with waste grain. "We don't turn cattle on it. Kenny is a player in the
wildlife game." Most of the cropland has a slope of no more than 3 per-
cent, but one area with an 8 percent slope has been farmed with no ero-
sion, Dave said.

Kenny alternates corn and soybeans in the deep, silty clay-loam soil, fer-
tilizing in March with phosphorous, potash, and anhydrous ammonia (to
produce nitrogen) for corn—enough phosphorous and potash to carry over
to soybeans the next year. The soybeans provide their own nitrogen. "We
put on just what we *know* we need, so there's no runoff." Both the corn
and soybean seeds are "Roundup Ready," genetically altered so the herbi-
cide Roundup can be applied without killing the crops. To protect birds
and reduce costs, no insecticide is used. "Crop rotation does away with
most insect problems," Dave says.

Dave's grandfather used to say, "When the Osage orange leaves are the
size of a squirrel's ear, it's time to plant corn." This usually happens in early
May. At the time of my visit the next year—late June—Kenny's corn was
barely a foot high and his soybeans were just sprouting. The spring had
been very wet, delaying planting.

And Dave was a bit behind in his cattle work because of two weeks in
and out of the hospital with kidney stones. His fifty cows—Angus,
Hereford, Limousin, and others—were grazing in belly-high grass. "I ro-
tate the grazing," he said, "so the grass doesn't get less than three to five
inches high." Much of his hay and pasture land was in fescue when he
bought it. Because of its density, fescue is a decidedly wildlife-unfriendly
species, and he was converting this to orchard grass, timothy, and legumes
like red and white clover and bird's-foot trefoil. "I've tried to convert some
areas to prairie grasses, burning them and not grazing, but I haven't found

a good way to replace fescue with these warm-season grasses. And it's expensive." (Perhaps he will have to try spraying with herbicides, as we've seen at Prairie State Park and will see at Dunn Ranch.)

Dave has a cow-calf operation, in which calves born in March and April are sold the following January or February. The two bulls are Black Angus, which produces mostly black calves from non-Angus cows. "You get fifty dollars more for a black calf," Dave said. "I don't know why. Maybe it's just a fad." The lower cost of his non-Angus cows makes up for the lower price of any nonblack calves. "I sell a cow when she reaches about ten years and still has some teeth." I asked what happens if a cow does not produce calves at all. "She's hamburger!" Dave said.

His cattle were separated into two herds, in different pastures. He wanted to move one across the road to the other pasture, so he could mow where they were now grazing. The mowing would clip off the seed heads of fescue, which often contain an endophyte fungus that causes fever in cattle and irritates their eyes.

In his white pickup, we drove to inspect the herd he wanted to move. Often, he would do this sort of thing on horseback, but the kidney stone operation didn't allow that now. We bounced through a field and down to a wooded draw through which flowed an intermittent stream. "I'd like to fence this off from the cattle," he said, "but I can't afford it. Fencing costs four thousand dollars per mile." The cattle were resting in a clump of trees. Dave got out to check them. Their eyes looked okay, and yes, the two bulls were with them.

Come November, he would move his cattle to Ronald Rhoades's farm, where there are better barns. In April they would be moved back to Dave's pastures. Though his cattle are necessary to make a living, and he has always enjoyed raising them, he does have one reservation: they compete with his beloved wildlife for food.

One morning I took a walk around some of Mackey's land. He'd suggested that I start by a cabin he'd built next to a wooded pond. As I walked in that direction, past the barn, I crossed a lot where a mare and her colt were grazing. The grandchildren had named the mare Sugar Mama and the colt Lizzie. Lizzie followed me, hoping for a pat, I suppose (which she got), or a sugar cube (which she didn't). This was a promising colt, and Dave was taming her gradually, brushing her at the same time he put a halter on

her, so she would associate the halter with the pleasant feeling of being brushed.

I followed trails mowed through a dense patch of woods to the cabin. Though it was late June, lots of birds were still singing. They especially liked the pond area, where red-winged blackbirds, red-headed woodpeckers, and many others were flying about. The well-constructed cabin had its name fastened above the door—"The Yettle House." Dave had explained this to me. "My young grandson Brian called it this. He couldn't say 'little.'" The Yettle House is a well-loved family gathering place for barbecues, children fishing for bluegills, and hunting days. Though an elderly minister friend who couldn't walk much had once shot a deer from the porch of the cabin, most of the actual hunting takes place elsewhere. The "cabin covey" of quail is left alone. This is essentially a sanctuary for wildlife and people, and that fresh, cool morning I could feel its sacredness.

On another piece of land, down the road, I walked the edge of a soybean field. I thought about the days when this was probably prairie, with all its grassland birds. Most of the grassland birds are still around. That morning I had seen meadowlarks, bobolinks, and a grasshopper sparrow in one of Dave's pastures, and he said upland sandpipers nest in the area and short-eared owls come in winter, especially to the CRP land. But the flagship bird of tallgrass prairie—the prairie chicken—is gone with the prairie. "In 1972," Dave had told me, "there was one prairie chicken in the south of the county—apparently the last—that had a dancing ground next to a road. It challenged a school bus and lost."

Beside the soybean field lay woods and thickets where Dave had mowed a strutting ground for turkeys, put up a J-shaped feeding tube, and erected a blind for hunting them. I saw no turkeys here, but on the far side of the soybeans I flushed a hen feeding in a patch of alfalfa. Down in an opening in a wooded draw, a gray-brown animal streaked out of sight—a coyote! I looked to see what kinds of trees Dave had on his land and noted a profusion of oaks: pin, shingle, white, red, post, and others; shagbark hickory, black cherry, walnut, American elm, cottonwood, maples, and mulberry. No doubt there are others.

All the arrangements of field and forest produced a variety of habitats and lots of edge—miles of it—which, in turn, allowed diversity of plants and animals. Besides the coyote, I saw deer, fox and gray squirrels, cotton-

tails, frogs, turtles, and forty-four kinds of birds, including quail and four-teen red-headed woodpeckers, a treat for me because both of these birds are scarce in the parts of the East where I spend most of my time. I knew the woods and fields held many more things I hadn't seen, like the red and gray foxes, muskrats, and mink that Dave had. Someday he may spot a bear. They've been seen in Knox County, and in the next county east a sow has raised cubs. Recently, a friend hunting on Dave's farm saw a mountain lion!

With all the demands of a farm ("there's always something that needs to be done"), I asked Dave how he found time to go fishing. "I always *make* time to go fishing," he replied, "usually every weekend." He had missed the previous weekend, so the next, lovely, Saturday he was more than ready to cast a lure. We shoved a small, square-ended aluminum boat into the ten-acre pond and worked its edges, the trolling motor pushing us quietly along. Trees rose along one shore, grassy fields the other.

Even before I was ready to cast, Dave had caught two crappie. It was like this the rest of the two hours we were out there—for both of us. Whether we were casting or trolling, the bluegills and crappie were eager to take our baits. This pond was *productive,* and no doubt would stay that way under Dave's careful management.

As much as he likes fishing, this activity is only part of his enjoyment on a day like that. He pointed with delight at Canada goose goslings waddling with their parents into the grass, and at a cloud of midges dancing in the sunlight. "Did you hear that pheasant?" he asked, happy that his acreage here was producing them. We went to his house with some thirty fish to fillet, and another beautiful outdoor day to remember.

When I asked Dave about his yearly rounds on the farm, he ticked off the times of fertilizing, calving, planting, and harvesting. "Then," he said, his eyes lighting up, "comes hunting season." This, I gathered, was the peak of his year, after the crops had been brought in and cattle put in the barns for winter. It was also a family time, when near and distant members assembled for the hunt, along with close friends. The Yettle House would be busy.

Dave has deer stands all over the farms, ready for wherever the deer are moving or whichever way the wind is blowing. He even has a freestanding, enclosed blind installed with a heater for the less rugged hunters, like his eight grandchildren, who are beginning to reach hunting age.

A photograph in Dave's basement attests to the deer-hunting potential on his land. Four family members and the aforementioned elderly minister stand in front of six dressed deer hanging near the Yettle House. During a recent ten-year period, 132 deer were taken on the Chigger Ridge Farms, and many more keep growing up for future hunts. Numerous, uncounted turkeys, quail, rabbits, and squirrels had been bagged as well.

When you have so much wildlife on your land, intruders are almost inevitable. One day, out of deer season, Dave was walking in one of his favorite hunting areas when a bullet whizzed by. He flopped to the ground just before a running doe fell right beside him. The perpetrators: some construction workers from the St. Louis area. They were apprehended and fined.

On another, more humorous occasion, Dave saw three hunters who didn't see him. He sat still as they passed, then fired up in the air. "They really jumped. I read them the riot act about hunting on my property. 'Would you like me to hunt in your yard?' I asked them. 'This is my yard and it cost a lot more than yours.'" He told them he had their license number and would report them if there was any repeat of this trespassing. He really didn't have their number, but when he did see it, he discovered that one was a state senator.

Because Joel Vance loves to hunt quail, it wasn't too difficult to persuade him to come up here early one December when I could join him and Dave. I'm not a hunter, but I enjoyed tagging along, observing the methods of men and dogs. Joel's two French Brittanys and Heidi, Dave's German shorthair, excitedly charged ahead, the less restrained Brittanys wearing locator collars that beeped, keeping them at least within earshot. Following the edge of woods, the dogs missed the first covey, which flew off in all directions, as coveys do. I trooped after Dave, who flushed one of the birds and fired. "I wounded it," Dave said, "saw a leg drop." But it flew too far to be found again.

As always, Dave was alert for signs of wildlife, enjoying the stories they told. He pointed out turkey scratchings, buck scrapes, stripped saplings where deer had rubbed off their velvet, hair and mud on a barbwire fence where a coyote had crawled through. Woodpeckers flew off from a strip of trees we were following. "They eat the small acorns of these shingle oaks," Dave explained.

The dogs also missed the second covey but did better with the third, fi-

Dave Mackey (left) and Joel Vance set out after quail. NAPIER SHELTON

nally remembering what they were supposed to do, it seemed. Heidi and one of the Brittanys went on point side by side, at the top of a gully. A quail rocketed away and Dave missed. Then another exploded in the opposite direction and Joel missed. Shortly after, a Brittany pointed two in the adjacent woods. Joel missed again. "This is harder than grouse hunting," he grumbled. Maybe the difficulty is one reason he loves quail hunting, I thought. In spite of the misses, however, I had to admire the split-second speed with which they both aimed and fired. It seemed instantaneous.

The hunt turned out to be shorter than expected, because one of Joel's dogs tore an ear on brambles or barbed wire, and he wanted to get it to a vet. The quail were victorious this day, but of course there was the joy of just being out there, breathing the crisp December air, working with the dogs, continuing a camaraderie.

Dave expects to have many more hunts, but he has planned for the days beyond his last one. He is teaching his grandchildren wildlife skills—Brian, at ten, has already shot his first deer and planted a food plot for turkeys—and Dave has put his land into a family trust. "That should hold it together for the next couple of generations," he said. He could only hope those generations would show it the same love and care that he has.

MAPPING MISSOURI'S
BREEDING BIRDS

Over four hundred of Missouri's avid birdwatchers participated
in this seven-year survey—probably the most extensive volunteer-
based all bird species inventory in Missouri's history.

BRAD JACOBS, *Birds in Missouri*

With any natural resource, it's important to know what you've got
and where it is. Furthermore, living resources change in abundance
and location, so you've got to survey them periodically. In 1986, Missouri
began work on an atlas of the state's breeding birds. The object was to pro-
duce a definitive picture of the distribution of each species, a baseline that
could be compared with future distributions; to determine the locations of
rare species; and to provide information for environmental planners.

The first such breeding bird atlas was published in 1976, covering Brit-
ain and Ireland. Continental Europe, Africa, Australia, and several U.S.
states soon took up the idea. In America, the work traveled roughly west-
ward from the East Coast, Maryland and Massachusetts being among the
leaders. Missouri was one of the earlier midwestern states to start an atlas
project.

Here it was the brainchild of James D. Wilson, known to his coworkers
as Jim D. to distinguish him from another Jim Wilson in the Missouri De-
partment of Conservation. He was soon joined in the project by Brad
Jacobs. Both were ornithologists on the staff of the Natural History Division,
which dealt with non-game species, a focus made possible by the Design
for Conservation Sales Tax of 1976. (In 2003 the Natural History Divi-
sion and Wildlife Research were merged into a Science Division.)

The two men came to this work from quite different backgrounds; Wil-
son's was fairly traditional, Jacobs's decidedly different. Jim D. Wilson grew

up in northwest Iowa: "I was a farmboy. I first became interested in birds when I was around twelve. I don't know why; it just happened. There were lots of natural lakes and marshland around, lots of opportunities to see different birds. As a farm kid, I did a lot of hunting, got to see birds and other wildlife up close. A neighbor boy had about the same interests as I did, but we learned on our own.

"I also drew ever since I was a kid. My art predates my interest in birds and wildlife. Both these interests sort of waned during my high school and early college years. But it was a good background for what I did later on."

The interest returned in time for Wilson to get a degree in animal ecology at Iowa State University. But after college he worked in agricultural lending with a bank in California, because of his farm background and the good pay. This didn't seem to satisfy him, however. "I started doing a lot of backpacking. I was escaping, I suppose, from all the congestion. Got me back to more natural things. That's when I made up my mind to go back and get my master's degree," again in animal ecology.

During the graduate work and for a few months afterward, he taught biology, zoology, anatomy, and "health" at a community college. He would return to such teaching after retirement from the Conservation Department, where he worked from 1977 to 2001. That work involved putting out information for the public; conducting research and surveys, such as the breeding bird atlas; and management-oriented projects such as restoration of bald eagles, ospreys, and peregrine falcons.

For Brad Jacobs, birds would be a continuing interest through a rather unusual series of jobs that eventually led to the Missouri Department of Conservation and a small farm east of Columbia. He grew up in Shelburne, Massachusetts, a little town along the Mohawk Trail near the Deerfield River. "My Scout leader, who was also the school bus driver, was a birdwatcher. The first thing that hooked me on birds was that nature merit badge: 'identify ten birds.' Sitting in the front of the school bus, we'd identify birds every day on the way to school. Every once in awhile he'd take me to a new place. After a couple of years, my dad got interested and he kept coming along. By junior high and high school, he and I would take off on spring break, driving to Texas for two weeks, Florida for two weeks, looking for birds." Brad joined the Norman Bird Club in nearby Greenfield, then the Forbush Bird Club when the family moved to Worcester.

At Cornell, Jacobs majored in conservation of natural resources, and, since he was planning to go into the Peace Corps, he also studied agricultural nutrition and Spanish. After graduating, in 1969, he had further language training in California and Mexico, then went to Colombia for two years with the Peace Corps. "I was a biological technical adviser in the national park system, teaching conservation to park wardens, in very remote areas, using dugouts and hammocks in the woods. One park was six hundred miles from the last town near the headwaters of the Orinoco River." In view of the drug gangs, and with a rumored CIA camp near one park, he was told never to carry a gun. "I carried a machete, but that was just for getting around."

Next came a transfer to the Galapagos Islands, where he worked for a year at the Charles Darwin Research Station, conducting, with other resident scientists, workshops for visiting high school teachers. Here he also worked on birds, banding albatrosses and boobies, and—his main research—studying the dark-rumped petrel, an endangered species. "I visited all the islands and tried to map the location of all the petrel burrows." Linda, his wife-to-be, who had also been with the Peace Corps in Colombia, came with him to the Galapagos, where she recorded field data in the station's permanent record.

"When she and I went back to the States, we wanted to go back to the land, because we'd liked living in peasant cultures. We ended up around Denver, working in different jobs. We finally decided we'd look for some cheaper land in Missouri or Oklahoma, because land around Denver and Boulder was like ten thousand dollars an acre. We didn't have that kind of money." They bought twenty-five acres in Ozark County, Missouri, and pitched a tent on it. "I'd worked in Colorado as a carpenter building houses, which I'd learned how to do from reading all the carpentry books. I started building a little house on our land in January 1974. We moved into it in March. We had a little spring where we got water. Didn't have any electricity. We didn't really want it. We were going back to the land.

"I started working with a company nearby doing alternative energy—solar, biogas, things like that. My wife and I wrote a grant proposal to see if we could train Peace Corps volunteers in biogas production, and we got it." The company rented a house in the little town of Dora and the couple trained, with four helpers, a group of volunteers, who then went off to

Ecuador. They taught other Peace Corps groups how to build gravity-fed hydraulic ram pumps, which "allow you to pump water uphill great distances without any electricity." At the same time, Brad was still building houses, installing on some of them solar collectors that he built "from scratch."

In 1980 he got a call from a friend who was teaching auto mechanics at a school on the Navajo reservation in northeastern Arizona, asking if he would like to come out and teach building trades. Brad asked Linda, and she said "sure." They locked up their house and took their two young children to Arizona. For a year Brad taught carpentry and drafting and coached the track team. Then, for three years, he was director of the vocational school at Rough Rock Demonstration School, which trained the 650 students in occupations such as auto mechanics, welding, carpentry, and business. Next, he spent a year at nearby Navajo Community College, in Tsaile, Arizona, setting up a building trades program there.

At this point Brad and Linda decided it was time to go back to school and get master's degrees. She studied library science at the University of Missouri and he, biological sciences, specializing in avian ecology. "That winter," Brad said, "I visited Jim D. and asked him what was going on in the Department. He offered me a job working on the breeding bird atlas." Brad began with the MDC in 1987, first helping to raise young eagles to release them into the wild and doing marsh and prairie bird surveys along with the atlas work. In 1988 he went full-time with the MDC.

The atlas, it might be said, began to be born when Chandler Robbins, a well-known U.S. Fish and Wildlife Service ornithologist, asked Jim at a national meeting, "When are you going to do an atlas?" Jim had been thinking about it and now decided to proceed. He and Tim Barksdale, a good, "wild-eyed birder that flitted around Missouri," attended an atlas workshop at Ithaca, New York, and adopted most of the methods presented there. Jim decided to survey one block, picked randomly, in each six-block, seven-and-a-half-minute U.S. Geological Survey topographic map quadrangle. This resulted in a sample of 1,210 blocks in Missouri, each 3 × 3 miles, or 5 × 5 kilometers. Next, he and Barksdale had to decide on "safe dates," the span of dates within which a species could be considered breeding in Missouri. When an instruction booklet, maps of the many blocks, and survey cards on which to record the birds observed had

been prepared, it was time to go out and get enough volunteers to do the job.

"The first thing I did was write an article in the *Missouri Conservationist*," Jim said. "I got quite a bit of response, but I'm not sure how useful it was. We got more useful response from Audubon Society members that we contacted at meetings and through their newsletters."

Volunteers were instructed to search each block thoroughly enough to record most of the species believed to be breeding there. This would typically take about fifteen hours of fieldwork to find what was generally fifty to seventy species. Atlasers were also asked to make more than one visit to each block, including nocturnal hours for birds like owls and whip-poor-wills. For each species found, the volunteer had to record whether it was a "possible," "probable," or "confirmed" breeder. There were criteria for each code: "Possible" were species just seen or heard in suitable habitat. "Probable" included more convincing evidence, such as a *pair* seen in suitable habitat. And a species could be "confirmed" by evidence such as building a nest or sitting on eggs.

During the seven years of the project, 438 people, most of them volunteers but a few state and federal employees, conducted the field surveys. As you might expect, the degree of skill varied quite a bit. "We'd let anybody go out and do what they could do," Brad said. "Some would send in a card with only twenty-five or thirty species. That was as far as they could take it. So we'd send someone else in to finish the block. Everybody seemed to know their capacity for doing the job. But if there was something weird on the card, and no documentation to substantiate the record, I'd just delete it."

Some participants did yeoman duty. "JoAnn Garrett, she was a good one," Jim said. She covered many blocks, as did Randy Korotev, a geologist at Washington University. One of the best surveyors was an Amish farmer. "He didn't go beyond his or his neighbors' farms, but he saw lots of nesting birds, farming behind a horse." Among the more distinguished citizens involved was Pierre Chouteau, a descendant of the Pierre Chouteau who was a financier of fur trade around 1800 and a mayor of St. Louis.

I was involved, too; I did a few blocks myself. Every few months I was coming from Maryland to visit my mother, who was in a nursing home in Marionville. She was in her nineties and was fading fast; tramping around atlas blocks helped to assuage the sorrow I felt. On those first few blocks,

west of Springfield, I particularly cherish the image of yellow-crowned night-herons fishing in Spring River and a sora rail, which was delicately picking its way across a vegetation mat on a tiny farm pond, in one of just three blocks around the state where this species was found. After my mother died, in 1989, I came back to do a few more blocks near Columbia and east of Kirksville. One of those last northeastern blocks sticks in my mind as a collage of red-headed woodpeckers. I must have seen thirty of them.

Jim and Brad both pitched in with fieldwork, surveying many blocks themselves. Brad traveled around the state, "doing blocks no one else wanted to." His method was exemplary. First he studied a topographic map of the area, noting the location of habitats such as forests, streams, and ponds. Then he drove all the roads, looking and listening. "Usually this put sixty to seventy species in the 'possible' category," he said.

After that, he spent time watching birds, to get evidence for raising them to the "probable" or "confirmed" levels. "I'd decide where I should show up before light in the morning, usually a place where I could get the

Brad Jacobs. JEAN STONE

nocturnal birds," such as between a big forest and open land, near water. "Woodcocks spend nighttime probing in the fields, and at dawn they move back into the woods and sit down. You could hear the great horned owls on one side and the barred owls on the other. Early in the mornings I tried to be in a forest area, so I could hear all the forest-interior birds singing. You can find birds in the shrubby areas all day long. If I wanted to find a particular species I'd go to the right habitat and play a tape recording of its song. Usually they come right out of the woods at you."

With all those volunteers out roaming the countryside, poking into woods and fields, Wilson and Jacobs hoped and prayed that no one would get hurt. "You worry that somebody might get killed, or something like that," Jim said. "We did have people that ran afoul of landowners. Sometimes they were even on the road, and landowners got suspicious." Or the police. A woman doing atlas work along the Missouri River floodplain was looking over a field of wild hemp (marijuana) when a suspicious policeman accosted her. "She was in a hurry," Brad said, "and lipped off at the policeman." The cops called Brad to check her out, and he assured them she was legitimate. "Luckily she didn't pop one in the head."

Brad had his own tense encounters. Most landowners gladly gave permission, but "one guy almost ran me off. The agents had been bugging him, I guess. He was a poacher. Poached like mad, trying to feed his family. Anyway, I pulled into his yard. I wanted to get down to the river to look for Swainson's warblers. I knew there was cane down there." Thick stands of giant cane are the preferred habitat for this rare summer resident. "He just didn't like me, because I was Conservation Department. 'I'm going to get my shotgun,' he said. I was standing outside the screen door trying to decide whether I could make it to my car or just talk fast. I kept standing there. I figured it would take a lot of nerve to shoot a stranger with a shotgun. He asked me some questions and finally settled down. We spent about fifteen minutes talking about his pigs and chickens. Then he let me go down and look for the Swainson's. I didn't find any."

There were amusing moments, too. "I was out in a block with another individual," Wilson reminisced, "and a titmouse landed on my head and tried to pull a hair out to build its nest. So we confirmed the titmouse for that block."

Each year, Jim and Brad sent out a newsletter, describing the progress

made, the work yet to be done, tips on how to improve bird observation, and anecdotes like the titmouse story. They even included crossword puzzles with a bird theme. The office work may have taken as much time as the fieldwork. Here Sharon Hoerner was the lead helper, handling prodigious volumes of volunteer correspondence and data entry.

As the project went along, it became obvious that many areas far away from big cities, where there were few birdwatchers, were not getting covered. The solution for this was "blockbusting," in which Jim and Brad rounded up a quick-strike force of birders who would go to an area for the weekend and do each block there. It's not a good way to get thorough coverage, but it's adequate. There were enticements for blockbusting. "We stayed in state parks with museums and fishing streams," Brad said, "and got interesting speakers to come in for the evening. We'd set up camp, have cookouts with steak and barbecue." It was a party.

After seven years, 1,207 of the 1,210 blocks had been covered, and that was enough. Of the 181 species that were recorded, 167 were judged as possible, probable, or confirmed breeders. These ranged from the ubiquitous northern cardinal to the very local short-eared owl and painted bunting. The number of species recorded per block ranged from 17 (in an unfinished block) to 96, with an average of 59.6.

During the same period, thirty-seven U.S. Fish and Wildlife Service breeding bird survey routes were being run each June throughout Missouri. Each of these involved fifty stops that were three minutes each, and one-half mile apart, in which all birds seen or heard were recorded. These routes were supplemented by sixty mini-route surveys, with fifteen stops, run twice during a single breeding season, each totally within an atlas block. The data from these two types of surveys were combined to provide numerical information on each species. This was presented in the atlas publication on maps for most species showing relative abundance by natural divisions of the state, such as the Ozarks and Glaciated Plains. The final product thus gave a picture of the distribution of each breeding species and the abundance of most in the various regions of Missouri.

The biggest surprise of the project was the discovery, on a blockbusting weekend in the Bootheel, of black-necked stilts nesting on low levees in rice fields. Three nests with eggs were found in two adjacent blocks. This

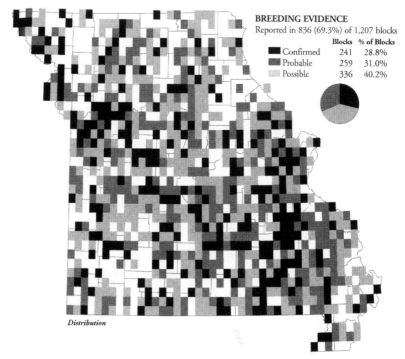

BREEDING EVIDENCE
Reported in 836 (69.3%) of 1,207 blocks

	Blocks	% of Blocks
Confirmed	241	28.8%
Probable	259	31.0%
Possible	336	40.2%

Distribution

Missouri breeding distribution of the Baltimore oriole. FROM BRAD JACOBS
AND JAMES D. WILSON, MISSOURI BREEDING BIRD ATLAS. COPYRIGHT 1997 BY
THE CONSERVATION COMMISSION OF THE STATE OF MISSOURI. USED WITH
PERMISSION.

was the first record of stilts breeding in Missouri; they nest primarily in
coastal areas of the Southeast and locally in the West.

The necessity of selecting only one out of each six blocks for survey-
ing—rather than, say, half of them—led to a couple of problems. The ran-
dom method of picking blocks sometimes clustered them and left large
areas unsampled. And the surveying of only one-sixth of the state missed
many patches of scarce habitat types, like marshes. So marsh birds such as
rails were underrepresented in the atlas.

To develop a better picture of the distribution of such local nesters, Jim
and Brad organized a "wild-card survey" in 1993, after the atlas work was
completed. "We had a list of about fifty species we knew the atlas wasn't
finding very well," Brad said. "So every fifteen-minute quad was examined
for good habitat, and one block in each was selected. This gave us a total

of about three hundred blocks. This survey was completed in 1999. We plan to compare these data with the atlas data and publish this, along with management recommendations for each of the scarce species. Make it more of a managers' book."

One of the greatest rewards of the atlas project, Wilson said, was "working with all these interested volunteers." "This was such a stimulus for birdwatching in Missouri," Jacobs said. "We developed one heck of a crop of birdwatchers. And people learned a lot." They discovered there were many birds and good birding spots near home that they hadn't known about before.

Published by the Missouri Department of Conservation in 1997, the *Missouri Breeding Bird Atlas* is generally similar to other states' atlases, in terms of ambition—in both the scope of content and style of publication. It presents largely just the information obtained from the surveys, in paperback form, and, except for the cover with its beautiful painting of a wood thrush, the text is in black and white. Some states chose to make a state bird book from the project, covering each bird's natural history and historical trends of abundance. Often these have been hardcover books with some color illustrations. At the other end of the scale are the states that published simply the maps of each species's distribution.

States also varied in the density of coverage. Maryland, with its relatively small size and many good birders, was able to cover all the area of the state—with no sampling. Michigan, where I also volunteered, surveyed all the blocks in the southern Lower Peninsula, half of the blocks in the northern Lower Peninsula, and one-fourth of the blocks in the lightly settled Upper Peninsula. Farther west, except on the heavily populated and birded West Coast, the number of volunteers and coverage declined. Besides, as Brad pointed out, what's the use of surveying every square mile of wheat?

Whatever the number of atlasers, participants around the continent have enjoyed the quest, which was sometimes an adventure. In northern Ontario, paid atlasers were flown in to remote lakes where they would camp for a week surveying the local blocks. "I thought that would be fun," Jim said, "until I went to one of the atlas meetings, and the Ontario people told me 'We get people from the Lower 48 to fly up there into those mosquito-infested marshlands.'" Missouri's forests, prairies, and farmland were much

more benign. Both Brad and Jim hope the Missouri breeding bird survey can be repeated, to document changes over the years.

Jim D. Wilson retired from the MDC in 2001. He looks back with satisfaction at his many accomplishments besides the breeding bird atlas and other surveys. Among the most rewarding were restoration projects. He supervised management and expansion of canebrakes for Swainson's warblers, the opening of glades for the scarce Bachman's sparrow, and raptor restoration.

Hacking—the raising of young raptors in hack boxes and subsequently releasing them into the wild—of bald eagles, ospreys, and peregrine falcons led to the reestablishment of these raptors as nesting birds in Missouri. Eagles had not been known to nest in Missouri since 1962, but they were hacked from 1981 to 1990. In 1983, a pair nested at Mingo National Wildlife Refuge (one of the hacking sites), and now there are more than one hundred nests in Missouri, a success, Jim says, "we think partly due to the hacking we did."

Peregrine falcons were hacked in St. Louis, Kansas City, and Springfield, and now there are nesting pairs in both St. Louis and Kansas City. "We probably didn't continue the program long enough to establish them in Springfield," Jim said. Peregrines do well in cities because there are clifflike buildings to nest on, pigeons to feed on, and a lack of great horned owls, which prey on the young. Jim hopes peregrines will also return to some of the former nesting cliffs along rivers.

Ospreys were hacked at Montrose Lake—a Kansas City Power and Light cooling lake near Clinton, in a project funded by that company, as was the Kansas City peregrine restoration. It was at Montrose Lake where "ospreys returned to nest in Missouri in the year 2000," Jim said, "for the first time since 1900—a hundred years—as a result of our releases. They're nesting again this year." (I was speaking to him in 2001.) "I guess they've got three young, on a platform we put up about ten feet from the place where they were released." The return of nesting ospreys and peregrines to Missouri, Jim says, is directly due to the hacking programs.

Though he is proud of such accomplishments, Jim D. is greatly enjoying retirement. "I feel refreshed," he said; he is now able to pursue his own interests outside of the inevitable confinements in a bureaucracy. Wilson now is a full-time professor teaching biology and environmental science at William Woods University in Fulton. "I've always had a general interest

**Jim D. Wilson with an
immature bald eagle.**
MISSOURI DEPARTMENT
OF CONSERVATION

and fascination with biology and delight in sharing it with others. Birds are just one of the elements of what I do now, and I like it that way."

He's also busy writing books for "backyard birders," people who "simply want to know the identity and something about the birds they see around their homes, flitting outside their office windows, or flying overhead as they are stopped at a traffic light." Midwest and Eastern editions of *Common Birds of North America,* published by Willow Creek Press, are already in their second printing. In the fall of 2002, he was working on a Southwest edition. For each of the ninety or so birds in each book, there's a color illustration that was painted by Jim. "I did most of the illustrations over the years," he said, but the Southwest book was requiring at least fifty-six new ones. He depicts most of the birds in action, going about their daily lives. To Jim, contributing to people's enjoyment of the natural world ranks up near his career contributions to knowledge and conservation of Missouri's wildlife.

Brad Jacobs is still going full steam at the Missouri Department of Conservation. He has written a book, *Birds in Missouri,* on the job. This is

for the lay enthusiast, he says, but it goes beyond the scope of Wilson's books. All 398 of the species recorded in Missouri are discussed, and most are illustrated in full color. Published in 2001 by the MDC, "the book sold like crazy," he said, and it was still selling about fifteen copies a day in mid-2002.

That project could be called public education. Most of his other work is conservation-oriented. He is, for instance, chairman of the Midwest Steering Committee of Partners in Flight, a multi-organizational program that deals with the decline of migrant land birds, a decline apparently caused by problems in North American breeding and tropical wintering areas as well as stopover sites on the routes between.

He's also deeply involved with the Grassland Coalition, which works with nine "focus areas" in Missouri, of 10,000 to 45,000 acres each, and tries to restore prairie plants and animals on them. Most have a protected core area—such as Prairie State Park or Dunn Ranch—and are paired with a nearby unmanaged area for comparison, "to see if management is doing any good." And he is coordinating a grant project on native seed production, establishing seed plots in various parts of Missouri using Missouri ecotypes (that is, distinct populations of a species that developed in specific locations in Missouri). These seeds will be used for restoration of native plants to areas such as highway right-of-ways and MDC lands, where formerly seeds from all over the country were used as long as they were the correct species.

Brad has not abandoned his youthful impulse "to go back to the land," nor has he allowed his building skills to get rusty. He lives on a thirty-acre farm east of Columbia, where he and Linda raise sheep and rabbits. His wife weaves with wool from the sheep and makes hats with wool and rabbit fur. Brad has doubled the size of the farmhouse (this one has electricity and indoor plumbing). When I visited him there, his two Australian shepherds followed us around as he showed me his own native seed garden, in which he had thus far planted butterfly milkweed and swamp milkweed. "When I retire," he said, "I'll make a little spare cash selling seeds to native-plant nurseries and individuals."

He has recorded about 160 species of birds on his place. And if his property falls in a block of the next breeding bird atlas, that block will be well covered.

DUNN RANCH

No one has ever fully restored a diverse, fully functional,
landscape-scale tallgrass prairie. We would like to make Dunn
Ranch the Silicon Valley of prairie restoration technology.

> DOUG LADD, Director of Conservation Science,
> The Nature Conservancy, Missouri Chapter

The four-hundred-acre burn began on a late March afternoon with one
match igniting a small patch of grass. From this the two drip-torches
were lit, and two pairs of men proceeded in opposite directions, leaving
behind them thin lines of fire, eventually to meet at the southwest corner
of the burn area.

By midafternoon the two lines of fire were converging and smoke was

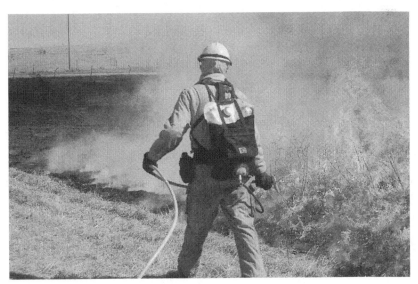

Igniting a burn at Pawnee Prairie. NAPIER SHELTON

towering into the sky. Brush piles ignited by the blaze punctuated the holocaust. By the next day the hilly land was bare and black, with smoke still rising from a few logs and chimney-like hollow trees. In a month or two it would be green again, with less woody vegetation and, the men hoped, less fescue and more bluestem.

This was one small step in one of Missouri's most exciting prairie restoration projects. In 1998, The Nature Conservancy bought Dunn Ranch, a wide swath of rolling hills in northwest Missouri, just a few miles from the Iowa border. Its thousand acres of unplowed prairie, with forty inches of topsoil, was believed to be the largest such area on deep fertile soil remaining in the Central Tallgrass Ecoregion, whose glacial soils stretch from northwestern Indiana to eastern Nebraska. Though "battered" by decades of heavy grazing, haying, and planting of fescue, Dunn Ranch Preserve still has the main elements of native prairie—a full suite of grassland birds and a high proportion of other prairie animals and plants. The Nature Conservancy believes that in time it can be fully restored.

TNC had bought nearby Pawnee Prairie in 1996, site of the burn just described and adjacent to the Missouri Conservation Department's 476-acre Pawnee Prairie Conservation Area, bought that same year. Together

The Pawnee Prairie burn in full flame. NAPIER SHELTON

with Dunn Ranch and recent additions to that, the complex now totals
about 3,500 acres. This can be called "landscape scale," a size that so far has
maintained Missouri's largest, most stable population of greater prairie
chickens, perhaps the most demanding prairie species.

As manager of The Nature Conservancy's Dunn Ranch and Pawnee
Prairie, Keith Kinne has the chief responsibility for "fully restoring" the
tallgrass prairie here. It is a long-term, complex challenge, one of applying
what's known, and of trial-and-error, year-to-year learning.

Keith is perhaps the ideal person for this job. "I'm a born-and-bred
northwest Missouri farmboy," he said. "I grew up around Hamilton, farm-
ing with my dad, running cattle and sheep. About a year after I was out of
high school, in the early eighties, the ag scene didn't look real good, so I
decided to go to college. I went to Northwest Missouri State, got a degree
in ag education. I taught vocational agriculture for thirteen years, the last
ten here in Eagleville high school.

"Then this position came open with the Conservancy. I own a farm and
always have been kind of a grass management nut. This type of thing piqued
my interest. So, really without knowing much about the Conservancy, I
applied for the job and ended up landing it. If you'd asked me twenty years
ago if I'd be working for a conservation group doing prairie management I
probably would have told you that's crazy. But it's been a good change for
me."

When Kinne came on the job, July 1, 1999, he was faced with land that
had much potential but also many challenges. Because of past manage-
ment, fescue covered many acres, and other exotic plants, like the difficult
sericea lespedeza, had crept in, especially on land that had been plowed.
Trees and brush had invaded drainage channels. More of the same was
added with subsequent purchases: the Boatright Tract, at the east edge of
Dunn Ranch, in 2001; the Eckard Tracts, at the northwest and southwest
corners, in spring 2002; and the Westlake Tract, also on the northwest, in
2000. The last was a key acquisition, because it completed ownership of
the immediate Dunn Ranch watershed, but it, like much of the rest, was
mostly fescue dominated.

All these pieces, which form one contiguous block, have been divided
into thirty-two units for management purposes, depending on past man-
agement, dates of acquisition, planned uses, and so on. These have numbers

preceded by letters (such as *D* for units of the original Dunn Ranch purchase). TNC's Pawnee Prairie has been divided into two management units: a grassland north section and a wooded south section.

Burning, early intensive grazing (which reduces fescue), mowing, brush removal, and spraying or plowing followed by seeding are the primary methods for restoring prairie, and all have been used at Dunn Ranch—with varying results. Keith explained these with meticulous devotion as we looked at a map of the units.

"D1, when I got here in '99, really looked like a fescue field, with a little bit of scattered prairie grass in it. We've early intensely grazed it now for four years and we've got a lot of big bluestem, little blue, and cordgrass. There's very little fescue left in that. That's mainly from grazing. We've never burned it. It's forb-poor, though. It's mainly a grass-dominated prairie.

"Over a third of D2 was hedge-dominated forest." (That means there were a lot of Osage oranges, which are dense, bushy trees, used as living fences by the settlers.) "The upper part, to the west, was pretty much a fescue field. We have sheared all those trees, we've burned it for three years now. We grazed it this year for the first time. We're starting to see a little better prairie vegetation on the east side where we sheared the trees, but on the upper slopes it's still pretty much fescue. In the areas we sheared the trees off that weren't farmed for a lot of years, I've seen butterfly milkweed, a lot of different asters.

"D4 is probably one of the more disappointing ones." Farming was probably done here. "The first two years we early intensely grazed it, and we just haven't seen any response there. It just doesn't seem to have the prairie in it that these other pieces do. We've mainly been grazing it and managing it for prairie chickens. That's the unit with the main booming ground. For prairie chickens you want patchy structure—short, tall. So we've put fairly low stocking density on there to get more of this patchiness, so they've got openness and escape cover.

"D7A and D7B is a kind of test area. We're in our fifth year of it now. We've annually burned it. D7A we early graze, then pull out by the fifteenth of June. D7B is strictly an annual fire unit. At this point, the non-grazed part has had a better response than the grazed part. D7B has the best forb diversity and best grass diversity of any unit we have, and it's looking better every year. Now, is that because of our management? There's always these questions.

"D8 was very fescue dominated. We have burned it about every other year. A year ago we took forty acres out of the southwest corner and did a dormant season [November] spraying and virtually eliminated all the fescue. We're starting to see some forb response and some grass response in there. That's probably one of the more exciting units we've got right now as far as the fescue reduction. We burned the whole thing this spring. It was extremely dry. One thing I've noticed—it seems that burning cool-season grasses in an extremely dry spring will knock them back. Will it kill them? I don't know yet. If you burn them in a wet spring, it actually seems to help them.

"D11 and D13 are basically one management unit. This was fescue dominated. In the summer of 2002 we sprayed the whole area with Roundup. We came back in January and with an Airship"—a fertilizer spreader that blows seeds into the ground—"we seeded a prairie mix into it. Right now it's ragweed dominated."

Ragweed, an annual, comes in abundantly on newly exposed ground. Keith pointed out its value to prairie chickens. Besides providing seeds in winter, it forms a structure that allows young to move about but have cover overhead. In D11 and D13, Keith said, "I'll guarantee you there are prairie chickens raising broods in there." In succeeding years, the ragweed dies out as perennial prairie forbs and grasses take over.

"D12 is forty acres that was done before I came to work, in the spring of '99, the very first prairie planting done here by the Conservancy. It was a crop field. We mowed it the first two years, we've burned it two years, sheared trees. We're starting to see a pretty good mix of stuff in there—coneflowers, blazing star, butterfly milkweed, lot of big blue and little blue. It's a kind of isolated little island there, but one of the better ones."

The Boatright units, on the east edge, "have virtually no prairie." They've been hayed and grazed. "Eventually, we'll spray these areas, shear the trees, and replant it to prairie." Some of the Westlake units, too, were slated for haying, spraying, and then prairie seeding. The Eckard units, E1 and E2, were being grazed. "We're going to do a little rotational grazing just to help the prairie chicken management. There's a historical booming ground on E2."

Not far from there, on D4, I sat in The Nature Conservancy's dark green blind very early on a morning in late March, waiting for the prairie chicken mating ritual to begin. With me were a man from Albany, Missouri, his

two small children, and our guide, Betty Grace, who was bringing people here daily, by reservation, during the booming season. The wheeled, moveable blind had velcro-fastened flaps that could be opened to make windows. Padded chairs and a propane heater helped our comfort level on that chilly sixteen-degree morning.

Well before sunrise, male prairie chickens began to fly in and start booming. With the light, and some birds as close as twenty or thirty feet, I could see details of their fantastic maneuvers. They would rapidly stamp their feet, then bow and boom as the orange throat sacs inflated. Sometimes one would jump up in the air, with cries. Frequently two males would face off, with their "ears" (pinnae—feathers that give the bird another name: pinnated grouse) and tails raised; then they would boom, jump at each other, then back away.

Betty, who was making notes on the activity, said you could almost map the territories of the birds near us. "They occupy the same areas each day." When females arrived, there was much excitement and shifting of position among the males spread along the hilltop, but then interlopers were chased back to their own territories.

Brad Jacobs, in his book *Birds in Missouri,* says that "within a lek the most dominant males display near the middle and the least dominant males around the periphery." When two males jump at each other, "the less dominant bird quickly retreats from the prized, more central location. After the female selects and breeds with one of the displaying males, she leaves the lek, nests in nearby grassland habitat, and cares for the eggs and young on her own."

Dunn Ranch now has fifty or so male prairie chickens that display on several leks, and possibly three times that many total birds, but for a time it had none. When Charles Schwartz studied Missouri's prairie chickens in 1944, he found some at Dunn Ranch, on the same lek I visited in 2002. Later, the ranch lost all its prairie chickens. They were restored there by releases beginning in 1987. These birds were augmented by others that had been released at the nearby Kellerton Wildlife Management Area in Iowa but then flew down to Dunn Ranch. Prairie chickens have mysterious ways!

One of the reasons for removing brush and trees at places like Dunn Ranch and Prairie State Park, besides opening new areas for prairie plants,

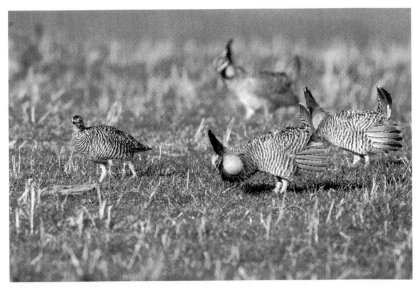

Prairie chickens on the booming ground.
MISSOURI DEPARTMENT OF CONSERVATION

is to reduce travelways and perches for predators of prairie chickens. Rac-coons, for instance, are a major predator of prairie chicken chicks, and red-tailed hawks use trees to watch for the birds. Studies have shown that prairie chicken nests near treelines are less successful than those farther away. The broader and more treeless the prairie, the better it is for these birds.

On a June visit to Dunn Ranch, though not seeing any prairie chickens, which were busy nesting then, I was delighted with the visible abundance of other grassland birds. Bobolinks, dickcissels, and meadowlarks were every-where. Tiny grasshopper sparrows sat on many a fence post. After a few days, I lost count of the upland sandpipers and loggerhead shrikes I'd seen. With the exception of the sandpiper, all these species are losing ground in Missouri and all of them in much of the East.

The wildflowers were a bit of a disappointment, however. I'd just wit-nessed the marvelous display at Prairie State Park, and the blooms at Dunn Ranch seemed scarce by comparison. I soon realized that this was largely a matter of stage of restoration. Most of Dunn Ranch was still heavily vege-tated with fescue, having had only a few years to combat it. But the seeds

and root systems of many prairie grasses and forbs still lay in the soil, awaiting their chance, as it were, when the competition from fescue was broken.

Summer is the time at Dunn Ranch when most of the spraying of brush and exotic plants takes place. Several mornings I was greeted by Dennis Perkins, Kinne's assistant, as he set out to spray one thing or another. Often it would be sericea lespedeza, a very tough customer, as I'd seen at Wilson's Creek battlefield. Burning won't kill it. Keith showed me one of the problems with this plant when we drove down a track on the west side of Dunn Ranch. It was intermingled with prairie species, like leadplant, that need to be encouraged. The sericea couldn't be sprayed without killing those other plants. "I guess we'll just have to sacrifice them here," he said. Otherwise, the sericea would continue to spread. He knew most of the places this invader was growing, and hoped to hit all those spots before they became large. Along the highway bordering Dunn Ranch he pointed out brown patches where Dennis had already sprayed the sericea, and he commented that the transportation department had also sprayed the right-of-way, killing much of the fescue. "I wonder what they're using," he said. "I'll have to find out."

Up at TNC's Pawnee Prairie, we stopped to check conditions in the wooded south section, which a contractor was going to clear. Keith decided that the ground was dry enough for operating heavy machinery. "After this is cleared," he said, "prairie plants will start to come back, on their own, from seeds and roots in the soil." A year earlier, a contractor had taken out the black walnuts for timber, netting The Nature Conservancy ten thousand dollars. The money would go the other direction in the present operation. I asked Keith how far up the drainages they would be clearing trees. "Until my money runs out," he said. "I've got twenty thousand dollars."

A few days later, I came back to observe the clearing operation, as Keith had said it was an interesting sight. And indeed it was. A big red "feller buncher" was at work. With two huge tires at the back and one small one forward, it turned this way and that, shearing tall trees at the base with pincers, grabbing them with giant claws on a long arm, and depositing them in a pile. Back and forth and around it went, cutting and clutching all woody growth, like some creature out of *Jurassic Park*. In only two hours, it had converted an acre of woods to bare ground.

Eventually, more than eighty acres of woods would be thus converted, sparing only a slope where a natural grove of bur oaks grows. That will be periodically burned, restoring it to oak savanna.

Next to TNC's Pawnee Prairie, on the west, is the MDC's Pawnee Prairie. Here, Keith showed me seed plots where prairie plants were being grown to supply seed for restoration work. We stopped at a thirty-by-fifty-foot plot of blazing star. "Last year we got fifty pounds of seed from this," Keith said. "That would cost five thousand dollars if we had to buy it." Other plots grew pale purple coneflower, compass plant, rattlesnake master, gray-headed coneflower, leadplant, and others—twenty-eight species in total. Looking at all these, Keith laughingly reflected, "I spent the first half of my life spraying all this stuff to kill it, and now I'm spending the second half restoring it."

The 3,500 acres encompassing Dunn Ranch and the two Pawnee Prairie sections, important as they are for restoring a landscape-scale prairie, are also part of something still larger: the Grand River Grasslands Focus Area, 32,000 acres that also includes TNC's 240-acre Perkins Tract, the Ringgold Wildlife Management Area in Iowa, and private land. This is one of nine such focus areas established in Missouri by the Grassland Coalition, a loosely organized group of agencies and individuals formed to preserve and expand prairie and to promote the use of prairie grasses on private farmland.

The object is to create areas large enough to maintain viable prairie ecosystems, large enough especially to support stable populations of prairie chickens. The focus areas thus were chosen to include the best remaining prairie chicken populations in Missouri, with the assumption that the small, isolated populations would probably continue to decline.

Success of the focus areas will depend to a great degree on the extent to which private landowners are willing and able to convert fescue hay and pasture lands to the warm-season prairie grasses. This makes economic sense, because fescue is a poor pasture grass in summer, when it ceases growth and produces an endophyte fungus that is debilitating to cattle. Opinions vary as to how much of one's pasture should be in warm-season grasses. Keith Kinne thinks about 20 percent. Others think as much as 50 or 60 percent. The only problem is the expense of making the conversion. Certain federal programs, such as EQUIP (the Environmental Quality Incentive Program), are the best solutions, but these are modestly funded.

Each focus area has a team that plans its work. Keith Kinne, of course, is on the Grand River Grassland team. Another member is Randy Arndt, an MDC wildlife management biologist based at Albany. He told me that most of the prairie restoration work on private land is clearing trees and brush. This has been funded by federal and state programs and by grants from the National Fish and Wildlife Foundation, Miller Brewing Company, Phillips Petroleum, and other sources. Some of this grant money has also gone specifically for projects at Dunn Ranch, which is not eligible for some types of government funding.

The Nature Conservancy's vision for its Dunn Ranch complex includes bringing back native animal species that once were there and now are gone. The white-tailed jackrabbit is one, when enough prairie has been restored. The Topeka shiner, a small fish, is another, if the stream habitat can be made suitable and cattle kept out of it. Most exciting is the bison, which in 2003 appeared to be on the brink of reintroduction—perhaps there will be about twenty to start with, as soon as stronger fencing could be built.

I thought about some of these possibilities as I walked about in unit D7B shortly before leaving Dunn Ranch. Especially, I thought about the future prairie vegetation, here in the unit Keith had said was one of their best. As I wandered under a warm blue sky filled with puffy white clouds, a meadowlark and a bobolink mellifluously serenaded me. Bumblebees attended big patches of tube beardtongue. Regal fritillaries festooned purple-flowered milkweeds. I found compass plant and pale purple coneflower, hairy wild petunia, spike lobelia, white wild indigo, and what I guessed was ashy sunflower, about to bloom. And native grasses, short and tall.

The land seemed to be saying, This Dunn Ranch prairie *will* be fully restored.

SQUAW CREEK NATIONAL
WILDLIFE REFUGE

The area is too far south to be of any great consequence as a nesting area. However, it will be of great importance as a protection, resting and possibly wintering area.

Narrative Report of Squaw Creek Refuge,
Civilian Conservation Corps, 1935

Mention Squaw Creek to midwestern outdoors people and their first thought probably will be: snow geese and bald eagles. Almost every spring and fall, snow geese by the thousands stop over at Squaw Creek National Wildlife Refuge, near the Missouri River in northwest Missouri, and bald eagles by the dozens or hundreds follow them, looking for the sick and wounded.

This is high drama in a yearly cycle full of wonder and uncertainty, one that has been written about for centuries. On August 26, 1631, Captain Luke Fox, on a voyage looking for a Northwest Passage, wrote in his journal while at Hudson Bay: "A N.N.W. wind hath conveyed away abundance of wild geese by us; they breed here towards the N. in those wildernesses. There are infinite numbers, and, when their young be fledged, they fly southwards to winter in a warmer country."

Most of the snow geese that pass through Missouri winter on the Gulf Coast, though good numbers may winter as far north as the Missouri Bootheel. On the return trip, they reach peak numbers at Squaw Creek in March, then depart for the Arctic, where they nest. Most of the midwestern migrants nest around Hudson Bay and the Arctic islands farther north. The tundra may be snow covered when they arrive, forcing them to wait. A really late spring may cause breeding failure.

On the fall migration, hundreds of thousands of snow geese fly from

Hudson Bay to the Dakotas, stopping first at several national wildlife refuges in North Dakota: Des Lacs, Devil's Lake, Upper Souris, J. Clark Salyer. They move from there to Sand Lake, South Dakota, then to DeSoto National Wildlife Refuge in Iowa, a hundred miles north of Squaw Creek on the Missouri River. Some stop over at state wildlife management areas as well.

The peak at Squaw Creek usually comes in the second half of November, when as many as four hundred thousand or more may be present. Many also go to Swan Lake National Wildlife Refuge, in north-central Missouri, and to Otter Slough Conservation Area in the Bootheel. The severity of winter usually dictates when and how far south the geese go, though Louisiana, Texas, and Arkansas always eventually get the majority.

Bald eagles follow a similar pattern in the U.S. segment of this broad migration route, though lagging the geese a bit. At Squaw Creek they tend to peak in early December, when the refuge has its annual Eagle Days, when the public can attend talks, see a live eagle up close, view Glenn Chambers's film *Where Eagles Soar,* and take trips around the refuge to see multitudes of eagles in action. As many as 476 eagles have been recorded

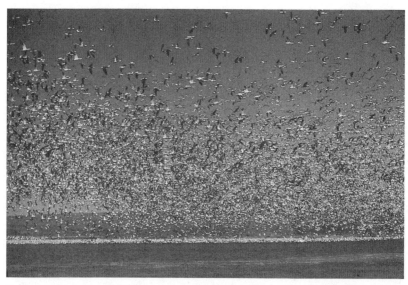

Snow geese in a normal fall. USFWS, SQUAW CREEK NATIONAL WILDLIFE REFUGE

at one time. Many eagles go no farther south than Missouri, finding adequate open water for fishing and waterfowl hunting along the big rivers and around the large impoundments.

When and where the geese go are at the mercy of weather. My experience in 2002 bore this out. As I drove north in mid-March, the snow geese seemed to be accompanying me, or vice versa. At Prairie State Park, small flocks flew over, announced by their high-pitched calls. Down the road toward Lamar, I came upon a field that was white with snow geese. There must have been ten thousand, and more were circling in. Farther north, I saw other flocks descending on other fields.

At Squaw Creek, from the ridge along the loess hills (composed of fine dust blown during the Pleistocene) behind headquarters, I looked out over the refuge and far across the broad Missouri River floodplain toward the hills in Nebraska. In front of me, the south end of Eagle Pool was full of tightly packed snow geese, a white pool within the larger one.

Driving around the ten-mile auto tour route, I saw an immature bald eagle diving at one of those snow geese. The others had flown, but this one just thrust upward at the eagle when it came close. After a while, the eagle gave up and flew away, but I supposed that that goose, if unable to fly, was done for.

Out at Mallard Marsh, an eagle sat on its nest, incubating eggs. Other eagles perched in trees, or flew slowly over the impoundments, watching for prey. Migrating white pelicans were resting, appropriately enough, in shallow Pelican Pool.

Late in the afternoon, big flocks of snow geese took off, heading out to grain fields. An hour or so later, as the sun approached the horizon, flocks returned, again whitening Eagle Pool.

These early spring scenes were about normal, the expected. The late fall scene was not. I arrived in mid-November, expecting to see the snow goose climax at Squaw Creek—the air white with masses of flying birds. Instead I saw brown, waterless impoundments and no geese. The long drought in 2002 had shut off most of the water supply. This was the first year since 1988 that the failure of rain had dried out the Squaw Creek refuge and turned the snow geese elsewhere, exceeding the impact of 1988, when some geese—up to twenty thousand—did arrive here.

I knew they were around somewhere, because I occasionally saw flocks

Refuge impoundments in a dry fall, with loess hills in the distance.
NAPIER SHELTON

going over, as if commuting to or from some feeding area. I drove toward the Missouri River, hoping to find out where they might be sojourning this year. I didn't find out, but the day's trip did pay off. Stopping on a levee along the river, I looked back over a vast field of corn stubble. Then I heard geese, approaching from the south. They began circling the field, the birds now white, now dark, as they turned in the sunlight. For some minutes they swirled around, gradually going lower, as if cautiously checking out the field. Then a few geese began dropping to the ground, then more, like falling snow from a cloud. Finally, all were on the ground, spread over a quarter mile. It wasn't the two or three hundred thousand I had hoped to see at the refuge, but it was a magnificent spectacle nonetheless.

Although Eagle, Pelican, and Snow Goose pools—the large impoundments where snow geese normally gather—were almost dry, the marshes at the north end of the refuge had *some* water, enough for ducks. Hundreds of mallards, gadwalls, and others flew up as Ron Bell, the refuge manager, and I drove along dikes in a pickup, checking water levels. Ron takes prime responsibility for control of water on the refuge, and now his chief aim was to spread the available water farther south on the refuge, to make more wild millet, smartweed, and other food available to the ducks.

But the beavers had a different objective: hold the water back to maintain the depths they need. So we stopped at the outlets from one pool to another, Ron putting on his hip waders to get in and clear away the debris with which the beavers had plugged the outlets. "The beavers are getting desperate," he said. "Got to keep their water. Last fiscal year, we hired a trapper who caught thirty beavers in less than a month." But that didn't seem to slow beaver obstructionism very much. He wonders where the beavers go when the impoundments dry up. "My theory," he said jokingly, "is that they freeze-dry." Alternately, he speculates that they go into the ditches.

When water levels become too low, the refuge gets some help from two wells adjacent to the streams that flow into the refuge: Squaw Creek and Davis Creek. We stopped at the pump beside Squaw Creek. "This pumps water into Mallard Marsh," Ron explained. "We pump from 9 p.m. to 5 a.m., to avoid the time when neighbors might be using their wells, which are only twenty feet deep. Ours are ninety feet." Now he shut this one off—done for the winter. He called headquarters to tell Joanna Foster, the administrative technician, to tell the electric company it had been shut off. "This pump costs about $1,500 a month to run," he said. "The pump at Davis Creek runs on propane. Costs us $125 a day." The Friends of

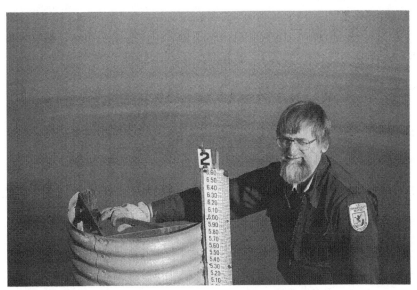

Ron Bell, refuge manager, checks beaver damming at an impoundment outlet.
NAPIER SHELTON

Squaw Creek, a private group, had placed a notice on the Internet requesting donations to keep that pump running. "They will buy the propane," Ron said. "It's much more complicated to donate money to the Fish and Wildlife Service."

Water is of course the lifeblood of the refuge, but it brings a problem down from the watersheds: silt. When spring flows are especially high, Ron directs them past the impoundments, on down the straight ditches that Squaw and Davis creeks now are. "If we are to survive another fifty years," he said, "we have to solve the siltation problems, because it fills up our pools." As a starter, the Fish and Wildlife Service has provided economic incentives to stop erosion in the hilly, sixty-thousand-acre watershed north of Mound City. In many fields upstream, terraces have been constructed along the slopes to channel water toward retention pools.

Ron described another problem that besets refuges, parks, and other public lands nationwide: exotic plants. At Squaw Creek, reed canary grass, hemp (also called marijuana, introduced widely during World War I to make rope), musk thistle, and garlic mustard are the main offenders, displacing native plants. He was talking with the highway department about a two-year project to dig soil from thirty-five to forty acres of the refuge for road fill. This would also benefit the refuge by removing canary grass and creating new marsh.

As we drove along the auto tour road, a big buck walked across in front of us, following a doe who had lain down in the vegetation of dry Pelican Pool. Ron said he would start hunting (elsewhere) on opening day. He hoped to get three deer. "I'm a meat hunter," he said. "I don't mind shooting a fawn, either. The younger ones taste the best."

The refuge has about three times the regional average for density of deer and has instituted a short season to try to hold the numbers down. "We used to have a 'primitive weapons' season for all deer," Ron said, "but the bowhunters only wanted big bucks and didn't kill many deer. Now we have only a muzzle-loader season, for antlerless deer." (They make counts before and after the Missouri firearms season; I'll describe one of these counts later.)

Our morning ride, besides giving me a window onto management issues, was enjoyable simply for the wildlife seen: more deer in the woods; red-tailed hawks, as common as eagles, watching for rabbits and

rodents; ponderous great blue herons taking off at our approach; musk-rats preparing their houses for winter. And of course the thousands of ducks.

Squaw Creek was among several national wildlife refuges created to compensate for losses of habitat along an age-old waterfowl route, the Missouri River, whose marshes had been drained and its channel straightened, eliminating sloughs and oxbow lakes. Drainage problems and the Great Depression made the land available from hard-pressed farmers. In the year of the refuge's establishment, 1935, the Civilian Conservation Corps moved in to help, as it did at so many other parks, forests, and refuges. As many as 203 men constructed roads and trails, buildings, dikes, water management structures, fish shelters, and nesting islands (for Canada geese, they hoped). By the end of 1936, they had completed the thirty-five jobs assigned them. The CCC narrative report ended thus: "This concludes the work laid out for the present camp. We are taking our departure with the knowledge that we have done a good job, and so rests our case. Respectfully submitted by: Michael J. Hanick, Assistant Civil Engineer."

The waterfowl, seeing more than seven thousand acres of new pools, marshes, and forested swampland, were not long in coming. In the spring of 1938, it was estimated that 40,000 geese and 200,000 ducks used the refuge. Over the years, with reduced continental reproduction, creation of other refuges may have spread out the remaining ducks; Canada geese have used Squaw Creek sparingly, but spring and fall visitation by snow geese rapidly rose to the spectacular levels seen today. For awhile, spring numbers were greater than those of fall, but by the late 1970s there was a switch. Since 1980, the fall peak in most years has ranged from 200,000 to 600,000, the spring peak from 20,000 to 200,000. (The duck numbers are smaller: in recent years, typically 65,000 to 130,000 in fall, and 45,000 to 65,000 in spring.)

There is, however, a dark side to the goose numbers, as exciting as they may be to viewers. Snow geese have increased to the point that they are destroying their Arctic nesting grounds. The midcontinent population alone (other populations migrate to the western United States and the east coast) more than tripled between 1969 and 1994. Increasing at least 5 percent per year, it now probably has reached 5 million or more.

The reasons are mostly human related. Snow geese formerly migrated

from northern staging areas and James Bay directly to the Gulf Coast, where they wintered and fed in salt grass marshes. After the 1940s they expanded their winter foraging into the rice fields of Texas, Louisiana, and Arkansas. Creation of refuges along their route changed and slowed their migrations, giving them safe havens and access to other farm fields. Now they exploit corn, wheat, barley, oats, and rye up and down mid-America as they travel. This enhanced food supply puts them in prime breeding condition when they head north. Further factors are a decline in hunting; a warming trend in the Arctic, which allows earlier nesting in the spring; and a southward shift of the breeding range by the birds themselves.

The results? Around Hudson Bay, where a large percentage of midcontinent snow geese nest, about two-thirds of the salt marshes used by the geese are no longer productive, and most of the rest is heavily fed upon. Snow geese pull up sedges and other forage plants, as well as graze on them, exposing the underlying marine sediments to evaporation and salinization. Moss carpets, which are not fed on by geese, can develop. Experts conclude that if the population continues to increase, habitat recovery probably will not be possible, and if the population declines, recovery will probably take decades, where possible at all.

What to do? The primary recommendation is to increase hunting of snow geese, by extending hours and seasons (including a spring season) and limits, permitting methods such as baiting and electronic calls, even subsidizing hunting, and encouraging subsistence hunting and egging by residents of the far north. In Missouri, recent regulations have allowed a spring season and unlimited possession of snow geese. Ron Bell told me that one party had shot seven hundred near Squaw Creek (waterfowl hunting is not permitted on the refuge itself). Hunters travel from Michigan and other states to the Squaw Creek area just for the spring season on snow geese. If such draconian measures do not succeed in reducing the population 5 to 15 percent a year, the recommendations include commercial harvesting of snow geese for meat and the killing of birds in the migration and wintering areas by wildlife agencies.

So, there must be human solutions to a human-caused problem. If they work, and the overgrazed Arctic can recover, we will continue to enjoy the dramatic spectacle of snow goose travels at places like Squaw Creek. Otherwise, snow goose populations could totally collapse.

Snow geese and other waterfowl are the primary, but not the only, resource to be protected at Squaw Creek National Wildlife Refuge. There is a wide variety of wildlife, and the vegetation it depends on, to be monitored and managed. Ron Bell is the man ultimately responsible for seeing that all this happens successfully.

Ron is a slim, brown-haired man in his fifties, with a full gray beard. He is energetic; his motor is always running. He talks fast, walks fast, does everything fast. Ron didn't aim to be a refuge manager at first. It was the wildlife work that he especially liked. "I grew up in Westville, in northern Indiana. I got interested in the fifth grade, when I went to a church camp. A game warden showed slides and talked about his work. From then on, that was what I wanted to do."

He went to Purdue, "because it had the only wildlife school in Indiana," and got a B.S. in agriculture, focusing on wildlife biology and management. For three summers he assisted Durward Allen in his now-famous wolf-moose studies on Isle Royale, in Lake Superior. Ron ran moose pellet plots, collected moose kill remains, and recorded the vegetation in those areas. "We howled for wolves to find out their location in summer, with battery-powered megaphones." I was surprised to learn that he remembered me from one of those summers, when I was researching a book on Isle Royale.

Next came eighteen months of military service, then an M.S. in zoology from Ohio State, where he wrote a thesis on birth control of white-tailed deer. The research was conducted in a two-thousand-acre fenced property in northern Ohio owned by NASA. "They were having car collisions with deer and wanted to reduce them without killing them. I live-trapped females and implanted antifertility hormones. I had to catch them before they bred and use the right dosage. I must have trapped a couple hundred deer. It was a lot of fun. The method proved effective in reducing deer, but it only works well on small enclosed herds." (So it's not a solution for farmers, suburban gardeners, and other overpopulated places like Squaw Creek National Wildlife Refuge.)

Ron first worked for the Fish and Wildlife Service in the Kansas City office, mostly reviewing environmental impact statements to see if they considered wildlife. He got his chance for work on the ground with a job as wildlife biologist at DeSoto National Wildlife Refuge, north of Omaha

on the Missouri River. "I managed the cooperative farming program—three thousand acres—conducted biological surveys, took care of duck nesting boxes, and did grassland and other habitat management."

He became especially enthusiastic when he described working at Agassiz National Wildlife Refuge in northwest Minnesota, where he was the primary assistant manager, in charge of operation and management. "This is a waterfowl production area," Ron said. "It has 40,000 acres of wetland out of 61,000 total acres. We were number one in production of canvasbacks and number three in redheads in Region 3. . . . There were timber wolves, moose, and of course deer. . . . It was cold up there. My first winter, 1977, we had eighty-five straight days below thirty-two degrees and thirty-five days—all day—below zero. The lowest was minus thirty-nine. . . . I used snowshoes a lot. I didn't know anything about snowmobiles—thought they had a reverse. I got stuck in a snowbank and couldn't back out. They never let me forget that.

"I really enjoyed Agassiz. One of my favorite things was catching ducklings on moonless nights from an airboat, using a spotlight. We'd scoop them up with a dip net. When we had forty or fifty, we'd band and release them, then continue. This was a bit dangerous, as you might hit something or tip over." (Charley Shaiffer, down at Mingo, would smile and nod at that.)

The Squaw Creek opportunity, which would bring Ron and his wife closer to their parents, came in 1987, when he was selected as a "training manager," supposedly for just two to four years. When the Fish and Wildlife Service stopped the program, "I said I was still learning here. The service doesn't want to move people very often now, so I'm still here." And he's happy that he is.

Besides managing the water in ten pools and fourteen moist-soil units—raising levels in the fall for ducks, and lowering them in spring for shorebirds—he supervises a permanent staff of seven. These include an assistant manager, an environmental education specialist, a wildlife biologist, a maintenance mechanic, two tractor operators, and an administrative technician. This last person, the aforementioned Joanna Foster, "meets visitors," Ron said, "answers the phone, pays bills, helps us spend the money, orders stuff, does time and attendance slips, is putting together the annual narrative from material the staff gives her. If she wasn't here we'd be in

deep trouble." Supervising his staff, he says, is not difficult. "They're all self-motivated."

Frank Durbian, a big, high-energy man, is the wildlife biologist. He worked in two national wildlife refuges in Montana before coming to Squaw Creek. It was now time for the annual deer counts, and he invited me to come along. As darkness descends, we travel around the west side of the refuge on a twenty-one-kilometer route, with two wildlife students from Missouri Western State College—Leonard Hanway and Rebecka Goins— standing in the back of the pickup. Another team is taking a fourteen-kilometer route on the east side of the refuge.

Frank drives and records data on a clipboard, simultaneously explaining the procedure to me. The two in back shine spotlights on both sides of the road. When deer are spotted, they tell Frank, who usually has already seen them. He stops at a point directly opposite the deer, and a student looks at each one through a Laser Range Finder—a type of binoculars that shows the distance in meters. The distance and category of deer—male, female, or fawn—are announced to Frank. All the data, including the road mileage points at which deer are seen, will be fed into a computer program that converts the information to deer per square kilometer/square mile, taking into account the habitat and the fact that the number of deer seen decreases with distance from the road.

We see the most deer in two soybean fields, one of which has a strip of clover on the far side. Both bucks and does are assembled there. One buck, which everyone recognizes, carries his antlers tipped to one side. Our final total, after three hours of driving, is 163. The other team spots 239, for a combined total of 402.

The Squaw Creek staff has been conducting deer counts since 1988, and they've used the present method since 2000. Frank usually does three counts before the Missouri gun season and three counts afterward. "One reason for the counts," he says, "is to justify our muzzle-loader season if it's opposed by animal rights groups. The deer density here is three or more times the density for this part of Missouri." (The current refuge density is about sixty deer per square mile. The goal is to get it down to twenty or twenty-five.)

On our evening drive, we also saw a lot of raccoons foraging in the marshes, a few cottontails, and a 'possum. We heard coyotes barking and,

in the impoundments favored by ducks, continuous quacking. "They never sleep," Frank said, "or maybe they sleep in shifts."

I asked him about other wildlife monitoring on the refuge. "We monitor just about everything here," he said, "waterfowl, other birds, small mammals, reptiles, amphibians, even dragonflies. The diversity here is impressive for a small refuge," he added. (The refuge is home to 34 species of mammals and 36 species of reptiles and amphibians. Over 300 kinds of birds have been recorded. The first dragonfly survey found 23 species.)

Population monitoring is especially important for waterfowl management—the refuge's prime purpose—and for species considered rare or in trouble. Among the latter are certain denizens of wet prairie habitats. Squaw Creek has about sixteen hundred acres of wet prairie—the largest in Missouri—and within it the state's largest population of eastern massasauga rattlesnakes, a small, retiring reptile now restricted to just a few locations between Missouri and Pennsylvania. In 2001 Frank Durbian found eighty-five. Studies have been conducted to determine where the massasaugas go in summer when they leave their crayfish burrows, and to learn the effects on them of prescribed burning, needed to maintain healthy prairie. (No massasauga mortality was found during the first study of burning.)

Point counts out in the cordgrass and prairie flowers recorded common yellowthroats, red-winged blackbirds, cowbirds, pheasants, dickcissels, sedge wrens, and grasshopper sparrows. Of these, the last three are declining throughout the grasslands of midwestern and eastern United States. A study of sedge wren ecology was undertaken at Squaw Creek to learn more about the habitat needs of this secretive little bird.

The first survey of breeding frogs and toads was conducted in 2001. One purpose was to look for deformities, a worldwide, unexplained concern with amphibians. The survey identified six species, among which the deformity rate ranged from 0 to 4.2 percent, happily mostly within the normal rate of 1 to 3 percent.

Muskrats are an important part of the refuge's aquatic ecosystems, eating out sections of cattail and American lotus, which benefits waterfowl, and providing food themselves for numerous predators. In early winter the staff counts the muskrat houses, which the animals build for winter shelter and food. (They can eat the vegetation forming their houses if outside forage becomes scarce or hard to reach.) From headquarters, up on the hill-

side, I could see dark muskrat houses dotted about in the mostly dry Eagle Pool, with rings of water around them where the muskrats had removed the vegetation, digging moats around their castles, as it were, which they could enter underwater. With the dryness, this winter of 2002–2003 might be hard on them. "The muskrats in Eagle Pool," Ron said, "will have tubers of American lotus to feed on, but they'll be more exposed to predators without water." They might even move clear off the refuge, as they were reported to have done in the dry winter of 1988–1989.

In an airboat, Ron, other staff members, and wildlife students also count nests of least bitterns, moorhens, and pied-billed grebes, marsh birds that are scarce and local in Missouri. In 2001, 123 least bittern, 6 moorhen, and 43 pied-billed grebe nests were found. But the serious drought of 2002 hurt them. "We found only seven or eight least bittern nests this year," Ron said. "Pied-billed grebes did better because they nest a month earlier, in late April to early May," before the drought took its full toll.

The refuge doesn't exist in isolation, of course. It's part of a mosaic of wetlands and farm fields on the broad Missouri River floodplain, and waterfowl, deer, and other animals come and go from one place to another. This led a local farmer to suspect that the wild pigs on his farm had come from the refuge. He entered the headquarters one morning to complain. Ron told him he didn't think there were any wild pigs on the refuge. (He was probably right—the staff keeps pretty close tabs on its animal life, as I've described.)

The waterfowl, however, certainly do move back and forth, and they are an important component of the area's economy and culture. When the refuge was created, in 1935, there was concern about the effect on hunting. According to a newspaper article of the time: "Some local sportsmen are deploring the loss of this good shooting territory which has attracted duck hunters in season from many miles away. Others, however, believe the establishment of this protected region will attract waterfowl in such numbers that the hunting will be improved in nearby swamp lands."

In 1950, another newspaper article reported that Judge H. H. Hall had been acquitted of shooting ducks illegally on his farm, which, he said, had been "plagued by the hundreds of thousands of ducks eating his corn for weeks." He was protecting his property, he said. The judge had been arrested by the superintendent of Squaw Creek refuge.

Visitors entering Mound City from I-29 get a clue to the importance of

waterfowl around here when they see Malcolm Mallard, a giant duck on a pole whose wings revolve in the wind. Notices in the lobby of Audrey's Motel said: "HUNTERS. <u>Hunting dogs</u> are only allowed in rooms with direct access to the out of doors." And: "ATTENTION HUNTERS—$250.00 FINE. PLEASE DO NOT CLEAN GAME ANIMALS IN ROOM OR DISCARD ANIMAL REMAINS IN OR AROUND DUMPSTER/MOTEL."

Waterfowl hunters go to the hunt clubs scattered in wet patches among the corn and soybean fields from Squaw Creek westward to Big Lake. Most are relatively small—forty to three hundred acres. From the refuge auto tour road I could see, just outside, flocks of snow goose decoys, little white flags flapping in the breeze. The Fish and Wildlife Service would like to buy some of the adjacent land from willing sellers, including hunt clubs, which occasionally come on the market, to increase the refuge's resource management potential and versatility.

The service would also like to buy more of the wooded loess hills that lie along the refuge's eastern edge. These hills, which border the Missouri River floodplain from south of St. Joseph to northern Iowa, were formed from wind-blown, glacier-scraped rock dust that blanketed much of Missouri during the Ice Age. A short trail leads to the narrow top of the ridge behind the headquarters. Another, the Mike Callow Memorial Trail, follows its foot. (Mike Callow was the assistant manager at Squaw Creek from 1991 to 1998. He was killed in a plane crash on the Columbia River while engaged in waterfowl surveys.) At the end of the trail, on the hillside, lies a prairie patch of sideoats grama, Indian grass, and little bluestem. The staff is restoring such patches on south- and west-facing slopes with the help of prescribed fire and brush cutting. Photographs from the 1930s show where many of these prairie patches used to be, before trees invaded.

After walking the trail, back at headquarters, I met Jim Broker, a retired minister from Mound City. He is a volunteer at the refuge, greeting visitors, answering the phone, cleaning up, "whatever is needed." Such volunteers—currently more than one hundred strong—contribute thousands of hours of help each year, staffing the visitor center on spring and fall weekends, repairing trails, painting signs, and helping in many other ways to supplement the work of the few employees. Most of them come from the Burroughs Audubon Society at Kansas City and the Midland Empire

Audubon Society at St. Joseph. Students from Northwest Missouri State University and especially Missouri Western State College help with wildlife projects.

The volunteers also formed the Friends of Squaw Creek group, which acts as an advocate for the refuge and raises funds. The group's president got $250,000 for the refuge as a rider on a bill by Senator Kit Bond. The money is being used for several facility needs, especially an auditorium addition to the visitor center, part of the headquarters building.

The volunteers are thus highly valued members of the Squaw Creek "family," and Ron Bell works with all of them closely. His professional world is centered in his small office and radiates out from there in ever-widening circles: next to his office, those of his staff; next to them, the exhibit room, with mounted wildlife and a case of insects collected by Ron himself (he once thought of becoming an entomologist); outside, the refuge, with its living wildlife and manifold needs; beyond, towns and farmland linked in many ways to the refuge; and farther, to all the people concerned with Squaw Creek and the rest of the national wildlife refuge system.

Ron does a lot of planning, and one plan he was engaged with was the forthcoming celebration of the hundredth anniversary of the refuge system. On March 14, 1903, President Theodore Roosevelt established America's first national wildlife refuge: three-acre Pelican Island, on the Gulf Coast of Florida, for the protection of waterbirds then under heavy attack by commercial hunters and poachers. He added fifty-five more such sanctuaries, and today there are over 535, embracing nearly a hundred million acres, all across the country.

In Missouri, Squaw Creek and the rest of the national wildlife refuges join with the many other federal and state lands dedicated to the conservation of natural resources and public enjoyment of them. It's a sparkling network, one to be proud of and to cherish.

CHALLENGE OF THE CHRISTMAS BIRD COUNT

All across North America, in every state, in every province, cars filled
with birders were drawing together—heading for brightly lit house-
holds, church halls, and traditional old bars. In hundreds of locations,
tired but happy figures were shaking off their heavy garments, shout-
ing greetings across crowded rooms—to friends and fellow birders
who had shared the challenge and adventure of the day.

PETE DUNNE, *The Feather Quest*

In the predawn at Squaw Creek's visitor center, Mark Robbins had
greeted his volunteers, who had arrived from various parts of Missouri
and Kansas, and assigned them to sectors. Ron Bell, Brad Jacobs, and I
would take the western half of the national wildlife refuge. But first we
were checking a wooded area around an old homestead other birders
could not get to. The woods seemed full of birds and suggested we'd have
a good day.

We were engaged in the Squaw Creek Christmas Bird Count on
December 17, 2003, one of about two thousand such counts being con-
ducted throughout North America, parts of Central and South America,
Bermuda, the West Indies, and the Pacific Islands. This massive undertaking
had its origin back in 1900, when Frank Chapman, a scientist later associ-
ated with the American Museum of Natural History in New York, per-
suaded twenty-seven conservationists to go out on Christmas Day and
count birds, in twenty-five localities across the country. He saw this as a bet-
ter alternative to the tradition of the "side hunt," in which teams competed
on Christmas to see who could *shoot* the most birds and small mammals.

Conservation finally won, as the side hunt became history and the
Christmas count became an ever more popular tradition. A few rules were

developed: each count would be held during a twenty-four-hour period within a fifteen-mile-diameter circle, during two-plus weeks bracketing Christmas Day. Beginning with the 2000–2001 count, this period was set permanently at December 14 to January 5. The basic purpose is to gather data on bird populations, but the count is popular mainly because of the camaraderie and competition—who can find the most species—at this special time of the year.

The challenge, then, is to find the most variety and number of birds within the 177-square-mile count circle. Participants must work with the land in the sense of knowing it and how it supports birds. What habitats are there, and what kinds of birds use each kind of habitat? Birders with the most skill in identifying birds and most knowledge about their behavior and choice of habitat, as well as familiarity with the assigned sector, will find the most species and perhaps also the highest numbers of birds.

The total result in each count circle depends on the diversity of habitats (especially regarding water areas), the number and skill of birders (as described above), the weather, and the latitude: Inland from coastal zones, the more southerly areas have more birds in winter than more northerly ones. Counts in the Americas may range from a single raven in northern Alaska or Canada to more than three hundred species in some tropical areas. To a much lesser degree, the same pattern holds true from north to south in Missouri.

Success of a count also depends on how it is organized and, you might say, its personality. Has the count compiler attracted a good number of enthusiastic participants, including experienced birders? Are the best birders, with or without less expert people to provide more pairs of eyes, assigned to the most productive sectors? And has the count developed a gung-ho spirit, which compels people to go out before dawn to listen for owls, or persevere through a day filled with rain, sleet, snow, or chilling wind? Missouri's counts, as in other states, range from top effort to a more casual approach.

I would have to rank Squaw Creek's count pretty high for level of expertise and commitment. There were only thirteen of us in 2003, but that included the compiler, Mark Robbins, who is an ornithologist at the University of Kansas, ornithologist Brad Jacobs and others from the Missouri Department of Conservation, Don Arney, the compiler for the Kansas

City count, Tommie Rogers, a local woman who had become a very good birder and knew the area well, and several other experienced people. Mark had come from Lawrence, Kansas, others from even farther away.

As dawn broke, the teams headed out to five sectors, two encompassing the refuge, one around Big Lake State Park, one around the Bob Brown Conservation Area on the Missouri River, and another on the east side of the count circle. After checking the area around the old abandoned homestead and recording numerous chickadees, woodpeckers, and other woods birds, our threesome moved to the refuge. Brad followed Ron and me in his pickup camper, keeping in touch with tiny walkie-talkies he'd brought. Before Thanksgiving there had been 320,000 snow geese at the refuge. But subsequent cold weather had frozen almost all the pools and the geese had left—all, that is, except the thousand or so that couldn't fly because of sickness or wounding and had gotten frozen into the ice. Now some two hundred eagles remained to feed on the dead, making big dark spots all over Eagle Pool and other impoundments with goose carcasses. Eagles came and went all day, many perching in trees fringing the pools.

Brad constantly scans the landscape in all directions on a count, and soon he came in on the walkie-talkie: "Cooper's hawk at five o'clock." It was behind us and we missed it. Then, "rough-legged hawk at ten o'clock." We'd seen this one, hovering ahead of us over distant marshes, this wonderful large hawk down from its Arctic breeding grounds.

Driving slowly along a dike, we flushed a bunch of meadowlarks. They settled nearby and the question became, Are they eastern or western meadowlarks? The two species are almost identical in appearance. Brad's experience settled this. Through his scope, he could see yellow extending from the breast onto the cheek, and the type of barring on the tail feathers. "Western," he announced.

Later, in our rearview mirror, we noticed that Brad had stopped and was looking at something far behind us. We backed up and discovered that we had driven right by a small falcon perched in a dead tree. Brad came to our pickup showing us the image he'd gotten in his digital camera through his telescope. The distinct tail banding and other features showed it to be a merlin, another "good" bird—meaning scarce or unexpected.

Late in the afternoon, we trudged through a brushy area near woods in the northwest part of the refuge. Just before scattered rain and sleet began

to fall, we flushed a big flock of sparrows and cardinals. Brad managed to pick a Harris's sparrow out of the bunch, our only one of the day. Ahead of us, five wild turkeys flew off toward a clump of trees.

We finished out on the dikes again to check ducks in one of the few patches of open water. "I'm best at waterfowl," Ron said, unhappy that there were so few on the frozen refuge. A blue-winged teal that he identified made him happier. This is a bird normally not found this far north in winter. As dusk settled, we watched for short-eared owls in the wet prairie area, but the rain apparently kept them from hunting that day.

Around five o'clock, all the participants returned to the visitor center for a quick tally of species. The full details from each party, including numbers of each species, would be sent to Mark later. As he went through the list of possible species, exclamations greeted reports of the less expected ones. Mark's group had found a sandhill crane and a hermit thrush that were north of their normal winter ranges. Don Arney and Tommie Rogers had three trumpeter swans and a ruby-crowned kinglet, another late-lingering migrant. The party from the eastern sector of the circle had spotted a redpoll, an arctic breeder at the southern edge of its winter range. Our blue-winged teal, a Gulf Coast winterer, was also a surprise. Snow geese totaled several thousand; flocks flew over even though open water for overnighting was scarce. Food, however, still abounded in grain fields. Altogether, the five parties had seen around three hundred bald eagles, the majority on Squaw Creek refuge.

"Eighty species," Mark concluded. This was a good total considering the recent cold weather, the frozen water, and the small numbers of blackbirds and sparrows, which Mark thought might be due to the drought of the last three years, reducing the food supply. "Most years," he told me, "we get up to a million blackbirds coming into the refuge in the evening to roost." Nobody hung around to socialize. It was off to distant homes, the drive warmed by thoughts of a good day afield.

The Columbia Christmas count, on December 20, was very different. Seventy-one people participated, the largest number in Missouri. And most gathered in the evening for a potluck supper and a detailed tally of birds. It was a pleasant social occasion as well as an intense day of birding.

Susan Hazelwood, a senior grant writer in the Office of Research at the University of Missouri–Columbia, is the compiler. "I try to make this a

fun event," she said, "and help recruit new Audubon members." She figured that most of the teams have "one-third good birders, one-third intermediates, and one-third 'newbies.'"

Fun it was, but Susan was also out to find every species, if possible, that was in the count circle. As usual, she had gathered most of the twelve sector leaders on the first Thursday in December to plan the count. She had lists of previous participants and a list of hard-to-find birds that would require special effort. She was also in touch with feeder watchers, some of whom had unusual birds at their feeders. On the count, however, she herself would just fill in wherever needed, for example, "taking a woman with a bladder infection around who needed to be not far from a bathroom" as they counted birds.

The twelve sectors of the Columbia count circle include a wide range of habitats, from open farmland in the northeast, to urban areas, to heavily wooded "breaks" south of town, to the open pools of Eagle Bluffs Conservation Area along the Missouri River, where most of the waterfowl would be found. A unique habitat has been created in the Columbia sewage system—a string of marshes downstream from the treatment plant to filter out heavy metals and other pollutants that the plant can't remove. Birds like killdeers, snipes, and rails overwinter in these little wetlands, which the Columbia Audubon Society has special permission to visit on the Christmas count.

I joined Brad Jacobs again, to help him cover his sector on the east side of the count circle. This is mostly farmland, with small patches of woods. Two other helpers had backed out, requiring us to work the whole sector ourselves, visiting only the best spots. Brad knew these well, having covered that area many times.

Our prime piece of landscape was the University of Missouri's large, experimental Bradford Farm, in which various crops are grown. Strips of grassland, bare fields, wet draws, and two large ponds complete the patchwork picture. Certain birds could be expected here that might not be found elsewhere in the count circle, so we hunted especially for these. The western meadowlark wasn't too hard, as its "chuck" alarm call identified six of them without close examination of plumage.

The Le Conte's sparrow was a greater challenge. This secretive little bird hangs out in tall, thick grass and weeds in winter and must be flushed by

walking through such stands. Unless it perches momentarily on a stem where it can be studied with binoculars, there is little hope of making an identification. Brad and I began with a strip of Indian grass perhaps twenty yards wide and a hundred yards long, walking parallel routes through the dense, head-high stuff. Three or four sparrows flushed, but none perched for us. And all refused to be flushed again. We were equally unsuccessful in other such strips. Brad recalled, somewhat ruefully, the year he counted thirty Le Conte's sparrows here.

Sure enough, at the tally no one reported Le Conte's sparrow, but plenty of other interesting birds had been found. First, though, sitting around a dozen round tables in the basement of a Community of Christ Church, we tucked into the venison, buffalo, and vegetarian chili and other contributions to the supper. Then Susan's assistant began going through the bird list, calling out each sector for its count of each species, and typing in the numbers on a laptop.

This, to me, is always interesting—not just to hear about the unusual birds, but also to compare the numbers of each species in the different parts of the count circle. We, for instance, had found six kinds of woodpeckers, but the heavily wooded sectors had found many more of each, with the addition of the large pileated, a bird of mature forest.

As expected, the team in the Eagle Bluffs Conservation Area had most of the waterfowl and most of the bald eagles (we saw only Canada geese and a lone snow goose—our ponds were all frozen). A late-lingering catbird had been found, and in the sewage treatment marshes five Virginia rails. A Eurasian tree sparrow, a species normally restricted to the St. Louis area and up the Mississippi from there, was still coming to a feeder in Columbia. All told, ninety-six species had been recorded. That made several consecutive years in which Columbia had ninety or more species; in 2000, its ninety-six had been tops for the state.

The Liberal count, in southwest Missouri, does not expect to compete for the top list because it lacks variety of waterbirds, but it has its own special interest. Most of the circle is former prairie, now farmland, but it also includes existing prairie in Prairie State Park, and ponds and marshes in Shawnee Trails Conservation Area. Also, enough woods remain to provide habitat for most of the woodland species.

This count, begun in January 2002, is run by Larry Herbert, a meat

inspector for the USDA from Joplin. That's primarily to make a living, he says—birds are his great love. Larry runs a rather laid-back count, trying to allow his volunteers to cover whatever sector they're interested in, even if all want to go to the same area, but at the January 3, 2004, count, the seventeen participants were fortunately well spread out through the six sectors. I was teamed with Cyndi Evans, the Prairie State Park naturalist, and Connie Laughlin from Joplin.

It was a mild morning with temperatures in the sixties, but a cold front soon moved in, plunging readings to the forties and below. In my Ford Explorer we cruised the southern half of the park, stopping at likely spots for sparrows and other birds. We kept an eye on the broad expanses of prairie, now in various shades of brown, for hunting raptors. As usual in winter, there were many red-tailed hawks and northern harriers. Two rough-legged hawks, frequently hovering over the grassland as they watched for voles, were more exciting because less common. Most of the bison had been moved into units east of the railroad tracks, and we didn't run into them.

Our sector was the only one where prairie chickens could be expected, so we made a special effort to find them. Cyndi conducts counts of these birds throughout the winter and spring because the prairie chicken is scarce and declining in Missouri and therefore is carefully monitored. The birds at the state park had been using an area of fields and grassland at the east end, so there we headed. Since prairie chickens band together in winter, we could have covered most of the park without seeing any. Luckily, after we'd walked far down a grassy track, a flock of forty burst up from the edge of corn stubble and flew far into the distance. This may have been all the prairie chickens in the park.

After lunch, we entered a totally different habitat, the Lester Davis State Forest, on the south edge of the park. In the mid-twentieth century, Davis, an entomologist who lived in nearby Mindenmines and who worked for the Missouri Department of Agriculture, had planted 256 species of trees and shrubs—native and nonnative pines, oaks, and others—on this coal-mined land to see what would grow. Now a rather exotic mature forest covers this deeply corrugated surface. Here we ran into a big flock of woods birds, with yellow-rumped warblers, golden-crowned and ruby-crowned kinglets, brown creepers, and other species, topped off by a noisy pileated woodpecker.

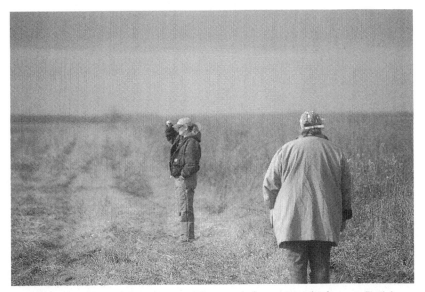

Cyndi Evans (left) and Connie Laughlin search for prairie chickens at Prairie State Park. NAPIER SHELTON

We ended our day looking for birds we'd not yet seen, in the run-down little town of Mindenmines. Specifically, we were checking bird feeders for house finches, and we found some. Two common grackles were a bonus.

This count had a lunch gathering but no debriefing at the end of day, and it was some time before all parties had sent Larry their results. The final tally was eighty-three species, a very good count, Larry said. About 21,000 individual birds were recorded, more than half of them snow geese. European starlings were a distant second at 1,524. According to ornithologist Jim D. Wilson, southwest Missouri boasts the largest concentration of wintering raptors in the state, and the count reflected this. We saw 350 hawks, most of them red-tails, harriers, or kestrels, plus four bald eagles and 30 owls, including 20 short-ears. It's good sparrow country, too; we found 11 different species.

Some of the best finds of the day were red-shouldered hawk, prairie falcon, eastern phoebe, marsh wren, gray catbird, Le Conte's sparrow, and Lincoln's sparrow. Yes, it was a very good count, and a very enjoyable one.

When the count period was over, I called around to find out how others had fared. Ken Vail's group, in the circle including the Ted Shanks

Conservation Area, had found sixty-some species, including twenty-five thousand mallards and a rare northern shrike. Susan Hazelwood, freed of her Columbia compiler duties and now birding full-bore, had spotted the shrike.

Don Arney's count circle on the east side of Kansas City is getting filled in with residential communities, but enough parkland remains to make it productive of birds. It encompasses Swope Park, Fleming Park (with large lakes), Longview Lake, and the James A. Reed Memorial Wildlife Area. Twenty-five birders had found eighty-three species and 35,115 individual birds, fewer than usual, perhaps because of drought, Don said. This count is one of the granddaddies of Missouri Christmas bird counts, having been started in 1907 and still using the same circle.

The Mingo count, run by Bill Reeves, a lawyer from Farmington, had its usual good day. Although it took place after Christmas (December 27), "the weather was outstanding," Reeves said, "and there was little frozen water. We had record high counts of eighteen species and one never before found on Missouri Christmas counts—an American redstart." This colorful small species of warbler winters in Central America, so Mingo's brave, stupid, or infirm redstart was indeed unusual. Thirty people, including good birders from St. Louis, Columbia, and Kansas City, had found 101 species.

For many years, Mingo usually had the top species count. Its far south location, in the Bootheel and on the Mississippi Flyway, variety of rich habitats, including bodies of shallow and deep water, swamps, and farm fields, and the expertise of its participants have combined to make this count seemingly unbeatable. But Fred Young of Independence thought he had discovered a contender.

During the breeding bird atlas project, Fred had covered a block in the vicinity of Four Rivers Conservation Area, north of Nevada, and found it full of a great variety of birds. He thought a Christmas count here would uncover an impressive assemblage of winter birds. But it took three years to convince other good birders to give it a try. The results in 1995 and 1996 were modest, but in 1997 ten observers recorded 101 species, the first Missouri Christmas count to reach 100 or more. The next year a larger group found 110 species and 493,632 individual birds; in this case, the high number of waterfowl was far exceeded by masses of blackbirds.

The 104 species tallied in 1999 made three years in a row that Horton/ Four Rivers had achieved the highest count in the state. Bumper crops of acorns and hickory nuts have attracted unusual numbers of red-headed woodpeckers; the 348 in 1998 and 411 in 2001 were the most on any count in the United States those years. (Mingo had 458 red-headed woodpeckers in 2002, though this was a few birds short of the U.S. high count at Union County, Illinois.)

So Horton/Four Rivers has indeed challenged Mingo for the top species list, though some others, like Taney County, with its hundreds of thousands of wintering robins, may have the most total birds. Four Rivers is about seventy-five miles farther north and higher in elevation than Mingo, so it is likely to have lower temperatures; but its mix of extensive wetlands, woods, and farmland, its being searched by some of the state's best birders, and its sometimes earlier count date than Mingo's makes the contest fairly even.

Weather is likely to determine the winner. In 2000, half a foot of snow and temperatures down to three degrees led to a low count of 58 species at Four Rivers. Frozen water drives out the waterbirds. More seasonable weather the next year produced 103 species. In 2003, nature struck again, with six to eight inches of snow, restricting road access and freezing most of the water. Nevertheless, the twenty-one observers—including eighty-two-year-old Fred Young, who had turned over the compiler duties to Roger McNeill—managed to find 96 species of birds. Mingo's list, however, at 101 had won that year, as it had in 2002. Occasionally, another count can sneak in with the top list, like Columbia in 2000, when its big corps of observers found 96 species.

I've played up the competitive side of the Christmas bird counts because it's fun, but more important scientifically is the information they produce. Randy Korotev, a "lunar geochemist" at Washington University, is the regional editor for the Missouri Christmas counts. His analysis, with those of the other regional editors, is published in *American Birds* by the National Audubon Society, sponsor of the counts. He reported that the Missouri counts, of which there are twenty-seven now, document a number of population changes. Among these is the long-term rise of bald eagles and sharp-shinned and Cooper's hawks, benefiting from the prohibition of persistent pesticides in the early 1970s; the appearance and

spread in the last few years of the introduced Eurasian collared-dove; the spread in western Missouri of the great-tailed grackle, a southwestern species; the decline of northern bobwhites; a recent drop in numbers of blue jays and American crows, which have been hard hit by the West Nile virus in some metropolitan areas; and continuing trouble for the loggerhead shrike, whose population in Missouri is only about one-quarter of that in the mid-1960s. Although more sophisticated studies are needed to explain many such changes, the Christmas counts are valuable for showing the existence of these changes and the species' geographic patterns.

Each year the number of Christmas bird counters will probably continue to rise, attracted not only by the company of birding friends and the chance to gather useful information, but also by the challenge of finding as many birds as possible in a given piece of terrain.

EPILOGUE

This kind of quest—getting to know the land—of course has no final end. There is always more to learn and experience. But I felt I had at last some grasp of the state, and it was all now part of me—the flat Bootheel, the wooded Ozark hills, the rich farmland of the north, the big rivers and little streams, the remnant prairies.

I came away with great admiration for the people who work with that land. They are dedicated and skilled. And they work well with each other, regardless of whose interests they technically serve, whether federal, state, or private. The needs of the land and their love of it bind all in one strong fellowship.

Now I can see even myself as another in the long line of people who in some way have worked with the land of Missouri, from the earliest Native Americans to the first European settlers to the outdoor professionals and amateurs of today. It is a lineage to be proud of.

My Missouri memories have expanded a hundredfold. Among the best: canoeing the Current River, learning about the interesting career path of Jenny Farenbaugh, watching snow geese descend in their thousands, boating Pomme de Terre Lake with Jeff Graham, seeing Mingo refuge the way Charley Shaiffer sees it, marveling at Roaring River's Opening Day, experiencing the joy of Ste. Genevievians as they dedicated their new levee, feeling the suspense as Joel's and Dave's dogs pointed quail.

These and many other experiences have enriched my life and, I hope, vicariously the lives of readers. Thank you, Missouri and Missourians.

FURTHER READING

I used the following books in writing my story, and readers who want to delve further into Missouri natural history and conservation should also find them useful. Many are available at nature centers and at state and federal sites.

Batt, Bruce D. J., ed. *Arctic Ecosystems in Peril: Report of the Arctic Goose Habitat Working Group.* Arctic Goose Joint Venture Special Publication. U.S. Fish and Wildlife Service, Washington, D.C., and Canadian Wildlife Service, Ottawa, Ontario, 1997.

Bellrose, Frank C. *Ducks, Geese, and Swans of North America.* Harrisburg, Pa.: Stackpole Books, 1981.

Changnon, Stanley A., ed. *The Great Flood of 1993: Causes, Impacts, and Responses.* Boulder, Colo.: Westview Press, 1996.

Fiennes, William. *The Snow Geese: A Story of Home.* New York: Random House, 2002.

Flader, Susan, ed. *Exploring Missouri's Legacy: State Parks and Historic Sites.* Columbia: University of Missouri Press, 1992.

Franzwa, Gregory M. *The Story of Old Ste. Genevieve.* Tucson: Patrice Press, 1998.

Greater St. Louis Archeological Society. "The Archeology of Missouri and Greater St. Louis." *Central States Archeological Journal* 37, no. 4 (October 1990).

Hall, Leonard. *Stars Upstream: Life along an Ozark River.* Chicago: University of Chicago Press, 1958.

Hawker, Jon L. *Missouri Landscapes: A Tour through Time.* Rolla: Missouri Department of Natural Resources, Division of Geology and Land Survey, 1992.

Heitzman, J. Richard, and Joan E. Heitzman. *Butterflies and Moths of Missouri.* Jefferson City: Missouri Department of Conservation, 1996.

Henry, Steve. *Mountain Bike! The Ozarks.* 2d ed. Birmingham, Ala.: Menasha Ridge Press, 2000.

Jacobs, Brad. *Birds in Missouri.* Jefferson City: Missouri Department of Conservation, 2001.

Jacobs, Brad, and James D. Wilson. *Missouri Breeding Bird Atlas, 1986–1992.* Natural History Series, no. 6. Jefferson City: Missouri Department of Conservation, 1997.

Johnson, Tom R. *The Amphibians and Reptiles of Missouri.* 2d ed. Jefferson City: Missouri Department of Conservation, 2000.

Keefe, James F. *The First Fifty Years.* Jefferson City: Missouri Department of Conservation, 1987.

Kight, Teresa, comp. *Conservation Trails: A Guide to Missouri Department of Conservation Hiking Trails.* Jefferson City: Missouri Department of Conservation, 1999.

Kirt, Russell R. *Prairie Plants of the Midwest: Identification and Ecology.* Champaign, Ill.: Stipes Publishing, 1995.

Ladd, Douglas M. *Tallgrass Prairie Wildflowers: A Field Guide.* Helena, Mont.: Falcon Press, 1995.

Lauber, Patricia. *Flood: Wrestling with the Mississippi.* Washington, D.C.: National Geographic Society, 1996.

Madson, John. *Where the Sky Began: Land of the Tallgrass Prairie.* Ames: Iowa State University Press, 1995.

Missouri Department of Conservation. *Missouri Nature Viewing Guide.* Jefferson City: Missouri Department of Conservation, 1995.

———. *Missouri's Conservation Atlas: A Guide to Exploring Your Conservation Lands.* Jefferson City: Missouri Department of Conservation, 2000.

Missouri Natural Areas Committee. *Directory of Missouri Natural Areas.* 1996.

Naeger, Bill, Patti Naeger, and Mark L. Evans. *Ste. Genevieve: A Leisurely Stroll through History.* Ste. Genevieve, Mo.: Merchant Street Publishing, 1999.

Nelson, Paul W. *The Terrestrial Natural Communities of Missouri.* Jefferson City: Missouri Department of Conservation, 1987.

O'Brien, Michael J., and W. Raymond Wood. *The Prehistory of Missouri.* Columbia: University of Missouri Press, 1998.

Palmer, Kay, and Bill Palmer, eds. *A Guide to Birding in Missouri*. N.p.: Audubon Society of Missouri, 2001.

Pflieger, William L. *The Fishes of Missouri*. Rev. ed. Jefferson City: Missouri Department of Conservation, 1997.

Rossiter, Phyllis. *A Living History of the Ozarks*. Gretna, La.: Pelican Publishing, 1992.

Schuchard, Oliver (photographs), and Steve Kohler (text). *Two Ozark Rivers: The Current and Jacks Fork*. Columbia: University of Missouri Press, 1984.

Stevens, Donald. *A Homeland and a Hinterland: The Current and Jacks Fork Riverways*. Washington, D.C.: National Park Service, 1991.

Tryon, Chuck. *Fly Fishing for Trout in Missouri*. Rolla, Mo.: Ozark Mountain Fly Fishers, 1999.

———. *200 Missouri Smallmouth Adventures*. Rolla, Mo.: Ozark Mountain Fly Fishers, 2001.

Vance, Joel M. *Down Home Missouri: When Girls Were Scary and Basketball Was King*. Columbia: University of Missouri Press, 2000.

Wilson, James D. *Common Birds of North America: An Expanded Guide Book*. Midwest Edition. Minocqua, Wis.: Willow Creek Press, 2001.

INDEX

Page numbers in italics refer to illustrations.

Agassiz National Wildlife Refuge, 230
Allen, Durward, 229
All-terrain vehicles (ATVs), 92, 103, 104, 105–6
Amphibians, 30–31, 44–45, 127, 232
Ancestors of the author, ix
Anderson, Bill, 168
Animals, extinct, 122
Arndt, Randy, 220
Arney, Don, 237, 238, 239, 244
Audubon, John James, 160

Badgley, Kevin, 2–4, *3,* 9, 12
Barbee, Carl, 182–83
Barksdale, Tim, 201
Bass: white, 53, 55, 61; largemouth, 54, 55, 59–60; smallmouth, 75, 95, 123
Bat Conservation International, 96
Bats: at Wilson's Creek National Battlefield, 41–42; in Mark Twain National Forest, 85; 105; at Ozark National Scenic Riverways, 114, 123
Bauman, Vernon, 164, 165, 166, 168–69, 170
Bean, Kolleen, 91
Bears, black, 45, 122, 140, 195
Beavers: at Mingo National Wildlife Refuge, 137–38; at Ted Shanks Conservation Area, 181–82; at Squaw Creek National Wildlife Refuge, 225
Bell, Ron, 224–26, *225,* 229–31, 233, 235
Big Lake State Park, 238
Big Muddy National Wildlife Refuge, 150
Big Piney River, 75, 89, 91, 95
Bird dogs, 151, 196–97
Birds: counting of, 12; at Pomme de Terre Lake, 55–56; at Mingo National

Wildlife Refuge, 136; mounted by Audubon, 160; at Ted Shanks Conservation Area, 180; at Dave Mackey's farm, 194, 195; and James D. Wilson, 198–99, 201–2, 203, 204–5, 206, 207, 208–9; and Brad Jacobs, 198, 199–200, 201, 202, 203–5, 206–7, 209–10; at Dunn Ranch, 217; at Squaw Creek National Wildlife Refuge, 232, 233; Squaw Creek count of, 238–39; Columbia count of, 240–41; Ted Shanks count of, 244; Kansas City count of, 244; Mingo count of, 244, 245; Horton/Four Rivers counts of, 244–45; population changes of, 245–46
Bisbee, John, 91
Bison, 1, 5, *7,* 8, 9, 10, 11, 13, 15–16
Blackwell, Mark, 40–41
Bladderpod, Missouri: on Bloody Hill, 36; biology of, 42; management of, 43
Bloody Hill: fighting at, 34, 36; brush on, 36, *37;* glade at, 36
Bluestem: big, 13, 27, 38, 214; little, 13, 27, 214, 234
Bob Brown Conservation Area, 238
Bolduc, Louis, 160
Bond, Senator Kit, 235
Bootheel, Missouri, 127, 131, 187
Bradford Farm, 240
Breeding bird atlases, 198, 201–8
Broker, Jim, 234
Brunner, Roland M., 24
Bureau of Land Management, 101
Burroughs Audubon Society, 234
Butler, Keith, 118
Butterflies: counting of, 12; at Wilson's Creek National Battlefield, 36, 44

Camping: at Prairie State Park, 10; at
 Roaring River State Park, 17; at Pomme
 de Terre Lake, 51, 56, 65; in Mark
 Twain National Forest, 91–92, 93, 94;
 at Duck Creek Conservation Area, 138
Canebrakes, 122, 204, 208
Canoeing: on Current River, 108–9,
 116–17, *117,* 120; in Mingo National
 Wildlife Refuge, 140
Catfish, 50, 53, 63, 154, 184, 185
Cattle, 188, 192–93
Caves: at Roaring River State Park, 29;
 animals in, 29, 125; in Mark Twain
 National Forest, 85; in Ozark National
 Scenic Riverways, 110, 114, 123, 125
Cedar, eastern red: at Roaring River State
 Park, 27–28, 29; at Wilson's Creek
 National Battlefield, 43; in Mark Twain
 National Forest, 82, 84
Chambers, Glenn: at home, 67; growing
 up, 68–69; career of, 69–72, *71;* otter
 programs, 77–79; Alaska adventures of,
 79–80; advice on photography, 80
Champion trees, 136
Chapman, Frank, 236
Chariton River, 145
Chigger Ridge Farms, 190, 196
Chilton Creek Watershed, 114, 116
Chouteau, Pierre, 202
Christmas bird counts: history of, 236–37;
 factors in success of, 237; at Squaw
 Creek National Wildlife Refuge,
 237–39; at Columbia, 239–41; at
 Liberal, 241–43, *243,* at Mingo
 National Wildlife Refuge, 244, 245; at
 Horton/Four Rivers, 244, 245; informa-
 tion from, 245
Cinematography, 70–72, 80
Civilian Conservation Corps (CCC): at
 Roaring River State Park, 24–25; at
 Mark Twain National Forest, 82, 83, 93;
 at Squaw Creek National Wildlife
 Refuge, 227
Columbia Audubon Society, 240
Connally, Ernest, 160
Conservation Reserve Program, 190
Cordgrass, 214, 232
Corps of Engineers, U.S. Army: at Pomme

de Terre Lake, 49, 52, 56, 57, 62;
 Kansas City District of, 56; at Ste.
 Genevieve, 162, 163–64, 167; at Ted
 Shanks Conservation Area, 185–86
Cottonmouths, 130, 131, 140, 142
Coyotes, 10, 11, 16, 180, 194, 231
Crabtree, Chris, 11
Crappie, 50, 54, 55, 60, 64, 191, 192, 195
Culpepper, Bryan, 124
Cultural resources, 45–46, 91, 118
Cunningham, Brian, 180–82
Cunningham, Rosa, 180–82
Cupola Pond, 98, 122
Current River, 108–10, 115, 116–17, 126
Cut-off (Chariton River), 145

Dablemont, Christy, 65
Darrough, Guy, 140
Davis, Jim, 56–57
Dean, Jerry, 19, 20–23, *22,* 32
Deer, white-tailed: at Prairie State Park,
 13, 14, 16; at Ozark National Scenic
 Riverways, 118; hunting of, at Ted
 Shanks Conservation Area, 177–80;
 hunting of, in Knox County, 189; hunt-
 ing of, on Dave Mackey's farm, 195–96;
 hunting of, at Squaw Creek National
 Wildlife Refuge, 226; control of, with
 antifertility hormones, 229; counting of,
 at Squaw Creek National Wildlife
 Refuge, 231
Design for Conservation Sales Tax, 149,
 198
DeSoto National Wildlife Refuge, 222
Dinosaurs, 140–41
Doe Run Company, 100–101
Dogwoods, 29, 30, 31, 90, 108
Dragonflies, 85, 89, 232
Drey, Leo, 84, 114
Drought, 20, 223, 239, 244
Duck Creek Conservation Area, 73, 138
Ducks Unlimited, 71
Dunn Ranch: as part of a focus area, 210,
 219–20; prescribed burning on,
 211–12, *211, 212,* 214, 215, 219; de-
 scription of, 212; management of,
 213–15; prairie chickens on, 214,
 215–17, *217;* and sericea lespedeza,

218; Pawnee Prairie section of, 218–19; animal restoration on, 220

DuPont Reservation Conservation Area, 187

Durbian, Frank, 231–32

Eagle Bluffs Conservation Area, 240, 241

Eagles, bald: at Prairie State Park, 6; at Roaring River State Park, 18, 25, 31; at chicken farms, 25–26; at Wilson's Creek National Battlefield, 41; at Pomme de Terre Lake, 63; at Mingo National Wildlife Refuge, 141; at Ste. Genevieve, 159; at Ted Shanks Conservation Area, 172, 177, 184, 185; restoration of, in Missouri, 208; at Squaw Creek National Wildlife Refuge, 221, 222–23, 238, 239; increase of, 245

Eberly, Jody, 96, 97

Ecosystem management, 91

Edwards, William, 35

Eleven Point River, 95, 111, 112

Elk, 5, 6, 13

Endangered species: at Prairie State Park, 9; at Wilson's Creek National Battlefield, 36, 41–43; in Mark Twain National Forest, 85, 89; at Ozark National Scenic Riverways, 114, 123

Environmental Quality Incentive Program (EQUIP), 219

Erickson, Dave, 73, 76

Evans, Cyndi, 6–7, 9–10, 12, 16

Falconry, 182–83

Falcons, peregrine, 2, 208

Farenbaugh, Jenny, 101–4, *104,* 105

Farming: in the Ozarks, 82, 87, 111; in Ozark National Scenic Riverways, 114; in the Mingo basin, 131; around Dalton, 145–46; and soil erosion, 148; at Ste. Genevieve, 157, 159; on Dave Mackey's farm, 190, 192–93; by Brad Jacobs, 210

Feller buncher, 218

Fescue: at Prairie State Park, 11; at Pomme de Terre Lake, 62; in Mark Twain National Forest, 88; at Ozark National Scenic Riverways, 122; on Dave

Mackey's farm, 192, 193; on Dunn Ranch, 214, 215; on focus areas, 219

Fire: effects on prairie, 4–5; in Mark Twain National Forest, 83, 92; use by Native Americans, 122; in the Ozarks, 148

Fish: rearing of, 21–22, 23, 32; predation on, 21–22, 26, 59; diseases of, 22; in Wilson's Creek, 35; in Pomme de Terre River, 63; in Vance's pond, 154; in Mackey's ponds, 191–92

Fish, Don, 97, 98, 105

Fish and Wildlife Service, U.S., 96, 186, 205, 226, 234

Fishing: at Roaring River State Park, 17–20; at private sites, 24; at Pomme de Terre Lake, 51, 53–55, 64, 65, 66; by Rich Meade, 61; by Robert Vader, 63; in Mark Twain National Forest, 89, 95; in Current River, 123; at Ted Shanks Conservation Area, 184, 185; on Dave Mackey's farm, 195

Fishing tournaments, 55

Floods: at Pomme de Terre Lake, 57; at Mingo National Wildlife Refuge, 131, 137; at Ste. Genevieve, 156, 158, 161–62, 162–66

Forests: in Roaring River State Park, 28–30; restoration of, 82, 115; in Mark Twain National Forest, 84, 93; in Ozark National Scenic Riverways, 110, 115, 122; in Mingo National Wildlife Refuge, 135–36; on Dave Mackey's farm, 194; Lester Davis State Forest, 242

Forest Service, USDA: practices of, x; and scenic river bill, 112, 114

Fort Kaskaskia, 158

Foster, Joanna, 225, 230

Fountain Grove Conservation Area, 187

Four Rivers Conservation Area, 244–45

Fox, Fred, 116

Franzwa, Gregory, 157

Frederickson, Leigh, 132

Friends of Mingo Swamp, 139

Friends of Squaw Creek, 225–26

Frogs: in Prairie State Park, 6, 7, 12; gigging of, 185; survey of, 232

Garrett, JoAnn, 202

Geese, Canada, 72, 129, 132, 133, 134, 184

Geese, snow: at Prairie State Park, 2; at Roaring River State Park, 31; at Hudson Bay, 221, 228; migration of, 221–22, 223; at Squaw Creek National Wildlife Refuge, *222*, 223, 224, 227, 238, 239; overpopulation of, 227–28; on Columbia bird count, 241; on Liberal bird count, 243

Geology: at Roaring River State Park, 28–29; and lead mining, 100–101

Gephardt, Representative Richard, 166, 169

Ginnings, Don, 50–51

Glades: characteristics of, 27; prescribed fire in, 27–28; at Wilson's Creek National Battlefield, 36; in Mark Twain National Forest, 84, *106;* in Ozark National Scenic Riverways, 118

Gladetop Trail, 106–7, *106, 107*

Glock, Robert, 89–90, 92

Goforth, Reid, 128

Goins, Rebecka, 231

Gossett, Mike, 123

Gott, Jerry, 82, 95

Graham, Dail, 52

Graham, Jeff, 52–55

Grand River Grasslands Focus Area, 219–20

Grand Champ, Le, 157, 159

Grass, Indian, 27, 38, 234, 241

Grass, reed canary, 175–76, 226

Grasses, warm-season, 88, 193, 219

Grassland Coalition, 210, 219

Grazing: effects on prairie, 5; in Ozark forests, 82–83; in Mark Twain National Forest, 87, 88; at Dave Mackey's farm, 192, 193; at Dunn Ranch, 214, 215

Green-tree reservoirs: at Mingo National Wildlife Refuge, 135; at Ted Shanks Conservation Area, 175

Grouse, ruffed, 69

Guibor's battery, 36

Hall, Judge H. H., 233

Hamilton, Dave, 73–75

Hanway, Leonard, 231

Harrell, Bob, 99

Hatcheries: Shepherd of the Hills, 21, 23; Roaring River, 21, 24; Chesapeake (at Neosho), 22, 23, 24; Bennett Springs, 23

Hawks: red-tailed, 16, 182–83, 217, 226, 242; rough-legged, 16, 238, 242; Cooper's, 238, 245; sharp-shinned, 245

Hazelwood, Susan, 239–40

Hendrickson, Laura, 64–65

Herbert, Larry, 241–42, 243

Herons, great blue: at Prairie State Park, 6; at Roaring River State Park, 21; at Wilson's Creek National Battlefield, 34; at Pomme de Terre Lake, 63; at Ste. Genevieve, 159; at Ted Shanks Conservation Area, 184; at Squaw Creek National Wildlife Refuge, 227

Hills, loess, 223, *224, 234*

Hoerner, Sharon, 205

Hoffman, Michelle, 10

Homesley, Tim, 19–20

Horses: at Wilson's Creek National Battlefield, 47, 48; in Mark Twain National Forest, 88, 92, 94, 104; in Ozark National Scenic Riverways, 116, 119, 123; on Dave Mackey's farm, 193–94

Horseshoe Lake, 175, 181, 185

Hudson Bay, 221, 222, 228

Hummingbird, David, 91

Hunting: at Pomme de Terre Lake, 61–62, 63; in Mark Twain National Forest, 92; at Mingo National Wildlife Refuge, 139–40; by Joel Vance, 150–51; at Ted Shanks Conservation Area, 171, 172–75, 177–80, 182, 185; on Dave Mackey's farm, 194, 195–97; at Squaw Creek National Wildlife Refuge, 226; of snow geese, 228; near Squaw Creek National Wildlife Refuge, 233–34

Interpretation: at Prairie State Park, 2–3, 4, 8–10, 13; at Roaring River State Park, 26, 30–31; at Pomme de Terre Lake, 65; at Ozark National Scenic

Riverways, 115, 124–25; at Mingo National Wildlife Refuge, 140
Ipock, Rex, 106–7

Jacks Fork, 109–10, 111, 115, 116, 119
Jackson, Keith, 176, 185, 186–87
Jacobs, Brad: early life of, 199; in Peace Corps, 200–201; on Navajo reservation, 201; and Missouri breeding bird atlas, 202, 203–4, *203,* 205, 206–7; other work of, 209–10; farm of, 210
James, Lucy W., 23
Jansen, Kenny, 192
Jenner, Julie, 164–65
Johnson, Larry, 118–19
Junior Naturalist Program, 30, 31

Kaintuck Hollow, 88–89
Kaskaskia, 158
Kaskaskia River, 158
Katy Trail, 149
Kayaking, 117
Kellerton Wildlife Management Area, 216
Kinne, Keith, 213–15, 218, 219, 220
Knox County, 188, 189, 195
Koppman, Pete, 139
Korotev, Randy, 202, 245

Lake of the Ozarks, 49, 51, 56, 57
Land and Resource Management Plan, 86
Landscape restoration, 33, 35, 41
Laughlin, Connie, 242
Law enforcement, 92–93, 118–19
Lead mining, 100–101
Lespedeza, sericea: at Prairie State Park, 12; characteristics of, 12; at Wilson's Creek National Battlefield, 37, 43–44; at Dunn Ranch, 213, 218
Lester Davis State Forest, 242
Levees: and the 1993 flood, 150, 163, 164, 165, 166; building of Ste. Genevieve urban design levee, 167–68; dedication of Ste. Genevieve levee, 168–69
Lichty, Mark, 171, 172–75, 185
Little Piney Creek, 93
Logging: at Roaring River State Park, 29; in the Ozarks, 82; in Mark Twain

National Forest, 85; in Current River area, 115; in Bootheel, 131
Louis Bolduc House, 160–61
Lusardi, Richard, 46, 48
Lyon, General Nathaniel, 33, 34, 36

Mackey, Dave: early life of, 188; career of, 188–89; farm of, 189–90; habitat improvements by, 190–91, *191;* farming methods of, 192–93; and Yettle House, 194, 196; wildlife on farm of, 194–95; fishing by, 195; hunting on farm of, 195–97, *197*
Mallards: studies of, 128–29; food of, 134, 135; pair bonding of, 135; at Ted Shanks Conservation Area, 171, 172, 175, 184, 185, 244
Mammals, 44, 45, 110, 232
Mark Twain National Forest: location of, 81; history of, 81–83; vegetation of, 84; management of, 84–87; Houston-Rolla District, 87–95; Doniphan\-Eleven Point District, 94, 95–98; Poplar Bluff District, 98–100; lead mining in, 100–101; Willow Springs\-Ava\-Cassville districts, 101–7
Marshall, Joe, 177, 179–80, 185
Maycroft, Kathy, 127, 139
McCulloch, General Benjamin, 33
McKinney, Debo, 75–76
McNeill, Roger, 245
Meade, Rich, 57–61
Meadowlark, 238, 240
Mehl, Molly, 140
Melick, Ross, 84, 85, 91, 98
Melton, Emory, 18
Merlin, 238
Methamphetamines, 92–93, 120
Midland Empire Audubon Society, 234–35
Mike Callow Memorial Trail, 234
Mill Creek, 89, 95
Miller, Brian, 10–11
Mingo National Wildlife Refuge: otters in, 73; description of, 127; duck banding at, 130; drainage at, 131; moist-soil units at, 132–35, *133,* 142; green-tree reservoirs at, 135–36; water level control

at, 136–37, *137;* beaver problems at, 137–38; hunting at, 139–40; eagles at, 141; snakes at, 141–42

Mississippi Flyway, 106, 244

Mississippi River: course of, 131, 158; floods of, 150, 156, 158, 161–66, 175, 186; 170, 172, 183; locks and dams on, 185–86; deepening channel of, 186–87

Missouri Canoe Floaters Association, 117

Missouri Conservationist, 145, 147, 153, 202

Missouri Department of Conservation, 21, 57–58, 59, 61, 62, 67–71 *passim;* otter restoration by, 72–75, 76, 77, 82, 83, 104, 114, 115, 130, 138, 139, 147, 148; and the conservation tax, 149, 150, 186, 187, 189, 198, 201, 204, 207–12 *passim,* 219, 220, 237

Missouri Department of Natural Resources, x, 62, 65, 98

Missouri River, 148, 150, 162, 224, 227, 238

Missouri Southern University, 3, 7

Missouri Western State College, 231, 235

Moist-soil units: at Mingo National Wildlife Refuge, 132–34, 142; at Ted Shanks Conservation Area, 186; at Squaw Creek National Wildlife Refuge, 230

Monopoly Marsh, 130–31, 136, 141

Montauk State Park, 23, 109, 123

Montrose Lake, 208

Morels, 144, 188, 191

Mountain lions: at Wilson's Creek National Battlefield, 45; at Ozark National Scenic Riverways, 122; on Dave Mackey's farm, 195

Multiple-use management, 81

Muskellunge, 53–54, 55, 57–59, *58*

Myers, Racine, 11, 13

Napier, Clyde, 111

National Audubon Society, 245

National Environmental Protection Act (NEPA), 102, 103

National Forest Management Act, 81, 102

National Park System, x, 108

National wildlife refuges: purpose of, x; growth of system, 235

National Wild Turkey Federation, 88, 96

Native Americans: use of bison parts by, 4; at Roaring River, 24; in Mark Twain National Forest, 91; in Ozark National Scenic Riverways, 121–22; at Ste. Genevieve, 157, 159

"Natural:" definition of, x

Natural areas, 29, 95, 98

Natural Resources Conservation Service, USDA, 188

Nature Conservancy, The: land purchases for Prairie State Park, 5; role in Pine Knot project, 96, 97; ownerships at Ozark National Scenic Riverways, 114; prescribed fire use by, 116; purchase of Dunn Ranch by, 212

Nelson, Paul, 98

Newkirk, Tarryn, 10

Northwest Missouri State University, 188, 235

Oaks: in Roaring River State Park, 29, 30; black, 29, 82, 90; scarlet, 82, 90; decline of, 90, 94; as waterfowl food, 135; at Ted Shanks Conservation Area, 175; on Dave Mackey's farm, 194

Oak savanna: restoration of, in state parks, 6; restoration of, at Wilson's Creek National Battlefield, 33, 39, 41; in Mark Twain National Forest, 88; restoration of, at Pawnee Prairie, 219

O'Donnell, Bill, 124–25, 126

Osage orange, 190, 214

Osage River system, 49, 56

Osprey, 208

Otter: as predator on fish, 21–22, 74, 75, 76, 78, 138, 181; raise and exhibited by Glenn Chambers, 67, 72, 77–79; Missouri restoration program, 72–75; attitudes about, 75–76; trapping of, 76, 77, 181; at Ted Shanks Conservation Area, 172

Otter Slough Conservation Area, 187

Outdoor Writers Association, 155

Owls, short-eared: at Prairie State Park, 6,

12; at Ted Shanks Conservation Area, 184; in Liberal Christmas bird count, 243

Ozark culture, 110–11, 116

Ozark National Scenic Riverways: rivers in, 108–10; description of resources in, 109–10; attitudes about, 110–11, 126; legislative history of, 111–12; land ownership in, 113–15; forest history in, 115; problems in, 116–19, *117,* 120–21; prescribed fire in, 122; animals in, 122–23; fish in, 123; interpretation in, 124–25; cave life in, 125

Page, Roberta, 92–93

Partners in Flight, 210

Pawnee Prairie (MDC), 219

Pawnee Prairie (TNC): prescribed burning on, 211–12, 219; clearing trees on, 218

Peace Corps, 200–201

Peck Ranch, 187

Pelican Island National Wildlife Refuge, 235

Pelicans, white: at Prairie State Park, 6; at Shepherd of the Hills Hatchery, 21; at Pomme de Terre Lake, 56; at Ted Shanks Conservation Area, 185; at Squaw Creek National Wildlife Refuge, 223

Perkins, Dennis, 218

Perry Lake, 185

Philipson, Jacob, 160

Photography, 68, 69, 72, 80

Pigs, wild, 233

Pinchot, Gifford, 90, 107

Pine Knot, 96–97

Pine savanna, 96–98, 115

Pioneer Forest, 84, 114

Places described in book: how chosen, ix; arrangement of, x

Poaching: in Ozark National Scenic Riverways, 118, 119, 121, 126; on Dave Mackey's farm, 196, 204

Pomme de Terre Lake: history of, 50–52; *52,* fishing at, 53–55; management of, 56–57; fisheries management at, 57–61; hunting at, 61–62; conservation agents

at, 62–64; and management of Pomme de Terre State Park, 64–65

Pomme de Terre River, 49, 50, 51, 63

Poppe, John, 176

Prairie, tallgrass: former extent of, 1, 212; characteristics of, 3, 4, 5; restoration of, 5, 38–39, 155, 212–15

Prairie, wet, 232, 239

Prairie chickens: at Prairie State Park, 1–3, 8, 16, 242; in Knox County, 194; at Dunn Ranch, 213, 214, 215–17, 219

Prairie State Park: prairie chickens in, 1–3, 8, 16, 242; bison in, 1, 5, 8, 9, 10, 11, 13, 15–16; prescribed fire in, 5, 10; history of, 5; flowering plants of, 6, 7, 8, 9, 10, 13, *14;* birds of, 6, 7, 8, 10; frogs of, 6; interpretation of, 2–3, 4, 8–10; monitoring at, 6, 12; training at, 10; maintenance at, 10, 11, 12; as part of a focus area, 210; Christmas bird count at, 242

Prescribed fire: at Prairie State Park, 10; at Roaring River State Park, 27–28, *28;* at Wilson's Creek National Battlefield, 38–40; changed attitudes about, 83; in Mark Twain National Forest, 88, 96; at Ozark National Scenic Riverways, 116, 122; on Vance property, 155; at Dunn Ranch, 211–12, *211, 212,* 214, 215, 219; at Squaw Creek National Wildlife Refuge, 232, 234

Price, Jim, 111, 115, 116, 120, 126

Price, John, 160

Price, Major General Sterling, 33, 35

Professions described in book, ix\–x

Pulaski's battery, 35

Putnam, Charles, 118

Quail (bobwhite), 150, 151, 172, 196–97, 246

Raccoon, 138, 181, 217, 231

Ragweed, 215

Rain, General James, 34

Rainbow Family of Living Light, 94

Rainey, Doug, 190

Rambo, Dwayne, 105

Rattlesnake: western pigmy, 27, 31; tim-
ber, 31, 142; eastern massasauga, 232
Ray, John, 34
Ray House, 34
Recreation: at Wilson's Creek National
Battlefield, 37, 47; in Mark Twain
National Forest, 91–92, 105; at Ted
Shanks Conservation Area, 172
Redstarts, American, 244
Reeves, Bill, 244
Reptiles, 30, 44–45, 127, 141–42, 232
Rhoades, Ronald, 193
Ringgold Wildlife Management Area, 219
River meanders, 157
Roaring River, 20, 24
Roaring River State Park: Opening Day at,
17–19, *18;* trout rearing at, 20–22; his-
tory of, 24–25; nature center at, 25, 27,
30, 31; trails in, 25, 28–30; interpreta-
tion at, 26, 30–31; prescribed fire at,
27–28, *28;* forests of, 29–30; seasonal
changes at, 31
Robbins, Chandler, 201
Robbins, Mark, 237, 239
Rockhouse Marsh, 132, 136
Rogers, Merle, 25, 26–27, 28, 30–31
Rogers, Tommie, 238, 239
Roosevelt, President Theodore, 235
Roundup (herbicide), 192
Rozier, Ferdinand, 160
Rubles, Leslie, 65

Salt River, 172, 180, 184
Sand boils, 135, 165
Sayman, Thomas M., 24
Scenic rivers, 111–12, 148
Schwent, Mick, 164
Scotland County, 188
Seeds, 38, 210, 219
Seibel, Betty, 166, 168, 169
Sevin, Leroy, 78
Shad, gizzard, 53, 55, 61
Shaiffer, Charley, 127–30, 130–31,
132–33, *133,* 134–35, *137,* 138, 139,
142–43
Shanks, Charles R., 187
Shawnee Trails Conservation Area, 241
Sigel, Colonel Franz, 33–34, 47

Siltation: of dams, 57; control of, on
Mackey's farm, 190; at Squaw Creek
National Wildlife Refuge, 226
Simmons, Dan, 177–79, 185
Simpson, Bill, 183
Smith, Tim, 30
Soil Conservation Service, USDA, 188
Soil erosion, 148, 192, 226
Southwest Missouri State University, 3
Sparrows: LeConte's, 240–41; Eurasian
tree, 241
Spring Creek, 89
Springs: at Roaring River State Park, 20,
24, 29; at Wilson's Creek National
Battlefield, 47; in Ozark National
Scenic Riverways, 109, 110, 116, 124
Squaw Creek National Wildlife Refuge:
snow geese at, 221–22, *222,* 223, 227,
238, 239; bald eagles at, 221, 222–23,
238, 239; waterfowl at, 224, 227; water
management at, 224–26; exotic plants
at, 226; deer population at, 226, 231;
Civilian Conservation Corps work at,
227; staff at, 230; animal monitoring at,
232–33; relation to adjacent land,
233–34; volunteers at, 234–35
State parks, Missouri: management of,
5–6; campground reservations in, 65
Ste. Genevieve: history of, 156–59; houses
of, 160–61; floods at, 161–66, *163;*
building levee at, 167–68; levee dedica-
tion at, 168–69, *169*
Steinman, Steve, 87–88, 92
Steuber, John, 66
Stevens, Donald, 111
Stilts, black-necked, 205–6
Stream management, 23, 89
Sturgis, Major Samuel, 34
Sullivan, Art, 123
Sullivan, Gary, 33, 37–38, *39,* 39–42,
43–44, 45, 46–47

Table Rock Lake, 20, 23, 25
Taney County, 245
Taylor, Donald, 100–101
Taylor Grazing Act, 102
Ted Shanks Conservation Area: duck-
hunting at, 171, 172–75; *173, 174;* loss

of oaks at, 175; invasion of reed canary grass at, 175–76; waterfowl habits at, 176–77; eagles at, 177, 184, 185; bowhunting at, 177–80, *179;* trapping at, 180–82; falconry at, 182–83; Christmas bird counts at, 183–84, 243–44; spring at, 184–85; frog gigging at, 185; history of, 185–86; management at, 186; water problems at, 186–87

Terry, Bill, 119–21, 126

Thomas, Lisa, 38, 42, 44

Timber management: on Mark Twain National Forest, 84–85, 89–90, 97, 104–5; at Ozark National Scenic Riverways, 114–15

Timber markets, 98

Timber sales, 87–88, 100

Tornado damage, 99–100

Trapping: of otters, 76, 77; of beavers, 137–38, 225; at Ted Shanks Conservation Area, 180–82

Trees, planting of, 82, 89, 175

Trout, brown: in Roaring River, 17, 19–20; introduction to Missouri of, 23–24; in Current River, 123

Trout, rainbow: in Roaring River, 17, 19–20; introduction to Missouri of, 23–24; in Mill Creek, 89; in Current River, 123

Tryon, Chuck, 20, 23–24, 75, 89, 100, 123

Tubing, 116, 120

Turkey, wild: filmed by Glenn Chambers, 70; restoration in Missouri, 148; on Joel Vance's place, 154; at Ste. Genevieve, 159; on Dave Mackey's farm, 191, 194; on Christmas bird count, 239

Tuttle, Merle, 102

Udall, Stewart, 112

University of Missouri\-Columbia, 22, 69, 128, 146, 153, 201, 239

U.S. Geological Survey, 101

Vader, Robert, 62–64

Vail, Ken, 183–84

Vance, Joel: youth of, 145–46; career of,

147–50; on conservation issues in Missouri, 147–49, 150; hunting of, 151, 196–97; on writing, 151–53; home and land of, *152,* 153–55

Vansel, Amanda, 9, 10

Voyles, Jim, 105–6

Wallace, Dennis, 62

Walleye, 60

Waltz, Mayor Kathleen, 169

Warblers, Swainson's, 122, 204, 208

Ward, Chris, 112–14, *113,* 116–18, 126

Ware, Eugene F., 36

Waterfowl: nesting of, 130, 184; banding of, 130, 230; food of, 131, 132, 133, 134, 135, 175, 224; numbers of, 132, 134, 171, 175, 176, 222, 223, 227; behavior of, 134, 142, 176; migrations of, 134, 221–22, 223, 227–28

Water management: at Mingo National Wildlife Refuge, 127, 131, 132, 133, 136–37; at Ted Shanks Conservation Area, 175, 186; at Squaw Creek National Wildlife Refuge, 225–26

Water quality: at Wilson's Creek National Battlefield, 46; at Pomme de Terre Lake, 61; at Ozark National Scenic Riverways, 116, 118, 123; in Missouri, 148

Weightman, Colonel Richard, 34

Welty, Eudora, 151

White, George O., 82

Wiggins, Charlotte, 83–84, 90

Wild Area, 28

Wildbranch writing workshop, 144, 151, 152, 155

Wilderness areas, 87, 94–95, 136

Wildflowers: at Prairie State Park, 1, 6, 7, 8, 9, 10, 13, *14;* in glades, 27, 84; in Roaring River State Park, 27, 30, 31; at Dunn Ranch, 214, 215, 219, 220

Wildlife management: at Pomme de Terre Lake, 62; by Dave Mackey, 189, 190–91, 192

Wildlife restoration, 148, 187, 220

Williams, Leroy, 50

Wilson, (Coach) Jim, 65

Wilson, James D.: early life of, 198–99; and the Missouri Breeding Bird Atlas,

201–2, 203, 204, 205, 206, 207; restoration projects of, 208, *209;* retirement activities of, 208–9

Wilson's Creek, 34, 35, 46

Wilson's Creek National Battlefield: Civil War battle at, 33–34; restoring oak savanna at, 33, 39, 41; tour road at, 34–37; exotic plants at, 37, 41, 43–44; restoring prairie at, 38–39; prescribed fire at, 39–40; endangered species at, 41–43; inventory of plants and animals at, 44–45; inventory of cultural resources at, 45–46; water quality at, 46; development pressures at, 47; recreational activities at, 47

Witt, Alec, 19

Witt, Richard, 19

Woodpeckers, 95, 140, 195, 196, 203, 241, 245

Young, Fred, 244, 245

Zerega, Jim, 162, 167, 168

ABOUT THE AUTHOR

Napier Shelton is a former writer and editor for the National Park Service. He is the author of a number of books, including *Huron: The Seasons of a Great Lake* and *Where to Watch Birds in Azerbaijan.* He resides in Washington, D.C.